NATIONAL GALLERY OF ART

KRESS FOUNDATION STUDIES

IN THE HISTORY OF EUROPEAN ART

NUMBER FOUR

FRANS HALS

BY SEYMOUR SLIVE

Φ

PHAIDON

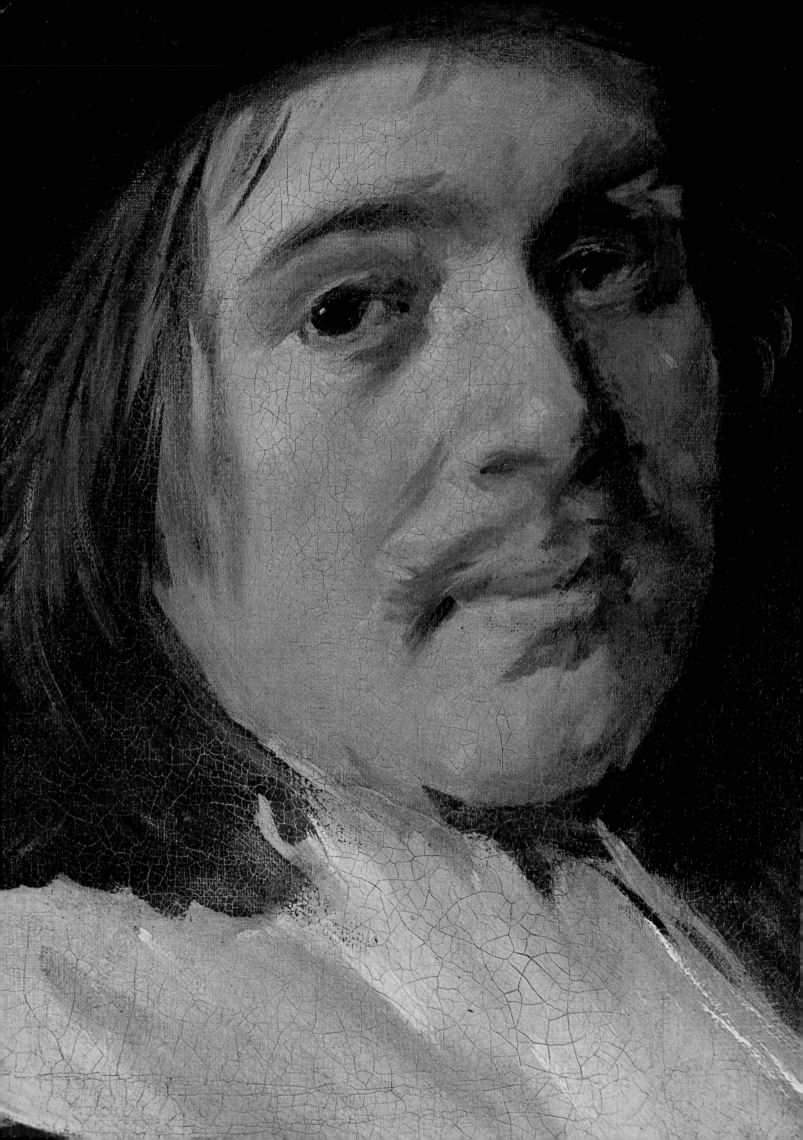

NATIONAL GALLERY OF ART : KRESS FOUNDATION
STUDIES IN THE HISTORY OF EUROPEAN ART

Frans Hals

SEYMOUR SLIVE

VOLUME ONE : TEXT

Φ PHAIDON

ALL RIGHTS RESERVED BY PHAIDON PRESS LTD
5 CROMWELL PLACE · LONDON S.W.7
1970

PHAIDON PUBLISHERS INC · NEW YORK
DISTRIBUTORS IN THE UNITED STATES:
PRAEGER PUBLISHERS INC
111 FOURTH AVENUE · NEW YORK · N.Y. 10003

LIBRARY OF CONGRESS CATALOG
CARD NUMBER 71-112414

ISBN 0 7148 1443 1 (set of three volumes)
ISBN 0 7148 1444 X (text volume)

PRINTED BY HUNT BARNARD PRINTING LTD · AYLESBURY · ENGLAND
COLOUR PLATES PRINTED IN THE NETHERLANDS BY DE LANGE/VAN LEER N.V.

To JAKOB ROSENBERG

Contents

Preface

THE Text Volume of this study of Frans Hals endeavours to centre on a discussion of the artist's works, his development and the significance of his pictorial achievement. An attempt has also been made to relate the little that is known about Hals' life and the reactions of his contemporaries to his art as well as to give an account of those attitudes of his period which might enhance understanding of his intent and accomplishment. A bibliographical note, which follows the text, has been compiled to provide references for readers who wish additional material on topics discussed within the volume. The Plate Volume includes illustrations of Hals' paintings arranged to show the main lines of the artist's development. Many of the plates were reproduced from new photographs taken expressly for this study; a special effort was made to include details of pictures which give a close view of the range of his subjects and the power of his technique. The forthcoming third volume will be a catalogue of Hals' paintings, copies, lost works and some of the borderline pictures which have been ascribed to him. Intended for the specialist and others who like to go into the kitchen, the Catalogue Volume will present more specialized discussions of attribution and chronology, documentation and additional bibliographical references to individual paintings.

I should like to acknowledge how much these volumes owe to earlier studies on Hals, in particular to W. Bode's pioneer publications (1871; 1883; 1914), C. Hofstede de Groot's catalogue raisonné (1910) which, it seems, will never outlive its usefulness, works by W. R. Valentiner (1921; 1923; 1936), and N. S. Trivas' book (1941) on the paintings. Students will recognize that I have occasionally disagreed with views expressed by these authors and some other specialists, but this does not lessen my debt to them. I have also benefited from the documentary material published by A. Bredius in a series of indispensable articles (1913–1921), the more recent archival research of J. van Roey, C. C. van Valkenburg and C. A. van Hees, and the iconographic studies by P. J. J. van Thiel, P. J. Vinken and E. de Jongh.

More personal is my debt to the private owners of Hals' paintings and to members of the staffs of museums who received me with great courtesy, offered assistance in one way or another, and kindly gave permission to illustrate works in their possession or charge. I extend my thanks to all of them.

To H. P. Baard, Director of the Frans Hals Museum, and C. A. van Hees, former scientific assistant at that museum, I owe very special thanks for unfailing helpfulness and hospitality while studying the incomparable collection of the master's works at Haarlem. Hardly less valuable was the constant help with many matters received from A. B. de Vries, Director of the Mauritshuis at The Hague. I am grateful to both Mr. Baard and Dr. de Vries for giving me the opportunity to compile the catalogue for the exhibition of Frans Hals' paintings held in Haarlem in 1962. Information included in that catalogue as well as some afterthoughts and observations made

Preface

during the course of the exhibition, when there was occasion to make repeated, close examinations of a large number of the artist's works, have been incorporated in this study.

Like all students of Dutch art I am grateful to H. Gerson and S. Gudlaugsson for numerous suggestions and for generously putting at my disposal valuable material at the *Rijksbureau voor Kunsthistorische Documentatie* in The Hague. The staffs of the Fine Arts Library of Harvard University in Cambridge, the Witt Library of the Courtauld Institute in London, and the Frick Art Reference Library in New York, solved many problems for me. G. H. Kurtz patiently helped me find my way in the Municipal Archives of Haarlem. Amongst many others who facilitated the preparation of the volumes I remember with particular gratitude the friendly aid received from Vitale Bloch, Karel G. Boon, L. C. J. Frerichs, J. G. van Gelder, Julius Held, J. Kusnetzov, I. Linnik, Neil MacLaren, I. Q. van Regteren Altena, A. van Schendel, Wolfgang Stechow, and Christopher White. Margaret Ševčenko, who typed the manuscript, tactfully made discerning comments which have been incorporated in the text.

Thanks is extended to the editors of *The Burlington Magazine* and *Oud Holland* for permission to reprint material originally published in their journals in a slightly different form. Some passages in the text on Hals' first civic guard piece (pp. 39–49) have been revised and translated from an earlier essay on *Frans Hals: Schützengilde St. Georg, 1616* (Stuttgart, Philipp Reclam Jun., 1962) and the suggested reconstruction of one of the artist's family portraits (pp. 61–6) was initially proposed in *Miscellanea I. Q. van Regteren Altena* (Amsterdam: Scheltema & Holkema, 1969).

Special gratitude is due to the John Simon Guggenheim Memorial Foundation for a semester fellowship which permitted me to lay the ground work for this project. I am also indebted to the American Council of Learned Societies, the Harvard Foundation for Advanced Study and Research, and the Henry P. Kendall Foundation for grants-in-aid which enabled me to make study trips and procure photographs. To the Trustees of the National Gallery of Art and to the Samuel H. Kress Foundation I am obliged for including these volumes in the Kress Foundation Studies in the History of European Art. I should also like to express my warm appreciation to I. Grafe of Phaidon Press; an author could not find a more sympathetic or cooperative editor.

Finally, for help in so many ways I am beholden to my friends and colleagues in the Department of Fine Arts at Harvard, especially to James S. Ackerman, John P. Coolidge, Sydney Freedberg and, above all, to Jakob Rosenberg, to whom these volumes are dedicated with deep gratitude for the enormous benefits received from our joint efforts on other studies in the history of Dutch art and for the many rich pleasures of close friendship.

<div align="right">S. S.</div>

Harvard University, Fogg Art Museum,
Cambridge, Massachusetts
January, 1970

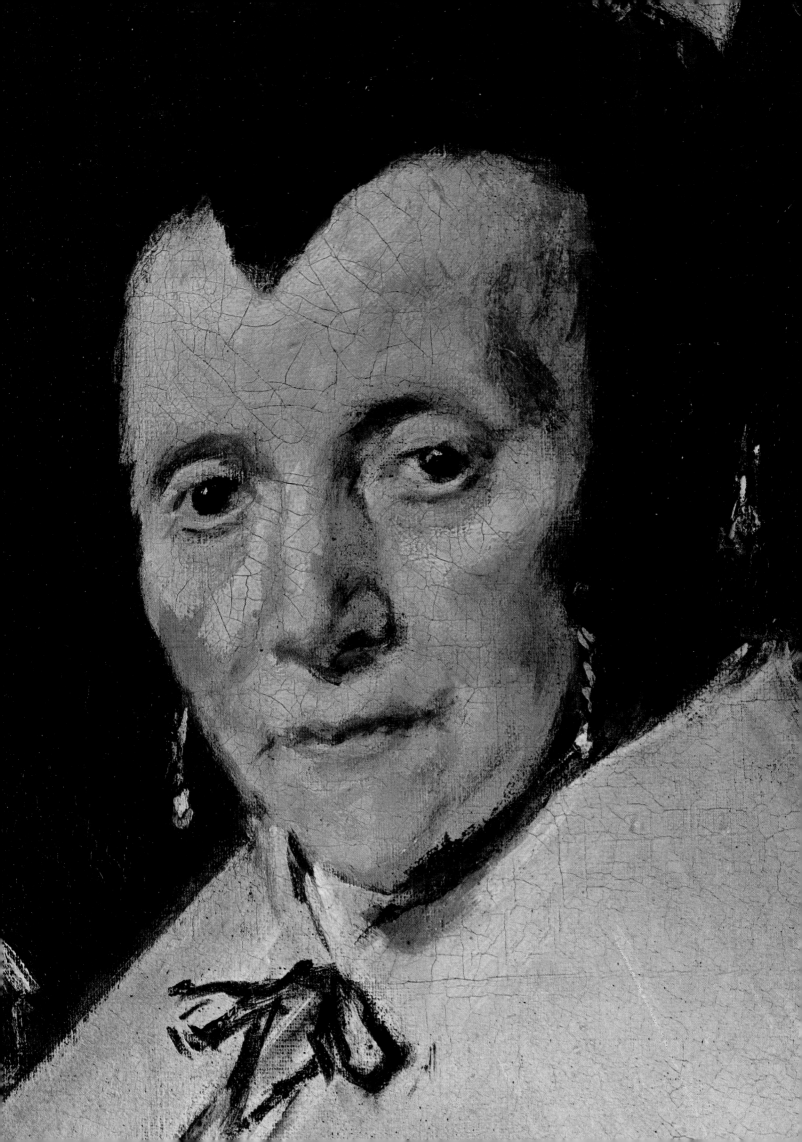

CHAPTER I

Introduction

THE annals of the poor are brief. The meagre references in the documents to Frans Hals, who was impoverished virtually all of his long life, offer a little biographical information; occasional remarks about him in the literature of the time do not add much more. None of his contemporaries wrote even a thumbnail account of his career. We can guess that he was literate – his steady signature appears on a few official papers – but not a single personal letter nor a single autograph note has been discovered.

Documentary evidence for the date and place of Hals' birth has not been found, but there is good reason to believe that he was born in Antwerp between 1581 and 1585, the son of Franchoys Hals, a cloth worker from Mechelen, and Adriaentgen van Geertenrijck of Antwerp. Only die-hard nationalists will be vexed that the most original representative of the heroic age of Dutch painting until Rembrandt appeared on the scene was not born in Holland but in neighbouring Flanders. He certainly spent most of his life in Haarlem, but there is equally no doubt that he was referred to there as 'Frans Hals van Antwerpen' and that he himself used this appellation more than once.

Information about Hals' parents is scanty also. It is known that his father lived in Mechelen, but it is not known when he left to settle in Antwerp or when he married Adriaentgen van Geertenrijck, although the latter event must have occurred in 1581 or later. The last reference to Franchoys in Antwerp is found in a survey made in 1585 of the religious faiths of the civic guards of the city. Hals' father is listed in this census as a Catholic. This may explain why his marriage was not recorded, for if the wedding ceremony was a Catholic one it must have been a clandestine affair since Catholic marriages were forbidden in Protestant Antwerp from 1581 until 1585. On the other hand, Protestant records of these years cannot be checked since all of them have disappeared. It is also possible that Hals' father and mother were lax about publishing their marriage banns – as we shall see, the Hals family never won a reputation for rigorous moral standards.

Joost Hals, another son of Franchoys and Adriaentgen who became a painter, was probably born in Antwerp too, for like his brother he is identified as 'Hals from Antwerp'. In 1608 'Joost Hals van Antwerp' was fined in Haarlem for insulting the town's guards and for throwing rocks which injured a pedestrian on the head. During the following decade there are various other complaints against him because he did not pay his bills. Except for the fact that he died before October 15, 1626, little more about him has been discovered. None of Joost's works has been identified and therefore the temptation to assign to him early copies or pictures erroneously ascribed to Frans Hals must be resisted.

Introduction

There is a gap in the history of the family between the last reference to Hals' father in Antwerp in 1585 and the baptismal record in 1591 at Haarlem of another brother Dirck, who was also to acquire a reputation as a painter, mainly of small, lively genre scenes. It is not difficult to guess what happened during the years in between. The family probably joined the thousands of Flemish citizens who migrated to the Northern Provinces after Antwerp fell to the Duke of Parma on August 17, 1585. The victorious Spanish re-established Catholicism in Antwerp, and Protestants were given four years to settle their affairs before they had to leave. Although, as we have already heard, Hals' father declared in 1585 that he was a Catholic, he may have left for religious reasons – this was a time when many Netherlanders challenged and changed their faith. The economic situation may also have played a role, for though the Spanish won Antwerp their victory was hollow. The Dutch strangled the trade of the most powerful city in the Low Countries by blockading the mouth of the Scheldt and cutting Antwerp off from the sea. When this happened the trek of Flemish refugees to the north, which had been taking place for more than a decade, became a mass emigration, and the mother country lost vigorous citizens of all classes and some of its finest spirits.

The rapid expansion that made Amsterdam the leading financial and trading centre of Europe during the seventeenth century dates from this period. Haarlem also grew. Around the end of the sixteenth century the textile industry, which, after brewing, was the most important in Haarlem, benefited from the arrival of over six hundred families of Flemish textile workers. One of them must have been the family of the cloth-dresser Franchoys Hals.

Nothing is known about Hals' boyhood or early training but it seems that the versatile mannerist painter, historian and poet Karel van Mander, another Fleming who had migrated to Haarlem, was his teacher. The source of this information is a brief note in the biography of Van Mander appended to the second edition of *Het Schilder Boek* (1618), Van Mander's encyclopedic handbook for artists and connoisseurs. Van Mander, his anonymous biographer wrote, 'had various students, some of whom became good masters, namely these: Jacob van Mosscher; Jacob Martensz.; Cornelis Engelszen; Frans Hals, portraitist of Haarlem; Evert Krynsz. van der Maes, of The Hague; Henrick Gerritsz. Pot, of the East Indies; François Venant, and many others too numerous to list here, as well as his oldest son Karel van Mander. . . . ' This is the earliest known published reference to Frans Hals.

The assertion that Hals was Van Mander's pupil is not contradicted by the little we know about the master's beginnings. It would, however, be impossible to deduce solely upon the basis of his existing early works that he studied with him. Van Mander himself did not mention the artist who was to become his most famous pupil. He had an opportunity to do so in the part of his *Schilder Boek* (1604) devoted to biographies of living Netherlandish artists. In this section Van Mander included an apology which suggests he sensed that a later age might accuse him of ignoring someone worthy of mention. His explanation is similar to those often made by critics who accept the challenge of writing about artists of their own time: he states that he is certain that there are many young painters who deserve a place in his book whom he does not know or

who do not come to mind. Hals, it seems, belonged to the latter group. Apparently young Hals failed to impress his teacher. He may have been a slow starter. Perhaps like many other great painters who lived long lives he needed a prolonged gestation period before bursting onto the scene. Or was young Hals, who was described by a contemporary as 'somewhat lusty in his youth,' deliberately ignored by his teacher because he failed to get along with him? Probably not. Though Van Mander laid down strict precepts in *Den Grondt der Edel Vry Schilder-Const*, the long poem published in the *Schilder Boek* on how young men who proposed to study the noble art of painting should live and work (not only must they learn the rules of painting, but they must avoid brawling, consort with philosophers and princes, be temperate, marry late in life, and choose a wife at least ten years younger), he also had his less didactic side. He drops his professorial manner more than once in the *Schilder Boek* and, according to his biographer, the practical jokes he played as a boy suggest he was the kind of master who would have enjoyed working with a high-spirited apprentice.

In his *Schilder Boek* Van Mander writes about three of the eight artists listed as his pupils by his anonymous biographer: Cornelis Engelszen, Jacob van Mosscher and Evert Krijnsz. van der Maes. It is noteworthy that Van Mander does not refer to any of them as his pupils, and in his entry on Cornelis Engelszen he specifically states that Cornelis van Haarlem trained this 'very good painter and outstanding portraitist from life.' He takes no credit for teaching him. This contradiction as well as his failure to mention that he taught Van Mosscher or Van der Maes does not strengthen our confidence in the roster of Van Mander's students compiled by his biographer. Either the latter was misinformed or Van Mander was excessively modest about his activity as a teacher.

Soon after Van Mander settled in Haarlem in 1583 he met Cornelis van Haarlem and Hendrick Goltzius, the leading Dutch graphic artist of the period. According to Van Mander's biographer the three friends founded an 'academy' where they could study from life ('*om nae't leven te studeeren*'). The precise character of their 'academy' remains problematic, but one thing is certain: it was not a formal art school where the theory and practice of art were taught according to a fixed programme. It would be erroneous to assume that young Hals studied under Van Mander at an art academy in Haarlem where aspiring artists matriculated. The Haarlem 'academy' had little in common with the *Accademia di San Luca* of Rome, which was founded in 1593, or the *Academie Royale de Peinture et de Sculpture* established in 1648 at Paris. As far as we know, it lacked everything an academy needs: a patron, a charter, a fixed curriculum, a faculty, and students. When it was started or how long it existed is a matter of conjecture, but it probably did not function much longer than most informal arrangements between artists do. Van Mander himself never mentions the 'academy' in his *Schilder Boek*. The omission is not unimportant, if we recall that he took every opportunity to praise the activity of artists in Haarlem and even invented stories to bolster the fame of his adopted city.

Like most Dutch artists, Hals probably served his apprenticeship under rules prescribed by the Guild of St. Luke. The Haarlem guild was one of the oldest and strongest in the north Nether-

Introduction

lands. Under its charter of 1514 it included glass-makers, embroiderers, pewter-workers, tinkers, potters and brass founders as well as goldsmiths, wood-carvers and painters. In 1590 more trades were brought under its control, apparently to protect Haarlem artists and artisans from the influx of Flemish refugees. The Guild now included printers, smiths, organ-makers, slate-layers, box-makers, plumbers and lantern-makers. Van Mander complained about this mixed lot in his *Schilder Boek*. He wrote that 'in Haarlem, where there have always been great painters, [now] tinkers, tinsmiths and old-clothes peddlers belong to the painters' guild.' Following the lead of Italian Renaissance theorists, Van Mander wanted painters to have a special status. Young Hals may have heard him grumble about the sad lot of Haarlem painters, but the issue, like many others vital to Van Mander, was apparently of little interest to him. Neither he nor any of his Haarlem contemporaries attempted to change or break away from the well-established guild.

If Karel Van Mander's biographer is to be trusted, Van Mander moved from Haarlem in 1603 to Huis te Zevenberge, a castle between Haarlem and Zevenberge, where he wrote most of his *Schilder Boek*. In the courtyard of his castle his pupils performed a play he had written; thus he continued to have contact with students after he left Haarlem. In 1604 Van Mander settled in Amsterdam, where he died September 2, 1606.

Hals joined the Guild of St. Luke at Haarlem in 1610. Two years later Hercules Seghers, by far the most original landscapist of the period, became a member. In 1612 Esaias van de Velde, the founder of the realist school of Dutch landscape painting, and Willem Buytewech, the most spirited painter of elegant genre scenes of his generation, also joined the Haarlem guild. It would not have been possible to assemble a more inspired group of young Dutch artists in the new Republic.

Around this time Hals married Annetje Harmansdr. Their son Harmen was baptized on September 2, 1611, and, like most of Hals' sons, he became a painter. Annetje died in June, 1615, leaving Hals with two children (the name of the second child is not known). She was buried in a pauper's grave, which is indicative of Hals' financial state at this time. Judging by the evidence we have, it did not improve in the following decades. The artist published the banns for his second marriage on January 15, 1617, in Haarlem. On February 12 he married Lysbeth Reyniers of Haarlem at the nearby hamlet of Spaarndam. Nine days later their daughter Sara was baptized.

Hals' second wife was illiterate and apparently came from a humble background. She was a vigorous woman and is known to have been involved in brawls. She bore Hals at least eight children and died when she was over eighty, surviving her husband by at least eight years. Three sons of the second marriage became painters: Frans Fransz. Hals the Younger (1618–1669); Reynier Fransz. Hals (1627–1672); and Nicolaes (Claes) Fransz. Hals (1628–1686). Their daughter Adriaentgen married Pieter Roestraten, a Haarlem genre and still-life painter who was Hals' pupil. Another son, Jan (Johannes) Fransz. Hals (active c. 1635–1674) was probably a child of Hals' second marriage too. As we shall see, Jan's portraits can be deceptively close to his father's works of the 1640s. If we count the four sons mentioned and add Harmen Fransz. Hals (1611–1669), a child of Hals' first marriage, Hals' two brothers Joost and Dirck (1591–1656) and the

latter's son Antonie (1621 – before 1702), we can cite the names of eight men in the family, besides Frans Hals, who were artists. Examination of their total production offers convincing proof that genius is not necessarily inherited. The problem of keeping track of them – which is as difficult and rewarding as sorting out the lesser members of the Breugel family – is further complicated by references in old inventories and earlier literature to the painters Willem Hals and Hendrick Hals. The artistic personalities of Willem and Hendrick remain as nebulous as their familial relationship to Frans. Understandable efforts have been made to recognize members of Hals' large family in some of his genre pieces and portraits, but none of the identifications which have been offered is convincing.

By 1620 Hals was beginning to make a name for himself. Four years earlier he had painted his first major commission: *The Banquet of the Officers of the St. George Militia Company* (Plate 19). To us the picture announces the great age of Dutch painting like a cannon shot, but there is no evidence that it made an overwhelming impression on the citizens of Haarlem. Van Mander's anonymous biographer did not find it worthy of mention, and more than a decade passed before the civic guards of Haarlem gave him other commissions for group portraits. Meanwhile Frans Pietersz. Grebber was employed to paint two banquet pictures for the St. George Militia Company (1618–19; c. 1624), and Cornelis Engelszen painted one of the St. Hadrian group of guards (1618). Why did the officers turn to these journeymen portraitists when Frans Hals was available? It is hard to avoid the conclusion that around this time he simply was not in special demand. Our age has learned to discern and appreciate qualities in his early work which apparently did not compel his contemporaries to queue at his door.

It is also possible that Hals declined at least one of these commissions – the one Frans de Grebber painted of the St. George company in 1618–19 (Fig. 31). This life-size group portrait might more accurately be described as a mob scene; it shows forty-six men at a banquet. Perhaps Hals thought such an assignment too dull. In any event De Grebber accepted. Poor De Grebber. Not only did his finished painting fail to meet the challenge, but the commission also brought him unexpected trouble. Shortly after the gigantic group portrait was finished, three men originally portrayed in it complained to the burgomasters of Haarlem that De Grebber had painted them out and had replaced them with portraits of three other men. They wanted to be put back in the picture. The authorities found their complaint a just one and ordered De Grebber to paint out their replacements and portray them once again. The curious disappearance and reappearance of these civic guards can probably be explained by the bitter religious struggle between strict Calvinists and the Arminians, a group that favoured a milder form of Calvinism. In those years the religious beliefs of a man determined his status as a member of a militia company. The affair also suggests that the municipal authorities had the last word on who was and who was not to appear in a civic guard group portrait.

There is additional evidence which indicates that young Hals did not make an overwhelming impression on his contemporaries. When the preacher and poet Samuel Ampzing published his poem in praise of Haarlem (*Lof van Haarlem*) in 1616, he did not mention Hals or his first group

Introduction

portrait. Of course his lines may have been composed before the banquet piece was painted. Ampzing did, however, cite Cornelis van Haarlem, Goltzius and the marine painter Hendrick Vroom. When Sir Dudley Carleton, the gifted English ambassador to The Hague, wrote a letter describing his visit to Haarlem in October, 1616, he mentioned the three artists Ampzing cites – perhaps Ampzing was his guide. Sir Dudley wrote:

> 'I found at Haarlem a whole towne so nete and clenlie, and all things so regular and in that goode order, as yf it had ben all but one house. The painters were the chiefest curiositie: whereof there is one Cornelius for figures, who doth excelle in colouring, but errs in proportions. Vrom hath a great name for representing of Ships and all things belonging to the sea: wherein indeede he is very rare, as may appeare by the prises of his works. . . . Goltius is yet living, but not like to last owt an other winter.'

Carleton's prognosis was correct; Goltzius was buried on January 2, 1617. Carleton added that Goltzius' 'art decayes with his bodie.' But not a word about Frans Hals or his work from this sound judge of painting, whose accurate and succinct appraisal in the same letter of the artistic situation in Amsterdam shows his good judgment and ability as a reporter: 'At Amsterdam I saw many goode pieces but few goode painters; that place being in this commoditie as in others, the ware-house rather than the worke-house.'

In 1621 Samuel Ampzing published *Het Lof der Stadt Haerlem in Hollant*, a revised and expanded version of his 1616 verses about the city. In this poem Ampzing once again praised his fellow townsmen Goltzius, Cornelis van Haarlem and Vroom, but he also included the Hals brothers in a list he made of more than a dozen artists of the city:

> ' . . . Floris van Dyck, Cornelis Claesz. van Wieringen, the De Grebbers, Jacob Matham, Hendrick Pot, Jan Jacobsz. Guldewagen, Cornelis Vroom, the Van de Veldes, the Halses Jacob van Campen, Cornelis Verbeeck (known as Smit), Salomon de Bray, Jan Bouckhorst and Pieter Molyn. . . . '

A printed note in the margin of the text tells us that Ampzing had Frans and Dirck, not Joost, in mind when he wrote about 'the Halses.' But he made no attempt to distinguish their qualities. They are sandwiched between the Van de Veldes and Jacob van Campen. Before the end of the decade, however, Ampzing noted the difference between the two brothers. In his *Beschryvinge ende lof der Stad Haerlem in Holland*, published in 1628, he enthusiastically wrote:

> 'Come Halses. Come forward and
> Take a place here that rightfully belongs to you.
> How nimbly Frans paints people from life!
> What neat little figures Dirck knows how to give us!
> Brothers in art, brothers in blood
> Nourished by the same love of art, and by the same mother.'

Ampzing also mentioned a large painting by Frans Hals of officers of the St. Hadrian Civic

Guards (Plate 78) at their headquarters which is 'very boldly done from life.' These lines are the earliest known specific printed reference to Hals' art. During the course of the artist's lifetime not many other explicit or extensive comments about his work were made. Ampzing paid more than lip service to Hals' ability to paint '*naar het leven.*' A few years after he had published his brief lines in praise of the artist he commissioned him to make a small oil portrait sketch of him (Plate 139).

By the time Ampzing invited Hals to take the place that rightfully belonged to him, the artist had already played a part in the civic life of the Haarlem community. He had been a member of the St. George Militia Company and served as a guardsman under the officers he portrayed in his group portrait of 1616. Membership in Haarlem's militia companies was not open to everybody. The officers generally belonged to the ruling class, and ordinary guards had to demonstrate that they had some means before they were allowed to serve. Judging from what we know of Hals' financial status, his gift as a painter, not his possessions, must have counted as his capital. He was listed as guard of the company again in 1622, and he appears in the group portrait he painted of the officers of the company about 1639 (Fig. 1). Though self-portraits are found in the Netherlands since Jan van Eyck's time, Hals' presence in the 1639 militia piece is unusual. Normally military rank, not artistic genius, determined whether or not a man was depicted in a group portrait of this type. Officers – from the company's colonel to its sergeants – were portrayed. Hals belonged to the ranks. Perhaps the officers invited him to include himself in the last militia piece he painted as a sign of their recognition of the service he had rendered the company both as artist and as guardsman. When he painted his self-portrait he was close to the end of a guard's term of duty; the mandatory retirement age was sixty. However, Hals was not at all prepared to retire as an artist in 1639. He continued to be productive for almost three more decades.

Early in his career Hals belonged to a literary society as well as to a militia group. From 1616 until 1625 he was an associate (*beminnaer*) of a local Haarlem chamber of rhetoricians (*rederijkers*). The origins of these popular groups can be traced back to medieval times, and most Netherlandish cities and towns had active chambers during the first decades of seventeenth century. These chambers were amateur literary societies whose members composed poetry, organized contests and staged plays. The rhetoricians performed at regular meetings, at competitions and at festivals. As a rule, the level of their efforts was not very high. The play staged by Bottom and his friends in 'A Midsummer Night's Dream' offers a good idea of the quality of their performances. Hals belonged to the Haarlem chamber called 'The Vine Tendril' (*De Wijngaertranken*), whose motto was 'Love Above Everything' (*Liefde Boven Al*). None of his works can be directly connected with the chamber's festivities, but his early painting of *Shrovetide Revellers* (Plate 8), gives us some idea of its spirit. Hals had contact with other rhetoricians, too. His 1616 painting of a man holding a smoked herring (Plate 13) is a portrait of Pieter van der Morsch in his role as Piero, the famous Leiden rhetorician and buffoon.

Like other members of the Guild of St. Luke, Hals had apprentices. According to Arnold Houbraken, whose brief biography of the artist is included in *De Groote Schouburgh*, an in-

Introduction

dispensable compendium of lives of Dutch artists published more than a half-century after Hals' death, his younger brother Dirck, his sons, and his son-in-law Pieter Roestraten studied with him. Houbraken also states that Adriaen van Ostade, Philips Wouwerman, Vincent van der Vinne, and, most outstanding, Adriaen Brouwer, were also his pupils. There were probably others, but identifying them has been as difficult as assigning firm attributions to paintings made by his students while they were with him or still working in his style. Probably his apprentices copied his pictures and made variants of them. This was accepted studio practice. But apparently he did not use them as collaborators. In any case I cannot point to a single picture that shows Hals' work and the touch of one of his pupils or a studio assistant. Evidently he was not the kind of portraitist who painted heads and gave the more routine job of doing drapery and backgrounds to a helper. His speed and facility as well as his temperament must have precluded this kind of assembly-line production. We shall see, however, that he did occasionally collaborate with established Haarlem masters on a single painting.

For a brief period Judith Leyster, the most clever painter of her sex in seventeenth-century Holland, and her husband Jan Miense Molenaer felt the impact of his style, and to a lesser degree so did the Haarlem portraitists Johannes Verspronck, Bartolomeus van der Helst and Jan de Bray. But if we consider the length of Hals' career, it cannot be said that he produced a host of pupils and followers dedicated to emulating his vision and pictorial innovations. Even the enormously gifted must have found it discouraging to try to imitate his original technique, and evidently he was not the kind of teacher who insisted that his pupils ape his manner. If Houbraken had not told us, would we have deduced that Ostade and Wouwerman were his pupils?

There was not a dramatic shift in Hals' reputation as he approached old age. The number of commissions he received during the 1640s indicates that he was still in demand as a portraitist. In 1648 Theodorus Schrevelius, a Haarlem schoolmaster and historian, gave him highest marks in a brief passage in *Harlemias*, a popular history of Haarlem. Schrevelius wrote that:

> ' . . . by his extraordinary manner of painting which is uniquely his, he virtually surpasses everyone. His paintings are imbued with such force and vitality that he seems to defy nature herself with his brush. This is seen in all his portraits – and he has made unbelievably many. They are painted in such a way that they seem to breathe and live.'

Schrevelius had long been an admirer of the painter. He commissioned a small-scale portrait from him in 1617 (Plate 23) and probably sat for him again around a decade later (Plates 74, 75). But neither commissions nor Schrevelius' high estimate of the artist's power and originality seemed to bring him prosperity. He remained continually in financial straits.

In an effort to help make ends meet he was occasionally active as a picture dealer – a not uncommon sideline for seventeenth-century Dutch artists. He also hired himself out to appraise pictures and there is evidence that he worked as a restorer. In 1629 he was paid for cleaning and changing pictures which belonged to the Brotherhood of St. John at Haarlem. Amongst its treasures the Brotherhood counted the most important fifteenth-century forerunner of Dutch

8

group portraiture: Geertgen tot Sint Jans' St. John altarpiece. It also possessed Jan Scorel's group portrait of *The Jerusalem Pilgrims*. We do not know if these two paintings were amongst the works Hals restored, but it is nice to think that the greatest group portraitist of the time was called upon to help preserve early masterworks of the most characteristic branch of Dutch painting.

But apparently these efforts to increase his income were also of little avail. During the course of his long life Hals was repeatedly taken to court by small tradesmen because he had failed to pay his bills. When the charges made against him are examined individually they appear trivial but the cumulative effect of his five-decade record of unpaid accounts for bread, cheese and canvas is heart-breaking. Nor is it easy to account for all of Hals' pecuniary problems. He was plagued by debts even when he had numerous commissions and, as we shall see, there is no reason to believe that he was ever without patrons. Perhaps, like many of us, he had difficulty managing a household budget. Or he may have had an uncommonly strong aversion to paying promptly the bills incurred by his large family.

The only existing record of a fee paid to him suggests that he was relatively well paid for his portraits. In 1633 he was to receive sixty-six guilders for each figure portrayed in a group portrait of Amsterdam militia men, *The Corporalship of Captain Reynier Reael* (Plate 134). The commission would have brought him over 1000 guilders. By our standards this sum was certainly no adequate reward for his genius, but by the standards of the day the fee was a substantial one. Nine years later, for example, when Rembrandt was at the height of his fame, he was paid about 100 guilders for each civic guard he portrayed in the *Night Watch*, an arrangement that brought him about 1600 guilders for his most famous painting.

Independence of spirit also seems to account for some of Hals' financial troubles. When he was summoned to Amsterdam to finish the above-mentioned group portrait of Captain Reael and his men in July, 1636, Hals needed money desperately. He had been sued by his landlord a couple of months before the Amsterdam militia men presented their demands, and in the following month a baker claimed payment for an unpaid bill. But Hals refused to make the twelve-mile trip from Haarlem to Amsterdam to complete the work, and insisted that the guardsmen come to him. They did not comply, and he never finished the picture and presumably never collected his full fee. The group portrait was completed in the following year by the Amsterdam painter Pieter Codde.

The first record of a small claim against Hals is dated August 6, 1616, when he was sued in Haarlem for money owed for paintings he had bought. In 1661 a similar charge was brought against him. These cases are two bits of evidence we have that he dabbled in picture-dealing. He did not appear to answer the 1616 complaint. A note in the margin of the rolls states that he is 'said to be in Antwerp' – the only record of a trip made by Hals beyond the borders of Holland. In September of the same year the custodian of his two children claimed that he owed her money. Hals did not appear to answer this complaint either. A few weeks later one of his children died. On November 8, he was sued again – this time for payment for the support of his child for one year. The defendant was still absent. Three days later the suit was pressed again. Hals was not

present but his mother appeared before the authorities and stated she was willing to pay part of the debt in a day or two. The commissioners ordered her to do so, and to obtain the sum from the headquarters of the St. George Militia Company. The court probably ordered that some of the money Hals earned for his group portrait of the *Banquet of the Officers of the St. George Militia Company* (Plate 19), completed that year, be used to pay the debt for the support of his motherless child. Finally, on November 15, 1616, Hals made his appearance before the authorities to account for the money he owed his child's guardian. He had returned from Antwerp, having spent about three months there – ample time, incidentally, to see what Rubens and his studio had been doing in Antwerp since the master's return from Italy late in 1608.

Hals was obviously in constant difficulties with the authorities over his finances, but there is no evidence to support the allegation that he was also a wife-beater and a chronic alcoholic, although this legend persists in the literature up to the present day. In 1866 the archivist A. van der Willigen thought he had found incontrovertible proof of Hals' bad character in a document which states that on February 20, 1616, a certain Frans Hals was asked to appear before the authorities because of cruelty against his wife. They reprimanded him and he promised to reform and abstain from drunkenness and immoderate acts. He was told that if he once again maltreated his wife or other persons he would be severely punished for the act already committed and the one for which he will be charged. This seemed to corroborate the statement published in 1718 by Arnold Houbraken in the *Groote Schouburgh* that Hals was 'generally filled to the gills with liquor every evening' – a remark which was embellished and popularized by later eighteenth and nineteenth-century writers. Further confirmation seemed to appear in 1871 when Willem Bode discovered and published the earliest known reference to Hals' character. Bode found a copy of *Het Schilder Boek* which contained autograph notes written by the obscure seventeenth-century German artist Mathias Scheits. One of them is the note we have already cited; Scheits wrote that Hals 'was somewhat lusty in his youth.'

Scheits and Houbraken may have had evidence for their statements, but the record published by Van der Willigen cannot be used to support their claims. The document cannot refer to our Frans Hals because, as we have seen, he did not have a wife to beat on February 20, 1616. He was a widower. His first wife died in June 1615; he did not marry again until 1617. Then who was the Frans Hals cited in the 1616 account? The answer is simple: there was another Frans Hals living in Haarlem at the time. The painter has been the victim of mistaken identity.

The 1616 document most probably refers to Frans Corneliszoon Hals, a Haarlem weaver whose name appears in the town's records of 1609, 1616, and 1621, and not to the painter, whose patronymic was Franszoon, not Corneliszoon. It is known that Hals the weaver was a quick-tempered man. He was taken into custody in 1609 for throwing around drinking glasses and he had other encounters with the authorities. This plausible identification of the culprit was published by Bredius in 1921, but it has not yet entered the mainstream of the literature. The erroneous idea that an artist who painted drinking men must needs himself have been a rowdy drunkard dies hard.

Conclusions about the quantity of alcoholic beverages Hals consumed or about their effect upon him cannot be deduced from the subjects he depicted. But if we tried to infer anything about this side of Hals' life from his paintings, we would at least have to conclude that he was invariably a happy drinker, never a belligerent one. In marked contrast to Brouwer, Adriaen van Ostade and Jan Steen, he never showed the depravity or brutal passions strong drink can arouse in men. Hals only portrayed the pleasures of drinking.

Although Hals enjoyed his greatest popularity during the 1630s, his precarious financial position did not improve and his bills remained unpaid. In 1630 he was sued by his shoemaker; the following year he failed to pay for a slaughtered ox; in 1635 he was dunned by the Guild of St. Luke because he did not contribute his annual dues of four stuivers; in 1636, the year he refused to go to Amsterdam to finish a group portrait which would have given him a handsome honorarium, his debts to his landlord and local merchants were overdue. The pitiful list continues until the very end, and the following decade brought additional difficulties.

In 1642 his son Pieter, who was an imbecile (*innocente*), was placed in solitary confinement in the institution where he had been committed because he was dangerous. In March of the same year Hals and his wife appealed to the civic authorities to send their daughter Sara to a workhouse to help improve her lax morals. In May, after she had given birth to an illegitimate child, the women who attended her testified that they heard her say 'in deepest distress that Abraham Potterloo, son of Susanna Masse, was the father of her child and no one else . . . upon further questioning by said midwife, if she had not been with some other men, she replied: "Yes, I have been with more." ' Two years later, in 1644, Hals was sued for one guilder, nine stuivers for board; the defendant's wife asked 'terribly for respite.' His miserable reputation as a debtor apparently did not affect the respect his colleagues in the Guild of St. Luke had for him; he was elected to serve as a member of the board of the guild in 1644.

The situation worsened in 1654 when a baker seized his property because Hals owed him 200 guilders for bread and money which he had borrowed. Hals surrendered three beds, pillows, linen, an oak cupboard and table and five pictures: a painting by his teacher Van Mander of *The Preaching of St. John the Baptist*, Heemskerck's *The Gathering of Manna*, an unidentified painting by Hals, another by his son Harmen and one by an unidentified son. A meagre lot compared to the inventory made of Rembrandt's effects and impressive collection after he was forced into bankruptcy in 1656.

Though the assertion that Hals spent his last years in the Old Men's Alms House at Haarlem is without foundation, there is no reason to believe that his financial condition altered at the very end of his life. In 1661 the Guild exempted him from the payment of annual dues (six stuivers) because of his old age. In the following year he pleaded for aid from the burgomasters of Haarlem. They awarded him an outright gift of fifty guilders and a subsidy of 150 guilders for one year. In 1663 Hals' subsidy was increased to 200 guilders annually and granted to him for his lifetime. Mathias Scheits tells us that the subsidy was given to him as an award for his art. The grant must have been as helpful as it was welcome, but it was not a lavish one. It gave him a bit

Introduction

more than the yearly income of the poorly paid men who worked in Haarlem's bleaching industry from dawn until dusk for three or four guilders a week. Textile workers were better paid than either of them; they earned about one guilder for a twelve-hour day.

At his request, Hals was given three cartloads of peat in 1664. Then, for at least a moment early in 1665, Hals possessed a large sum of money. In January of that year he was able to sign a note as guarantor for a debt of 458 guilders, 11 stuivers contracted by his son-in-law. Perhaps the payment he received for his two group portraits of the regents and regentesses of the Old Men's Alms House (Plates 340, 349) accounts for his sudden affluence. We have already heard that he was to receive 66 guilders for each Amsterdam militia man he agreed to paint in 1633. These were full-length portraits. Since he portrayed the regents and regentesses as three-quarter-length figures we can assume he was paid less; in Hals' day, as in ours, a bust portrait was cheaper than a full-length one and the prices for other sizes were adjusted accordingly. If we estimate that he received fifty guilders for each man and woman he portrayed in his late group portraits, he received a total of 550 guilders for these masterworks – more than twice the sum of his annual stipend and enough to guarantee his son-in-law's debt.

The burgomasters saw no reason to cut off his subsidy. The artist, who was now over eighty, was given the grant he had been promised again in 1666. He was not a burden upon the municipality for long. Frans Hals died during the same year on August 29, and on September 1 a grave was opened for him in the choir of St. Bavo's Church at Haarlem.

Two mysteries haunt the historian who attempts to reconstruct Hals' career as an artist. The first is the mysterious gap in our knowledge of his formative years and early activity as an artist. The second is the total absence of preliminary sketches and drawings which can be ascribed to his hand.

Hals' earliest existing dated work is the accomplished portrait of *Jacobus Zaffius* (Plate 1), which is inscribed 1611. As we shall see, only a few other known works can be dated around the same time. Earlier works are not known. Now if Hals was born around 1581, he was about thirty years old when we first recognize his hand, and if we accept the 1585 date, he was about twenty-six. What has happened to his earlier efforts? Are all of them lost? Or do some of them remain unidentified because it took the man who painted with unrivalled facility for more than fifty years an uncommonly long time to find his highly personal style? These questions remain open.

During the preparation of this book I hoped that the case of Hals' missing *juvenilia* would be solved by a lucky find in the archives of the Netherlands or Belgium. I had in mind an imaginary document which would have established that Hals was born around 1590, or even a few years later. It would have confirmed the hunch that this born painter was precocious, or at least that he was closer to twenty than thirty years of age when he showed a recognizable style. It would also have explained why Hals does not look his age on either of his two self-portraits (Figs. 1, 2). But archival research has shown that this solution to the mystery was without foundation.

As for the missing drawings, it is inconceivable that an artist who must have painted as easily

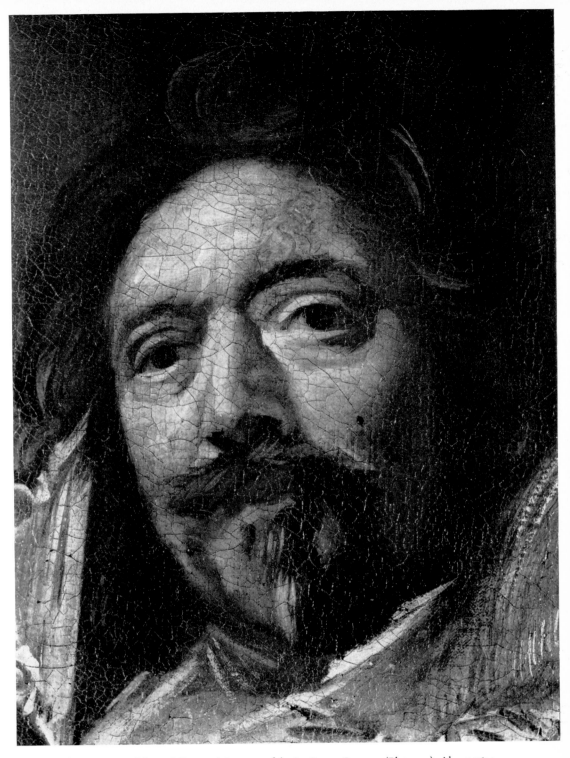

Fig. 1. *Self-portrait*. Detail from *Officers and Sergeants of the St. George Company* (Plate 201). About 1639. Haarlem, Frans Hals Museum

as he breathed never put chalk or pen to paper, but the fact remains that no original drawings have been found to give us a glimmer of Hals' private life and interests, and no drawings at all can be attributed to him with certainty. All of them are probably lost. On the other hand, he probably lacked that inner urge which constantly compelled Dürer, Rubens and, above all, Rembrandt to make drawings that are intimate records of their impressions and moods. And unlike Rembrandt, he did not make a series of self-portraits which can be read as an autobiography. Rembrandt left us around one hundred portraits of himself. As far as we know, Hals, the portraitist *par excellence*, only painted two, both of them late in life. The first (Fig. 1), made when he was about fifty-five or sixty years old, appears inconspicuously in the background of his largest group portrait, the *Officers of the St. George Militia Company* of 1639 (Plate 201). The other

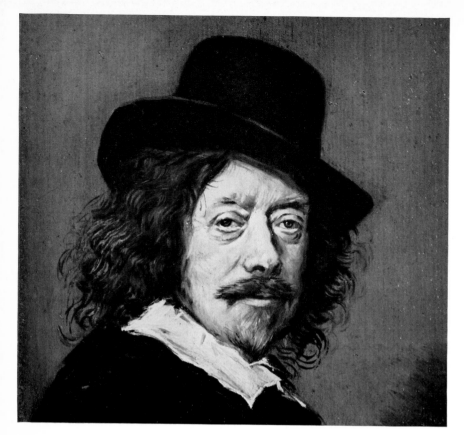

Fig. 2. *Self-portrait*. Copy after a lost original. Detail. Indianapolis, The Clowes Fund, Inc.

one (Fig. 2), which can be dated about ten years later, exists today in a number of versions after a lost original. Neither self-portrait speaks to us as the laughing clown his romantic biographers imagined him to have been.

From the moment we recognize his hand until the end of his lengthy career Hals worked as a portrait specialist. Around four-fifths of his existing paintings are portraits and most of the rest can be classified as genre pictures with a portrait-like character. Man – and more specifically his face – was Hals' principal subject. There are no nudes, no landscapes, no marine pictures, no architectural views, no still-lifes. Specialization, in one category of painting or another, was to become the rule among seventeenth-century Dutch painters. With the monumental exception of Rembrandt, they limited their liability. Hals was the first artist to demonstrate that a painter who concentrated his efforts on a narrow field could earn a place in the pantheon dedicated to the greatest Western artists, although his place there was not generally recognized for about two centuries after his death.

According to Hals' teacher the state of the art market in Holland led artists to become portrait specialists. Van Mander wrote in his *Schilder Boek* that 'making portraits from life is the kind of work that young painters, as well as others, most frequently find in this country. For this reason, and in order to make money, many artists work primarily, or exclusively, as portraitists.' From Van Mander's point of view this was regrettable. He accepted the view which was implicitly or explicitly endorsed by art theorists from the fifteenth until the nineteenth century that religious, historical or mythological subjects were more important for artists to paint than portraits. Van Mander agreed that nature must be studied but he insisted, along with other Renaissance and mannerist theorists, that it should not be slavishly imitated. Significant artists work from their imagination (*uyt den geest*) and depict the human figure – preferably nude – in its ideal form. It is the artist's duty to improve upon nature according to the idea he has formed in his imagination of perfected nature. Portraitists merely make slavish copies of naked faces.

14

Van Mander notes with approval that the Utrecht painter Abraham Bloemaert never made portraits from life because he did not want to hamper his imagination, and he reports that his friend Cornelis van Haarlem disliked painting portraits because it left him depressed. However, Van Mander did not condemn portraiture without reservation. He was a sensible man willing to concede that an artist who succeeds in at least one branch of painting deserves praise. Moreover, he himself made portraits (Fig. 8). The practice could also be defended by appealing to eminent authorities. Leon Battista Alberti, the founder of Renaissance art theory, began his treatise *Della Pittura* with a discussion of the power and magic of portraiture. When Leonardo searched for arguments to prove that painting is superior to all other human activities he noted that a portraitist's brush can show facial expressions that a writer can never describe with his pen. Since Renaissance theorists agreed that important painting must teach as well as delight, it could be maintained that portraits of famous men fulfill this requirement. They serve as exemplars of virtue. By the end of the sixteenth century these maxims were universally accepted, but in the final analysis none of Van Mander's contemporaries would have disputed his assertion that drawing and painting from life (*naer het leven*) was a 'side road or byway' of the arts.

Soon after Van Mander's death in 1606 this side road became a superhighway. Portrait painting was to become the most popular branch of painting in seventeenth-century Holland, and within a few decades more Dutch artists were making landscapes, genre scenes and still-lifes than subject pictures. For the first time in history a vast number of major painters dedicated themselves to creating works of art based upon what was familiar and could be seen close at hand. Although these artists did not think of themselves as radicals challenging well-established doctrines of art theory, their achievement was nonetheless a revolutionary one. The manifesto of their revolution was never written; it was painted and drawn.

Although Calvinism never became a state religion in the strict sense, the popularity of portraiture and the other branches of painting developed into specialties by Dutch artists can be related to the Calvinist precept that painters should depict the visible world and not scenes from Scripture. When Dutch Protestants took over Catholic churches they stripped them of their altar-pieces; new ones were not commissioned. The churches remained bare. Artists lost the patronage of the churches of their communities. To be sure, some were still employed to paint traditional devotional subjects for private chapels and homes, and, as Rembrandt's constant preoccupation with Biblical themes shows, if a Dutch artist had the inner urge to depict religious subjects he could follow it. Most artists, however, turned to other subjects, and the discovery that they occasionally painted religious pictures can come as a shock. This was the case when it was recently discovered that the artist who painted the *Laughing Cavalier* and *Malle Babbe* also made two religious paintings: *St. Luke* (Plate 72) and *St. Matthew* (Plate 73).

The rise of wealthy burgher and professional classes in Holland during the century also helps explain the rage for portraiture. Shortly after the United Provinces and Spain agreed upon a Twelve-Year Truce in 1609 the Dutch began to enjoy unprecedented prosperity. By 1648, when the Treaty of Westphalia was signed and the United Provinces achieved *de jure* recognition

among the family of nations, the Dutch were a world power and their country was the richest in Europe. The Dutch merchant fleet dominated the seas. A profitable colonial empire had been established in the East Indies and attempts were being made to found yet another in the New World. There were additional sources of income. When Piet Hein captured the Spanish Plate Fleet in 1628 the West Indies Company was able to pay its shareholders a fifty-per cent dividend. Around the middle of the century the East India Company paid 500 per cent interest to its members. Others made fortunes by building ships, fishing, manufacturing cheese, brewing, processing wool and linen or publishing books. People who profited from these ventures, as well as theologians, lawyers, doctors and professors, formed the bulk of a Dutch portraitist's patrons. The regents, who were the professional governors of the Netherlands during the century, could not leave titles of nobility to their heirs; they had no power to ennoble themselves. But they could leave their fortunes, their estates, their chattels, their moveables and – not least – their portraits to their successors.

During Hals' time the role of the Dutch nobility as patrons of the arts was puny compared to the part played by royalty in other European countries. There was little contact between the small court at The Hague and the leading artists of the period. When members of the House of Orange or their court wanted Dutch portraitists, they turned principally to Miereveld and to the mature Honthorst – two competent but not very inspired face-painters. The court also favoured Flemish portraitists or those who worked in their manner, and later in the century it turned, as so many others in Europe, to artists who adopted the style of the French. There is not a shred of evidence that Frans Hals ever worked for the House of Orange. A search through the inventories of the Stadholders revealed that by 1632 Rembrandt, who had already acquired a reputation for his small, exquisitely finished pictures, made one portrait of Amalia van Solms, wife of Prince Frederick Henry, and possibly a pendant portrait of the Prince, but as far as we know the court never commissioned a portrait from him again.

A patron with regal taste – most likely it was Prince Frederick Henry – missed a chance to employ Hals when he hired a dozen artists to paint a series of twelve Roman Emperors between 1618 and 1625; the set is now at Berlin, Jagdschloss Grunewald. Understandably the commission was mainly distributed among the Dutch and Flemish artists who had been to Italy and had had the opportunity to study classical prototypes first hand. They were Rubens, Gerard Seghers, Abraham Janssens, Paulus Moreelse, Goltzius and the Utrecht Caravaggists Terbrugghen, Honthorst and Baburen. Cornelis van Haarlem and Abraham Bloemaert, who had demonstrated that they could assimilate an Italianate style without crossing the Alps, were also invited to participate. Michiel van Miereveld and Werner van Valckert were given assignments too. But Hals' credentials were evidently considered inadequate by the man who wanted imaginary portraits of Emperors.

Hals was not the kind of portraitist who kept account books; certainly none has been discovered. Nevertheless we have a fairly good idea of who his patrons were since more than one-quarter of his sitters for single portraits can be identified. A review of them shows they were

mainly local burgomasters, ministers, merchants, brewers, artists, calligraphers and scholars. Hals' most famous sitter was a foreigner, not a Dutchman: René Descartes (Plate 264). Like Rembrandt, Hals was never asked to paint the leading Dutch statesmen, military heroes or literary figures of his time. The grand pensionary Johann de Wit, the bold admirals Michiel de Ruyter and Maarten Tromp, the outstanding poet Joost van den Vondel never sat to Holland's greatest portraitists.

The men Hals painted frequently commissioned him to make likenesses of their wives, and sometimes their children as well. Sentiments of love and affection as well as pride and vanity sent them and members of their families to him and, then as now, the portraits painted to satisfy personal or familial feelings were made to be enjoyed in private homes. His genre pieces must have also appealed to private collectors, and some of them probably decorated taverns and inns. In 1631 a Haarlem innkeeper had four of his paintings as well as some copies after his works and, as we shall discuss below, there is some reason to believe that the *Gipsy Girl* (Plate 100) may have hung in a bordello.

Hals also received major public commissions. Between 1616 and 1664 he painted nine large group portraits: six of militia men and three regent pieces. No leading portraitist of the time received orders for as many. This number becomes more impressive when we recall that in Protestant Holland, where altar-pieces were prohibited and the demand for large decorative paintings was small, a group portrait was the most important public assignment an artist could receive. Five were commissioned from Hals by officers of Haarlem's militia companies. The sixth was the one Hals began in Amsterdam in 1633. The invitation to paint a group portrait of Amsterdam civic guards indicates his considerable reputation. Hals of Haarlem was chosen by the guards instead of such well-established Amsterdam portraitists as Thomas de Keyser or Nicolas Eliasz; and young Rembrandt, who had made his name in the city the previous year with his spectacular group portrait of the *Anatomy Lesson of Dr. Tulp*, was also passed over in favour of Hals. The three group portraits of regents of charitable institutions of Haarlem were made in the last decades of Hals' life, when the vogue for large militia pieces went out of fashion.

From his very first militia company portrait of 1616 (Plate 19) to the nearly miraculous regent pieces made in the last years of his life (Plates 340, 349), Hals must have regarded each of his public group portraits a major accomplishment. Yet of the nine only the 1627 *Banquet of the Officers of the St. Hadrian Company* (Plate 78) is signed. This was his way. He rarely put his name or monogram on his paintings; perhaps he was convinced that his inimitable touch made a signature redundant. Contemporary documents relating to his works are even rarer than his authentic signatures and if we consider that with few exceptions our knowledge of the activities of his pupils, followers, and many sons is foggy, that virtually nothing is known about his workshop practice, that forgers began to produce wholesale quantities of fake Hals paintings soon after the master's pictures began to fetch high prices in the nineteenth century, and that counterfeiters have continued to manufacture them (Fig. 150), it is understandable why there have been differences in the estimates made of the number of paintings ascribed to Hals.

Introduction

An examination of the two latest catalogues of his works puts the problem in sharp focus. When W. R. Valentiner published his volume on the master in 1923, he included about 290 paintings in his list. Valentiner's study was based on the basic pioneer efforts of Willem Bode and C. Hofstede de Groot. He was aware that the catalogues made by his predecessors included paintings by students, copyists and followers, and he noted that it is not always easy to identify the best of known versions of a painting – an admission understandable to all students of Hals' work. Valentiner modestly added that he was not under the illusion that he always identified the original.

The most recent catalogue was published by N. S. Trivas in 1941. Trivas rightly rejected some of the unconvincing paintings published by earlier students, but he threw the baby out with the dirty bath when he reduced Hals' authentic *oeuvre* to 109 paintings.

The importance of establishing an acceptable canon of Frans Hals' work is self-evident: what an artist painted must be determined before his achievement can be appraised. If Hals made the 290 paintings Valentiner attributed to him, he was one artist. If he only painted the 109 which Trivas ascribed to him, he was quite a different one.

In my view, around 220 paintings can be accepted as authentic, and more than a score are known from painted copies, prints, drawings and photographs after lost originals. A catalogue of all of these works and some troublesome ones related to them will comprise the third volume of this study. Bibliographic references as well as data on the history of the paintings will be found in the catalogue volume.

From any point of view, even that of the most uncompromising expansionist, the number of Hals' existing works is small. We have already seen that no drawings can be firmly ascribed to him and apparently he never tried his hand as a printmaker. Even during the 1630s, when he was at the peak of his popularity, it is only possible to account for about sixty-five or seventy paintings done during the entire decade. Not a very impressive number for an artist who painted with occult surety and speed. His own promise to the Amsterdam guards that, if they came to Haarlem to pose, he would not take much of their time, is hardly needed to tell us that he painted swiftly. Like Goya, he probably was capable of painting portraits in a single session.

To be sure, the *oeuvre* of some Dutch artists is even smaller than Hals'. Today not even fifteen paintings can be securely ascribed to Hercules Seghers and only around thirty-five to Vermeer. Old inventories indicate that a number of Seghers pictures have been lost. As for Vermeer, his rate of production was apparently low. His way of working, as well as his metabolism, must have been infinitely slower than Hals', which helps explain why none of his uncontested works are straightforward commissioned portraits. Only at the end of the nineteenth century was a painter able to demand, as Cézanne did of Vollard, more than one hundred sittings for a portrait.

Rembrandt, whose life was at least twenty years shorter than Hals', presents quite a different case. Today we can cite more than 300 painted portraits by Rembrandt, not to mention about 200 other paintings, almost 300 etchings and approximately 1400 drawings. Miereveld's production, according to Sandrart, was even more prodigious. He reports that Miereveld claimed he painted

10,000 portraits. A simple arithmetical calculation shows that even if Miereveld directed a large portrait factory his claim was an exaggerated one, but there can be no question that he and his workshop must have turned out numerous official portraits. Study of them makes one regret that Miereveld was not more daring with his brush and less reckless with his claims.

Rembrandt's work was not avidly sought after by all collectors during the eighteenth and nineteenth centuries, but few during that period questioned his position as a leading master of the Dutch school. According to his critics, his trouble was that he was born a Dutchman and therefore had a tendency to imitate nature slavishly without searching for a more perfect truth – a pardonable sin in a portraitist. Moreover, there was always a group of connoisseurs able to appreciate some aspect of his genius. Rembrandt's name was never forgotten. His early character studies and fanciful portraits were found in the cabinets of distinguished collectors and his etchings never lost their appeal. Portraits painted by Rubens, Van Dyck and Velazquez – especially those made for royalty and nobility – were treasured from the time they were made. Though Velazquez had to wait until the nineteenth century before he earned the general esteem he deserved, he was always appreciated in Spain. The international reputations of Rubens and Van Dyck were never eclipsed.

Hals' case is different. Fire, flood, war, pillage, shipwreck, negligence and sheer stupidity have taken their share of every major artist's work. The percentage of lost portraits by Hals, however, seems to be far greater than that of other leading Baroque painters. Still, if we accept as a rule of thumb that there is a direct relationship between the longevity of a portrait and the popularity of its artist and model, it is remarkable that so many of Hals' works have survived. Hals never painted portraits which could be assured royal protection. Most of them were of the kind which is especially vulnerable. With the notable exception of his vivid sketch of Descartes (Plate 264), they were mainly portraits of ordinary mortals. We have already heard that Theodorus Schrevelius confirms the impression that he must have painted a great number of them. In his short but sensitive appraisal of Hals in *Harlemias*, published in 1648, Schrevelius notes that he made an unbelievable number of portraits. Family pride of course insured the life of some, but many were of the type which later generations confine to storerooms instead of drawing rooms after they become vaguely identifiable as an uncle on the side of a maternal grandmother. Changes in taste are also decisive in the life and death of family portraits. We can only guess how many seventeenth-century Dutch ones were discarded because their dark tonalities clashed with the light colours of rococo interiors. Since they seldom appear mounted on the walls of the rooms which eighteenth-century artists used as settings for their small-scale group portraits, there is not much reason to believe that many were highly valued until the general revival of interest in Dutch painting in the nineteenth century.

Some of Hals' portraits were hidden from sight even before their sitters were forgotten. In 1668, only two years after Hals' death, an inventory was made of the effects of the recently deceased artist Jan Miense Molenaer. In the attic of his house there were: 'Two portraits of Jan Molenaer and his wife by Frans Hals, without frames.' Neither portrait has been found.

Introduction

We have already noted that early in their careers both Molenaer and his wife Judith Leyster were followers, if not actually pupils, of Hals. Judith Leyster is known to have quarrelled with him. She sued him in 1635 for accepting an apprentice who had deserted her studio. Maybe she nursed a grudge and seized an opportunity to put the portraits out of sight. If this was the case, after her death in 1660 Molenaer apparently made no effort to rehang the portraits in his living quarters. One would like to believe that their continued exile in his attic after Leyster's death was an indication of the opinion Molenaer had of his wife and marriage, not of Hals. But since he did not choose to hang Hals' portrait of him alone, his estimate of Hals' art at this time could not have been very high.

Evaluations made by appraisers of Hals' works around the same time tell a similar story. A 1669 inventory lists a portrait by Hals as worth fifteen guilders, while in the same inventory a still-life by De Heem was valued at one hundred guilders and a copy of a De Heem at thirty. In 1675 a pair of his portraits was valued at twenty-eight guilders; four years later a man's portrait was listed at twelve, and his genre pictures were appraised at even lower prices.

Similar painfully low estimates continued to be made of Hals' works for almost two centuries after his death. During this period few critics or historians made a major effort to re-evaluate his significance as a portraitist or genre painter. The well-informed connoisseur Gustav Waagen did not exaggerate when he wrote of Hals as late as 1854: 'The value of this painter has not been sufficiently appreciated.'

Little wonder then that the number of existing works by Hals is relatively small. However, his precious *oeuvre* is large enough – thank heavens – to give us a clear idea of his development and achievement during the course of more than fifty years. It is these aspects of his work that we shall examine in the following chapters.

CHAPTER II

Tradition and Innovation: 1610-1620

SINGLE PORTRAITS

THE *Laughing Cavalier* (Plate 52) is one of the most familiar characters in the history of Western painting. In a way this is unfortunate. Because we have known him since our youth it is difficult to take him seriously. He is, however, worth earnest attention, for there are excellent reasons for his popularity. He is a man with whom men can identify when they are in a Walter Mitty mood and one whom many women would like to meet. The *Laughing Cavalier* is also one of the most brilliant seventeenth-century portraits. It shows Frans Hals' unprecedented ability to convey in a portrait a sense of heightened vitality and spontaneity enlivened by silvery daylight. The handsome model's eyes flash, his expression is a fleeting one (Plate 53). He must have been pleased with the vivid characterization Hals achieved – he lived at a time when people wanted portraits to look life-like – and he probably was equally delighted with Hals' accurate representation of his fashionable sparkling white lace collar and cuffs and his elaborate embroidered jerkin.

The traditional title of the portrait was not used until after the middle of the nineteenth century and, like many other popular names of pictures, it is not quite accurate. The swaggering gallant is smiling, not laughing, but it would be hopeless pedantry to attempt to change its title now. The vital statistics beautifully inscribed in the upper right corner of the canvas have not helped identify the model. The anthology of colourful emblems embroidered on his grey jacket (Fig. 3) might offer a clue to his identity, but most of them are too commonplace to be of much help.

One of the most prominent of these emblems, Mercury's cap and winged wand, is seen on the band of the Cavalier's slashed sleeve. Mercury's symbols had been made popular early in the previous century when his staff appears with the motto *Virtuti Fortuna Comes* (Fortune, Companion of Manly Effort) in the first edition of Andrea Alciati's *Emblematum Liber*. This Ur-emblem book, published in 1531, helped start an avalanche of emblem literature in all languages, as well as an international vogue which lasted for more than three centuries. In later editions of the book this device was made more elaborate (Fig. 4), and friends of Alciati assigned it to him when they struck a medal in his honour (Fig. 5). Mercury's symbols were repeatedly employed by later Renaissance and Baroque emblematists, who considered them appropriate for doctors, businessmen, scholars and artists, and Mercury himself still wings his way for an international association of florists which urges us to telegraph our messages in the language of flowers.

Once familiar with the smile on the model's face and the look in his eye, the other embroidered symbols on his clothing do not come as a surprise. Bees, as anyone who has dipped into emblem

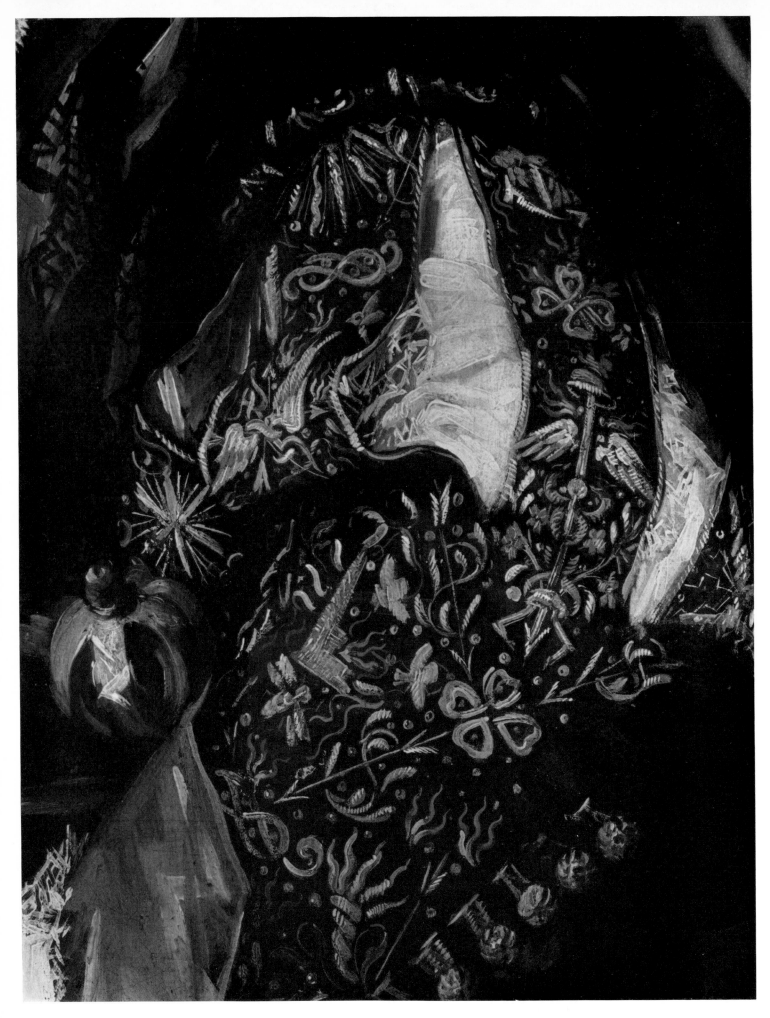

Fig. 3. Detail of the sleeve of *The Laughing Cavalier* (Plate 52). 1624. London, The Wallace Collection

Virtuti fortuna comes.

Anguibus implicitis geminis caduceus alis,
Inter Amalthea cornua rectus adest.
Pollentes sic mente uiros, fandiq; peritos
Indicat ut rerum copia multa beet.

Fig. 4. *Virtuti Fortuna Comes:* Woodcut from Andrea Alciati,
Emblematum Libellus. Paris, 1534

Fig. 5. Reverse of Janus
Secundus' medal
of Andrea Alciati. 1533.
London, British Museum

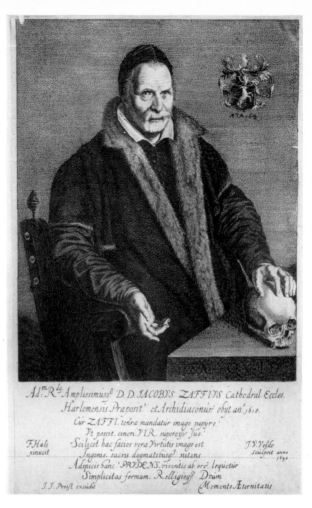

Fig. 6. Jan van de Velde: Engraving after Hals' *Jacobus Zaffius*
(Plate 1). 1630

literature knows, frequently sting like little Cupid, and the winged arrows, the flames and the flaming cornucopias are all familiar components in emblems on love. Lovers' knots, symbols of the bonds which make tyrants tremble and which are untied only by death, can also clearly be seen.

Whether or not all the embroidered symbols were meant to be read together as one gigantic emblem remains to be decided. Their presence, however, reminds us how common such emblematic devices were in Hals' day, when they were found on clothing, household furnishings, walls, ceilings and, of course, in books. The devices on the jacket of the *Laughing Cavalier* also show how easy it is for us to overlook them. They have never been mentioned in the literature on one of Hals' most famous portraits.

In some of his earlier paintings Hals made the symbolism much more overt. This was once apparent in his 1611 portrait of *Jacobus Zaffius* (Plate 1), the earliest known dated work by the master. As we know it today, the portrait is a fragment. An engraving made in 1630, before the picture was cut, shows that it was originally a half-length and portrayed Zaffius seated in an arm-chair by a table with his hand resting on a skull (Fig. 6). The meaning was clear. Hals' portrait of the aged man who was Provost and Arch-Deacon of St. Bavo's Church at Haarlem was meant to serve as a *memento mori* as well as a likeness. The motto *En Quid* on the print underlines the venerable message. Death's heads had been associated with portraiture since the early Renaissance. Soon after portraits began to be made and treasured as a record of a face, skulls were added as a reminder of the vanity of man's early life and of the certainty of death. *Cogitate mortem* was still a familiar admonition in the seventeenth century.

23

A conspicuous death's head appears in another early *Portrait of a Man* (Plate 2), now at the Barber Institute of Arts, Birmingham, which can be dated around the same time as Zaffius. The companion to the Birmingham picture is the *Portrait of a Woman* (Plate 3) at Chatsworth. She holds links of a heavy gold chain, not a skull. Her chain is a sign of wealth, a theme which easily lends itself to moralizing. We can only conjecture whether the elaborate locket at the end of the chain contained a miniature carved wood or ivory skull. If it did she followed tradition and kept it well concealed. Painted portraits of women displaying skulls are not unknown, but they are rare. Overt symbols of death were portrayed resting in the hands of men more often than of women.

The portraits of *Zaffius* and of the *Man Holding a Skull*, the only ones we know by Hals that make such manifest allusions to death, were painted when he still had close ties to the allegorizing and moralizing tendencies of late sixteenth-century mannerist artists. In his later commissioned portraits this symbol disappears, although a skull plays a prominent role in his so-called Hamlet (Plate 97), painted almost two decades later. The prop was also soon eliminated from portraits painted by other Dutch artists. Shortly after the turn of the century most Dutchmen preferred to be painted with gloves or a hat in hand rather than a death's head. Even preachers chose to be portrayed without the object which most forcibly reminds us that 'Man that is born of woman is of a few days. . . . He cometh forth like a flower and is cut down' (Job 14: 1–2). They are shown, as we see in Hals' later works, holding a book, working at a desk, or simply confronting the viewer.

Around the time seventeenth-century Dutch portraitists stopped using skulls as props the number of *vanitas* still-life pictures painted in Holland increased. In these works time-pieces, snuffed-out candles, books, money, jewels, musical instruments, and flowers as well as skulls and other paraphernalia (Fig. 76) were used to remind men of the fragility of learning, pleasure and all earthly life. The objects men live with and covet, rather than portraits of specific individuals accompanied by the most obvious symbol of death, were employed to exhort the pious to ignore the things which divert them from what was accepted as their main task in this world: to know and do the will of God. The shift marks a small step in the dehumanization of death.

A *vanitas* by Hals is cited in the 1636 inventory made of the possessions of Pieter Codde, the painter who finished the militia piece which Hals had begun at Amsterdam in 1633. Hals' *vanitas* painting has not been identified. It may have been a still life; if it was, it was unique in his *oeuvre*. But knowing Hals' predilections, it was probably a painting similar to his so-called Hamlet (Plate 97), a picture best interpreted as a straightforward *vanitas*. No matter what its subject was, we know that Hals' *vanitas* failed in Codde's household as an effective reminder of the importance of leading a righteous life. Codde's inventory was made in 1636 because he finally decided to separate from his wife, whose immoral conduct had long troubled him. Judging from what we know about Codde's character, he was no model of virtue either.

The fashion for portraits *cum* skulls was never revived, and other props were only occasionally used by Hals and his contemporaries in the following decades to make men ponder about the

Embroidered Sleeve. Detail from the *Laughing Cavalier* (Plate 52). 1624.
London, Wallace Collection

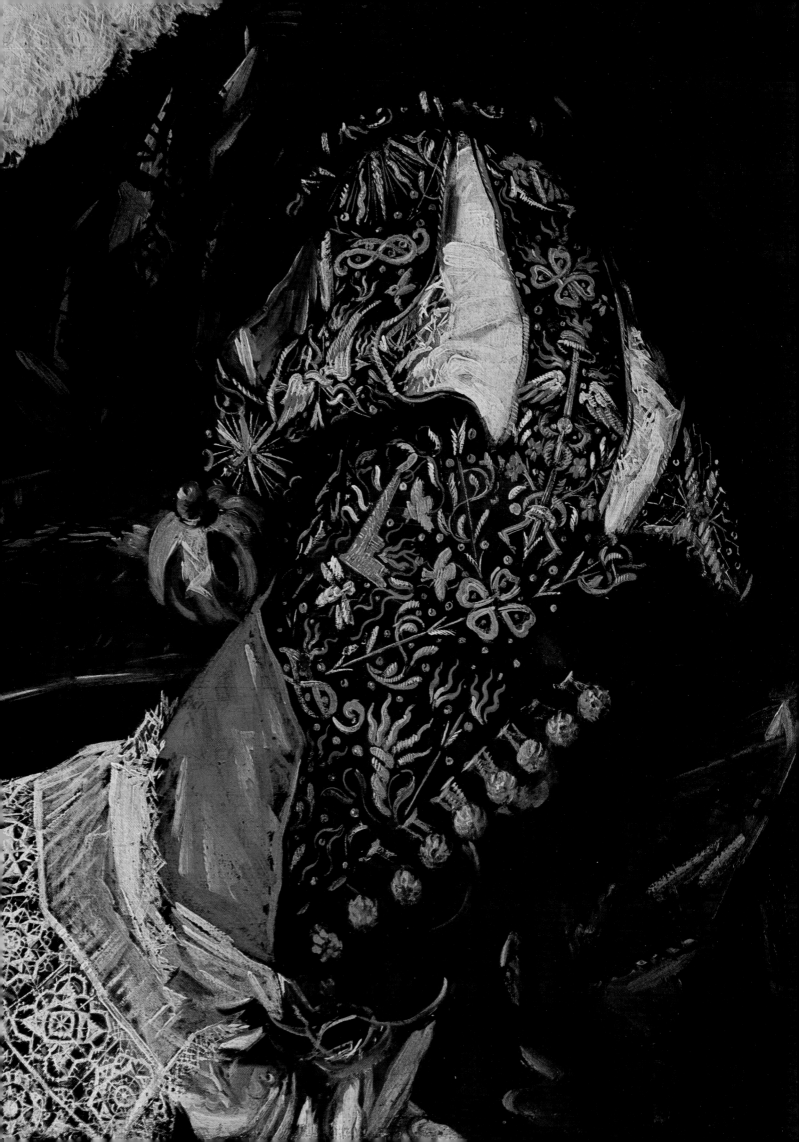

brevity of life and the certainty of death. The urns and architectural fragments on the right side of Hals' *Portrait of a Married Couple* (Plate 33) probably refer to the transience of human life and achievement, and, since time-pieces usually appear in Dutch paintings of the period as *memento mori* symbols, the watch held by the man who posed in 1643 for his portrait (Plate 229; The Barnes Foundation, Merion, Pennsylvania) was most likely put in this model's hand to point a moral, and not to indicate that he was a horologist or a watch collector. Such allusions, however, are exceptional in Hals' portraits. He and his patrons preferred to see life celebrated without being reminded of its inevitable end.

Hals' 1616 portrait of *Pieter Cornelisz. van der Morsch* (Plate 13) is another early work which shows the artist's close connection with the emblematic tradition popular in his day. The model for the portrait, a municipal beadle at Leiden and a well-known member of one of that city's chambers of rhetoricians, was identified in 1910. Later students concluded that he must have been a fisherman or fishmonger. If not, why does he hold a smoked herring (*bokking*) in one hand, and a straw basket of fish in the other? The motto inscribed on the painting WIE BEGEERT ('Who Wants It') also appears to bolster the idea that Van der Morsch is shown hawking his wares. However, interpretations of seventeenth-century Dutch paintings which do not take into account the visual and literary traditions of the time can be as wide of the mark as those made of works produced in other periods. An iconographical analysis made by P. J. J. van Thiel proved that this was the case here. The fish and motto have nothing to do with catching or selling herring, but were used to show Van der Morsch in his well-known role as Piero, the buffoon of the Leiden chamber of rhetoricians called *De Witte Accolijen*.

In an epitaph Van der Morsch composed, he characterized himself as both a beadle and as a man who distributed smoked herrings. Now, there is no doubt that he was a municipal beadle. Van Thiel's study shows, however, that in Hals' time the expression 'to give someone a smoked herring' (*iemand een bokking geven*) had nothing to do with distributing fish, but meant to shame someone with a caustic remark and was the equivalent of a slap or sharp rebuke. The inscription WIE BEGEERT is neither a reference to Van der Morsch's profession nor his own motto; it refers to the model's ever-ready sharp wit. The meaning of the herring and inscription would have been missed by men of Hals' time who did not know idiomatic Dutch, but the painting – like others made by the artist – was not made with an eye on winning acclaim from an international group of connoisseurs and critics. Hals' approach was more provincial, and his paintings were primarily made for the local market. Undoubtedly most of his Netherlandish contemporaries recognized that this portrait of a man ready 'to give a smoked herring' was a portrait of a biting buffoon, and some probably noted that the head of the ape that decorates the nail from which his escutcheon hangs is yet another reference to the man who played a fool.

The old tradition of using overt or covert symbolism in portraiture died hard. But Hals cannot be counted as one of the artists who struggled to keep it alive. We shall see that objects which have a symbolic or emblematic meaning are found in few of his portraits done during the following five decades. This is not astonishing; even the greatest innovators continue to have ties with the past.

Fig. 7. Hendrick Goltzius: *Jan Govertsen*. 1603. Rotterdam, Boymans-van Beuningen Museum (on loan from P. and N. de Boer Foundation)

Moreover, a portraitist is subject to special pressure from his patron. The desires of the latter rather than the predilections of the former may account for the ivy Hals used to symbolize steadfast love in his portrait of the *Married Couple* (Plate 33) or for the sprig of holly which alludes to constancy in his portrait of *Isaac Massa* (Plate 64). The rarity of such conventional symbolic allusions in his *oeuvre* suggests that this was indeed the case.

The importance of the residue of contrived emblematic conceits in Hals' work pales in significance when we consider the new vitality and vigour he brought to painting. From the moment he appears on the scene his power and originality are apparent. There is no sign of fumbling or groping in his earliest known works. To be sure, links with the style of his older contemporaries are evident. The composition and rather stiff pose Hals gave *Zaffius* (Fig. 6) is similar to the familiar one Goltzius used in 1603 for his portrait of the Haarlem shell collector *Jan Govertsen* proudly displaying his splendid specimen of a *turbo sarmaticus* (Fig. 7) while the pasty pinks and rose hues Hals used for Zaffius' flesh tints look as if they could have been painted with a palette laid by the Haarlem mannerist. However, Hals' vivid characterization of Zaffius, the strong light cast on the solid form of the head, and above all, the lively, detached brushstrokes clearly show the personal direction his art will take. As we see in his portrait of *Van der Morsch* (Plates 12, 13), by

26

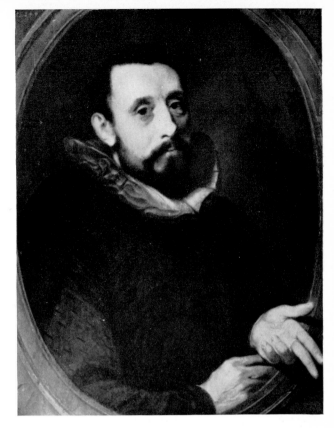

Fig. 8. Jan Saenredam: Engraving after Karel van Mander's
Portrait of Petrus Hogerbeets

Fig. 9. Gerrit Pietersz. Sweelinck: *Jan Pietersz. Sweelinck*, 1606.
The Hague, Gemeentemuseum

1616 he was already making bold use of disembodied touches to model form and suggest texture as well as give new pictorial life to the surface of his pictures.

Though not as conspicuous, Hals' animated brushwork is also apparent in his *Portrait of a Man Holding a Medallion* (Plate 14), which can be dated around 1615. The model is placed behind a simulated oval opening and to heighten the illusionistic effect, he is shown with his hand thrust forward beyond it. Porthole portraits of this type have a long history. The scheme was used by classical Roman sculptors, revived by Renaissance artists and was particularly popular during the late sixteenth century, when mannerist portraitists used simulated frames for inscriptions and as a support for rich emblematic displays (Fig. 8). Shortly after the turn of the century life-size painted porthole portraits were made; the earliest known one done in the North Netherlands is Gerrit Pietersz. Sweelinck's 1606 portrait of his more famous brother, the composer and organist Jan Pietersz. Sweelinck (Fig. 9). Hals followed the vogue and continued to employ the device for large and small portraits until about 1640, when he lost interest in creating such *trompe-l'oeil* effects (strictly speaking, of course, a tiny porthole portrait cannot be classified as a *trompe-l'oeil* – an effective one must be life-size).

Hals made small-scale portraits from the beginning and continued to paint them throughout his career. He is one of the rare masters equally at home working in a small or a monumental format. His portraits in little reveal a side of his genius not as well known as his life-size works and large group portraits. None of them, however, is a true miniature. They could not have been worn as pendants or have decorated the covers of precious little boxes. None is even as small as the portrait medallion held by the man who posed for the painting now at Brooklyn. Hals was not one of those artists who, according to the seventeenth-century miniaturist Edward Norgate, made portraits 'about the bignes of a penny, wherein the lives and likenes must be a worke of Faith rather than Sence.'

27

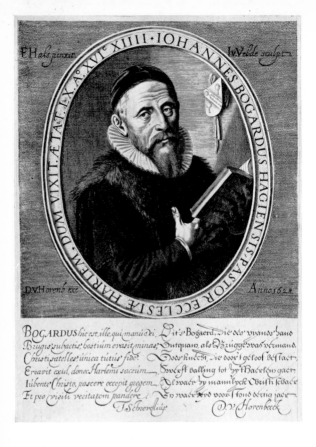

Fig. 10. Jan van de Velde: Engraving after Hals' lost
Portrait of Johannes Bogardus. 1628

The smallest painting which can be attributed to him with certainty is his 1617 portrait of
Theodorus Schrevelius (Plate 23), the perceptive Haarlem schoolmaster and historian who briefly
characterized Hals' art around the middle of the century. It is also the earliest existing small
portrait by the artist. But it is not possible to assert it is the first little one he painted. If we consider
the high mortality of portraits, it is evident that 'firsts' in this category must always refer to what
has survived, not to what was actually produced. His lost portrait of *Johannes Bogardus*, which
served as a modello for an engraving (Fig. 10) and can be dated 1614 or earlier, may very well
have been based on a miniature-like portrait.

The oval portrait of Schrevelius measures less than six by five inches – just small enough to be
held comfortably in one hand. It is painted on copper, a support favoured by miniaturists and
other artists who wanted to give their works a smooth, enamel-like appearance. But even when
Hals painted a little portrait on a support which readily lends itself to a high finish he made no
attempt to fuse his brush strokes. On the contrary. The lively accents which he used to animate
his life-size works from the very beginning are seen here on a small scale. Hals' technique was
the same whether he controlled the movement of his brush with his finger tips or made large
sweeping strokes with his arm. In Schrevelius' brief passage on Hals' work published in 1648, he
rightly commended the artist for his 'extraordinary manner of painting, which is uniquely his.'
Hals' highly individual way of painting will become more apparent in later works, but it is
already evident in the small portrait he made of Schrevelius more than three decades before his
estimate of the artist was published.

Hals appropriately represented Schrevelius holding a book, an emblem – or more accurately,
a quasi-emblem – which alludes to his subject's scholarly activities. He was rector of the Latin
School at Haarlem and later he occupied the same post at Leiden. When Hals painted this portrait
in 1617, eleven-year-old Rembrandt was studying Latin at the very school in Leiden which
Schrevelius was to head. The pose Hals gave the schoolmaster and the oval format of the work

28

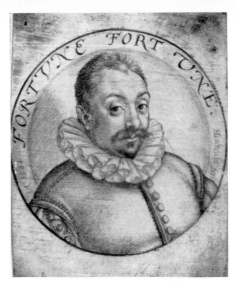

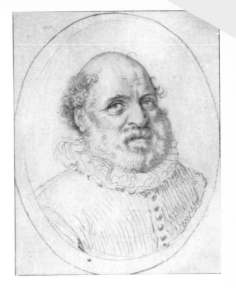

Fig. 11. Hendrick Goltzius: *Caesar Affaytadi.*
Metalpoint. Cambridge,
Fitzwilliam Museum

Fig. 12. Jacques de Gheyn II: *Portrait of a Man.* Metalpoint. Haarlem, Teylers Stichting

as well as its scale once again show the artist's debt to the late Dutch mannerists, particularly the exquisite miniature portraits made by Goltzius and Jacques de Gheyn (Figs. 11, 12). There is, however, one significant difference: Hals' work is done in oils; the mannerists were primarily graphic artists and rarely made painted portraits. Goltzius' painting of the conchologist mentioned previously (Fig. 7) is the only painted portrait which can safely be attributed to him, and not a single one by De Gheyn has been identified. On the other hand, as we have seen, not one drawing or print can be securely ascribed to Hals.

Many of Hals' small portraits were apparently made expressly as modellos for engravers. Contemporary prints of more than half of them have been identified and, thanks to the engraved copies, we have visual records of some of his lost works. The small portrait of Schrevelius was engraved by Jacob Matham a year after it was painted and Jonas Suyderhoef made a second print after it a few decades later. Little portraits of this type must also have been treasured as small cabinet pieces and sometimes the men who ordered them also commissioned companion portraits of their wives. Hals' small portraits of women remained more private; no seventeenth-century prints after any of them are known.

The artist was well served by the skilful seventeenth-century print-makers who made re-productions of his paintings; evidently he never tried to compete with them. If he turned to print-making one imagines that he would have found the relative freedom of etching more attractive than the laborious technique of engraving. Neither medium, however, was congenial to him. Black, white and shades of grey were inadequate for representing the world he wanted to depict. Hals always saw things in colour. Unlike Rembrandt, Rubens and Van Dyck, he did not leave us any grisaille oil sketches designed to be translated into the black lines of a print. Evidently he did not make pen or chalk drawings for engravers either. None of the prints made after his known or lost works are inscribed '*Hals delineavit.*' His credit line always reads '*Hals pinxit.*'

It has been suggested that some of Hals' small oil sketches were preparatory studies for his larger paintings. The hypothesis is attractive because, if it is correct, it would help explain why none of his drawings has been found: he substituted oil sketches for pen or chalk drawings. However, in my opinion no evidence has yet been discovered to support this hypothesis. I do

29

not know a single work which can be called an authentic preliminary oil study for one of Hals' paintings. All of the artist's existing small paintings either served as modellos for engravers or can be classified as independent works of art. In my view the handful which have been called preparatory studies are actually copies made by other artists after his finished works. The problem has been confounded by the life-size copies made by other painters after Hals' authentic small pictures. When the former are accepted as originals, the little autograph paintings erroneously fall into the category of preparatory studies.

The paucity of Hals' preliminary studies in any medium may be explained by his working method. Perhaps he worked directly on a panel or canvas, not merely to save time, but because he did not want any intermediate steps between his vision and his finished picture. It is difficult to imagine that he was merely an ape of nature who could only proceed when he had a preparatory study or a model before him. Surely he did not have the officers he depicted in his large banquet pictures pose smiling with their heads tossed back or with an arm outstretched squeezing a lemon over a dish of oysters. Like Daumier, who never haunted the streets of Paris with a sketch-book in hand, he must have been able to get vivid impressions of men by watching them and he could retain characteristic expressions and gestures firmly in mind. He may have deliberately avoided putting his observations down in sketches in order to keep them fresh and direct. Another great Baroque portraitist used this procedure. When Bernini was asked why he did not use preliminary studies for one of his portrait commissions, he responded: 'I do not want to copy myself but to create an original.'

Naturally, the possibility that some of Hals' small oil sketches are studies for more ambitious works which have been lost or never completed cannot be ruled out. Three little portraits (Plates 140, 141, 142) made around 1633 may have been preparatory studies for an unidentified militia piece and two painted in the mid-1640s (Plates 237, 238) may relate to a commission for a lost regent piece or for one which was never realized. However, the law of probability appears to crumble if we assume that five studies are known for group portraits which have vanished or never saw the light of day, whereas not a single authentic one for the 101 figures he represented in his nine group portraits has survived.

The mystery surrounding the absence of preparatory sketches or preliminary studies for Hals' group portraits cannot be completely explained away but consideration of what is known – and it is not much – about the way other Dutch portraitists of the period worked provides some hints. The rarity of drawings and oil sketches related to portrait commissions indicates that in seventeenth-century Holland patrons seldom wanted to see a sketch before they asked an artist to proceed with a full-scale, finished work. Moreover, no portraitist had a large workshop comparable to Rubens' studio, where assistants executed paintings following the master's carefully prepared modellos or drawings. It seems that Dutch portraitists developed the ability to work from cursory preliminary studies; these were probably discarded after they had served their purpose. Even Rembrandt did not leave us a single complete compositional study for one of his group portraits amongst the 1400 drawings which can be ascribed to him. His summary pen

drawing of *The Anatomy Lesson of Dr. Deyman* was once considered a preliminary study for the painting, but I. Q. van Regteren Altena has convincingly demonstrated that this sketch was made after the painting had been completed. It was drawn to show how the group portrait would look – or did look – *in situ* with a frame Rembrandt designed for the picture. Three preliminary drawings for Rembrandt's *Syndics* are known. None shows the total composition. No drawing can be related to Rembrandt's first group portrait, *The Anatomy Lesson of Dr. Tulp*, and what is even more extraordinary, not a single compositional drawing or preliminary sketch has been discovered for *The Night Watch*, the most elaborate and complex seventeenth-century Dutch group portrait. It is hardly conceivable that Rembrandt did not make some before he began these major commissions. Like those made by Hals, all of them are apparently lost.

GENRE PAINTINGS

THE *Banquet in a Park* (Fig. 13), formerly at the Kaiser-Friedrich-Museum, where it was attributed to Willem Buytewech, was, it seems, one of the earliest paintings which could have been ascribed to Hals. The painting was destroyed in a disastrous fire in Berlin at the end of the Second

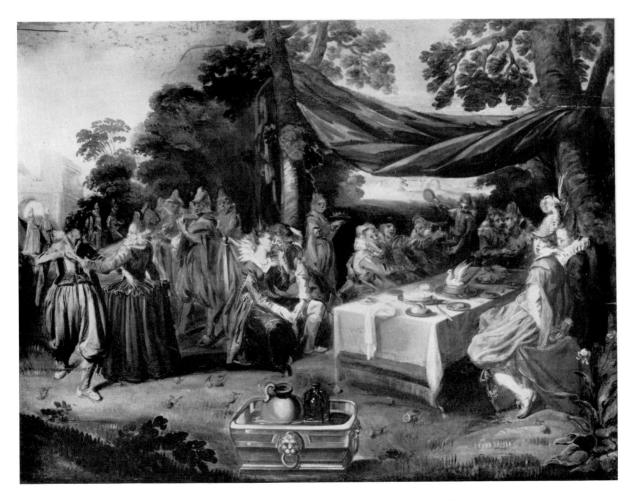

Fig. 13. Attributed to Frans Hals: *Banquet in a Park*. Destroyed. Formerly Berlin, Kaiser-Friedrich-Museum

Fig. 14. Detail from Fig. 13

World War; hence it is no longer possible to take a categorical stand about the attribution. However, there is good reason to believe that Hals, not Buytewech, painted the work around 1610. Recent students of Buytewech's work have understandably excluded it in the short list of paintings which can be attributed to 'Geestige Willem.' Although the subject is similar to those painted by Buytewech later in the decade, the dynamic rhythms set up by the lively groups which are interwoven into a zig-zag pattern and the flickering patterns of light and shadow are alien to him. Moreover, the brushwork in Buytewech's rare paintings never achieves the boldness or fluidity recognizable here. Hals is the only artist active at this time who worked with such exuberance and obvious delight in the fresh touch of fat, juicy paint (Fig. 14). Admittedly, attribution by elimination is hazardous. Plietzsch sensibly noted that the painting cannot

32

be assigned to Hals with absolute certainty until a conclusive *tertium comparationis* has been established, but he too maintained that the ascription to Hals is the most probable one.

Banquet scenes with musicians, dancers and lovers were popularized at the end of the sixteenth century by the late mannerists, who frequently used elegant merry crowds to moralize Biblical stories. Inscriptions on prints made after their designs of these parties make their intent unmistakable. The composition as well as specific details in the destroyed Berlin painting can be closely related to drawings of such subjects by Vinckboons, Van Mander and Dirck Barentsz., which were engraved by Claes Jansz. Visscher, De Gheyn and Jan Sadeler. The list of sources reads like a *Who's Who* of the mannerist artists who helped lay the foundation for the achievement of the first generation of seventeenth-century Dutch genre painters.

The banquet scene, like many earlier ones, may very well have had a didactic purpose. The demand for moralized illustration in Holland was still vigorous when the picture was painted. A print made after it, as others depicting similar subjects, could have borne verses foretelling the coming of the Lord: 'For as in the days that were before the flood they were eating and drinking, marrying and giving in marriage, until the day Noe entered into the ark, And knew not until the flood came, and took them all away; so shall also the coming of the Son of man be' (Matthew 24: 38, 39) or one from the parable of the prodigal son: 'And not many days after the younger son gathered all together, and took his journey into a far country, and there wasted his substance with riotous living' (Luke 15: 13).

But even before this seventeenth-century *fête galante* was painted, some Dutchmen were able to enjoy such scenes without Biblical references to moral or immoral conduct. Van Mander referred to them in his *Schilder Boek* as 'landscapes with little figures in contemporary dress' (*lantschappen met moderene beeldekens*) and he did not add that these pictures must teach a lesson. A verse of a poem he composed in praise of Haarlem in 1596 shows he was responsive to the pleasures derived from an excursion to the countryside. To the south of the city, he wrote, where one goes along the green meadows on the way to Leiden, one finds the Haarlem woods, where young and old can amuse themselves, sauntering or walking. Here and there people are sprawled or lying down in the green to delight their spirits, eating, drinking, playing, reading, singing without care, which drives away melancholy. It is like a village fair, he added: people, like clothing, must sometimes be aired.

We do not know if the artist who painted the destroyed Berlin picture had the lines written by Hals' teacher in mind when he painted his banquet scene but they are as appropriate as verses from Scripture as a source for his inspiration.

If Hals painted the work it was apparently the only small-scale painting of an outing of elegant dandies and their dames that he made. The subject was developed into a special category of Dutch painting during the course of the decade, at Amsterdam by Vinckboons and at Haarlem by Esaias van de Velde, Buytewech, and Hals' brother Dirck. Hals turned to life-size genre painting; in his hands it became a kind of portraiture which quickly attained a bolder and more revealing character than the formal portraiture of the time. His exuberant, life-size painting of

Fig. 15. Mathys van den Bergh: Ink drawing after Hals' *Shrovetide Revellers* (Plate 8). 1660. Paris, Collection F. Lugt

Fig. 16. Follower of Frans Hals: *Shrovetide Revellers*. Formerly D. Katz, Dieren

revellers at a table (Plate 8), now at the Metropolitan Museum, shows the original way he will go. No artist before Hals depicted people with such a love for the joy of life.

An inscription on the verso of a pen drawing (Fig. 15) made by Mathys van den Bergh after the painting in 1660 identifies these merry-makers as '*Vastavonts-gasten.*' They are celebrating *Vastavond,* a holiday equivalent to Shrove Tuesday, Mardi Gras or *fetten Dienstag* in other countries, which has connections with ancient rites of spring and fertility. The carnival enjoyed before the fast of Lent was traditionally dedicated to fools. The colophon of Sebastian Brant's *Ship of Fools,* published in 1494, appropriately reads: 'Here ends the Ship of Fools . . . printed at Basel at the Shrovetide which one calls the Fool's Festival. . . .'

Not all the figures depicted here are ordinary Shrovetide revellers. Amongst them are stock characters who took part in the theatrical farces of the time. Hals' principal models may have belonged to a group of travelling actors or they may have been members of a local amateur group. We have heard that around the time the painting was made Hals himself joined a Haarlem society of rhetoricians which took part in such festivities. The fat Falstaffian character (Plate 9), who plays such a prominent role here, was probably a well-known character in the city; he appeared again in a lost copy of another painting by Hals (Fig. 17) as well as in works made later by Buytewech, Dirck Hals and other Haarlem artists. In this picture, the two herring of his extra-ordinary garland identify him as *Peeckelhaering* (Pickle Herring), a stock type in contemporary Dutch farces. In Hals' other picture of him (Fig. 17) he assumed the role of *Hans Wurst,* another stock theatrical character. The shift was not unusual. Comic figures in Dutch farces of the time did not have the fixed traditions of the Italian *Comedia dell'Arte* players, who followed strict rules

34

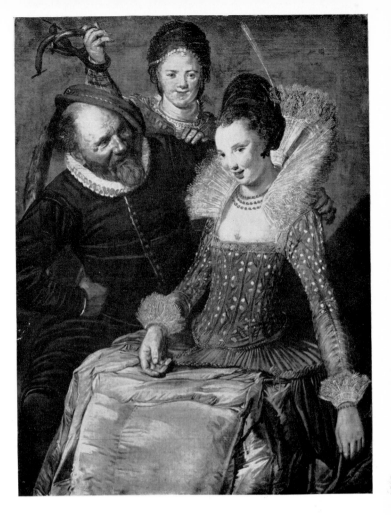

Fig. 17. *Merry Trio*. Copy after a lost painting by Frans Hals. Destroyed.
Formerly Berlin, Kaiser-Friedrich-Museum

governing their functions, costume and even their speech. In the north of Europe the names *Peeckelhaering*, *Hans Wurst*, *Jan Bouset* and *Jean Pottage* were applied to characters who did not essentially differ. This relative informality helps account for the increased popularity of Italian types beyond the Alps later in the century.

In the *Shrovetide Revellers* the man on the right, whose intent is made clear by the expression on his face as well as by his gesture, can be identified as *Hans Wurst* by the long sausage dangling from his beret (Plate 10). His grey costume trimmed in red, his huge buttons, panned trunk hose and old-fashioned codpiece are similar to those worn by buffoons in Holland and other countries at that time. The costume had a long life and, except for the beret, it is still the outfit Punch wears at puppet shows.

Stout *Peeckelhaering* – like Falstaff he appears to be a full two yards around – embraces a young woman crowned with laurel. But is the model really a woman? If her companions were either professional actors or amateur players acting out a Shrovetide farce, the central figure may have been a young man dressed as a woman. Female actresses were not unknown early in the seventeenth century, but in practice as well as principle around this time the theatre was virtually restricted to males.

Traditional Shrovetide food plays an important part in the picture (Plate 11). Shrove Tuesday in the Netherlands without pancakes and sausages was as unthinkable as Thanksgiving in the United States without turkey and cranberries. Only one pancake is seen here – on a wooden platter on the right – but sausages are in abundant supply and *Peeckelhaering's* garland of a pig's trotter, eggs, bean pods and oysters as well as sausages and herring make up a complete Shrovetide menu. The foods in his garland can also be read as traditional erotic symbols and emblems

35

Fig. 18. Adriaen Brouwer: *Smiling Man*. Ink.
Stockholm, National Museum

Fig. 19. Jan van de Velde: *The Rommel Pot Player*.
Engraving

of foolishness. Other objects in the picture allude to folly and debauchery too. The fox tail *Peeckelhaering* holds is a symbol of the fool; the spoon in the hat worn by the howling man standing behind him is a familiar allusion to prodigality, and the bag-pipe on the table may have been intended, as it was in earlier Netherlandish painting, as a sexual symbol.

The rather cramped symmetrical composition, the emphatic diagonals which do not yet help clarify the spatial arrangement and the bright colours indicate that the painting is an early one. In the background are crudely painted figures, which appear to have been hastily added, as if an irresistible *horror vacui* suddenly overcame Hals and he felt compelled to fill every interstice around the four main characters. In some of the passages in the background the quality of the painting lapses. We would like to suggest that the coarsely painted heads at the top of the painting were done by another hand but a close examination of them indicates they are autograph. At a later date they were painted over, probably by the same fastidious owner who cleverly had the obscene gesture *Hans Wurst* makes transformed into a walking stick (the equally vulgar gesture made by the man behind *Peeckelhaering* was apparently overlooked). When the painting was cleaned in 1951, *Hans Wurst's* walking stick disappeared and the boisterous figures in the background reappeared.

Hals' Shrovetide picture was a popular one. Dull, literal copies as well as some freer ones were made after it by Dirck Hals, Buytewech, Cornelis Dusart and some of his unidentified followers (Fig. 16). Adriaen Brouwer, who best grasped the vital impulses behind Hals' work, never copied it, but his small pen drawing of a man who would have been at home playing the role of *Hans Wurst* (Fig. 18) shows how close he could come to its spirit. If Hals made a rapid pen sketch, it is not difficult to imagine that it would have looked like Brouwer's drawing. Its energetic line is so similar to the decisive hatched strokes found in the older master's works from the beginning that Brouwer's highly personal style as a draughtsman may have owed a debt to lost drawings by Hals.

Another early painting which may be connected with the Shrovetide season is the *Rommel*

36

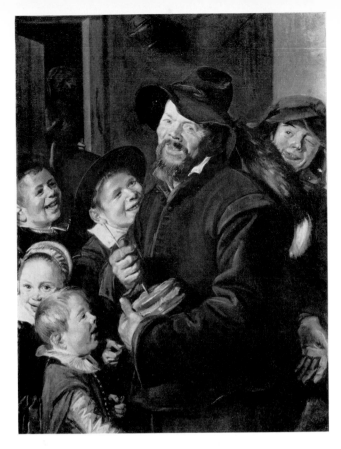

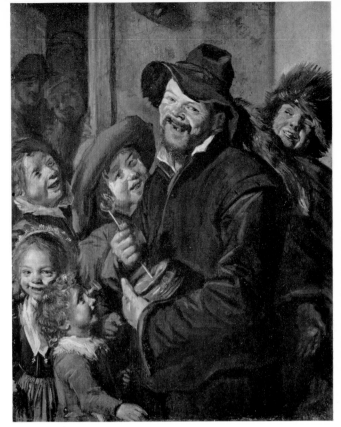

Fig. 20. *The Rommel Pot Player*, after Frans Hals.
Fort Worth, Texas, The Kimbell Art Foundation

Fig. 21. Attributed to Judith Leyster: *The Rommel Pot Player*,
after Frans Hals. Chicago, The Art Institute of Chicago,
Charles H. and Mary F. S. Worcester Collection

Pot Player. It too was frequently copied; more than a dozen variants of a lost original are known. Judging from the best of them – a life-size version at the Kimbell Art Foundation, Fort Worth, Texas (Fig. 20) and a small-scale variant attributed to Judith Leyster, The Art Institute, Chicago (Fig. 21) – the original was probably painted a few years later than the Metropolitan Museum's picture. Though the composition is crowded, the figures are no longer knit together in such a tight fashion; the artist has discovered the virtue of leaving some breathing space above the heads of his figures. The smiling rommel pot player, who wears the fool's fox tail, has gathered around him an audience of amused children offering him coins. The painting could illustrate the Dutch proverb inscribed on a print by Jan van de Velde of the same subject (Fig. 19) which was derived from Hals' invention:

> Many fools run around at Shrovetide
> To make a half-penny grunt on a rommel pot

The winking young fool wearing a huge beret in the old copy at the Kimbell Foundation (Fig. 20) suggests that the scene takes place at carnival time, but rommel pots were also played at other occasions. Young children make up the most suitable audience for the ghastly sounds made by this home-made instrument, which consists of a pig's bladder stretched over an earthware jug half-filled with water. When a reed stick is stuck through the middle of the bladder and is moved between the thumb and fingers the instrument produces a sound not unlike one emitted by a stuck pig.

Earlier Netherlandish artists had depicted street musicians, and around the turn of the century David Vinckboons painted small village scenes which include crowds of gnome-like children on

Fig. 22. G. van Breen: *The Adulterous Couple*. 1603. Engraving after Karel van Mander

Fig. 23. Hendrick Goltzius: *Musical Trio* (Hearing?). 1607. Black and red chalk, body colour. Vienna, Graphische Sammlung Albertina

a street listening to a blind hurdy-gurdy man. The settings for Vinckboons' pictures were ultimately derived from Pieter Bruegel's panoramic views of towns as were the pathetic blind musicians who are the protagonists in his paintings of this type. Hals' treatment of a begging street musician is completely different. Not only is the mood one of unadulterated joy, but he gives us a close-up view of the rommel-pot player and his audience. Only the doorway in the background suggests that we are probably witnessing a street scene. But it is difficult to be certain about this. Even in the best copies it is hard to determine if the summarily sketched figures in the doorway are looking out to the street or if they are peering into a room. With the notable exception of the lost outdoor banquet scene (Fig. 13), Hals showed little interest in defining the milieu in which man lives.

Though some of the types and situations he depicted in his genre scenes were new and his vital temperament transformed more traditional ones, in the final analysis Hals remained bound to the notion that the human figure was the most fitting subject for artists to represent. Everything else was subordinated to this. He soon began to favour neutral backgrounds for his genre pictures and if the copy made after his lost *Merry Trio* (Fig. 17) can be trusted he began to use them during this phase of his career. Nothing about the style of the *Merry Trio* contradicts the date of 1616 which Bode, who saw the work, gave to it. Compositions made during the first decade of the century by Van Mander (Fig. 22) and Goltzius (Fig. 23) of three-quarter length groups shows Hals' point of departure for such scenes as well as for his *Shrovetide Revellers*. His figures, however, are in a less restricted space and he has eliminated the table which both of the older artists placed in the foreground and which he himself made such good use of in the Shrovetide painting now at the Metropolitan Museum. Hals does not use a single prop to give us a clue about the *Merry Trio's* setting. If we consider his complete *oeuvre*, few include more than that.

In the *Rommel Pot Player* children take leading roles for the first time in Hals' work. Even in the copies it is evident that from the beginning he approached them with an unprecedented

38

Fig. 24. Smiling boy, detail from *The Rommel Pot Player*, after Frans Hals. Wilton House, Earl of Pembroke

Fig. 25. Antoine Watteau: *Smiling Boy*, after Frans Hals. Red, black and white chalks. Rotterdam, Boymans-van Beuningen Museum

sympathy and convincingly showed their moments of spontaneous joy. The theme was a novel one – no earlier painting relies so heavily upon the laughter of a group of children for its effect – and the many copies and variants testify to its wide appeal. One of the finest copies was made by Watteau about a century after Hals painted the original. It is a precious small drawing (Fig. 25), done in three colours of chalk, of a child who can be recognized in the variant now at Wilton House (Fig. 24). Watteau's characteristic firm chalk accents model the salient features of the boy's head, making the likeness to his model unmistakable. But something new has been added: an all-pervading light dissolves some of the forms and is even reflected in the shadows. None of the seventeenth-century copies suggests this, and it is doubtful if a Hals original painted during his early years showed the maze of shifting light on and around the lively head. However, as we shall see, in the following decade Hals will introduce the comprehensive forces of bright light and atmosphere into his work. These aspects of the visual world were the momentous discovery of Hals and some of his contemporaries. Watteau was one of the rare artists before the impressionists who grasped the significance of this new dimension which a small group of seventeenth-century artists gave to painting and drawing. It became such an integral part of his heritage that Watteau instinctively introduced sparkling light when he copied a work which lacked it. Hals would have applauded the addition. It can be seen as an *homage*, not a correction. Works which Hals himself painted in the following decade helped Watteau make his creative copy.

THE BANQUET OF THE OFFICERS OF THE ST. GEORGE CIVIC GUARD COMPANY, 1616

IN 1616 Hals painted his first group portrait for the St. George Militia Company of Haarlem (Plate 19). In the following decades he was commissioned to paint two more of the same company as well as two of the St. Hadrian civic guards. Both militia companies, like those of other cities in the Netherlands, had a long history. Originally they were organized as guilds under the patronage of a saint. The oldest was the St. George Company (*St. Jorisdoelen*), also known as

de Oude Schuts or 'the Old Shooting Company.' Reference to them is found as early as 1402, when one hundred and twenty Haarlem citizens were appointed members of a civic guard; at that time their weapon was the cross-bow (*voetboog* or *kruisboog*). The Dutch word *doel* (plural: *doelen*), which is the generic name for companies of militia men, as well as for the buildings which served as their headquarters, is also the Dutch word for target. In those days a member of the company had to provide his own weapons and armour, procure a new cloak annually, and pay for a servant whom he was required to bring to the field. Thus, from the very beginning the members of the St. George Guards were selected from the well-established citizens of the community. An ordinance of 1519 explicitly stated that the guards were to be chosen from amongst the best and most notable ('*beste en notabelste*') men of Haarlem. Soon after the *Oude Schuts* was organized there are records of private banquets attended by the members after shooting practice. The guild also had a religious aspect and in the beginning members celebrated Mass every week, then every day, at their own altar in St. Bavo's Church.

The other guard group active at Haarlem in Hals' time was organized in 1519 under the patronage of St. Hadrian expressly as a fire-arms unit; hence its name *Cloveniersdoelen* (Harquebusiers). It was also known as *de Jonge Schuts* or 'The New Shooting Company.' During the fifteenth and sixteenth centuries Haarlem had a third group, the St. Sebastian Guild, which was composed of men who could afford only a handbow. This group never attained much importance; their weapon was worthless against firearms, which had become common before the middle of the sixteenth century.

In 1558 the municipality of Haarlem agreed to give the leaders (*deken* and *vinders*) of the three guilds an annual banquet to celebrate the completion of their term of office. The decree began the tradition of giving feasts to Haarlem militia men.

The Haarlem guards were reorganized in 1560; the St. Sebastian Guild was disbanded and the other two guilds were transformed into what were in effect municipal militia companies. The opportunity for a hand-bow man to join the St. George or St. Hadrian Guild was slim. Men chosen for these two companies had to possess at least one hundred Flemish pounds; thus membership was not only an honour, but indicated that a citizen had achieved a certain degree of affluence. The guilds kept some of their religious character under the reorganization but they also had regular fire and night watch duties, and were responsible for quelling disturbances. Each guild was also given a new building. The St. George Guild lost theirs in a disastrous fire in 1576. New quarters were built for them and were ready for use by 1592. The St. George Guild's new building was known as the *Nieuwe Doelen* (the 'New Shooting Hall' or the 'New Headquarters'): this accounts for the confusing fact that the *Oude Schuts* of Haarlem occupied the *Nieuwe Doelen* and the *Jonge Schuts* was lodged in a place which the citizens of Haarlem called the *Oude Doelen*.

We must rely upon our imagination for an idea of what the three group portraits which Hals made for the St. George Company looked like *in situ* during the seventeenth century. No contemporary interior view of the *Nieuwe Doelen* is known. The oldest view of its street façade (Fig.

Fig. 26. Romeijn de Hooghe: *View of Nieuwe Doelen,
Headquarters of the St. George Civic Guards of Haarlem.*
Engraving

26), a late seventeenth-century etching by Romeijn de Hooghe, was made when the Haarlem militia companies were of such little consequence that the headquarters of the St. George Company was turned into an inn (*Heeren Logement*); the building in a much remodelled state still stands. The headquarters acquired by the St. Hadrian Guards can also be seen in Haarlem today. A print made after a drawing by Wijbrand Hendricks of the great hall of the headquarters of the St. Hadrian Company (Fig. 138) shows a late eighteenth-century view of the interior. It probably looked much the same in Hals' day. The two paintings on the far wall can be identified as Hals' group portrait of the St. Hadrian Company painted about 1633 (Plate 127) and Pieter Soutman's group portrait of the company's officers made around 1642.

When Haarlem fell to the Spanish in 1573 after a bloody seven-month siege, the Dutch leaders of the revolt were beheaded, the officers of the militia groups were imprisoned and Spanish soldiers, not Haarlem citizens, comprised the city's militia. The St. George and St. Hadrian companies were finally re-established in 1580. The old guild names were kept and they continued to be used until 1795. However, some significant changes were made. After their reorganization in 1580 the companies virtually lost their religious character. A pew in St. Bavo's was still reserved for them, but because of the radical change in religious life in the north Netherlands at this time, they no longer had an altar in the church or took part in religious processions. The guild titles of *deken* (deacon) and *vinder* (dean) were abolished and the military ranks of colonel, captain, lieutenant, ensign, sergeant and corporal were introduced in their place. The officers of the St. George and St. Hadrian civic guards now formed a corps under the common administration of the municipality. The officer corps of each guard group was made up of eleven officers: a colonel, a provost (after 1624 the provost was called a *fiscaal* – an officer who combined the duties of a master-of-arms and a disbursing officer), three captains, three lieutenants and three ensigns. Each group was divided into three companies (*vendel* = company) designated 'orange' (*oranje*), 'white' (*witte*) and 'blue' (*blauwe*), the colours of the newly established country. After 1657 a fourth company, 'the mottled' (*gecouleurde*) company, was added. Captains, lieutenants and ensigns were assigned to one of the three companies. Each company was in turn divided into four corporalships and had four sergeants and four corporals.

At Haarlem Hals was commissioned to paint collective portraits of the whole officer corps of a militia group (the pieces done in 1633 and 1639 include sergeants as well), while at Amsterdam

41

he made another kind of militia piece (Plate 134): a group portrait of a captain with his subordinates. This type, which was popular in Amsterdam, was commonly called a 'corporalship.' Rembrandt painted one for the *Clovenicrsdoelen* at Amsterdam in 1642; today that painting is erroneously called *The Night Watch*. Seventeenth-century Dutchmen accurately referred to it as the *Corporalship of Captain Frans Banning Cocq and Lieutenant Willem van Ruijtenburg*. Since the table of organization of a Dutch civic guard company must be presented before the correct title of Rembrandt's militia piece can be explained, it is safe to predict that the short, but erroneous title of the most famous Dutch painting will not be replaced soon.

The city authorities had control of the militia groups of Haarlem; ensigns, sergeants and corporals were selected by members of the civic guards but all officers of higher rank were chosen by the municipal government. The provost and the ensigns were the only officers eligible for re-election. But after a term out of the corps, a man's name frequently reappears – the ruling circle of Haarlem apparently was a small, closely knit one. The men repeatedly elected as officers were generally members of the regent families of the town and often held other municipal offices.

The ordinary guards, who ranged between eighteen and sixty years in age, numbered between three and four hundred. Their service was voluntary and this appears to have made for a certain laxity. Complaints about the watch are not infrequent. In the rules of 1580 nothing is said about military exercises or target practice. These matters were left to the discretion of the officers and it seems that they relaxed with their men more than they drilled them. By 1596 the companies again held competitions to test their proficiency with the hand-bow and the cross-bow as well as the musket. Interest at this date in the bow and cross-bow indicates that the groups had already taken on something of the character of sports clubs, and evidently the Dutch military leaders who conducted the war against the Spanish were not very impressed with the fighting ability of the reorganized Haarlem militia companies. There is no evidence that they ever called upon them for military assistance during the crucial years before the Twelve Year Truce with Spain was concluded in 1609.

In brief, by 1616 when Hals painted his first group portrait of the Haarlem civic guards, the militia companies had virtually lost their military character. On the two occasions in the following decade when they were called upon to serve outside the city they only saw rearguard action. Their contemporaries had no illusions about their military importance. When Theodorus Schrevelius recorded their exploits in his history of Haarlem published in 1648, he was able to sum up their action against the Spanish in a single sentence: 'Our armed citizens made an expedition to Hasselt in September, 1622, and afterwards to Huessden, in order to relieve the old soldiers there so they could be sent to encampments.' Not armed service, but commissioning Frans Hals to paint their portraits, won the officers of Haarlem's civic guards their fame.

In 1584 – four years after the St. George and St. Hadrian companies had been re-established – the municipality of Haarlem revived the tradition of giving the city's civic guards a banquet at the end of their year's duty. After the Dutch signed the Twelve Year Truce in 1609 and the

term of service of officers was changed from one to three years the banquet became a triennial affair. Hals' militia piece of 1616 (Plate 19) commemorates the banquet of the officer corps of the St. George Militia Company which retired in 1615. Nothing in Hals' earlier works prepares us for this masterpiece. Though it is possible to point to impressive characterizations and manifestations of his original technique in his rare early pictures, none of them suggests that he could create a monumental life-size group portrait which would far surpass the efforts of all his contemporaries and that he would be the first artist to secure a firm place for seventeenth-century Dutch painting on the international scene.

There is no precedent in the long history of Netherlandish group portrait painting for Hals' brilliant solution to the two basic problems faced by every painter of a collective portrait: to make an adequate likeness of each individual member and to show something of the character of the group by indicating the relationship of the individuals to it.

Admittedly there is no way of proving that Hals made good likenesses of his patrons. But like all great portraitists he convinces us that he has. We have heard that he had the advantage of knowing his models; he had served as a guard under them during their term as officers. The twelve men appear to exult in the healthy optimism and strength of a people who have just won their independence. Documentary evidence confirms the impression that we are confronted by men who could consume gargantuan quantities of food and drink. Five years after the painting was made, city officials noted in a set of fifty-two ordinances written to regulate the activities of the Haarlem guards, that some of the banquets given to them lasted a whole week. The city fathers objected. In view of the fact that the municipality had to pay the costs of the banquets and since times were troubled (the ordinances were written in 1621, after the Twelve Year Truce had ended and hostilities with Spain had resumed), the municipal authorities decreed that the celebrations 'were not to last longer than three or at the most four days.' The ordinances also state how much beer (three barrels) could be received free of tax, who was responsible for preparing a statement of the money spent, and precisely how much the servant of the group was to receive for his work at the banquet. Other ordinances of 1621 help recapture some of the spirit of these affairs. One expressly states that no women were to be fetched, brought along, or tolerated at the banquets. Another forbids children to enter, run around or play at the headquarters of the civic guards because the presence of children makes for a 'needless gobbling up of food and drink.'

The characterizations Hals made of the twelve men suggests that he had genuine respect and sympathy for the entire group from the colonel, the company's highest-ranking officer, who is shown with his upraised glass listening to one of his captains (Plate 17), to the servant of the guards (Plage 22). Hals made particularly keen appraisals of the company's dashing young ensigns (Plate 18). According to regulations, the ensigns attached to each Haarlem civic guard group had to be bachelors. As soon as one married he lost his rank. Apparently the authorities believed that a married man would not be as free to swagger or to spend money on uniforms as a bachelor. Two of the company's three ensigns wear long hair, a new fashion adopted by some members of the younger generation during the second decade of the century. The model for the *Man Holding*

a Medallion (Plate 14), a work painted around the same time, also wears long hair. This style soon became the most popular one in Holland and even longer hair became fashionable during the course of the century. Around this time older and more conservative men still cropped their hair short. Did they mutter, as some men do to-day, that long tresses become a woman, not a man?

Like most masters of the Baroque period, Hals convinces us of the palpability of the figures he portrayed, but unlike many of them he never makes us feel that we need an exegesis to explain who they are. Their vital presence can be enjoyed without extensive notes. However, we run the risk of misinterpreting their roles if we make no attempt to control our impressions. For example, it seems natural to conclude that the valiant officers Hals painted were amongst those who defended Haarlem against the Spanish. This was Bode's conclusion in the path-breaking study he published on Hals in 1871 (*Frans Hals und seine Schule*), and it has been repeated frequently. However, not many of the militia men in the 1616 painting could have borne arms against the Spanish when they besieged Haarlem in 1573. Later, Bode reconsidered his statement, and in the revised edition of his important work printed in 1883 (*Studien zur Geschichte der holländischen Malerei*) he wrote that the officers at the 1616 banquet were the *sons* of the Haarlem men who had fought the Spanish.

We must also remember that the arrangement of the twelve men, which looks so accidental to beholders familiar with split-second candid photographs and motion-picture stills, follows rigid rules of decorum and an established pictorial tradition. The officers have been given places according to their military rank. Hals' contemporaries would have recognized this straightway. As is fitting, the colonel, the highest-ranking officer, is seated at the place of honour at the head of the long table. The provost, the second-ranking officer, is seated in his proper place, on the colonel's right. The three men seated at the opposite end of the table are lieutenants, and those between the senior officers and the lieutenants are the three captains. The ensigns, the company's most junior officers, do not sit; two stand on the right side of the picture, and the third has been placed on the left between two of the captains. The twelfth man, who carries the plate of food, is the company's servant. He does not wear a sash. This is no accident either. Coloured sashes and plumes were used to identify a man's rank and unit, for until Napoleon's time the rest of a civic guard's uniform was determined by his personal taste and the size of his purse. Here only the colonel wears an orange sash, a favourite colour in the country loyal to the House of Orange. The sashes worn by all the other officers are red and white, Haarlem's heraldic colours.

Hals was certainly aware of the way his predecessors had depicted guards at banquets. During his formative years the most famous militia piece at Haarlem was the *Banquet of the St. George Company* (Fig. 27) which Cornelis van Haarlem had painted in 1583. Van Mander singled it out for special praise in his *Schilder Boek*. He wrote that it 'is very effectively composed and all the persons show their status or disposition by their actions. Merchants exchange handshakes, those who like to drink hold a tankard or a glass, and so on, each according to his manner. Furthermore, as a whole the work is excellent: the faces, which are good likenesses, are very effectively and freely painted; clothes, hands and everything else are similarly outstanding, so that this piece

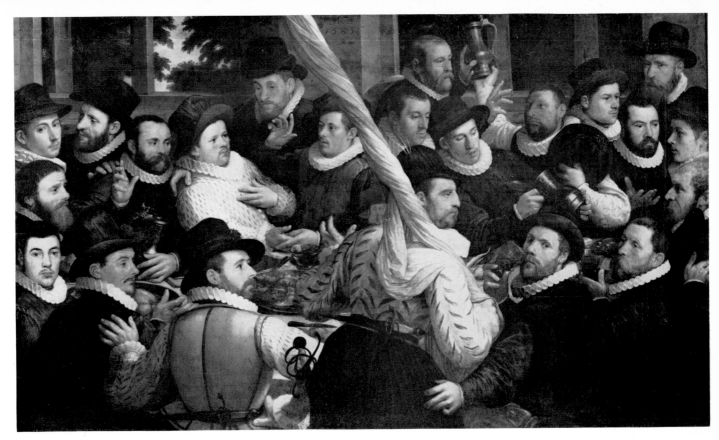

Fig. 27. Cornelis van Haarlem: *Banquet of the St. George Civic Guard Company*. 1583. Haarlem, Frans Hals Museum

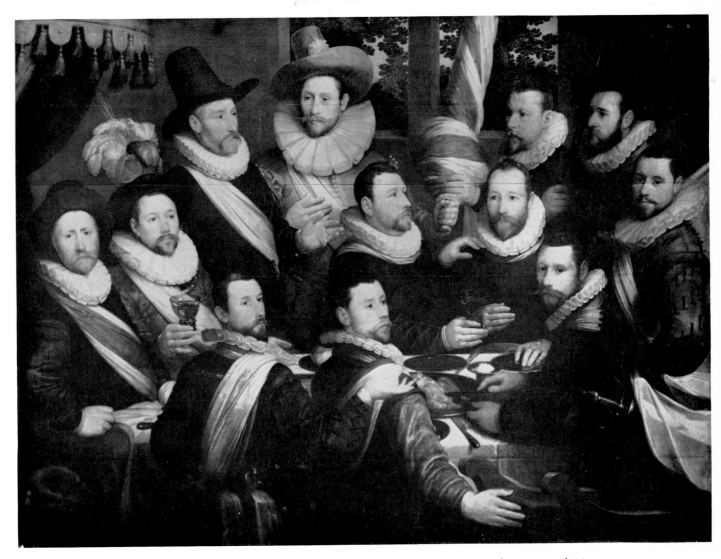

Fig. 28. Cornelis van Haarlem: *Banquet of the Officers of the St. George Civic Guard Company*. 1599. Haarlem, Frans Hals Museum

amongst all others there [at the headquarters of the company] will keep its worthy place.' It is significant that Van Mander maintained that Cornelis' 1583 group portrait was the best one on view and that he does not say a word about the banquet piece Cornelis had painted for the guards in 1599 (Fig. 28). He hardly ignored the latter because he did not know it. After reading the *Schilder Boek* it is difficult to imagine that there was a single painting in Haarlem that this patriotic emigré did not know. He probably failed to cite Cornelis van Haarlem's banquet piece of 1599 for the reason most people would give: it is boring.

Admittedly Cornelis' 1599 group portrait shows a gain in clarity and order over his 1583 picture. It was painted after Cornelis had abandoned the pronounced mannerist tendencies of his early phase and adopted a kind of bland classicism. This is apparent in the new way he arranged the men he portrayed. Instead of lining them up in irregular horizontal rows he adopted a pyramid-like composition, which gives the work a symmetrical order. There is less overlapping, less twisting and turning as well as less action; handshaking and peering into mugs have been eliminated. The crowded confusion of his earlier banquet piece has given way to a greater cohesion; but the total effect is monotonous. It is a case where the operation was a success but the patient died. The poses of the officers are too repetitious. Even their faces have become standardized. In his attempt to solve the classical problem of ennobling a face while making a likeness, Cornelis creates the impression that the officer corps of the St. George Company in 1599 comprised the male members of a large family which included a couple of sets of dull twins. We can believe that Van Mander knew what he was talking about when he wrote a few years later that Cornelis did not enjoy making portraits. Cornelis' attitude toward portraiture did not change: he painted allegorical and religious pictures until his death in 1636, but he painted no other group portrait, although commissions for at least eleven were given in Haarlem during those years.

After Cornelis van Haarlem had finished his group portrait of 1599 no Haarlem portraitist felt inclined to use it as a paradigm. When Frans Pietersz. de Grebber made a banquet picture in 1600 of a crowd of twenty-nine Haarlem militia men (Fig. 29), he followed the tradition of Cornelis' first, not of his second group portrait. De Grebber arranged the guards in two horizontal rows, one in the front plane and one in the background, and like Cornelis he made a border of three men on the right and three men on the left of the picture. Hand-clasping and mug-peering also reappear. In 1610 De Grebber (Fig. 30) made an even more crowded banquet picture of the St. George Civic Guards and once again he followed Cornelis' early, not his late conception. As far as De Grebber was concerned, Cornelis van Haarlem's attempt to bring a new kind of order into Dutch group portraiture was best ignored. It was Hals' genius to discover how aspects of Cornelis van Haarlem's effort of 1599 could be successfully incorporated into Dutch group portraiture. It was this group portrait which was Hals' most important source for his first attempt at the subject.

The two banquet pieces show signal similarities. The colonel in Cornelis' picture (a bunch of plumes upon his hat helps identify him), like the one in Hals' portrait, is seated at the head of the table with an upraised glass. It is not known if the man at the colonel's right in Cornelis' work was

Fig. 29. Frans Pietersz. de Grebber: *Banquet of the St. Hadrian Civic Guards.* 1600. Haarlem, Town Hall

Fig. 30. Frans Pietersz. de Grebber: *Banquet of the St. George Civic Guards.* 1610. Haarlem, Town Hall

Fig. 31. Frans Pietersz. de Grebber: *Banquet of the St. George Civic Guards.* 1618–19. Haarlem, Frans Hals Museum

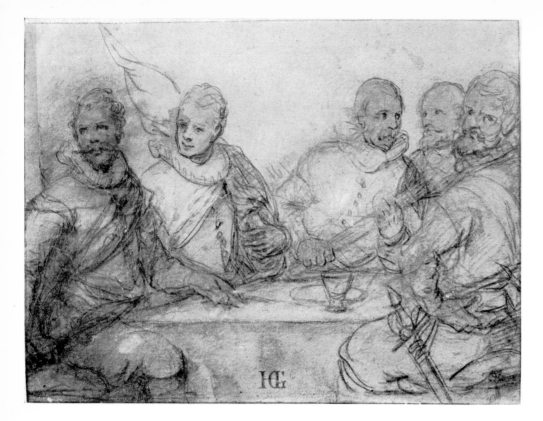

Fig. 32. Hendrick Goltzius: *Study for a Civic Guard Banquet*. Red and black chalk, body colour.
Amsterdam, Rijksmuseum, Prentenkabinet

the provost of the company, but it is evident that Hals adapted his pose for the provost in his 1616 painting. The ensign on the right side of the Cornelis' picture, who has turned to look at us, also appears in Hals' work. But there is a more fundamental connection between these two pictures than these correspondences. The rudiments of Hals' great composition of 1616 are found in Cornelis' group portrait of 1599. It is striking how similar the two compositions are if, in our mind's eye, we delete the officer in the left foreground of Cornelis' picture. In both works four officers have been posed on the left, three standing men have been placed on the right, and a group has been constructed of the men seated in front of the table and behind it. The man we painted out of Cornelis' picture in our imagination appears to have found a place in the group seated in the middle of Hals' painting. The similarities between the two compositions is yet another indication of the ties this bold innovator had with the past.

Hals may have been instructed by the guardsmen to use Cornelis' group as a model. The agreement the Amsterdam portraitist Nicolaes Eliasz made in 1642 to portray a group of civic guards 'as the sitters themselves specified' ('... *als de geconterfeyte personen selffs begeert en geordoneert hebben*') shows that questions of who stands where and in what attitude were not always left to the whim of the portraitist. Contrary to the belief commonly held, even the militia men who commissioned Rembrandt's so-called *Night Watch* were well aware of the place they would take in the militia piece and they were probably not as shocked or disappointed when they saw the finished painting as Rembrandt's overdramatic biographers would have us believe. Each guardsman paid Rembrandt according to the place he had in the *Night Watch*. Fees for a bust, half-length or full-length were most likely discussed before, not after, a man's position in a group portrait was established.

A lively drawing by Goltzius (Fig. 32) of five men seated at a table, which can be dated around 1600–10 and is most likely a fragment of a preliminary drawing for a banquet piece, shows that

48

in his last phase Goltzius anticipated Hals' arrangement of guards into small nuclei which are integrated into a larger group. In view of the similarities between the drawing and the left side of the 1616 group portrait it seems that Hals may have caught a glimpse of it or a similar drawing and had it, as well as Cornelis' painting, in mind when he worked out his composition. Not only does the general arrangement of the figures and the unusually free view of the end of the table, which increases the illusion of space and makes for a more convincing realism, appear to derive from Goltzius, but the officer in the front plane with his arm akimbo is found in reverse in the drawing.

The close connections which can be established between Hals' first militia piece and works by Cornelis van Haarlem and Goltzius do not diminish the young master's achievement. On the contrary, they show what a spectacular transformation he made of the tradition he inherited. Hals kept the symmetrical arrangement of Cornelis' composition but in his work co-ordination of individual parts of the picture gives way to a new integration. The prominent pairs of officers in Cornelis' work are not united into the group; each retains its independence. And there is no sign in Goltzius' drawing that he considered unifying the officers he portrayed with the kind of audacious diagonal accent provided by the flag held by an ensign on the left side of Hals' banquet scene. Hals also gave his officers more elbow room than earlier sitters for Dutch group portraits had ever enjoyed. The distinction between the men in the front plane and those in the middle ground is clear while the illusionism is heightened by the officers who look out of the picture directly at the beholder. An officer seated in front of the table stretches out his hand to us, others turn their heads as if they had just discovered our presence. These devices make us feel that we are participants as well as onlookers. Glances and gestures are also used to unify subordinate groups within the picture. Some men appear to turn and talk to their neighbours. A few look at their companions across the long table. The colour harmony unites the corps too. The painting is a dark, yet warm one. Blacks predominate but there is nothing sombre about the group portrait. Brilliant red, dazzling white, green and orange provide vivid accents. Swift, disconnected brush-strokes enliven the large painting and even the still life on the white damask tablecloth seems to have been animated by his suggestive touch (Plate 21).

By 1616 Hals manifests full control of his original technique and of the new pictorial organiza-tion he introduced to group portraiture. A painting which could serve as the climax to the career of another master was for him a point of departure. Five full decades lay ahead.

Portraiture: 1620-1630

SINGLE PORTRAITS

HALS continued to follow well-established conventions in the life-size portraits he painted during the 1620s. The poses he gave *Paulus van Beresteyn* and his wife *Catherina van der Eem* (Plates 27, 28) in 1620 were part of the stock-in-trade of Netherlandish portraitists; Hals himself had used very similar ones for the companion pieces, now at Cassel, that he probably painted a year or two earlier (Plates 25, 26). The three-quarter-length figures of Van Beresteyn and his wife are seen standing rather rigidly against neutral backgrounds relieved only by escutcheons; of atmospheric life there is not a trace. The colour scheme still shows the dark tonality of his early commissioned portraits, but here it is enriched by the minute precision of his treatment of the great display of lace and embroidery, particularly in Catherina's elaborate bodice and stomacher. Husband and wife are virtually mirror images. Both have been placed a bit off centre and the husband befittingly asserts himself more than his wife. Catherina van der Eem was not an easy subject for a painter. What was a portraitist to do with the pale glory of her moon-shaped face? We sense that Hals did not flatter her. Her eyes were beady, her nose is long and sharp, her chin is weak, and unless she shaved her forehead, the distance between her eyebrows and hairline was abnormally large. The shape of her coat-of-arms appears as a subtle commentary on the configuration of her extraordinary head, while her husband's exuberant escutcheon reflects some of his flamboyance. As always in Hals' works, the light comes from the left, and as always, the woman's face is lighter in tonality than her husband's. In the world of seventeenth-century Dutch portraitists the sun shines more brightly on women than on men.

Five years after he painted the Beresteyn couple Hals used a variation on the arrangement for portraits of *Jacob Pietersz. Olycan* (Plate 58) and his nineteen-year-old wife *Aletta Hanemans* (Plate 59). It takes an iron will to give these works the attention they deserve at the Mauritshuis, where they now hang flanking Vermeer's *View of Delft*. Here too Hals established a close harmony between the couple by making them mirror-like images, but he rang significant changes on the familiar poses. Olycan almost confronts us squarely instead of at a mannerist angle with his head sharply turned. His akimbo arm and draped cloak accent his massiveness. The modifications Hals made in Aletta's pose are less marked but one small alteration makes her cut a more symmetrical figure than her husband. Hals painted her hand resting on her stomacher instead of extending it down toward a chair – a minor change that regularizes her slender silhouette and helps establish a correspondence between the figures. Light and dark areas in one portrait are balanced by equivalent areas in the other, and both are enlivened by the vivacity of the brushwork.

The commission to paint companion pieces as large as life of a husband and wife was the type

of assignment Hals received most frequently during the course of his long career. We have seen that he began painting pendants around 1610 (Plates 2, 3) and at least thirty pairs of portraits made during the following decades have been identified. Thus more than one quarter of his existing *oeuvre* belongs to this category. Probably many of the single portraits known today once had mates; we can only guess at the number which have been lost. Since the revival of interest in Hals' work in the nineteenth century attempts have been made to reunite his separated couples. Not all of the reunions have been successful but it is eminently sensible to try to arrange such matches. Hals designed his companion pieces to be seen together, and in one pair – unfortunately now in separate collections – he even established an action between his two models (Plates 290, 291). In his portraits, if not in actual life, husband and wife always complement and complete each other. When his pendants are separated we see only half the commission he painted.

Portraits of a husband and wife in a single picture are rare in Hals' oeuvre. *The Married Couple* (Plate 33) painted around 1622 is the only one known. Alois Riegl maintained that Hals did not paint double portraits because he wanted to avoid the difficult, if not insoluble, problem of depicting a man and a woman in the same picture without subordinating one to the other. Riegl argued that Hals was fundamentally an enemy of all subordination ('*grundsätzlicher Hasser aller Subordination*') and therefore painted companion pieces which give men and women equal importance. A more prosaic reason for Hals' predilection for life-size pendants over large double portraits (it was one he shared with other Dutch portraitists) was the limited amount of continuous wall space in small seventeenth-century Dutch homes.

Besides the great number of portraits of women and the many genre scenes which glorify their domestic activities there is ample evidence to indicate that the place women held in seventeenth-century Dutch society was more important than it had been in earlier times. But in portraiture the male still took precedence over the female. This was acknowledged by Hals and other artists when they painted pendants or double portraits according to the laws of heraldry. The pictures were composed so that the husband assumed his rightful place of precedence on the dexter side and the wife was placed on the sinister side (the sides dexter and sinister refer respectively to the right and left of the person wearing the escutcheon). The tradition was an old one. It was used by fourteenth-century artists when they painted donors in altarpieces, and later portraitists continued to give husbands this kind of priority over their wives.

The dexter-sinister rule was not iron-clad, but it was not frequently broken. Hals' pendants now at Stuttgart (Plates 160, 161) are his only known breach of the accepted arrangement. Perhaps the portrait of the man at Stuttgart was made while the model was still a bachelor and felt free to glance in any direction; the companion piece may have been commissioned a bit later. This was not unusual. Pendants bearing different dates were done in earlier times and Rubens, Rembrandt and Van Dyck also painted some. In almost all these cases the man sat for his portrait before his female companion.

With the instinct of a great actor, Hals knew that a slight turn of the head or a flick of the wrist could help characterize a personality, and his ability to give artistic form to this insight kept the

traditional portrait schemes he used from ever becoming mechanical formulae. But not all of his portraits are variations on conventional attitudes. Some poses he employed only once. As far as we know he never repeated the one he used for his 1622 porthole portrait of a man with his arms folded across his chest (Plate 39). The light which plays across the model's richly embroidered sleeves (Plate 54) emphasizes his unusual attitude.

The gesture of crossed arms can have a variety of meanings, and like most gestures its significance is subtly related to facial expression and posture as well as to the situation of the subject. Crossed arms can signify defiance, insolent arrogance, impatience or incredulity. To the mannerist art theorist Lomazzo 'crossing arms' was a base action and to some of Hals' contemporaries, who were accustomed to regarding arm and even foot placement as part of fully articulated speech, folded arms must have symbolized inexpressiveness. Shakespeare mentions 'wreathed arms' in connection with discontent and melancholy: Titus implores Marcus, in *Titus Andronicus* (III, 2) to 'unknit that sorrow-wreathen knot, Thy niece and I (poor creatures) want our hands, And cannot passionate our tenfold grief with folded arms.' In *The Two Gentlemen of Verona* (II, 1), Speed tells Valentine that he knows Valentine is in love because he has learned to wreathe his arms like a malcontent.

Another scheme which Hals employed only once is the one he used around 1625 for his portrait of *Willem van Heythuyzen* (Plate 56). It is his only life-size full-length portrait. Small-scale whole-length portraits enjoyed a vogue in Holland during the century; life-size ones, however, were unusual. Few Dutchman, even among those at the court at The Hague, felt pompous enough to commission them and not many Dutch homes were large enough to accommodate them.

A passage in George Vertue's *Note Books*, suggests that the possibility of seeing a full-length by Hals could generate real interest in the late seventeenth century. It is found in Vertue's note on Pieter Roestraten, the Haarlem painter who was Hals' pupil and son-in-law. Vertue wrote that Roestraten promised to show a 'whole-length' by Hals to a friend. There was some delay and his friend became impatient, whereupon Roestraten 'suddenly call'd up his Wife (His Master's Daughter, whom he marry'd) and told him she was a whole-length of that master.' Horace Walpole repeated the story in his *Anecdotes of Painting in England*. He admitted the anecdote is trifling but asked what more important happens in sedentary and retired lives; in his view it was at least as worth relating as the witticisms of philosophers. The story indicates that Hals had at least a small reputation in England around the middle of the eighteenth century. The tale may be apocryphal but there can be no doubt that Vertue's and Walpole's contact with Hals' work was real. Vertue noted that he owned a monogrammed 'picture $\frac{3}{4}$ painted of a Doctor by France Hals.' His painting has not been firmly identified. But we can point to at least one by the artist which Walpole knew well; the *Portrait of a Man* (Plate 256) now in Washington, hung at Houghton Hall until it was acquired by Catherine the Great's agents for her collection.

Who was swaggering Van Heythuyzen and why the great sword? One likes to imagine that the man proudly displaying his weapon helped defeat the Spaniard, sailed to the Indies to carve

out a colonial empire for his country, and subdued the bloodthirsty pirates who harassed Dutch merchant vessels off the coast of Africa. But there are no grounds for believing that he was a military hero or an adventurer. His name does not even appear on the roster of the Haarlem civic guards. He was a wealthy Haarlem merchant best remembered for his efforts to help promote the welfare of his fellow citizens. Among other philanthropic deeds, he endowed a small home for old people on his country estate at Middenhout near Haarlem which still serves the needs of twelve old women. The remarkable small portrait Hals painted of him (Plate 198) about fifteen years later, which is as informal as the large one is formal, was owned by the home he established until late in the nineteenth century.

We do not know whether Hals or Van Heythuyzen himself decided that he should be portrayed standing big as life. The scheme was more often used by Renaissance and Baroque artists for portraits of royalty and noblemen than of burghers. Perhaps Hals caught a glimpse of Flemish or Spanish portraits of this type when he visited Antwerp in 1616 and he may have known some of Van Dyck's early whole-lengths. But there is no need to search for specific prototypes. The type had been part of the repertoire of Netherlandish artists since the middle of the sixteenth century, when Antonio Moro painted them, and they continued to be used, particularly by court painters, during the course of the following century. Around 1635 Van Dyck used the pose for his most grand portrait of Charles I, and Rigaud employed it in 1701 for a state portrait of Louis XIV. What other artists did for kings, Hals did for a citizen of Haarlem. No portrait better portrays the confidence and vigour of the proud men who made Holland the leading nation of Europe during the first half of the century.

The tautness of his pose gives us a sense of Van Heythuyzen's vitality. His every nerve is alert and it seems that he has just moved his eyes, but not his head, to rivet us with his glance (Plate 57). There is no slack in his figure. One arm juts out, as firm as the heavy sword he holds; the other makes a sharp angle from shoulder to elbow to wrist, and even his fingers take part in the dynamic angular rhythm. The strong, even light which models his powerful head and hands is characteristic of the commissioned portraits done during this phase, but a new awareness of its animating power is evident in the reflections on his black satin jacket.

The Baroque trappings behind Van Heythuyzen are a rare note in Hals' work. Although the swatch of violet drapery has been integrated into the great sweeping curve formed by his cloak and his colossal knee-breeches, and the vertical pilaster emphasizes his erect carriage, Hals was not at home using these props. He has designed an impossible structure out of bits and pieces of classical architecture, and there is no question that Van Heythuyzen is weightier and stands more firmly than the curious construction behind him. Since nothing is known about the layout of Van Heythuyzen's country estate at Middenhout – we do not even know if he owned it when this portrait was painted – we cannot tell if the vista in the background is derived from a view of his garden there. The view may very well be an imaginary one. Hals used a similar vista in the *Married Couple* (Plate 35) now at Amsterdam, which he had painted a few years earlier. The couple in the garden behind Heythuyzen, like the ones in the Amsterdam picture, appear to have

53

strolled in from one of the little pictures Haarlem genre painters made around this time of fashionable young people at an out-door party.

The garden in which the Amsterdam *Couple* is seated is a fit setting for a married pair, a traditional garden of love. Perhaps the garden in the background of Van Heythuyzen's portrait had a similar symbolic meaning. If so, this bachelor appears out of place; in the ideal world where gardens of love exist each man is usually accompanied by a woman. However, the possibility that the garden as well as the prominent roses at Van Heythuyzen's feet and behind his sword refer to some secret affair of the heart cannot be ruled out. Roses were often used in Baroque times as symbols of love, and their thorns made appropriate allusion to the pain which can accompany love. But in the context of this formal portrait it is more probable that the roses refer to the vanity of life than to the joys and torments Venus offers. The popular emblematist Livin Lemmens, who recognized the flower as a symbol of love, also tells us in his *Herbal for the Bible* 'nothing sooner fadeth away and withereth than doth the Rose, therfore is the fraile, brittle, transitorie and momentarie life of man, with all the gay glorie, pompe, pride and magnificence thereof which quickly passeth away, very aptly there unto resembled.' Roses were as familiar *vanitas* symbols in Van Heythuyzen's day as the skull, hour-glass and inverted torches, which appear on his tomb at St. Bavo's Church at Haarlem. An inscription on his tomb serves as an appropriate motto for Hals' portrait of him:

I wrought	I suffered
I stood	My peace
I sought	I have achieved.
I found	

The history of Van Heythuyzen's portrait is obscure until 1789, when A. Loosjes singled it out for special mention in a poem written in praise of Hals and noted that it belonged to G. W. van Oosten de Bruyn. The latter was a historian of Haarlem and collector who also owned Vermeer's *Little Street*. Thus the portrait enjoyed a certain notoriety in Haarlem around the end of the eighteenth century. But not everyone was equally impressed by it. When it was sold at auction there in 1800, it fetched only fifty-one florins. Later, when it was purchased at another auction in 1821 for the Liechtenstein Collection, it was thought to be by Bartholomeus van der Helst, not by Hals. This erroneous attribution, made at a time when Van der Helst was held in far greater esteem than Hals, is a tribute to the picture's quality as well as an index of the state of knowledge about Dutch painting during the first decades of the nineteenth century. But things changed rapidly. When Bode published his monograph on Hals in 1883 he called it 'the masterwork of Hals' single portraits.' Bode's judgement has stood the test of time and the market place. In 1969 the portrait was purchased by the Alte Pinakothek, Munich, from the Liechtenstein Collection for 12,000,000 German marks, one of the highest prices ever paid for a painting.

While Hals' whole-length of Van Heythuyzen shows what he could achieve within the international tradition of formal portraiture, the one of *Isaac Abrahamsz. Massa* (Plate 64) painted in 1626 is an outstanding example of his departure from it. The painting is the earliest known

Fig. 33. Bartolomeo Passerotti:
The Astrologer.
Rome, Galleria Spada

Fig. 34. Dirck Barentsz.: Detail from *Banquet
of the Civic Guards* ('*De Pos-eters*'). 1566.
Amsterdam, Rijksmuseum

Fig. 35. Égide Sadeler: Detail from *Portrait
of Bartholomäus Spranger with an Allegory on
the Death of his Wife.* 1600. Engraving after
Bartholomäus Spranger

single portrait of a casually seated model turned in a chair with his arm resting on its back. Mannerist artists (Fig. 33), who wanted to show a transitory aspect of a patron rather than a more characteristic one, made some attempts in this direction. In a group portrait by Dirck Barentsz. (Fig. 34) and in a *Self-Portrait* by Spranger (Fig. 35) we find figures anticipating the pose Hals gave Massa, but in none of these is the movement so lively or is life so convincingly grasped as something moving in space and time.

Massa's body is turned toward the right while his head is shifted to give a full view of his ruddy face (Plate 65). The piercing glance he throws to the far left suggests he has abruptly turned his head to look at something close by. His parted lips make us feel they are about to move. Hals discovered early that a portrait was enlivened if the model looked as if on the verge of speaking. Bernini, who told Chantelou that 'the half-open mouth as if about to speak is the best moment to choose for a sitter,' came to the same conclusion. Without making him appear frozen, Hals convinces us that we are viewing an instant in Massa's life and that in the next one his attitude and expression will change. Movement is also suggested by the disconnected hatched brush-strokes which model the forms of his powerful head and fine lace collar while suggesting the vibrating effect of shimmering light. Preoccupation with the momentary did not lead the artist to lose sight of the over-all organization of the portrait; sweeping curves and diagonals boldly organize the design.

After Hals had invented the pose he gave Massa he continued to employ it, but always with significant modifications: he was not an artist who plagiarized himself. The pose was quickly adopted by other Dutch artists and an international group of portraitists (Fig. 36), and it con-

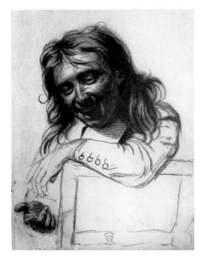

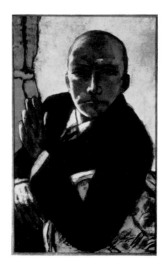

Fig. 36. Charles Beale II:
Carter, the Colour Man.
Red, brown and black chalks, black lead.
London, British Museum

Fig. 37. Max Beckmann: *Self-Portrait.* 1944.
Munich, Bayerische Staatsgemäldesammlungen

tinued to be used during the following centuries (Fig. 36). Nor was it discarded by more recent artists. Max Beckmann's *Self-Portrait* of 1944 (Fig. 37) is ultimately derived from a scheme Hals introduced in 1626.

It seems that Hals never portrayed a professor, a preacher or a woman in the informal pose he gave Massa but not enough is known about his sitters to make a firm correlation between this attitude and the profession, personality or sex of his patrons. Quite a bit, however, is known about Isaac Abrahamsz. Massa. Although his name suggests a Jewish origin, the tradition that he was a descendant of an Italian Protestant family that had emigrated to Holland after the Reformation is probably closer to the mark; his brother's name was Christiaan, hardly the name a Jewish father would give his son. Around 1601, when Isaac was about fifteen years old, he was sent to Russia to learn the silk trade. He remained there for eight years and had the good sense to learn Russian; he was one of the few Dutchmen of his time who handled the language with ease. During these years he lived through 'The Time of Troubles' when Russia was plagued by war, famine and intrigue. His Journal of what he witnessed (*A Short Narrative of the Origin and the Beginning of the Wars and Troubles of Moscow*) includes a rare account of the life and murder of the False Dimitri, the pretender who became Czar after the death of Boris Godounov. Massa returned to Russia on trade and diplomatic missions six times before his death in 1643. He also won a reputation as a cartographer and geographer. Among the maps he published is a rare plan of seventeenth-century Moscow, which, he wrote, was obtained with great difficulty because in 1605 it was considered an act of treason for a Muscovite to give one to a foreigner. He also published the first accounts of Russian penetration into Siberia and drew a valuable map of the northern coast of Russia and Siberia. These publications were of interest to his contemporaries who were eager to procure Russian furs and even more eager to find a northeast passage to India and China. Massa was sceptical about finding a route to the Orient through arctic seas and declined to join an expedition put afloat to find one.

Massa must have had fabulous stories to tell and he must have enjoyed telling them, judging from this portrait and the small one (Plate 168), which Hals painted of him about a decade later. Hals probably heard many of these tales, for we know that he and his model were friends; in 1623, three years before he painted the portrait, Massa was a witness at the baptism of one of the artist's daughters. Although Hals' natural inclination may not have led him to paint the sprig of holly Massa holds in his hand, he surely had no objection to finding a place for this traditional emblem of friendship and constancy in the portrait.

The view of the northern landscape behind Massa (Fig. 38) is probably an allusion to the forests of Russia which this energetic traveller saw. It is one of the few instances where a plain background is not found in a portrait by Hals. Italian and Northern Renaissance portraitists frequently showed a model in an interior with a view of a landscape seen through an opening or a window in a wall behind them. The device was used as early as 1460 by Haarlem-born Dirck Bouts. But unlike most of his predecessors, Hals made no attempt to create the illusion that we are looking through an actual window set into a wall. There is no evidence of a window sash and no indication of

Fig. 39. Pieter Molyn: *Landscape with Fir Trees*. Ink and wash. Munich, Graphische Sammlung

Fig. 38. Detail of *Isaac Abrahamsz. Massa* (Plate 64). 1626

Fig. 40. Pieter Molyn: *Landscape with a Road and Farm Houses*. 1628. Prague, National Gallery

mouldings around the opening in the wall here or in his rare other portraits that use this scheme (Plates 202, 334). Hals concentrated on making figures appear palpable and not on fragments of architecture.

In my opinion the exceptional landscape in Massa's portrait was not painted by Hals. Not a passage in it shows his characteristic hatched brushwork although it is particularly evident on Massa's collar and his sprig of holly. The hypothesis that Hals may have used one mode of painting for portraits and another for landscapes around 1626 is weakened when we discover that his personal touch is as evident in the landscape backgrounds of *The Married Couple* (about 1622; Plate 33) and his *Portrait of Van Heythuyzen* (about 1625; Plate 56) as it is in the principal figures of those portraits. But if Hals did not paint the background, then who did? Comparison of the landscape with drawings and paintings made by the Haarlem landscape specialist Pieter Molyn reveals a striking similarity. A drawing by Molyn at Munich, for example (Fig. 39), shows the same unusual type of wind-whipped firs; other landscapes he painted around this time also display the long, liquid strokes of the pinaceous trees and the tiny dabs and touches of the heavy foliage (Fig. 40). The conclusion seems inescapable that Hals had called upon Molyn to help him complete his picture.

Nor was collaboration between artists on a single work unusual in seventeenth-century

Netherlandish painting. Those who specialized in one branch of painting often worked with colleagues who were experts in another. David Bailly, for example, painted the still-life in the little portrait Thomas de Keyser made of him (Fig. 131). We shall see that Pieter Molyn's hand can be recognized in a few other works by Hals. In 1630 Hals collaborated with the obscure still-life painter Claes van Heussen (Plate 112), and there is also documentary evidence that Hals and Buytewech worked together on a pair of portraits. The former painted the figures and the latter was responsible for the *comparquement* (the meaning of *comparquement* is obscure; perhaps it refers to elaborate framing cartouches for porthole portraits). Hals, however, did not take part in such joint efforts frequently. The cases cited here are the only ones known.

Massa himself may have suggested that Pieter Molyn be called upon to paint the northern landscape in his portrait. In any event Hals did not often rely for assistance upon his fellow artists. He had no need to. In his own field he was without peer. On the occasions when he included more than a figure or a group of figures in a picture he showed that he could successfully match and even surpass specialists who worked in other branches of painting. The still life in his *Shrove-tide Revellers* (Plate 11) and the laid banquet table in his militia piece of 1616 (Plate 21) make clear that he exceeded by far what other artists were doing in this category during the second decade of the century. Landscape backgrounds in his genre pictures painted a few years after the portrait of Massa had been completed indicate that he kept abreast of the epoch-making strides Molyn, Van Goyen and Salomon van Ruysdael made in depicting the freshness of the Dutch countryside with their new tonal effects. It is tantalizing to imagine what he would have achieved if he had decided to paint pure landscapes. Hals, in turn, was seldom asked to paint staffage for other artists. The figure he did for Van Heussen's still-life is unique in his *oeuvre*. Perhaps he had little taste for this kind of joint effort. On the other hand his colleagues may have been sceptical about Hals' ability to modify his highly personal style so that it would satisfactorily integrate into their work.

Massa was not Hals' only patron shown in a momentary pose. In 1627 the artist made a small portrait of the preacher *Johannes Acronius* (Plate 81), where the foreshortening of his body behind the painted oval as well as his suspended hand suggest the preacher has just turned away from his book to look at us. The sitter's attitude appears as spontaneous as Hals' brushwork. More formal portraits were also animated with lively gestures. Around 1626 Hals depicted the preacher *Michiel van Middelhoven* (Plate 62) with his thumb touching his forefinger as if he were emphasizing a point during the course of a sermon. His thumb, we sense, will move to the tip of another finger as soon as he develops the next point in his argument. The contrast between Middelhoven's action – small as it is – and the immobility of his seated wife (Plate 63) helps establish the difference between the active male and the more passive female. In the same years Hals showed a similar relationship between a couple in his small, sparkling portraits of the historian and poet *Petrus Scriverius* and his wife *Anna van der Aar* (Plates 60, 61): the woman remains well behind the painted opening, while her husband's hand appears to project forward toward the spectator's world. In another small *Portrait of a Man*, painted in 1627, the model makes an even more direct appeal to the spectator as he stretches his hand out beyond the painted frame (Plate 82). Although Hals

continued to place his models behind painted ovals during the following decade this was the last time he used the *trompe-l'oeil* effect of a hand protruding beyond a simulated opening.

In May, 1628, the Utrecht jurist Aernout van Buchell, who had a passion for art, visited Hals' early patron Theodorus Schrevelius at Leiden. Van Buchell noted in his journal that he saw two portraits by Hals there: one of his host, who at that time was rector of the Leiden Latin School, and one of the Haarlem historian Petrus Scriverius. It is difficult to pinpoint these works. The portrait of Schrevelius may have been the small one Hals painted in 1617 (Plate 23) or it may have been one of the other fine small paintings (Plates 74, 75) which have been identified as portraits of the schoolmaster. The portrait of Scriverius could have been the little one now at the Metropolitan Museum (Plate 60) but it is unlikely that this little gem was ever separated from its mate (Plate 61), and Van Buchell made no mention of the companion piece. He did, however, make an interesting comment about another young artist on the same page that contains his notes on Hals. He wrote: '*Molitoris etiam Leidensis filius magni fit, sed ante tempus.*' This short sentence is the earliest known reference to Rembrandt's art. Perhaps Schrevelius' warm enthusiasm for an alumnus of his Latin School prompted Van Buchell to write that the son of the Leiden miller was highly esteemed. His conclusion that young Rembrandt was prematurely praised may have been partially formed by comparison he could make between his works and the quality of the two portraits by Hals owned by the rector of the Latin School.

Van Buchell's reservation about young Rembrandt's achievement underlines a point often overlooked when the accomplishments of Rembrandt and Hals are compared: the artists belonged to different generations. In 1628 Rembrandt was a twenty-two-year old genius just beginning to fulfill his promise while Hals was a mature master of about forty-five who had already created an *oeuvre* that invigorated Dutch painting with a new force and naturalism. The range of possibilities open to Rembrandt when he began his career around 1625 was quite different from that which young Hals had found a quarter of a century earlier.

FAMILY PORTRAITS

SEVENTEENTH-CENTURY Dutchmen took unusual pride in their families. They had gold and silver medals struck to mark betrothals, marriages, baptisms and wedding anniversaries (Figs. 193, 194). More than their share of major and minor poets wrote verses to mark special family occasions. And they put a small army of artists to work painting portraits of their families. Portraitists were commissioned to show members of a household everywhere – in interiors, in gardens and fields, in streets and courtyards, on terraces and docks, and sometimes in the guise of Biblical or mythological characters. Donor portraits of a worshipping family divided into two groups on either side of an altar-piece, with males on one side and females on the other (Figs. 161, 162), were not unknown, but they were rare. By 1600 the demand for these had virtually disappeared in Protestant countries. As early as 1527 Holbein's portrait of Sir Thomas More's family set an im-

pressive precedent for a self-contained family portrait where neither the intermediary role of saints nor a division of the family by sexes into two groups at prayer was a consideration. Holbein's family portrait was probably painted to commemorate Sir Thomas' fiftieth birthday and no doubt many later group portraits of this type were made to mark specific familial events.

The popularity of family portraits can be related to the Protestant exaltation of marriage and its natural consequences as well as to the delight some Dutchmen had in showing their possessions. Abolition of monasticism and of clerical celibacy in the new Republic led to an increased emphasis upon the importance of marriage and family life. The family, not the monastery or the nunnery, became the ideal place for Bible instruction and character development. It would be rash, however, to make a causal connection between the new stress Protestants placed on the family and the large number of family portraits painted in seventeenth-century Holland until the religious faiths of a fair sample of the patrons has been established. This is difficult because so many of the families portrayed remain anonymous. None of those painted by Hals, for example, can be firmly identified. Yet the identity of a sizeable number of his sitters for single portraits has been established and we know the names of almost all the people who appear in his civic guard and regent group portraits.

The young child who appears with a woman in the lovely double portrait (Plates 36, 37, 38; Berlin-Dahlem, Staatliche Museen) which Hals painted around 1620 has been identified without foundation as a member of the Ilpenstein family. The name, which appears in the older literature on Hals and in the catalogues of the Berlin Museum, was erroneously introduced when the portrait was sold with the effects of Ilpenstein castle in 1872. Ilpenstein never housed a family of that name; it was the seat of the Teding van Berkhout family. According to a nineteenth-century tradition the woman in the double portrait is the child's nurse. Her modest black dress suggests this may be the case but it is not impossible that Hals was commissioned to portray a mother who was willing to see her child the centre of attention. The motif of a woman offering fruit to a child was a common one in Netherlandish family portraits and does not supply proof of profession or kinship. The sex of the child is uncertain too; around this time young Dutch girls and boys both wore skirts and lace caps. But there can be no question about the high level of Hals' achievement here. The double portrait is an outstanding example of his sympathetic characterization of women and children as well as of his ability to satisfy his patrons' demand for a meticulous treatment of a sumptuous display of rich embroidery and lace. The woman, it seems, was about to offer an apple to the young child when their attention was diverted by the spectator, to whom they appear to turn spontaneously. Naturally, Hals did not paint his models while they posed in this position. The point is an obvious one but it is worth making because of the popular notion that Hals was a kind of human kodak who merely painted what he saw in front of him. One wonders how long the young child actually posed. Children are notoriously bad models and not all artists find them attractive subjects. Vermeer, the father of eleven, never painted one. Children wiggle, squirm, and squeal – but never in Hals' world. The conviction that we are sharing a passing moment in the life of the woman and child is a result of the conscious intellectual effort Hals made to relate

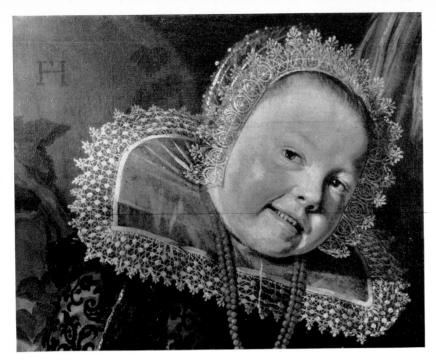

Fig. 41. Salomon de Bray: Detail from *Family Portrait in a Landscape* (Plate 29). Bridgnorth, Shropshire, Viscount Boyne

Fig. 42. Detail of a young child in *Family Portrait in a Landscape* (Plate 29). Bridgnorth, Shropshire, Viscount Boyne

the figures to each other and to the onlooker. Their fleeting expressions of warmth and smiling contentment had to be observed and fixed.

Around the same time the double portrait was made, Hals painted the life-size *Family in a Landscape* (Plate 29), now in the Collection of Viscount Boyne, Bridgnorth, Shropshire. The painting, which is the earliest of his four family groups, is not well known. Neither Hofstede de Groot nor Valentiner were able to procure photographs of it when they published the painting and it has seldom been exhibited. Hofstede de Groot rightly noted, however, that the traditional identification of the Boyne painting as the 'Family of Jan de Bray' must be rejected; Jan de Bray was born in 1625, about five years after the picture was painted.

In the Boyne *Family Portrait* the father and mother are shown seated on the ground surrounded by seven children. Although the group is out-of-doors the space remains shallow. The parents and the three children at the right are in one plane, while the three behind establish another close to them. Variety of movement, gesture and expression create an unusual diversity of interest and, to judge from the way they were depicted, it appears that when one member of this family glanced or gesticulated toward another member he seldom received a response. The artist placed his models so that some are almost on the same horizontal level while others form a vertical row, but this arrangement does not create the dominant accents which unify Hals' other group portraits. Something is amiss here. It has never been mentioned that the smiling child in the lower left corner is partially responsible for this. She – if we are permitted to identify her as a girl – was not part of Hals' original composition but a later addition by another hand. When a close view of her head (Fig. 41) is compared with the young child on the right (Fig. 42) it becomes evident that she is not painted with the fluent touch found in Hals' works from the beginning. The paint is dry, and the characteristic bold, lively accents are missing. Her face appears as polished as her coral beads, which according to tradition were a good thing to put around the neck of a child because they 'driveth away troublous and terrible dreams, and mittigateth the fear children have in the night.'

The convincing visual evidence that Hals did not paint the child is confirmed by the signature

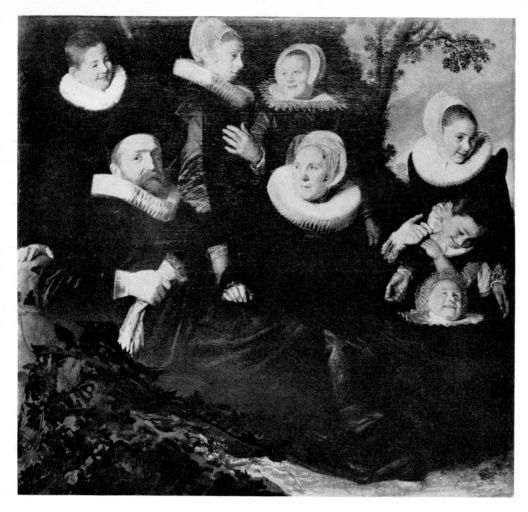

Fig. 43. Reconstruction of the *Family Portrait in a Landscape* (Plate 29),
with the child painted by Salomon de Bray deleted

on the sole of her left shoe. It reads: 'S. de Bray 16[2]8.' Thus, the only family portrait Hals signed
– his monogram is clearly visible on the rock below the father's elbow – also bears the signature of
the Haarlem painter Salomon de Bray. This is not the only point of contact between Hals and
Salomon de Bray, who had won a reputation as an architect and poet as well as a painter. He was
a member of *De Wijngaertranken* during the years Hals belonged to that society of rhetoricians
and as we shall see he was also influenced by some of Hals' genre pictures. Perhaps a confusion
between Salomon and his son Jan de Bray accounts for the traditional erroneous identification of
the family portrait.

The fact that Hals painted eight figures and the landscape in the large group portrait and De
Bray only painted one figure indicates that this was not the kind of planned collaboration which
took place on rare occasions between Hals and Molyn, Van Heussen or Buytewech. But it is not
difficult to deduce what happened. The baby painted by De Bray was probably born after Hals
finished the work, and for some reason De Bray, not Hals, was commissioned to add the portrait.
This type of addition was not exceptional in Renaissance or Baroque times. The patrons who
commissioned such addenda did not endorse the view almost universally accepted in our day
that the integrity of a work of art is irrevocably compromised if a hand other than its creator's
touches it. Evidently when the baby was added neither the patron nor De Bray thought it
necessary for the new portrait to conform to Hals' style. Whether De Bray was willing or able to
make the adjustment is moot. We do know, however, that Pieter Codde made an earnest effort
to imitate the master's style in 1637 when he completed the Amsterdam militia group portrait
which Hals refused to finish (Plate 134).

A reconstruction of the *Family Portrait* with De Bray's child removed is seen in Fig. 43. The reconstruction was made by transplanting the thistle from the lower left corner of *The Married Couple* (Plate 33), which can be dated a few years later than the Boyne portrait. In both pictures Hals used a plant to fill the triangular area formed by a lounging figure and the edges of the painting. Admittedly the gardening done in the reconstruction produces an unlikely hybrid. The plant which grows in the corner of the Boyne painting is not a thistle, but ivy, which was frequently included in family portraits as an emblematic allusion to marital fidelity. Nevertheless, if the hypothesis that the child is a later addition by De Bray is correct, some idea of Hals' original composition can be gathered from the reconstruction.

Substitution of the plant for the child does not make a marked improvement in the composition. To be sure, removal of the child creates some diagonal accents which are characteristic of those Hals used to unify his group portraits in his early phase, but here they end in an unusually abrupt fashion. In *The Married Couple* (Plate 33) a similar compositional device has been brilliantly balanced by the open view into a garden and a distant landscape. The Boyne *Family Portrait* reveals other anomalies. The almost square format for a large group portrait is exceptional at this time; oblong ones are the rule. And if we recall Hals' success at subordinating lively figures and groups to the overall design of his large Banquet piece of 1616 and consider that his ability to control even more animated ones increased in the militia pieces of 1627, the Boyne picture is curiously uncoordinated. Granted, the two small children who smile at each other on the right form a small unified group; the girl who stands behind her mother looks at her serious sister; the father looks directly at us, and his wife looks at him. But three of the children glance toward the right. What are they looking at? And the mother appears to be calling attention to something on the right. What is she pointing to? The suggestion offered here is that originally she pointed to the *Three Children with a Goat Cart* (Plate 30), now at Brussels, and that this is a fragment of the Boyne *Family Portrait*.

Though the attractive Brussels picture makes a much more satisfactory effect than the Boyne *Family Portrait* when it is seen alone, there is considerable evidence to support the proposal that it was originally part of it. A reconstruction of the joined pictures which includes an imaginary two-inch strip of canvas between them is reproduced in Fig. 44.

The close similarity of the Brussels picture to the Boyne *Family Portrait* was noted when it was first published in 1929 by Leo van Puyvelde. He did not, however, conclude that the pictures were once one. Van Puyvelde wrote: 'The identity of the [Boyne] picture with the technique of the Brussels one is striking; we find in it the same brown and greyish shadows, the same careful modelling of the faces and the same red relieved by a yellow highlight in the cheeks of the children. The presentation of the subject is also identical; not only are the figures shown in a garden, but the children at play beside their parents are laughing with the same careless gaiety. The costumes are of the same period and the pleated collars worn by the youngest are those which became the fashion about the year 1630.' In my view Van Puyvelde dated the costumes and the picture about a decade too late, but I agree with his conclusion that the handling and presentation are identical

with the Boyne *Family Portrait.*

Consideration of the way the two pictures align strengthens the case for the proposed reconstruction. They are virtually the same height; the original support of the relined Boyne painting measures fifty-nine and a half inches while the Brussels picture is fifty-nine and seven sixteenths inches in height. Equally striking is the way the right edge of the *Family Portrait* aligns with the left edge of the *Three Children with a Goat Cart.* A continuation of the path in the Brussels painting is found in the lower right corner of the Boyne picture; what appears to be a continuation of the girl standing above her younger brother and sister can be seen to the left of the goat's head; the horizons join; and the clouds make a continuous pattern.

It should be emphasized that the Boyne and Brussels pictures are not in the same state of preservation. The former is in good condition although a surface coating of discoloured varnish makes it appear considerably darker than it actually is. In its present state even in the original it is difficult to see that the father has both feet firmly placed on his wife's violet skirt or that the colour of the costumes worn by the figures in the background is not identical with the hue of the trees behind them. If the portrait were stripped of its veil of old varnish its spatial relations would become clearer and it would harmonize better with the tonality of the Brussels painting. On the other hand, the painting with the three children and goat has suffered badly. The paint was flattened during the course of a relining and some passages – particularly the heads of the little girls, the large expanse of foliage and the landscape in the background – have been abraded and repainted by a rather clumsy hand. However, it is still evident that the scale of the foliage is the same in both works, and a comparison of the head of the boy leading the goat cart, which has not been repainted, with the head of the one on the left side of the family portrait reveals the same handling and supports the conclusion that both were done at the same time.

When the two pictures are joined, the diagonal movement in the Boyne family portrait is no longer over-emphatic. It is now near the centre of the painting and is counterbalanced by the path and group on the right. The lively gestures and glances make better sense in the reconstruction, and figures on either side of the picture make contact with the beholder. The horizontal format of the reconstructed picture is also the normal one for a large group portrait painted around this time. Jacob Gerritsz. Cuyp's *Family Portrait with a Goat Cart,* dated 1631, now at Lille (Fig. 45), shows the conventional shape for a portrait of this type.

An X-ray examination of both paintings would probably help clinch the argument that the two pictures were once one. Unless their canvas supports were made up of strips of cloth which do not have the same weave, X-rays of the canvas of the 'cut' lateral side of the Brussels picture should match those taken of the 'cut' side of the Boyne group. Thanks to the cooperation of curators at the Brussels museum shadowgraphs are available of their painting; however, it has not yet been possible to procure an X-ray examination of the Boyne portrait. Hence all that science can tell us about the relationship of the two paintings is not yet known. But the little that has been discovered about their early history bolsters the proposed reconstruction.

The painting of the *Three Children with a Goat Cart* can be identified with a picture which

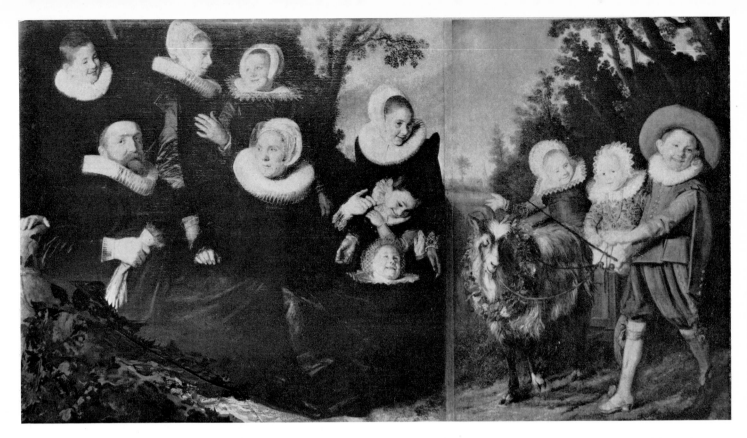

Fig. 44. Proposed reconstruction of the original state of the *Family Portrait in a Landscape* (Plate 29) and *Three Children with a Goat Cart* (Plate 30)

Fig. 45. Jacob Gerritsz. Cuyp: *Family Portrait with a Goat Cart*. 1631. Lille, Musée des Beaux-Arts

appeared at the sale held on April 1, 1829, of the collection of J. A. Bennet, a professor at the University of Leiden. His auction was principally a book sale – about three thousand were listed. Natural history specimens, shells, minerals, gems, scientific instruments as well as engravings, drawings and paintings were also offered. His painting collection included only sixty lots, but he owned some choice pieces. At the time of his sale the most important ones were Cornelis Troost's NELRI series, now at The Mauritshuis. As one might expect, these five views of men enjoying an evening of revelry and excessive drinking were catalogued as 'le chef d'oeuvre du Hogarth hollandais.' Lot no. 58 is listed as:

'F. Hals, h. 5pd. 4½ p. *l.* 3 pd. 10p. Jeune garçon conduisant à la promenade, ses deux petites soeurs dans un charlot trainé par une chèvre, peinte sur toile.'

The entry can safely be identified with the painting now at Brussels. The lot which preceded it in the Bennet sale is catalogued as:

'F. Hals. h. 5 pd. 3ps. *l.* 5pd 8ps. Grand tableau de famille, père, mère et plusieurs enfants, peint sur toile.'

This description alone is too brief for a firm identification but coupled with the dimensions cited (the catalogue states that the sizes are given in *pieds et pouces de Rhynlande* and include the frames), it is reasonable to accept the suggestion that the entry refers to the Boyne *Family Portrait*.

In brief, there is excellent reason to believe that both paintings were in Bennet's collection in 1829. Of course it is not impossible but hardly probable that an early nineteenth-century collector owned two unrelated life-size group portraits by Hals, particularly two which have as much in common as these paintings. There is no evidence indicating that any amateur active during the first decades of the nineteenth century developed a passion for collecting Hals' group portraits. A man who owned two which have as much in common as these works most likely had them because they belonged together. It is not known how or in what state they entered Bennet's collection. Perhaps the painting, cut or uncut, was bequeathed to him as an ancestral portrait (Bennet acquired Troost's famous NELRI series from his mother-in-law).

Thus the history of the two works as well as strong stylistic evidence supports the hypothesis that the Boyne and Brussels paintings were originally part of one family group which suffered a fate not uncommon to large pictures. The original work was probably cut down to fit a new wall, a new frame, or because some vandal thought the divided work would be more saleable. If the proposed reconstruction is correct, the reconstructed *Family Portrait* adds a new large-scale composition to Hals' early *oeuvre*.

In the *Married Couple in a Garden* (Plate 33) Hals convinces us that unrequited love was not as common in seventeenth-century Holland as poems by Gerbrand Bredero and P. C. Hooft might lead us to believe. The life-size double portrait is brimful of what appears to be mutual, unalterable affection. Yet everything about the pair appears transitory. The attitudes and expressions are momentary: the husband looks as if he were about to speak while his wife's smile is at the point where it must either broaden into a wider one or relax (Plate 34). Her hand, which rests lightly on his shoulder, must shift as soon as he changes his rather precarious position. Light

plays over their faces and glistens here and there on their costumes. Even the winding ivy behind them appears to rustle and throw shadows on the sturdy trunk to which it clings; this inspired passage anticipates the *plein air* effects which were to permeate his work before the end of the decade. The rest of the landscape follows the conventional three-colour scheme: warm browns in the foreground, cooler greens in the middle ground and shades of blue in the background. The imaginary garden in the middle distance (Plate 35) recalls the setting of the lost *Banquet in the Park* (Fig. 13) and, as we have seen, Hals used a similar vista of a garden a few years later in his life-size portrait of *Willem van Heythuyzen* (Plate 56).

The arrangement of *The Married Couple* is as original as it is bold. Instead of placing the pair in the centre of the picture, Hals shifted them to the side. The man's traditional pose – one arm akimbo, the other resting on his chest – has been transformed by the pronounced inclination of his seated figure. Though he is larger than his wife and set slightly forward he does not dominate the scene. Husband and wife, *pace* Riegl, have equal importance here. She has been placed in the centre, and the intense light on her face and hands as well as the wide expanse of her millstone ruff and the violet and plum-coloured accents of her costume focus attention on her. Equally vigorous and fluid brush strokes model their costumes, and subtle correspondences in their poses help establish a concordance between the well-matched pair.

Attempts to discover the name of the famous couple show the difficulty of reaching a consensus about the identity of Hals' sitters when the principal evidence for the identification is visual. The pair has been variously called a self-portrait of Hals and his second wife Lysbeth Reyniers; Dirck Hals and his bride; Isaac Massa and his wife Beatrix van Laen. The suggestion has also been made that the man in this double portrait posed for *Hanswurst* in Hals' *Shrovetide Revellers* (Plate 10) and for the 1622 portrait of a man with wreathed arms at Chatsworth (Plate 39). It seems to be a case of paying your money and taking your pick. The Isaac Massa – Beatrix van Laen identification, the only one worth serious consideration, is bolstered by the fact that they were married in 1622, the date which can be assigned to the portrait. However, Beatrix van Laen was thirty years old in 1622 and it is debatable whether the coquettish woman looks thirty. But Hals did not always make his sitters look their age and everyone will agree that estimating a woman's age – either from a portrait or in real life – is as difficult as it is indiscreet. A more serious objection to the identification was raised when there was an opportunity to compare Hals' single portrait of Massa (Plate 65) with this one at the Frans Hals exhibition at Haarlem in 1962. When the two works were seen side by side the identity of the sitters was not compelling. Some of the apparent similarities appear to be the result of the artist's idiosyncrasies as a portraitist rather than of a transcription of the physiognomy of the same model painted at different times.

That the painting is a marriage portrait there can be no doubt. Hals' contemporaries would have noticed that the charming woman proudly displays her wedding ring on her index finger instead of her third finger, a new fashion which became popular in spite of criticism of it by Dutchmen bound to the more traditional convention. They would have observed too that her elaborate cap edged with gold lace and trimmed with a pink ribbon was an unusual one for her

to be portrayed in. It is an undercap held in place with 'head irons' and was usually completely covered by an outercap. More learned Dutchmen would have recognized how appropriate it was to portray the couple in a garden, one of Venus' traditional abodes. Lovers have been represented seated in a garden since the fifteenth century, and numerous later emblems made to illustrate marital fidelity and happiness popularized the scheme (Fig. 192). Rubens was aware of the tradition when he painted his *Self-Portrait with Isabella Brant in a Honeysuckle Bower* around 1609 or 1610. Perhaps Hals saw Rubens' double portrait when he visited Antwerp in 1616; if he remembered it when he painted *The Married Couple* he firmly resolved that no one would ever accuse him of plagiarizing the Flemish master's marriage portrait. As a thorough study by E. de Jongh and P. J. Vinken shows, familiarity with emblematic literature would also have alerted Hals' contemporaries to other symbolic and allegorical allusions in the painting. Here ivy, a familiar symbol of steadfast love and faithfulness, plays a more conspicuous role than in the Boyne *Family Portrait*. It lies on the ground at the feet of the smiling woman and winds behind her. The sparkling vine clinging to the tree behind the couple is a reference to marital love and dependence. Vines even cling to a dead tree, hence the mottos which accompany pictures of them wound around sturdy stumps in emblematic literature: 'His decline cannot tear him away from me'; 'This is a friend after death'; 'As in life so in death'; 'True love continues after death.' The prominent thistle (called *Männertreu* in German) is a reference to love and fidelity, while the urns and architectural fragments on the extreme right probably allude to the transitory nature of life on this earth. The frequency with which Juno and her attributes appear on Dutch marriage medals indicates that it is not far-fetched to suggest that the peacocks in this imaginary love garden are a reference to the goddess and protectress of marriage.

Seventeenth-century men were obviously better prepared than we are to make an inventory of the emblematic allusions in the double portrait. They also responded to them more readily than we do. Cataloguing them gives us a glimpse of an old iconographic tradition which was still vigorous in Hals' time. Today it is dead. But we need not feel unconsolable. When all the conjugal symbolism in the painting is dissected and heaped together it tells us less about the bond between man and wife than the artist's vital characterization of the couple.

CIVIC GUARD GROUP PORTRAITS

In September and October of 1622, members of the St. George and St. Hadrian companies were sent to Hasselt near Zwolle in Overijssel. On this exceptional occasion the citizen guards of Haarlem were given a military assignment but they were not sent to the front. They travelled to Hasselt to relieve a garrison of seasoned mercenary troops who were needed by Prince Maurits to help relieve Bergen op Zoom, more than one hundred miles to the south, which had been placed under siege by Spinola in July, 1622. The situation was serious: nearby Steenbergen had already been taken by the Spanish. It is telling that in these circumstances Prince Maurits put little

faith in the combative ability of the town's municipal militia companies, and preferred to use mercenaries on the fighting line. The only danger the Haarlem guards faced in Overijssel was the possibility of skirmishes with the Spanish who were making raids into Friesland from bases in the east. This never happened and the Haarlem guardsmen returned to their native city without seeing action.

According to a frequently repeated story Hals' group portrait of the *Officers of the St. Hadrian Militia Company* (Plate 78) was made to commemorate the banquet given to these men before they left on the 1622 Hasselt expedition. The story is fictitious. This officer corps did not serve there. The Haarlem officers who did held their commissions from 1621 to 1624. These men served from 1624 to 1627, and since the group portrait includes two officers commissioned on November 2, 1625, the painting must have been made after that date.

Acceptance of the erroneous relation of the work to the 1622 Hasselt expedition led earlier students of Hals' work to date the picture around 1623–24. Comparison of it with the group portrait which Hals painted of the St. George officer corps banquet (Plate 85), and which is traditionally dated 1627, seemed to support the early date; the latter is freer in handling and has a more subtle pictorial organization. However, since the St. Hadrian group portrait could not have been painted before November 2, 1625, it is reasonable to assume that it was made, as was the custom, after the farewell banquet given to the officer corps in 1627.

It is safe to assert that, if we did not have these crumbs of documentary evidence about the St. Hadrian officer corps, their banquet picture would still be assigned to 1623–24. This small correction is an excellent reminder that Hals' undated works, like those by other masters, defy a year-to-year chronology based solely on stylistic criteria. In Hals' case the problem becomes more acute when we realize he was not only capable of working in more than one manner in the same year but he sometimes varied his way of working in a single picture. This is seen when we turn to the *Banquet of the Officers of the St. George Company* (Plate 85), traditionally dated 1627. A close view of the figures on the left shows they were done with a more fluent touch and with thinner, more liquid paint than those on the right.

The traditional date of 1627 for the St. George group portrait rests on a fairly firm foundation. The officers represented served from 1624 to 1627, and are probably shown at the banquet given to commemorate the end of their term of duty. Moreover, Ensign Dirck Dicx, who appears as the second standard-bearer from the right, only joined the company after April 21, 1626, when the ensign he replaced was married. The exclusion of ensigns who were not bachelors from the corps establishes a *terminus post quem* for this group portrait.

It is only fair to add that, although the officer corps represented in the two banquet pieces never saw action, some of these officers made a military excursion during their three-year period of service. A group of them were sent with their men in 1625 to Heusden, a town in North Brabant near s'Hertogenbosch, to replace more seasoned troops, who were needed about twenty miles to the southwest, where Spinola had Breda under siege. The Dutch were unable to withstand the ten months' siege and Breda finally surrendered to Spinola in June, 1625. This was the Spanish

general's finest hour, and his victory was the subject of another famous Baroque painting: *The Surrender of Breda* by Velazquez.

In both group portraits Hals shows with unprecedented illusionism the dynamic character of a large, animated group in a room filled with brilliant, silvery daylight. The bright, fresh colours, the blond tonality and the free technique of the large paintings are anticipated in some of his earlier works but never before was he so consistently audacious with his pictorial innovations. Both works give the impression of a chance encounter at a banquet that has had a good start. A few of the men have turned to look at us while others are related to each other by instantaneous movements and expressions. More of the figures of some can be seen than of others, yet each man stands out with equal importance. Only the servants in each group have been slightly sub-ordinated to the corps they serve.

As in his 1616 militia piece, Hals followed a hierarchical order in the arrangement of the men around their banquet tables. The colonel in the St. Hadrian group (Plate 80) is seated on the left at the head of the table with his fiscal (the next-ranking officer) at his side, the three captains are seated in the middle, the three lieutenants are grouped together at the foot, while the three ensigns stand. In the St. George group the colonel has also been given the place of honour on the extreme left, his senior officers are seated close to him and his junior ones are again at the other end or they stand. There is, however, one exception. In the St. George piece Captain Nicolaes Le Febure is not seated with the other senior officers; he is seen standing in the foreground on the far right (Fig. 46). Perhaps Hals broke military protocol in this case in order to adhere to rules of decorum and good taste. Since the Renaissance, art theorists had maintained that artists must not only give their models attitudes, gestures and costumes which befit their station, but also have due regard for their dignity and make an effort to mend or hide their defects. Precedents for this practice were found in the writings of classical authors. Pliny reports how Apelles, in his portrait of Antigonos, hid the fact that he was blind in one eye, and Plutarch wrote that when the ancient artists painted kings with some defects they tried to mend them as well as they could, while still keeping a likeness. Now, it is unlikely that Hals read either the classical sources or more recent theoretical texts on painting, but by the seventeenth century these ideas were common coin. Hals' decision to place Le Febure standing in a corner minimizes the captain's defect. He was a midget. Looking at the picture, one is hardly conscious of his deformed body, and his head is virtually on the same level as those of his seated peers.

In each work the tremendous variety of candid effects is subtly interlaced, and the tremendous diversity of movement is ordered by a design that ingeniously links the figures while clarifying the spatial arrangement. In both the officers are divided into two main groups joined by long diagonals. The diagonal accents are less forced in the St. George picture than in the St. Hadrian piece, where pronounced subordinate ones have been formed, not the least by the two captains seated back to back in the front plane. The main groups show a single seated officer around whom others are seated or standing. At the crossing of the principal diagonals, a seated officer in the second plane serves a crucial function; he establishes a kind of centre and sets up a horizontal

bond between the officers seated on either side of him. As effective as the hidden order that underlies the casual appearance of the portraits is the vibrant daylight which floods the interiors, brightens the air, shimmers over faces and surfaces while heightening their harmony and pictorial unity.

One cannot help but wonder what Hals' contemporaries thought about the artist's spectacular accomplishment in these works. Since both were painted around the same time we can guess that the qualities of the first one encouraged the officers of the other militia company to commission theirs. Samuel Ampzing was one of the rare contemporary Dutchmen to publish a specific reference to one of them. In 1628 he wrote that Hals' St. Hadrian group was 'very boldly painted after life.' He tells us nothing more, but not many seventeenth-century Dutchmen wrote much about the painting of their time. One of the few who did was Constantin Huygens, the talented secretary of Prince Frederick Henry. Around 1630 he wrote a succinct appraisal of some Netherlandish artists. His notes include informed judgments about Rubens and young Rembrandt. He was aware of the breakthrough the landscapists were making; their new style, he stated, enabled them to show the warmth of the sun and the movement of cool breezes. He also noted that Jan Ravesteyn, who had been making portraits at The Hague since the turn of the century, now seemed old-fashioned. No better support for that claim could have been given than reference to the banquet pieces Hals had painted for Haarlem's civic guards a few years earlier. But Huygens wrote not one word about Frans Hals.

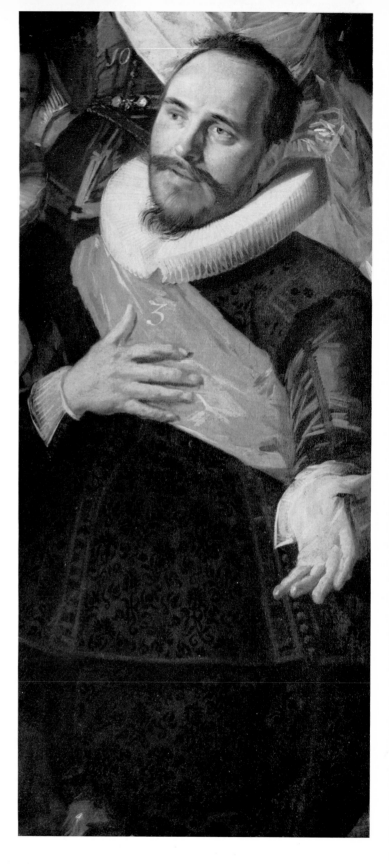

Fig. 46. *Captain Nicolaes Le Febure:* Detail from *Banquet of the Officers of the St. George Company* (Plate 85). About 1627. Haarlem, Frans Hals Museum

CHAPTER IV

Genre, Allegorical and Religious Paintings:
1620–1630

THOUGH there is ample evidence that Hals could paint with equal ease on a small or a large scale, he apparently made no attempt to satisfy the current demand for little pictures of elegantly dressed crowds grouped in interiors or gardens. In his genre paintings, he preferred to show his fellow men close up, as big as life. The so-called *Jonker Ramp and His Sweetheart* (Plate 42; Metropolitan Museum of Art), dated 1623, is an outstanding example. The exuberance of the life-size couple fills the canvas while the compact diagonal arrangement of the pair allows for little more than a suggestion of the servant and the furnishings of the interior behind them. Here he minimized the background view by covering more than half of it with a curtain; within a few years he was to eliminate even these summary glimpses of interiors from his genre paintings.

Around the same time as the Metropolitan Museum's picture was made, a group of other Dutch artists were painting interiors where the setting was beginning to gain equal importance with the figures. Their modest works, not Hals', laid the foundation for the great accomplishment of the artists of the following generation who specialized in genre scenes set in interiors: Terborch, Pieter de Hooch and Vermeer. A work that belongs to the incunabula of this important category of Dutch painting is Dirck Hals' small picture of a fashionable group of young people gambling in a tavern (Fig. 47). Here, as on other occasions, Dirck borrowed a motif from his brother: the fireplace in the background is the same as in the Metropolitan Museum painting. Dirck used it to help establish a spatial environment of not only one, but two rooms for his genre scene. His effort at perspective was not a total success; but he would have been ill advised to turn to his brother for help. Frans was supremely well prepared to teach his younger brother how to record an immediate visual impression in paint, but judging from what we know there was not much he could have told Dirck about rendering a rationally constructed interior.

Jonker Ramp and His Sweetheart acquired its romantic title late in the eighteenth century, when the lively young man was identified as Pieter Ramp, an ensign who appears in Hals' St. Hadrian banquet piece (Plate 78) as the standard bearer in the middle distance on the right. Even if one imagines him with a moustache and beard identical to those worn by Ensign Ramp in that group portrait the resemblance between the two is hard to find. It is idle to speculate on who served as the models for this vivid expression of life lived at an intense pitch, but it is possible that Hals intended the painting to represent more than a joyous moment in a tavern. The reasonable suggestion has been made that the work is actually Hals' version of the *Prodigal Son* which was mentioned in inventories made at Amsterdam in 1646 and 1647.

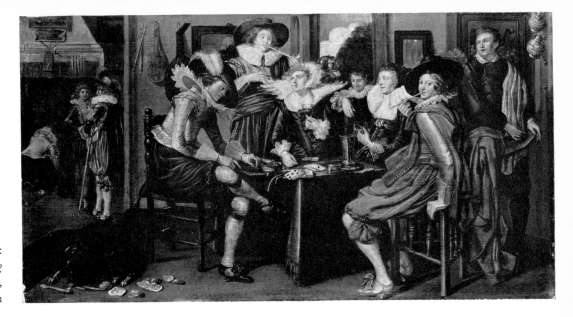

Fig. 47. Dirck Hals:
*Merry Company Gambling
in an Interior*. Germany,
Private Collection

There was a hardy iconographic tradition in Netherlandish art for depicting the prodigal carousing in a public house with many companions. Perhaps Hals modified it by extracting the protagonist and one of his girl friends from an earlier crowded tavern scene for his interpretation of the Biblical subject. A raised *roemer* had frequently been used to identify the fashionably dressed prodigal who wasted his substance; the innkeeper or servant in the background indicates that Hals' couple is not at home, but in a public house. The dog in the lower right corner is no stranger in this context either. In earlier works dogs were used to signify gluttony or unchastity, and they often appear in sixteenth- and seventeenth-century Netherlandish pictures of inns and brothels. Since the spaniel in Hals' painting seems to have been copied from the one in the engraving Goltzius designed for an allegory of the *Sense of Smell* (Fig. 55), Hals probably knew that the symbolism of the dog was multivalent. Hals' teacher Van Mander also wrote that a dog can stand for smell, for fidelity, or for the true teacher who continues to bark fearlessly as he watches over the souls of his pupils and punishes their sins.

An engraving on the title page (Fig. 48) of a play published at Amsterdam in 1630 by Willem Dircksz. Hooft called *The Contemporary Prodigal Son* (*Heden-daeghsche verlooren soon*), which shows the modern prodigal with his *roemer* raised high in a similar setting – a dog appears here too – indicates that at least some of Hals' contemporaries would have had no difficulty in regarding the Metropolitan Museum's painting as a scene from the Parable. Hooft's play was moralistic in

Fig. 48. Engraving from the title page
of W. D Hooft,.
Heden-daeghsche verlooren soon.
Amsterdam, 1630

73

Fig. 49. Rembrandt: *Self-portrait with Saskia on his lap*.
Dresden, Gemäldegalerie

intent and if Hals' picture was meant to illustrate an episode from Scripture it was so too. It is doubtful, however, whether a painting which so convincingly shows the pleasures of wine and women would ever be very effective in reforming a confirmed or potential prodigal.

More than a decade after Hals made his picture, Rembrandt painted a self-portrait with Saskia on his lap (Fig. 49), which, as I. Bergström has shown, can also be related to the engraving in *The Contemporary Prodigal Son* and other earlier representations of the prodigal's riotous living. Rembrandt depicted himself with his young wife not in their dining room, but in a tavern, which can be identified as such by the scoreboard hanging on the wall in the left corner. A scoreboard on which the drinks ordered by patrons were tallied was a familiar piece of equipment in sixteenth and seventeenth-century pothouses; a servant in Dirck Hals' little painting of *Gamblers* (Fig. 47) is seen noting on his board that one of the players is to be charged for a glass of wine, and a conspicuous scoreboard also appears behind Hals' *Young Woman Holding a Glass and Flagon* (Plate 43). These boards are often found in earlier prodigal son scenes, where they can be regarded as symbols of a wasted patrimony; one is shown in the engraving made for the title page of Hooft's *Contemporary Prodigal Son* (Fig. 48). The peacock pie which appears in Rembrandt's double portrait is found in the print too. Since the peacock is a traditional symbol of *superbia*, the peacock's tail in these works can be read as a symbol of pride, one of the seven deadly sins. It has also been noted that the peacock was also used by seventeenth-century Dutchmen as an attribute of worldliness, an allusion which is not out of place in these works. Both the action and setting of the double portrait suggest that Rembrandt depicted himself and his young wife in such a wordly fashion to illustrate a lusty scene from the Parable and not to show the extravagant way he and Saskia were living shortly after they were married in Amsterdam. Rembrandt may

74

even have wanted publicly to confess that he and Saskia were prodigals in desperate need of forgiveness. In any event, his candour here is unprecedented. Hals' exuberance never touches such a personal chord.

We have already mentioned that Hals' couple in a tavern is dated 1623. Except for the *Fruit Seller* (Plate 112), which was clearly signed and dated 1630 by Hals' collaborator Claes van Heussen, it is the only known picture by the master, excluding his commissioned portraits, that bears a date. The chronology of all his other genre, allegorical and religious pictures must be established by what we know about the development of Hals' style, his personal predilections, and by our knowledge of the general tendencies of other artists working in Holland in his time. If we do not insist upon hearing the grass grow, the task is not an insurmountable one. Hals' dated portraits give us a distinct idea of the way he worked during different phases of his long career and, though no one would maintain that the dedicated efforts of a small battalion of historians and critics have solved all the chronological problems of seventeenth-century Dutch painting, the characteristics of its different phases have been sufficiently determined to serve as an additional reliable check.

No one of course would argue that Hals' development was a perfectly linear one. The distance between an early work and a late one by a creative artist is never measured by a straight line. We have seen that Hals was able to work in more than one style not only in the same year but in the same picture. Occasionally his own whim or that of a patron may have encouraged him to revive an earlier mode of painting. When we consider his genre pictures we must be prepared to take into account leaps and bounds which he did not feel free to make – or which he was not allowed to make – while working on formal portraits.

His spirited brushwork is evident in the portrait he made in 1626 of *Sara Hessix* (Plate 63), the elderly wife of a minister, but it is not astonishing to find that it is less conspicuous there than in his painting of a couple in a tavern done three years earlier. He was freer to use a bolder technique for paintings of merry drinkers, laughing children and musicians than in commissioned portraits of respectable burghers and their wives. In the 1620s the blouse worn by a young hussy (Plate 100) could be suggested with bold touches of his brush; the clothing worn by the wife of a Haarlem patrician had to be delineated with greater precision. After carefully painting heaps of ruffs and yards of intricate lace and embroidered brocade on his commissioned portraits, it must have been a pleasure for him to let himself go on more informal subjects. Van Mander tells us that some of Goltzius' portraits and pictures of peasants were painted for his own delight. No doubt some of Hals' most vivacious works were painted from the same motive. *The Laughing Boy* (Plate 49), now at the Mauritshuis, is probably such a painting. Its lack of conventional finish indicates that the tondo was not a commissioned portrait and, since the boy is neither engaged in a specific activity nor accompanied by an attribute, it cannot be properly called a genre painting or an allegorical piece. The subject is more original: it is Hals' record of a child's sheer joy in living. Here is the laughter which, as Gogol wrote, is as distant as heaven from the convulsions of a vulgar clown. One senses that other equally spirited studies of young children (Plates 50, 51)

Fig. 50. Johannes Torrentius: *Still-life*, *Allegory on Temperance*. 1614. Amsterdam, Rijksmuseum

Fig. 51. "Elck wat wils", emblem from Roemer Visscher, *Sinnepoppen*. Amsterdam, 1614

were painted for pure pleasure and that the flute or soap bubble in these sketches were added as afterthoughts to make them conform to popular iconographic themes; the flute transforms the sketch of a boy into an allegory on 'Hearing,' while the soap bubble is a traditional allusion to the fragility and insignificance of man's earthly life.

Around this time Hals seems to have followed the ancient idea of adjusting his style to the subject he depicted: free, disembodied touches for genre pictures and more carefully fused tones for commissioned portraits. But apparently the difference in finish was more a result of his temperament and sensitive response to the demands of his clientele than of his adherence to a rigidly formulated doctrine. There is no evidence that he was aware of Aristotle's influential theory that different styles should be used for different subjects. An examination of his *oeuvre* shows that he did not anticipate the late seventeenth-century French academician Henri Testelin, who argued that distinctly differentiated styles should be used for the representation of God and saints, heroes, noteworthy people and peasants. Hals' paintings of the Evangelists *St. Luke* and *St. Matthew* (Plates 72, 73) are as free as his painting of the scoundrel *Verdonck* (Plate 96), and passages in the two civic guard banquet pieces done in the 'twenties are painted in the same style he used for pictures of fisherboys and young musicians. Moreover, after 1640 when he apparently stopped painting genre pieces, he used in his portraits of theologians, burgomasters and wealthy merchants the bold technique favoured earlier for popular subjects.

The *Young Man Smoking with a Laughing Girl* (Plate 41) can be dated around 1623–5. It too appears to represent a scene in a tavern. The figure of the attractive youth smoking a long gouda pipe has been boldly turned but the space allotted to him and his affectionate companion remains shallow. A green curtain has been draped behind them and in the background there is a woman holding a flagon. Though only the busts of the couple are seen and an octagonal format is used, the design recalls the one he employed for his 1623 painting of a couple (Plate 42). As in that work, recession is suggested by a sharp diminution in scale and the sketchiness of the figures in the background. In both paintings interrupted brushstrokes counteract an isolation of the individual forms and help keep the instantaneous expressions from petrifying; however, in the painting of

76

Fig. 52. Emblem from Roemer Visscher, *Sinnepoppen*. Amsterdam, 1614

Fig. 53. Emblem from Jacob Cats, *Silenus Alcibiadis*. Middelburg, 1618

the smoker the touch is more uniformly impulsive and varied. A foretaste of the characteristic short parallel hatched strokes which become more evident in paintings made later in the decade is found in the highlights.

A third tavern scene, a half-length of a *Young Woman with a Glass and a Flagon* (Plate 43) also appears to have been done around 1623–5. If the painting is merely a portrait of a barmaid then Hals, not Manet, must be credited with first having the courage to paint a life-size picture of a moment in the life of a tapstress. However, familiarity with the prominence given to a glass and flagon in Johannes Torrentius' emblematic *Still-life* (Fig. 50) and in other contemporary emblems (Fig. 51) which are admonitions for temperance suggests that Hals had something different in mind than Manet did when he painted his *Le Bar aux Folies Bergère*. There may be a moralizing message here. Perhaps the violin hanging on the wall in Hals' picture has no special significance, but it may allude to the harmony men should establish between themselves and strong drink. The inscription on the sheet of music in Torrentius' *Still-life* spells out that message: 'That which is immoderate has an excessively bad fate.'

The meaning of the *Young Man Smoking with a Girl* (Plate 41) is less enigmatic, although it is possible to offer more than one interpretation of it. The painting can be related to the fad of 'eating and drinking smoke', which disturbed moralists in Hals' day as much as it distresses doctors in ours. Seventeenth-century Dutchmen were frequently warned in sermons, pamphlets, emblems (Fig. 52) and paintings (Fig. 75) not to add this new vice to old ones. Pipes became as common as skulls in *vanitas* still-lifes, where they served as graphic reminders of the admonition found in Scripture: 'For my days are consumed like smoke . . .' (Psalms 102: 4). Only a few years after he painted his *Young Man Smoking*, Hals made a portrait of the poet and historian *Petrus Scriverius* (Plate 60), who published his *Saturnalis de Tabaco* at Haarlem in 1628. An anonymous woodcut on the title page shows two smoking pipes and a tobacco plant, as well as the traditional *vanitas* symbols of a winged hour-glass and a skull. For the popular moralist Jacob Cats 'Smoke is the food of lovers.' Cats' maxim, which is found in an emblem he published in 1618 (Fig. 53), could also serve as the motto for Hals' picture of the handsome youth embraced by a girl as could his

Fig. 54. Jacob Backer: *The Five Senses*. Around 1630. Etchings

Fig. 55. Jan Saenredam: *The Five Senses*. Around 1595. Engravings after Hendrick Goltzius

Fig. 56. Jan Miense Molenaer: *The Five Senses*. 1637. The Hague, Mauritshuis

Fig. 57. Dirck Hals: *The Five Senses*. 1636. The Hague, Mauritshuis

Fig. 58. Gonzales Coques: *The Five Senses*. Antwerp, Musée Royal des Beaux-Arts

reference to Proverbs 27: 7: 'The full soul loatheth an honeycomb; but to the hungry soul every bitter thing is sweet.'

The *Young Man Smoking with a Girl* can also be viewed as a secularized representation of the sense of taste. Other paintings by Hals can be connected to series showing The Five Senses. We have already noted that his sketch of a *Boy with a Flute* (Plate 50) probably alludes to 'Hearing' and the matchless tondos at Schwerin, known in the older literature as a *Drinking Boy* (Plate 91) and a *Boy with a Flute* (Plate 92), most likely depict 'Taste' and 'Hearing' respectively. Whether Hals ever made a complete set of the Five Senses is not known, but the number of existing ones by seventeenth-century Netherlandish artists indicates how popular they were. A few artists continued the earlier tradition of representing each of the senses personified as an idealized female figure accompanied by familiar attributes. Jacob Backer etched a feeble set of this type around 1630 that also includes mythological scenes related to the subject in the background (Fig. 54). But most Dutch artists represented this allegorical theme by showing scenes of daily life. A series engraved around 1595 by Jan Saenredam after drawings by Goltzius (Fig. 55) had announced the new way the subject was to be treated. Goltzius had represented each sense by the appropriate activities of five couples, but he had still employed the animals (cat, stag, dog, monkey and turtle) traditionally associated with the five senses. During the following decades these animal references become less frequent, and many changes were rung on the way the theme was represented. Jan Miense Molenaer used five scenes of life among the lower classes to illustrate the subject (Fig. 56). A set by Dirck Hals (Fig. 57) shows how the action of a child, or simply a picture of a child with a fitting familiar object, could be used to allude to one of the senses. The Antwerp painter Gonzales Coques made a series (Fig. 58) based on portraits of contemporary Flemish artists; the man who represents taste has not been firmly identified (the suggestion that he is Coques himself is not fully convincing), but sight is personified by the sculptor Artus Quellin at work, hearing is probably represented by the flower-painter Jan Philips van Thielen playing a lute, smell by the sculptor Lucas Fayd'herbe, and touch is most likely represented by the painter Pieter Meert. Others show how the age, sex, manners and social status of the figures, as well as their activities, could vary in representations of the theme either in one or in a series of pictures.

Genre, Allegorical and Religious Paintings: 1620-1630

A fair question arises: how do we know if Hals' *Young Man Smoking with a Girl* (Plate 41) represents one of the senses, or if it is a moralizing genre picture, or if it is *genre pur*? We faced similar problems in our discussion of other so-called genre pictures. Is the couple in a tavern (Plate 42) a depiction of an episode in the life of a prodigal son or is it simply a painting of a merry pair? Did Hals' contemporaries see an allusion to temperance in his painting of a *Young Woman with a Glass and Flagon* (Plate 43) or did they view it as a straightforward portrait of a barmaid? Other subject pictures by Hals pose analogous questions. In only a few cases do we have contemporary references which give firm clues. Thanks to the note inscribed on Mathys van den Bergh's drawing after Hals' early painting of merry-makers (Fig. 15) the work has been recognized as a *Shrovetide Revellers* scene. *Verdonck* (Plate 96) and *Peeckelhaering* (Plate 102) have been identified by inscriptions on seventeenth-century prints. For the meaning of others we must rely principally upon the relation of each individual work to the pictorial, iconographic and literary traditions of the time, and, as in the case with the *Young Man Smoking*, familiarity with them does not always permit a single, unqualified interpretation.

When musicians are included in sets of the Five Senses painted in Holland during the seventeenth century, we can be certain, after accounting for the other four senses, that they personify hearing. Musicians, however, were also the subject of many independent pictures made during the period. As such they may be portraits with or without another level of meaning; Hals' *Daniel van Aken Playing the Violin* (Plate 211) is a work which can be placed in this category. Moreover, musicians were also used by seventeenth-century Dutch artists to represent the vanity of the arts, to symbolize harmony and accord, or to extol the power of music to ease the soul and raise man's thoughts to God as well as to personify the sense of hearing. Sufficient evidence is not always available to determine whether Dutch artists intended to depict one of these themes or were making pictures of performing musicians without allegorical or moralistic references.

One thing, however, is always evident in Hals' pictures of singers, lute-players and violinists: his delight in music. After painting, it seems there were few things he enjoyed more than people making music. In his *Two Boys Singing* (Plate 44) at Cassel he captures the intense momentary pleasure of children concentrating on a song. The picture contains one of Hals' rare *pentimenti;* originally he painted the plume worn by the boy with the lute extending almost to the right edge of the picture. He then changed it into a smaller one, an adjustment which gives the arrangement of the two figures a more regular pyramidal shape. Hals used a similar compositional scheme for *St. Matthew and the Angel* (Plate 73) and again for *Two Boys with a Jug* (Plate 90). After 1630 he abandoned this arrangement but other Haarlem artists continued to use it. In 1636 Salomon de Bray employed it for his carefully worked up preliminary chalk drawing for a painting of *Judith with the Head of Holofernes* (Fig. 59). It is noteworthy that in De Bray's drawing the up-raised hand, used by Hals and other genre painters to indicate the rhythmic beat kept by a musician, has acquired a different meaning; it expresses the amazement of Judith's companion at the sight of a severed head. Gestures as well as symbols have multivalent meanings, which must be related to their context before they are interpreted. In a version of De Bray's painting of this

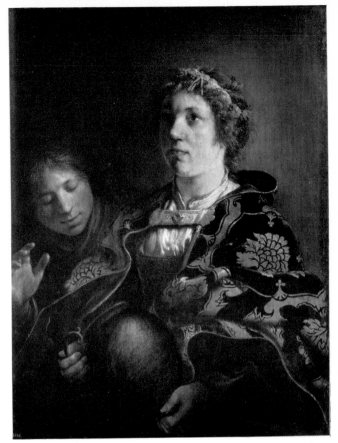

Fig. 59. Salomon de Bray: *Judith with the Head of Holofernes.* 1636. Drawing, black chalk. Constance, Wessenberghaus, Brandesstiftung

Fig. 60. Salomon de Bray: *Two Figures* (originally *Judith with the Head of Holofernes?*). Madrid, Prado

subject now at the Prado, the head held by Judith has been painted out and replaced by a large rock (Fig. 60). Apparently a former owner of the picture made the alteration because he found the original subject too gruesome. A judicious removal of the repaint in the Prado painting might reveal Holofernes' head and once again suggest that the boy's raised hand expresses surprise at the bodiless head instead of astonishment at the poor quality of the overpainting and ungainly shape of the earthenware jug.

Some of Hals' paintings have also been subjected to a radical transformation by later hands. One of them is *Verdonck* (Plate 96). When it was given to the National Gallery of Scotland in 1916, it was called 'The Toper,' and showed the shaggy man wearing a large velvet beret instead of bare-headed and holding a short-stemmed goblet, not a jaw-bone, in his right hand (Fig. 61). In 1927 the Dutch restorer A. M. de Wild suggested that the beret and glass were later additions. His observations were sound. The beret was crudely painted and the shape and decoration of the repainted goblet were as preposterous as the manner in which the glass was held. De Wild also noted that the original picture was identical with the contemporary engraving of the painting made by Jan van de Velde (Fig. 62) which includes a quatrain that identifies the subject:

> This is Verdonck, that outspoken fellow
> Whose jawbone attacks everyone.
> He cares for nobody, great or small,
> That's what brought him to the workhouse.

X-ray photographs proved that De Wild's observations about the clumsy later additions were correct. After he removed the beret and glass, the original painting of Verdonck's unruly hair and jawbone were found intact.

81

Dit is Verdonck, die stoute gast,
Wiens kaekebeen elck een aen tast.
Op niemant, groot, noch kleijn, hij past,
Dies raeckte hij in t Werckhuis vast.
Velde fecit.

Fig. 61. *Verdonck* (Plate 96), before restoration. Around 1627. Edinburgh, National Gallery of Scotland

Fig. 62. Jan van de Velde: Engraving after Hals' *Verdonck* (Plate 96)

De Wild published his findings and the procedure he used for cleaning the picture in *Technische Mitteilungen für Malerei* in 1930. The appearance of De Wild's article prompted H. Birzeniek, secretary of Riga's Art Museum, to send a letter to the editor of the journal which purported to tell how and why Verdonck was repainted. To preserve the anonymity of the people who played the leading roles in his report, he used initials instead of names.

During the 1890s, Birzeniek wrote, the Chamberlain S. N. N. collected old Dutch pictures in St. Petersburg. This Russian's life was not a happy one. He was married to the daughter of the wealthy merchant W. and she, not he, was the master of their household. She did not share her husband's passion for collecting and under no circumstances would allow paintings she did not consider pretty to enter their house. One day S. N. N. triumphantly arrived home with his great discovery. It was the picture we know today as Frans Hals' *Verdonck*. His wife found the painting horrid. She refused to permit him to hang in their home a portrait of a coarse fellow holding a jawbone. What was there to do? S. N. N. took his treasure to the well-known St. Petersburg picture restorer J. L. N. and asked him to beautify it. The sensitive restorer refused. It would be sacrilegious to alter a single stroke painted by the great Dutch master. S. N. N. then played his trump card. If J. L. N. would not make the necessary changes he would go elsewhere to have them done. The virtuous restorer was caught – a man who did not know his business might ruin the picture. Therefore he agreed to do the work. He first coated the painting with mastic varnish and allowed it to dry, then, using paint from which as much oil as possible had been removed and which was heavily diluted with mastic varnish, he transformed the jawbone into a goblet. The repaint was so thin, Birzeniek noted, that the original paint layer could be seen through it and could easily be removed with turpentine or even by rubbing the passage with one's fingertips. This alteration was not enough for Madame S. N. N. She felt that Verdonck was still badly in

Fig. 63. Salomon de Bray: *Verdonck*. 1638.
Ink and grey wash.
Haarlem, Municipal Archives

need of a haircut. For this reason the beret was added. After this additional change had been made Verdonck found a place in the collection of Chamberlain S. N. N.

Birzeniek wrote that he had heard the story from the lips of the restorer who had made the alterations. He added that his informant was delighted to learn that his repainting had been removed and that, in effect, he had saved a work by Frans Hals. De Wild responded that he welcomed this chapter of the picture's history but did not fail to add that the repaint was neither solvent in turpentine nor could it be removed with his finger tips. The repainted passages were, in fact, very difficult to strip.

Though we know that works of art are sometimes tampered with to make them conform to the caprice of a collector, we seldom learn the precise circumstances that bring about the changes. Thus we too welcome this Chekovian story. It sounds credible. But is it? There is reason to doubt it. According to the records of the National Gallery of Scotland the version of *Verdonck* which De Wild restored was never in St. Petersburg. Documents at the Gallery indicate that it was in the possession of the Vaile family in Kent from the 1820s until 1895, when it was sent by Mr. Lawrence W. Vaile to Christie's, where it was bought by Messrs. Agnew, who subsequently sold it to Mr. John J. Moubray of Naemoor, who presented it to the Gallery in 1916. This provenance makes it highly improbable that the Edinburgh picture was ever in Russia. It had been in Great Britain for about a century before it entered the National Gallery of Scotland. If Birzeniek's tale is not a hoax or if the restorer J. L. N. did not have a fantasy, another version of *Verdonck* wearing a beret and holding a goblet may still be in some collection in the Soviet Union.

According to the poem on Van de Velde's print, Verdonck was an unruly Haarlem wit. Evidently his jawbone got him into much more trouble than the 'smoked herrings' Cornelis van der Morsch distributed (Plate 13). Van de Velde's print as well as a drawing of him made in 1638 by Salomon de Bray (Fig. 63), which includes two lines of the poem inscribed in the engraving, testify that he enjoyed some local notoriety. Perhaps Hals painted Verdonck expressly as a modello for Van de Velde's engraving, which was then sold as a cheap broadside. Such prints hung in the taverns where peasants painted by Brouwer and Adriaen van Ostade caroused.

83

Fig. 64. Hendrick Terbrugghen: *Flute-Player*. 1621.
Cassel, Hessisches Landsmuseum

Fig. 65. Gerrit van Honthorst: *Merry Violinist*, 1623.
Amsterdam, Rijksmuseum

Hals began to paint single life-size genre figures around the beginning of the 'twenties. The vogue for them – especially for characters dressed in theatrical costumes – was not started by Hals but by Caravaggio's Dutch followers who were active in Utrecht during the 1620s. There was also an indigenous Netherlandish tradition for such works; Massys, Pourbus, Aertsen and others painted them in the sixteenth century. However, the Dutch artists who had been to Italy, where they made contact with Caravaggio's spectacular achievement, gave it new life. Although Terbrugghen, Honthorst and Baburen, the leading Dutch *Caravaggisti*, had all been to Rome, apparently none of them actually worked with the Italian realist. Terbrugghen arrived in Rome around 1604 but there is no evidence that he had personal contact with Caravaggio. The others appeared there after 1606, the year Caravaggio had to flee from the city because he had killed a man. From the day of his quick departure until his untimely death in 1610 Caravaggio never returned. During his enforced exile he was virtually always on the move, either running or hiding. An entourage of pupils was the last thing he wanted. But enough of Caravaggio's works could be seen in Roman churches and private collections for the receptive Dutch artists to assimilate aspects of his uncompromising realism and the expressive power of his chiaroscuro. Italian *Caravaggisti* active during the second decade of the century, particularly Bartolomeo Manfredi, who specialized in painting life-size genre pictures derived from Caravaggio's early compositions, must also have given decisive impulses to the young Dutch artists.

By the beginning of the 1620s Terbrugghen, Honthorst and Baburen had settled in Utrecht and were painting pictures which incorporated their own personal interpretation of Caravaggio's motifs and stylistic innovations (Figs. 64–66). All of them made half-length compositions of single figures which had an immediate appeal. As early as 1621 Abraham Bloemaert, who had never been in Italy, painted his *Flute-Player* (Fig. 67), which incorporates dramatic Caravaggesque

84

Fig. 66. Dirck van Baburen: *Singing Man*. 1622. Halberstadt, Das Gleimhaus

Fig. 67. Abraham Bloemaert: *Boy with a Flute*. 1621. Utrecht, Centraal Museum

lighting derived from his study of works by Honthorst and Baburen. Hals followed the fashion but not slavishly. The nocturnal effects popularized by the Utrecht *Caravaggisti* did not interest him. A possible exception is the *Denial of Peter* attributed to Hals in a sale held at The Hague on April 20, 1779. The subject is traditionally shown as a night scene but the picture is untraceable and there is no way of determining the validity of the attribution. In any event none of Hals' existing works shows figures at night illuminated by artificial light. His pupils and followers were not as committed to *plein air* effects. Dirck Hals, Brouwer, Judith Leyster, Molenaer and Adriaen van Ostade all painted nocturnal scenes.

The range of Hals' themes and his *dramatis personae* were also more limited than those used by the *Caravaggisti*. As we have seen, even in his genre pictures he remained *au fond* a portraitist. He more often characterizes an individual than he shows the reaction of his subject to a specific situation. Unlike the Utrecht painters he never depicted cheating card-players, gambling soldiers, playful arcadian shepherds or gnarled lechers with seducible young companions. The erotic overtones found so frequently in their works are rare in his *oeuvre*. We know no paintings by Hals of Lot and his daughters, no procuress scenes, no licentious couples. The woman in his lost early *Merry Trio* (Fig. 17) and the so-called *Gipsy Girl* (Plate 100) wear the only décolletages he painted in his genre pictures.

The smiling *Lute-Player* (Plate 40), now in the collection of Baron Alain de Rothschild, Paris, is probably one of his earliest single half-length genre figures. The vivid reds of his buffoon's costume and the strongly focused daylight, which still models form more than it suggests a bright, airy atmosphere, places it rather early in the 1620s. A seventeenth-century copy of it at the Rijksmuseum (Fig. 68) is much better known than the original and when first viewed it appears to be an excellent copy. But a juxtaposition of the two works shows that Hals' subtle

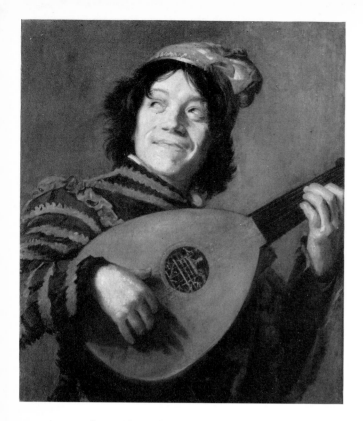

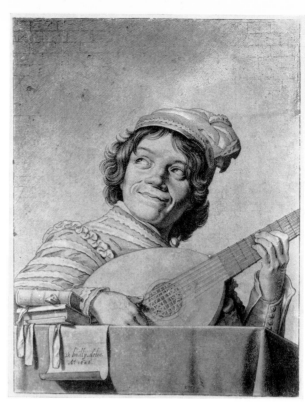

Fig. 68. Copy after Hals' *Lute-Player* (Plate 40). Amsterdam, Rijksmuseum

Fig. 69. David Bailly: Copy of Hals' *Lute-Player*. 1626. Pen and wash drawing. Amsterdam, Rijksmuseum, Prentenkabinet

modelling was far beyond the copyist; this is apparent when the plucking hands are viewed side by side (Figs. 70, 71). Fine gradations in the value of the flesh tones securely define the structure of the hand and the position of the fingers on the strings in the original, while in the Amsterdam picture the hand looks like an inflated rubber glove. The copy was formerly attributed to Hals himself, then to Dirck or to one of Frans' sons, and it is now ascribed to Judith Leyster. Since it, and not the original, was most likely used as the basis for a drawing David Bailly made of the work in 1626 (Fig. 69), the copy was probably painted in or before that year. Whether Judith Leyster was capable of making such a copy in 1626, when she was only seventeen years old, is another symphony, but the date on Bailly's drawing establishes a firm *terminus ante quem* for Hals' original.

Hals created the impression that the *Lute-Player* is seen from below, a view Bailly rationalized in his drawing by placing the figure behind a table set well above the beholder's eye-level. Probably the painting was originally intended to hang high, the way two of Hals' paintings are mounted in an interior painted by Jan Steen (Fig. 93). Hals did not invent the idea of showing a model from this point of view. Italian painters of illusionistic wall and ceiling decorations had been placing figures on balconies seen in steep perspective since the Renaissance. Their *trompe-l'oeil* tricks appealed to the Utrecht Caravaggesque painters, particularly to Honthorst and Baburen, who can be credited with introducing *di sotto in su* compositions to Holland. Honthorst made some ambitious compositions of this type in 1622 and 1623; Baburen painted a few around the same time. Hals could have known them but he dispensed with the balustrades and windows employed by the Dutch *Caravaggisti*. For us the illusionism is heightened, not diminished, by the elimination of these props. Hals also recognized that a model seen from below – even ever so slightly – appears to tower over the spectator. He made good use of this knowledge in his commissioned portraits of the so-called *Laughing Cavalier* (Plate 52), *Claes Duyst van Voorhout* (Plate

86

Fig. 70. Detail from *Lute-Player* (Plate 40). About 1620–23. Paris, Baron Alain de Rothschild

Fig. 71. Detail of copy after Hals' *Lute-Player* (Fig. 68)

195) and of haughty *Jasper Schade van Westrum* (Plate 261). Hals also quickly realized that the darting glance which he gave this lute-player could be used to enhance the instantaneous effect of a portrait as well as a genre piece. He used it as early as 1626 for his unorthodox portrait of *Isaac Massa* (Plate 64).

In his half-lengths of a *Boy with a Flute* (Plate 45) at Berlin-Dahlem and *Merry Lute-Player* (Plate 48), now in an English private collection, it is difficult to decide what to admire most: the spontaneous movement and natural gaiety of the young musicians or the effect of full daylight playing over them. In both works the pronounced diagonals and courageous foreshortening characteristic of the 1620s increase the impression of lively animation while the suppression of detail heightens the visual drama and tension. The bright light does not enter as a beam but floods each of the figures and the light grey backgrounds producing a kind of overall, open air atmosphere. Terbrugghen led the way for such *plein air* effects in his exquisite pendant *Flute-Players* which were painted in 1621; one of them is reproduced in Fig. 64. Hals must have been familiar with such works by the most gifted of the Dutch *Caravaggisti*. By 1624 he used this type of bright illumination for his portrait of the so-called *Laughing Cavalier* (Plate 52). These two musicians as well as the young one making a *Finger-Nail Test* (Plate 47) – the boy has inverted his glass to prove that he has emptied it so thoroughly that not a drop will fall on his finger-nail – were probably painted around the same time. Hals' musicians, however, belong to a different race than Terbrugghen's. His young people live at a higher pitch, their pulse beats faster. The Utrecht painter's restrained, tender poetry and delicate mood remained foreign to him and he never responded to the ample, slow, classical rhythms Terbrugghen assimilated after spending about a decade in Italy.

A picture which belongs to the same group is the *Young Man Holding a Skull* (Plate 97), although the largeness of its forms, the greater intensity of the light and the more fluid touch suggest that it was probably painted a few years later. A close view of the young man's outstretched hand (Fig. 72) shows Hals' extraordinary power as a draughtsman as well as his absolute control over his revolutionary technique. As always the form was first brushed in with a middle tint; then, using this as a foundation, he drew the foreshortened fingers with a few emphatic touches of light and shadow which model them while suggesting the flow of shimmering light over their surface. Understandably this painting of a young man with a skull has often been called Hamlet. It has been associated with the grave-diggers' scene, in which Shakespeare's hero discourses upon a skull that had a tongue and could once sing, and upon the pate of a politician, a courtier, a lawyer, a buyer of land, and finally with skull in hand, upon poor Yorick's. Although we know that Hals occasionally used theatrical characters as subjects for his paintings, that other seventeenth-century artists depicted scenes from contemporary plays and at least one company of travelling English actors performed in Holland before the *Young Man Holding a Skull* was painted, it is hardly probable that he represents Hamlet. Most likely the picture is a straight-forward *Vanitas*. We have already heard that in 1636 Pieter Codde owned a *Vanitas* painting by Hals. There was a venerable tradition for putting a skull in the hand of a youth to represent this

Fig. 72. Detail from *Young Man Holding a Skull* (*Vanitas*) (Plate 97). About 1626-8. Peterborough, Major Sir Richard Proby, Bt.

idea. Lucas van Leyden had engraved the subject as early as 1519 (Fig. 73); Goltzius had used the theme for a splendid drawing dated 1614 (Fig. 74); and not long after Hals' painting was made, Craesbeeck placed a skull in the hands of his *Smoker* (Fig. 75) to allude to the familiar Biblical warning (Psalm 102: 3) 'My days are consumed like smoke.'

The *Young Man Holding a Skull* (Plate 97) appears to be addressing someone on his left. Perhaps he had a pendant. Dutch genre pieces designed as companion pieces are not uncommon. Ter-brugghen's *Flute-Players* of 1621 are perhaps the best known ones but others can be cited. Even Rembrandt etched a pair of peasants designed to be seen together (Bartsch 177, 178): the inscription on Rembrandt's print of a shivering peasant reads 'It is very cold'; his warm-blooded companion bravely replies 'It's nothing.' If Hals' man with a skull had a pretty young woman as a companion piece she would not be inconsistent with the *Vanitas* theme. Numerous published sermons and pamphlets testify that hedonism was not unknown in seventeenth-century Holland. If Dutch moralists had not thought that many of their countrymen were too interested in the pleasures of life they would not have admonished them so frequently.

Seventeenth-century Dutch *vanitas* still-life painters also reminded men of the ephemeral nature of man's joy and power. The oval painted by Petrus Schotanus (Fig. 76) contains the *Vanitas* painter's usual paraphernalia: the skull and bone, the beautiful rose which has already

89

Fig. 73. Lucas van Leyden: *Young Man Holding a Skull* (*Vanitas*). 1519. Engraving

Fig. 74. Hendrick Goltzius: *Young Man Holding a Skull and a Tulip* (*Vanitas*). 1614. New York, Pierpont Morgan Library

Fig. 75. Joos van Craesbeeck: *Man Holding a Skull and a Pipe* (*Vanitas*). Location unknown

Fig. 76. Petrus Schotanus: *Vanitas Still Life*. Detroit, Detroit Institute of Arts

Fig. 77. Title page of Crispin van de Passe, *Le Miroir des plus Belles Courtisannes de ce Temps*. 1631

lost a petal, the globe, and the books, which usually signify knowledge that leads to pride. The crumpled and torn book which dangles over the edge of the table in this still-life is an unusual one. It is one of the editions of a volume first published in 1630 by Crispin van de Passe entitled *A Looking Glass of the Most Beautiful Courtesans of These Times*. The title page was printed in three languages: French, Dutch and German (Fig. 77). The text added English as a fourth language, and the courtesans mentioned represent almost all the countries of Western Europe. The book is included in the still-life to remind man of the sinful and ephemeral nature of carnal pleasures. The men depicted in the engraved frontispiece of Van de Passe's book seem to be in need of the reminder (Fig. 78). One is shown seated at a table examining the portrait of a courtesan which has been presented for his approval; the other, who appears to have just entered the chamber, gives his cloak to a maid and points to one of the six portraits mounted upon the wall. The reader of Van de Passe's book is also offered a gallery of portraits of courtesans. Each one is

Fig. 78. Frontispiece of Crispin van de Passe, *Le Miroir des plus Belles Courtisannes de ce Temps*. 1631. Engraving

91

Fig. 79. Crispin van de Passe: *The faire Curtezane
Zavenara*. Engraving

Fig. 80. Crispin van de Passe: *Faire Alice*.
Engraving

accompanied by a short doggerel verse. An exposed page of Van de Passe's book painted in the
still-life shows one of them, and another from the volume, the fair Zevenara, is reproduced here
(Fig. 79). Frans Hals' so-called *Gipsy Girl* (Plate 100) at the Louvre, which was painted around the
same time as Van de Passe's book was published, could be put in the same kind of gallery.

Portrait galleries of courtesans actually existed in Holland during the seventeenth century.
When the French dramatist Jean François Regnard visited Amsterdam in 1681 he wrote (*Voyage
en Flandre, en Hollande, en Danemark et en Suède*) that Amsterdam could perhaps claim to have,
Paris excepted, more debauchery than any other city in the world. However, he noted there was
something quite unique about the bawdy houses there. The companions a gentleman seeks,
Regnard wrote, are kept in closed rooms. Portraits and prices of the rooms' occupants are fixed
above their doors, and a selection is made upon the basis of these pictures. One is never shown the
original, Regnard writes, until the fee has been paid, and he concludes 'tant pis pour vous si la
copie a été flâtée.' Everyone is familiar with 'Dutch treat,' 'Dutch uncle,' 'Dutch wife,' 'double
Dutch.' The game Regnard describes might be called 'Dutch roulette.'

Under Hals' brush the common subject of a portrait of a mischievous young woman is raised
to the highest art. The *Gipsy Girl* is a celebration of a fleeting moment of palpitating life. Hals'
vigorous touch gives the work an unrivalled vivacity and the impasto of his paint appears as
supple as the young woman's flesh (Plate 101). Every square inch of the canvas seems to pulsate
in exultation of her youthful vigour and health. Unwholesome feelings are the last things she
evokes. Yet Hals' contemporaries must have recognized something special about her more
readily than we do. Her uncovered head, her casual hairdo and her décolletage marked her as an
unusual type. In Hals' time, women wore more, not less, when they wanted to appear at their best.
When the *Gipsy Girl* was painted, a proper Dutch woman wore a high, stiff, buttoned-up bodice
and a mill-stone ruff, two mortal enemies of the plunging neckline. However, care must be taken
not to jump to hasty conclusions about the character of a woman upon the basis of the clothes

92

Fig. 81. Christian van Couwenbergh: *Merry Couple*. Location unknown

Fig. 82. Carel de Moor: *Touch*. Etching after Jacob Backer

she wears. 'Fair Alice,' a courtesan honoured with a place in Crispin van de Passe's book (Fig. 80), wears the cap, mill-stone ruff and stiff bodice which were the height of fashion in regent circles around 1630.

Other Dutch artists depicted courtesans. Honthorst painted a smiling young woman in 1625 (Fig. 83) who can be identified as a courtesan by her costume and by the painted medallion she holds, which shows a nude woman seen from the back. The motto inscribed on the medallion is not chaste; translated it reads: 'Who recognizes my arse from the rear'. Christian van Couwenbergh used the theme more than once, and in his hands the treatment of the subject became gross and sometimes brutal (Fig. 81). Jacob Backer also made such pictures; his courtesan, popularized by an etching by Carel de Moor (Fig. 82), was used to represent 'Touch' in a Five Senses series – a far cry from the allegorical figure he had used earlier to symbolize the same subject (Fig. 54). It is doubtful if Hals' so-called *Gipsy Girl* alludes to the sense of 'Touch' but it is worth noting that Backer's painting of 'Touch' was incorrectly attributed to Frans Hals in the eighteenth century, when it was in Sir Joshua Reynold's collection. The painting by Couwenbergh which is reproduced here was also formerly called a work by Frans Hals. These erroneous ascriptions were apparently based on mistaken ideas about Hals' character rather than his style or his treatment of such a subject. As far as we know, Hals, who was called a toss pot and worse by his early biographers, did not paint a single coarse or vulgar picture during his long career.

It is also significant that in the so-called *Gipsy Girl* he made changes in his original conception. A photograph of the lower half of the painting taken in a raking light (Fig. 84) shows brushstrokes underneath the surface of the top layer of paint (Fig. 85). These strokes – the diagonal ones on the left side of her bosom are most evident – reveal that Hals originally made her décolletage less daring. *Pentimenti*, as we have already mentioned, are rare in Hals' work. He worked with a godly surety from the beginning until the end. The unusual *pentimenti* in the *Gipsy Girl* indicate

93

Fig. 83. Gerrit van Honthorst: *Young Woman Holding a Medallion*. 1625. St. Louis, Missouri, City Art Museum

that Hals' first impulse, or if one can still use the phrase, his natural impulse, was to make his unselfconscious model more decorous than she is now.

Clearly not every woman is what she appears to be, as we have already noted in our discussion of Hals' early *Shrovetide Revellers* (Plate 8); since it depicts a group of celebrants who can be identified as stock characters from theatrical farces of the time, the young woman crowned with laurel in the centre of that picture may very well be a young male actor in a wig. Hals also painted other theatrical types. His so-called *Mulatto* (Plate 103) at Leipzig and another painting of the same model at Cassel (Plate 102) both represent the comic theatrical character *Peeckelhaering*. He is identified as the popular figure in a contemporary engraving of the Cassel picture (Fig. 88),

94

Fig. 84. Detail from *Gipsy Girl* (Plate 100), in raking light.

Fig. 85. Detail from *Gipsy Girl* (Plate 100)

and there is a reference to a *Peeckelhaering* by Hals as early as 1631 in an auction list made of works which belonged to Hendrick Willemsz. den Abt, keeper of an inn called the 'King of France' at Haarlem. The size of Den Abt's collection suggests that he was a picture dealer as well as an inn-keeper. A dozen drawings and more than seventy paintings are included in the list. Amongst his paintings were four by Frans Hals (*Peeckelhaering*, a portrait and two tondos), six by Dirck, five by Young Hals (probably by Frans' twenty-year-old son Harmen), four little portraits by Molenaer and also 'various copies after Frans Hals', 'various copies after Dirck Hals' and no less than 'twelve copies after Porcellis.' References to contemporary copies of works by Frans and Dirck as well as a dozen after Porcellis are a salutary reminder to compilers of *oeuvre* catalogues with expansionist tendencies. The German impressionist Max Liebermann had a word for contractionists: 'It is the job of art historians to deny that artists painted their bad pictures.'

The paintings of *Peeckelhaering* at Cassel and Leipzig can both be dated around the end of the 'twenties and if the reference in Den Abt's inventory refers to one of them, 1631 can be considered its *terminus ante quem*. In both works the comedian bears little resemblance to the fat *Peeckelhaering* Hals had painted about fifteen years earlier in the *Shrovetide* picture at New York (Plate 8). He now recalls Brighella, the popular *Commedia dell'Arte* player. This character was a popular one in Haarlem in the 1630s. He appears in other contemporary engravings and paintings; Dirck Hals showed him wearing the same costume as he pours wine into a goblet in his *Merry Company* scene now at Stockholm (Figs. 89, 90). The servant keeping score of the liquor consumed at this party is not missing; she is seen at work on the left. The Stockholm picture is one of the paintings by Dirck which suggests that Frans could not have been excessively proud of all of his brother's efforts. Yet it is of some historical interest because it gives us an idea of the way pictures were hung in Dutch interiors. The interior as well as the pictures hanging on the rear wall may be Dirck's invention and not an attempt to reproduce an actual setting, but it is noteworthy that he coupled a nocturnal painting of a 'Reading Woman' with a 'Portrait of a Man.' Jan Steen also showed companion pieces hanging in his interiors. In his *Baptismal Party* (Fig. 93), now at Berlin-Dahlem, he showed two genre pictures as pendants. One of the pictures within the picture is Hals' *Peeckelhaering* (Fig. 92) now at Cassel. Its companion piece is a Malle Babbe type with a pipe (Fig. 91); judging from the faithfulness of Steen's copy of the Cassel *Peecklhaering* it is probably an excellent miniature copy after a lost picture by Hals (until it is possible to prove the entertaining but highly improbable idea that this crone was the wife of *Peeckelhaering* there is no reason to cite these pendants as an exception to the dexter-sinister rule for portraits of couples mentioned above, p. 51). Jan Steen knew the *Peeckelhaering* well – perhaps he owned it. It appears again in his *Doctor's Visit* (Fig. 87) now at Apsley House, London.

Hals' other portrait of *Peeckelhaering*, the so-called *Mulatto* at Leipzig (Plate 103), was probably in England in the seventeenth century; it was engraved in London by Edward Le Davis around 1670 (Fig. 86). Le Davis called his engraving 'The Mountebanck Doctor and his Merry Andrew'; he gave *Peeckelhaering* the traditional name of an English quack's assistant. The verse inscribed on his print proclaims that Merry Andrew plays the fool in order to sell his master's

Fig. 86. Edward Le Davis: *The Mountebank Doctor and His Merry Andrew*. Engraving after Hals' *Mulatto* (Plate 103) and *Portrait of a Man* (Plate 214)

Fig. 87. Jan Steen: Detail from *The Doctor's Visit*, with a copy after Hals' *Peeckelhaering* (Plate 102). London, Wellington Museum, Apsley House

packets, which cure nothing but the mountebank's consumptive purse. The mountebank confesses, in turn, that though he wears a velvet coat he really is not worth a groat a year.

The second state of Le Davis' engraving, which is reproduced here, is inscribed 'Franc Hault Pinxit'; the first state, which does not bear the verses, spells the artist's surname 'Haultz.' These are the earliest known English references to Frans Hals. A *Merry Andrew* by F. Hals sold at London in 1765 fetched ten shillings, ten pence. If it was the painting now in Leipzig – or, indeed, any genuine work by Hals – it is a serious contender for the record low price for a painting by the master.

The portrait of the mountebank doctor in Le Davis' engraving is also a copy of a picture by Hals. The painting which served as the engraver's model is the *Portrait of a Man* (Plate 214) now at the Hermitage in Leningrad, and it too was probably in England by about 1670. Pairing these two paintings was probably Le Davis' idea, not Hals', but the juxtaposition is another indication that Hals' contemporaries liked to see a genre picture with a mate. Around 1750 George Vertue wrote in one of his notebooks that he owned a monogrammed 'picture ¾ painted of a Doctor by France Hals'. Perhaps his portrait was the 'Mountebank Doctor' engraved in London by Le Davis. If it was, the painting did not remain in England long after Vertue's death in 1756. Hals' *Portrait of a Man* was acquired at Berlin in 1764 for Catherine the Great. Catherine's remarkable agents were prepared to buy more unconventional pictures by Hals. One of them purchased four of his religious paintings at Amsterdam in 1771.

In the catalogue raisonné of Hals' work which the indefatigable Hofstede de Groot published in 1910, there are references to eighteenth-century auctions in which four Evangelists attributed to Hals were sold. Hofstede de Groot also noted the references he found in old catalogues and inventories to a handful of other religious subjects by the artist: a *Denial of Peter* and a *Mary*

97

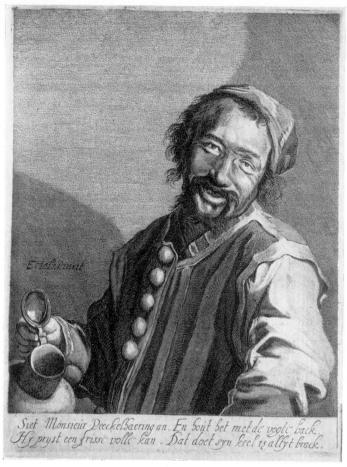

Fig. 88. Jonas Suyderhoef: Engraving after Hals' *Peeckelhaering* (Plate 102) Fig. 89. Detail from Fig. 90

Fig. 90. Dirck Hals: *Merry Company*. Stockholm, National Museum

Fig. 91. Jan Steen: Detail of Fig. 93. Probably a copy after Hals' lost *Woman with a Pipe* (Malle Babbe?)

Fig. 92. Jan Steen: Detail of Fig. 93. Copy after Hals' *Peeckelhaering* (Plate 102)

Fig. 93. Jan Steen: *Baptismal Party*. Berlin–Dahlem, Staatliche Museen

Magdalene, and the *Prodigal Son*. Except for the last mentioned picture, which as we have seen may have been identical with his so-called *Jonker Ramp and His Sweetheart* (Plate 42), few students of Hals' works took these references seriously. Attributions in old catalogues, like those in new ones, can be dead wrong. Most specialists believed that there was about as much chance of discovering an Evangelist painted by Hals as there was of finding a still-life by Michelangelo. But the discovery was made when Irina Linnik identified two pictures which she found gathering dust in a storeroom at Odessa as Hals' lost *St. Luke* (Plate 72) and *St. Matthew and the Angel* (Plate 73). She published them in the Soviet journal *Iskusstvo* in 1959.

Hofstede de Groot knew that four Evangelists with their attributes were ascribed to Hals at an auction at The Hague in 1760 and that they were purchased by Iver, a Dutch auctioneer. Hofstede de Groot also noted that the pictures appeared again in a sale at The Hague in April of 1771. A few weeks later they were sold at Amsterdam and again Iver purchased them. Irina Linnik unequivocally established that the two pictures now at Odessa are two of the four that Iver purchased in Amsterdam in 1771, the very year in which he was commissioned by Catherine to buy pictures for the Hermitage. Part of the subsequent history of the pictures is also known, but how and when Hals' two Evangelists travelled to Odessa has not been discovered, nor have the pictures of St. Mark and St. John yet been found.

In short, the Odessa paintings are those which were attributed to Hals as early as 1760 and were at the Hermitage by 1773. One important question remains: was the eighteenth-century attribution a correct one? I admit that upon the basis of the first photographs I saw of them it was hard not to have some reservations about the ascription to Frans Hals. It was not surprising to learn they were catalogued in the museum at Odessa as works by an unknown nineteenth-century Russian painter. The pictures do indeed seem to have something in common with the world of nineteenth-century Russia. One cannot help thinking of Tolstoy and his life at Yasnaya Polyana. They seem to offer yet another proof of Oscar Wilde's dictum that every day nature is getting to look more and more like art. Moreover, passages of the drapery of both figures are dull and mechanical. St. Luke's left sleeve is difficult to read, and the jerky, angular neck-line of his garment is disturbing. Parts of the St. Matthew are awkward too. His huge book is clumsily drawn and so are his fingers. However, confrontation with the originals removed all doubts. The total effect of both is convincing and their style is entirely consistent with works which Hals painted around the middle of the decade. The composition as well as the touch in *St. Matthew and the Angel* is closely related to his *Two Boys Singing* (Plate 44) at Cassel and *Two Laughing Boys* (Plate 90) on loan at the Boymans-van Beuningen Museum, Rotterdam. The similarity between the heads of Luke (Fig. 94) and Damius (Fig. 95), the provost in the *Banquet of the St. Hadrian Guards*, is so great that it would come as no surprise to learn that Damius posed for the Evangelist not long before the militia piece was painted. The practice of using a specific individual as a model for a picture of a Saint was not unusual. According to Van Mander, Rijkaert Aertsz., who had a 'nice picturesque face' ('*een fraey schilderachtighe tronie*'), posed for Frans Floris' *St. Luke Painting the Virgin* (1556; Antwerp, Musée des Beaux-Arts). Van Mander also tells us that Cornelis Ketel

Fig. 94. Detail of *St. Luke* (Plate 72). About 1625

Fig. 95. Provost Johan Damius: Detail from *Banquet of the St. Hadrian Civic Guards* (Plate 78). About 1627

painted a series of Christ and the Twelve Apostles which were portraits of contemporary artists and art lovers. And about a decade before Hals painted his Evangelists, the Haarlem shell collector Jan Govertsen (Fig. 7) served as a model for a drawing which Goltzius made of St. Luke (1614; Collection Veste Coburg).

After the shock of discovering that religious pictures by Hals really exist, some impressive qualities appear. The word shock is used advisedly. The man whom Max J. Friedlaender called the *ewige Neinsager* is the one who is incapable of getting over this kind of shock. We are prepared for certain kinds of responses to pictures painted by masters we know. There is a Pavlovian re-action to works of art as well as to bells. This is experienced on an elementary level in our reaction to the work of popular cartoonists. We are set for one and only one kind of reaction to their cartoons. Similarly, we are prepared for a certain kind of response to a picture by Hals which was made during the 1620s. Until Linnik's brilliant discovery of the Odessa pictures, it did not include the possibility of a St. Luke lost in thought or a St. Matthew concentrating upon a text.

Who commissioned these works or where they originally hung has not been discovered. Perhaps they were made for a private or hidden Catholic chapel. It is significant, however, that the paintings of the *Four Evangelists* done by Terbrugghen in 1621 were presented by his son to the city of Deventer in 1707; thus, his series apparently remained in the family after his death. Did they remain in the Terbrugghen family because such religious pictures were unsaleable in seventeenth-century Holland?

It has been rightly noted that Terbrugghen's *Four Evangelists* (two are reproduced here; Figs. 96, 97) can be considered prototypes of those Hals painted. However, it is also evident that there are important differences between the ways the artists depicted the saints. Hals' brushwork remained free and impulsive even when he painted Evangelists. He concentrated on the heads of

Fig. 96. Hendrick Terbruggen: *St. Luke*. 1621. Deventer, Stadhuis

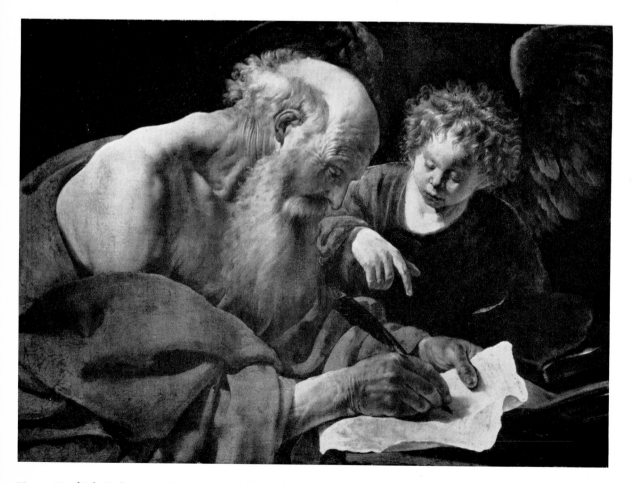

Fig. 97. Hendrick Terbruggen: *St. Matthew and the Angel*. 1621. Deventer, Stadhuis

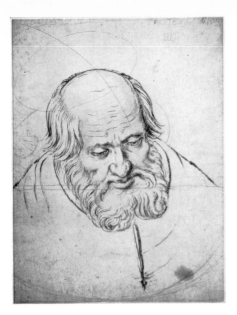

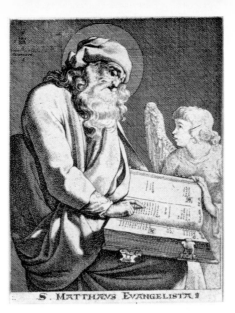

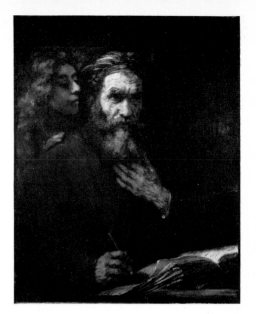

Fig. 98. Hendrick Goltzius: *St. James Major*. 1586. Brush and red chalk. Leiden, Rijksuniversiteit, Prentenkabinet

Fig. 99. Jacques de Gheyn III: *St. Matthew and the Angel*. 1617. Engraving

Fig. 100. Rembrandt: *St. Matthew and the Angel*. 1661. Paris, Louvre

his figures. His wingless angel, who looks up with innocent admiration at Matthew, is a closer cousin to the young boys who appear in his genre pictures than he is to the curly-haired one in Terbrugghen's work shown dictating to the Saint. Benedict Nicolson has keenly observed that in Terbrugghen's paintings 'a hand can be relied on to do the work that normally a face does.' Terbrugghen studied gesture with the intensity of a master-mime and the epidermis of a hand with the care of an expert dermatologist. Not Hals. The hands of his Evangelists are summarily painted and their garments are so broadly mapped in that it is hard to suppress the feeling that the commission was not one that exacted a major effort. Hals made no attempt to compete with Terbrugghen's mastery of the grand *largo* rhythms which can be established when a bare shoulder, breast or arm is set off by a large swatch of drapery. The Utrecht painter showed as much flesh as he dared; all of his Evangelists wear off-the-shoulder drapery. But Hals, as always, instinctively covered flesh which did not belong to a face or hands.

Hals' Evangelists should be seen in relation to the Biblical personages depicted by the generation of his teachers as well as those done by Terbrugghen. The head of his St. Luke (Fig. 94) has less in common with the Evangelists painted by the Utrecht Caravaggesque artist than with Goltzius' large brush drawing of *St. James Major* (Fig. 98). Goltzius' powerful drawing was made in 1586, only a few years after Hals was born and one or two years before the birth of Terbrugghen. Jacques de Gheyn III, who belonged to the following generation, made figures of the same type and spirit (Fig. 99). Hals learned from the Dutch *Caravaggisti*, but he also followed a well-established Netherlandish pictorial tradition when he painted his Evangelists. It was a tradition which found its most profound expression a few decades later in Rembrandt's mature paintings of holy men, saints and evangelists (Fig. 100).

According to the catalogue of a sale held at London on April 6, 1773, Hals also tried his hand at a *Democritus* and a *Heraclitus*, another favourite theme of his Dutch contemporaries. The compiler of the catalogue noted: 'tho' this master was not used to treat such subjects, he has shewn great expression of grief in one, and drollness in the other.' Discovery of at least one of these lost paintings would probably be even more sensational than the recent identification of the Odessa Evangelists. No Baroque painter was better qualified than Hals to paint Democritus,

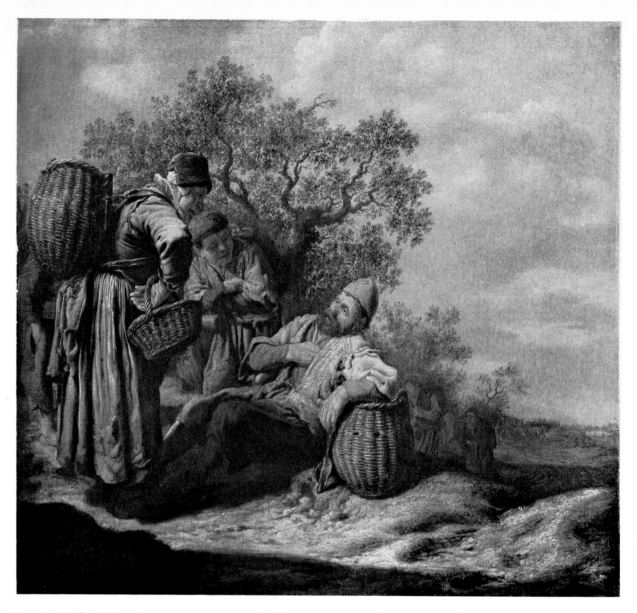

Fig. 101. Unidentified 17th-century Dutch artist: *Fisherfolk in a Landscape*. Budapest, Museum of Fine Arts

the philosopher who laughed at the world's folly. But how did he depict Heraclitus, the sage who wept at its foolishness?

Although Hals virtually ignored interior settings, toward the end of the decade he began to give some evidence of interest in exterior ones. A glimpse of dunes and water appears behind his life-size half-lengths of fisherfolk painted in the following years. The exceptionally vivid colour accents and rather heavy paint of the *Laughing Fisherboy with a Basket* (Plate 86) at Burgsteinfurt places it as one of the earliest; the *Left-Handed Violinist* (Plate 87) was probably painted not long afterwards.

It has been suggested that the *Left-Handed Violinist* is a self-portrait made from a mirror and that for this reason the violinist is depicted bowing with his left hand. This is nonsense – the ruddy violinist bears no resemblance to Hals' known self-portraits and besides, if he had painted what he saw in a mirror, we would be looking at a brush and palette, not a violin and bow. (There *are* such things as left-handed violinists, and even ambidextrous ones.)

In any event, both the *Laughing Fisherboy* and the *Left-Handed Violinist* wear the shaggy blue wool caps frequently worn by seventeenth-century Dutch sailors and fishermen. The boy's intense blue one makes an unforgettable contrast with his platinum-blond hair. His crossed arms indicate that even fisherchildren were given gestures which help identify them. Hals painted

104

Fig. 102. Jan Steen: Detail of a fisherboy in *Garden of an Inn*.
Berlin–Dahlem, Staatliche Museen

another fisherboy in a similar attitude (Plate 115), and other seventeenth-century Dutch painters showed fisherchildren with their arms in the same position (Fig. 101). Perhaps this posture helped them bear the weight of their heavy baskets. Its use for fisherchildren makes the wreathed arms of Hals' 1622 *Portrait of a Man* (Plate 39) at Chatsworth appear even more unorthodox.

Pictures of fishermen were popular, as might be expected in a country where fishing was the basis of the economy. Fishermen appear in early Dutch prints of the various occupations and they were used in allegorical series of the 'Four Elements' to help personify 'Water.' They are also frequently found in scenes of Holland's coastlines, dunes and in genre pictures. The happy young man who peddles shrimp and fish in Jan Steen's crowded scene in the courtyard of an inn on a sunny summer afternoon (Fig. 102) suggests that Steen studied Hals' pictures of fisherfolk as carefully as he copied his paintings of *Peeckelhaering* and the lost *Malle Babbe*. But Hals, it seems, invented the idea of a half-length, life-size painting of a fisherboy or girl, and thereby he can be credited as the first to make a working child the principal subject of a picture. This was a radical departure, although it cannot be said that Hals painted such pictures to promulgate revolutionary social ideas. Like the other young people he painted, his fisherboys and girls seem to burst with health and joy. There is no suggestion that they were unjustly exploited or lived in miserable

conditions; there was no suggestion of need for reform. Hals was not out to challenge the existing social order; few seventeenth-century Dutchmen were.

Paintings of fisherfolk were also made by Hals' close followers. This has led to some confusion. In my opinion Bode, Hofstede de Groot and Valentiner included some of these amongst the pictures they ascribed to the master's hand. On the other hand, Trivas went too far when he rejected every picture of this category from his catalogue of Hals' *oeuvre*. If Hals' paintings of fisherboys and girls did not exist we would have to invent them: how else could one account for the numerous school pieces?

The landscapes of the *Fisherboy* at Burgsteinfurt and the Lugano–Castagnola *Violinist* recall those painted at Haarlem in the late twenties by Molyn as well as some by Jan van Goyen and Salomon van Ruysdael, but I see no reason why they cannot be attributed to Hals himself. The one in the *Fisherboy* is little more than a backdrop. In the *Violinist* the view is given greater prominence and the diagonal massing of the dunes serves as an effective counterpoint to the tilted pose of the musician; however, the spaciousness and atmospheric effect remains rather primitive here too. Around this time Hals was more successful at suggesting the over-all brightness of the open air in paintings that have no indication of a landscape background than in those which do.

Highpoints of Hals' depiction of bright shimmering daylight animating elusive moments of joyful life are his *Drinking Boy* (Plate 91) and *Boy with a Flute* (Plate 92) now at Schwerin. Perhaps these pendants were the two tondos mentioned in the list made of Den Abt's pictures at Haarlem in 1631. The notion often put forward that two of Hals' children served as models for the paintings is an attractive one but there is no way of confirming it. We have already heard that the tondos are related to traditional representations of 'Taste' and 'Sight.' There is, however, nothing traditional about their highly individual brushwork and sparkling silver tonality, which anticipates the most brilliant manifestations of nineteenth-century impressionism. They set a high standard and they should be consulted before making attributions of other pictures of laughing children to Hals. A number of seventeenth-century copies and variants by other hands, as well as some modern forgeries in this popular category, have been erroneously ascribed to him.

A close view of the head of the boy with a flute (Plate 95) shows Hals' fully developed technique. Bold brushstrokes keep their identity as they take the direction needed to suggest shapes and surfaces while distinct hatched ones lend a vibrancy to the sculptural solidity of the forms and enliven the surface life of the whole. Full consideration is given to each stroke's relation to the form represented and to the vital part it plays in the total tonal organization of the picture. A detail of the hand of the boy holding a glass (Plate 93) reveals the unsurpassed suggestive power of his tonal painting. Instead of emphasizing outlines and the sculptural roundness of the hand and glass, he used broadly brushed areas of light and dark tones to indicate the shape of both. Then, with uncanny control of a few swift accents and daring impasto highlights, he adds touches which suggest that forms have been built up and their positions in space have been securely defined. When the passage is seen close it appears to be nothing but random daubs and disconnected strokes laid on large patches of colour. But seen at the right distance all resolves into a coherent

impression suggesting the flow of intense, sparkling light on a hand holding a glass. We know the violent reaction of the critics and public in Paris during the 1870s to similar passages in paintings by the Impressionists. Hals made much less of a stir in Haarlem during the 1620s. We can imagine, however, that Karel van Mander – who praised Pieter Aertsen's virile technique and who was equally impressed by the way Frans Floris could make the beholder believe that things are there when they stand at a little distance which are not there when they stand close up – would have been thunderstruck if he had lived to see the technique which his pupil perfected.

Hals' contemporaries had little to say about the way a picture was painted; they preferred to discuss its content. Some might have criticized his showing a young boy raising a *roemer* of wine to his lips. Many Dutchmen, as well as visitors to the Netherlands, deplored the excessive drinking of men, women and children there. Van Mander called the love of drinking the universal disease of the country. Evidently Haarlem was not immune; in ancient times, according to an old legend, a wood near the site of the present city was dedicated to Bacchus. Association with the woods gave the ancestors of Haarlem's citizens the name of Bacchiades. There can be no question that the god continued to have its devotees in the vicinity.

Beer was the national drink of Holland, and Haarlem breweries made some of the best. The beverage was available in two strengths: a simple beer (*enkelbier*) and double beer (*dubbelbier*). According to all reports the latter was a deadly intoxicant. Though it is not easy to determine precisely how much beer was brewed or consumed in Haarlem, a study of excise taxes paid by tavern keepers and by porters who made home deliveries shows that around 1600, when the town had about thirty-nine thousand inhabitants, they sold more than thirty thousand barrels, and this substantial figure does not take into account beer imported from Germany and England. During the seventeenth century Haarlem's brewing industry expanded; more than seventy breweries helped quench the thirst of the town and the new nation.

While beer was the principal drink among the populace, the well-to-do drank wine, which became increasingly popular during the course of the century and was also consumed in great quantities. A French visitor to Amsterdam in 1681 describes a banquet he attended where the guests were at the table for five hours and drank Rhine wine incessantly, shouting toasts, spilling drinks and smashing glasses. Some drank as many as fifty glasses of wine, but, he adds with understandable amazement, no one appeared to be drunk. Jan Steen's paintings give a good idea of such parties; firsthand accounts of Dutch drinking habits indicate that even Steen's most Rabelaisian drinking bouts were not overdone. No wonder municipal councils issued edicts to help control the consumption of alcoholic beverages and exhortations to temperance are found in the literature and paintings of the period. Small wonder, too, that drinkers so often appear in Dutch art. Still, when we recall that many other nations have also produced generations of hard-drinking men, but only few artists portraying them, we hesitate to draw a firm correlation between drinking habits in Holland and one of the favourite subjects of its painters.

The Utrecht *Caravaggisti* popularized the theme during the 1620s; life-size pictures of drinkers seen in strongly focused light, appealing to the beholder with their gestures and expressions, were

Fig. 103. Maerten van Heemskerck: Detail from *Family Portrait*. About 1530. Cassel, Hessisches Landesmusum

Fig. 104. Cornelis Anthonisz. (Teunissen): Detail from *Banquet of the St. George Civic Guards of Amsterdam* ("*Brasspenningmaaltijd*"). 1533. Amsterdam, Rijksmuseum

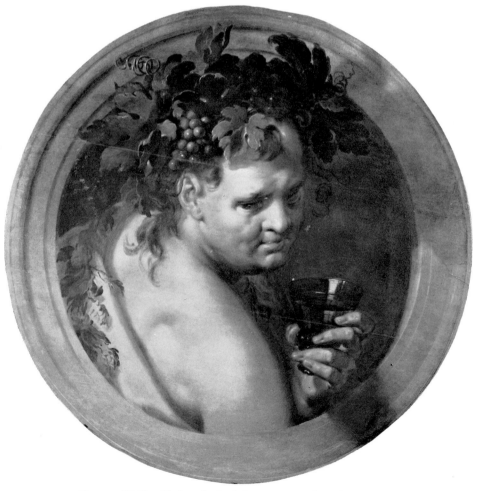

Fig. 105. Unidentified Netherlandish painter: *Bacchus*. About 1600. Buscot Park, Berks., Lord Faringdon

Fig. 106. Jacob Matham: Engraving after
Cornelis Ketel's lost *Portrait of Vincent Jacobsen*. 1602

part of their stock-in-trade (Fig. 65). But drinkers had made their appearance in Dutch painting much earlier. Around 1530 Maerten van Heemskerck depicted the father in his *Family Portrait* (Fig. 103) with a glass in his hand as if ready to propose a toast, and after Cornelis Anthonisz. had introduced one in his Ur-banquet piece of 1533 (Fig. 104), they often appear in Dutch group portraits of militia companies. Drinkers also play prominent roles in early Prodigal Son scenes and moralizing genre pictures. Bacchus himself frequently appears in works done by the late Netherlandish mannerists (Fig. 105) with a drinking glass in hand. Portraits of men holding glasses were done around 1600 too. Van Mander singled out for special mention Cornelis Ketel's portrait of Vincent Jacobsen holding a fine *roemer* filled with Rhine wine; Ketel's lost painting is known from an engraving made after it in 1602 by Jacob Matham (Fig. 106). If we disregard the elaborate mannerist frame around the print and overlook the sitter's rather melancholic expression, Ketel's portrait appears as a precursor of the many single pictures of merry drinkers painted in Holland later in the century. Ketel's intention, however, was not to show the joy of drinking or to paint an allegory of taste. The glass held by Vincent Jacobsen is an attribute of his profession; he was a wine-gauger. His *roemer* is yet another reminder that the interpretation of the meaning of every-day objects found in seventeenth-century Dutch paintings can vary.

Original studies of men holding drinking glasses were made by Jacques de Gheyn about the same time as Ketel painted his portrait of the wine-gauger. De Gheyn, like most Dutch manner-ists, is best known as a draughtsman and printmaker. The swelling and tapering lines, hatchings and dots of his drawings are reminiscent of those used by his teacher Goltzius but he was com-pletely personal in his choice of subjects. His pen drawing of a fisherman seated on a basket and holding a beer glass (Fig. 107) is one of the vivid studies which secure him a place as a leading precursor of the outstanding seventeenth-century Dutch genre painters. This drinker is no

Fig. 107. Jacques de Gheyn II: *Drinking Fisherman Seated on a Basket.*
Pen. About 1600. Groningen, Museum voor Stad en Lande

Bacchus. He does not represent an allegory of one of the senses. His glass is not an allusion to his trade. He is not a member of a class which normally commissioned a portrait. De Gheyn's approach is more modern. His drawing is a careful record of his intense scrutiny of a fisherman without reference to traditional iconographic convention. De Gheyn's penetrating characterization of the sturdy fisherman's weatherbeaten face, his sensitive rendering of the weight and texture of his shaggy wool cap, and his small observation that this man sat with one foot firmly planted on the ground and the heel of the other upraised, all indicate that the drawing was made *naer het leven* and not *uyt den geest.* Perhaps it was sketched on the beach at Scheveningen, the fishing village near The Hague where the artist spent most of his life. There can be no doubt that another study of a drinker by De Gheyn was actually drawn from life (Fig. 108). An inscription on it in the artist's hand specifically states that this was the case. It reads: 'The worthy Halling drawn from life while still a bailiff of the Court of Holland. Anno 1599. DG Fe.' It has been noted – and correctly – that the study on the right of the sheet of the intense woman giving her breast to an infant is larger in scale and drawn from a slightly different point of view; thus, what at first glance appears to be a family group is in fact two independent studies made at different times. Both, however, breathe the same air of immediacy and domestic intimacy which sets them apart from earlier Netherlandish drawings after life. De Gheyn's drawing of the nursing mother anticipates Rembrandt's sketches of women and children, while his vivid characterization of a man with a glass offers a foretaste of the naturalness of drinkers portrayed by Hals in his banquet and genre pieces.

To turn to Hals' *Merry Drinker* (Plate 107) after looking at drinking men depicted by his gifted predecessors and contemporaries is to see how closely one of his best known works follows established Dutch pictorial and iconographic traditions. Yet it is difficult to categorize the paint-

110

Fig. 108. Jacques de Gheyn II: *Bailiff Halling Seated at a Table and a Woman Nursing a Child*. 1599. Pen. Amsterdam, Rijksmuseum, Prentenkabinet

ing. It has been called a genre piece. It has also been interpreted as a representation of the sense of taste and related more specifically to the pleasure of drinking as opposed to its bitter aspects. The possibility that it is a portrait cannot be ruled out either. Could it be Hendrick den Abt, the Haarlem inn-keeper who owned four of Hals' paintings in 1631? The medal which the model wears may offer a clue to his identity but Hals' impressionistic technique makes it difficult to establish the subject of the medal.

Is it pure genre, an allegorical subject or a portrait? In Hals' hands these categories of painting are not mutually exclusive. He worked along the borderlines where they merge and, as is so often the case when we consider one of his paintings, the question of how to classify it seems relevant until we are confronted by the picture. Then pigeon-holes are forgotten. The *Merry Drinker* speaks to us as a startling expression of life charged with all its vital energy. For this unique subject there is no traditional label.

CHAPTER V

The Middle Phase: 1630-1640

SINGLE AND FAMILY PORTRAITS

THE decade 1630–1640 marks the high point of Hals' popularity as a portraitist. In that same period, his younger contemporary, Rembrandt, also painted more portraits than in any other phase of his career. After dedicating the first five or six years of his professional life as an artist to subject pictures, young Rembrandt began to make commissioned portraits in 1631. The following year he painted the *Anatomy Lesson of Dr. Tulp*, the sensational group portrait which established his reputation overnight as the most fashionable portraitist of Amsterdam.

The journey from Haarlem to Amsterdam was an easy one, and Hals made the short trip at least once during the decade. There is no evidence that the two painters ever met there, and what would they have discussed if they had? Once they had compared notes about portrait painting, there would not have been much left. Rembrandt's artistic ambitions were alien to the older master's, who was now in his fifties and fairly settled in his ways. From the beginning Rembrandt was determined to make his mark as a painter of religious subjects and, once settled in Amsterdam, he eagerly responded to the challenge presented by the international currents of High Baroque art. He was determined to beat Rubens at his own game. Hals had no appetite for the sound and fury of that struggle. During these years Rembrandt also began to study and assimilate the ideals of Italian Renaissance artists. Not so Hals. Who can imagine him making drawings after prints of Leonardo's *Last Supper*?

Yet a gradual shift does take place in the mature artist's style during the course of this decade. The bright colours of his earlier works begin to give way to more monochromatic effects, the shimmering silvery light of the 'twenties changes to a deeper, more golden one. Pictorial accents become more restrained and his pictures gain a greater unity and simplicity. The new trend was a general one in Holland at the time. It can be noticed in the tonal landscapes of Jan van Goyen and Salomon van Ruysdael as well as in the monochromatic still-lifes of Pieter Claesz and Willem Heda. The change can also be seen in the fashions of the day: the gaily coloured and richly embroidered clothes worn earlier in the century went out of style, and the sober black regent costume became the vogue.

Evidence of the shift in Hals' work is first seen in his imposing three-quarter-length pendant portraits of the Haarlem burgomaster *Nicolaes van der Meer* (Plate 123) and his wife *Cornelia Vooght Claesdr.* (Plate 124) of 1631. Their deep tonalities, dark grey backgrounds and the simplified silhouettes of the figures all strike a new note. Hals had painted Van der Meer once before. He appears as the captain with his arm akimbo seated in the foreground of the 1616 banquet piece (Plate 19). At that date it was already safe to predict that Van der Meer, one of Haarlem's many

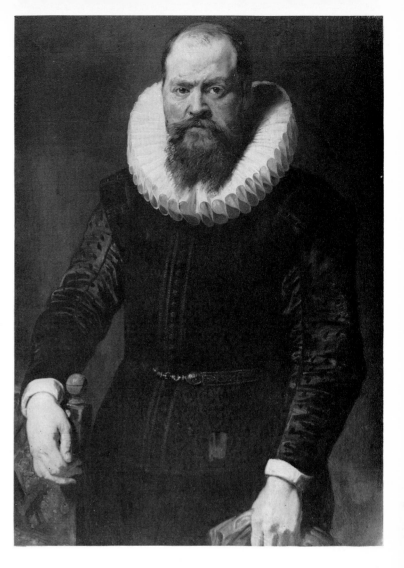

Fig. 109. Anthony van Dyck: *Portrait of a Man*. About 1618.
Brunswick, Herzog-Anton-Ulrich-Museum

brewers, would gain weight as he grew older. Hals made no effort to minimize his girth when he depicted him fifteen years later. In the pendants the artist established a connection between the two models by suggesting that both are in the same room. The wall behind Van der Meer, who stands with his hand resting on the back of a chair, appears to be continued in the companion piece to the corner where his wife is shown seated. This scheme was not novel: it had been used by his predecessors as had the idea of showing a husband standing while his more passive wife remains seated.

There were also precedents for the poses Hals set for the Haarlem burgomaster and his wife. A few years earlier Hals himself had used the casual attitude he gave Van der Meer for his *Portrait of a Man* (Plate 108) now at the Frick Collection. Other artists used the scheme too. Van Dyck had employed it for some of the precocious portraits painted at Antwerp around 1618. In the one now at Brunswick (Fig. 109) Van Dyck concentrated on the head of his model; there the thick application of the heavy paint shows an unmistakable debt to Rubens, but his colours are less luminous than those of the older Flemish painter and his shadows remain more opaque. Within a few years Van Dyck abandoned this type of robust portraiture for an ideal of elegance which gives his patrons an unsurpassed air of impeccable breeding and refinement.

Van Dyck's aristocratic world remained outside Hals' ken. Hals' genius was to endow the less formal, more personal side of man's nature with a new authority. The naturalness of the familiar pose which Hals gave Van der Meer is invigorated by the grand design he made of his huge figure and by an increase in spaciousness and atmospheric effect.

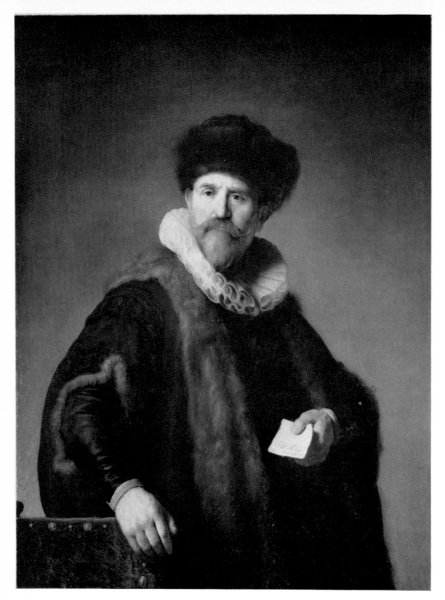

Fig. 110. Rembrandt: *Nicolaes Ruts*. 1631.
New York, The Frick Collection

In 1631, the same year in which Hals portrayed Van der Meer, Rembrandt used the same schema for his life-size portrait of the Amsterdam fur merchant *Nicolaes Ruts* (Fig. 110), one of those first commissioned portraits which were to lead him in this new direction. It is painted with the same cool colour harmonies and refined technique as the precious little subject pictures he made around this time. His scrupulous attention to detail results in a certain loss of dramatic concentration, but strikingly original are the contrasts of light and shadow in the background which appear to fluctuate and give an indication of what he was soon to achieve with richer chiaroscuro effects. The pose Rembrandt used for this early portrait was a well tried one. Was the young master playing it safe? Did he choose to put his new wine in an old bottle, in one of his first essays as a professional portraitist? Or did Nicolaes Ruts specifically ask to be portrayed this way? Although little is known about the transactions between portraitists and their patrons in seventeenth-century Holland we can be certain that there was no pressing demand for novelty.

With the modern demand that art be as new as the front page of this morning's newspaper and the premium placed in our time upon originality, it is natural for us to conclude that a portraitist who repeats a pose betrays laziness, or still worse, a lack of creative power. But this was not always the case. There were periods when painters willingly followed well-established conventions. There is no reason to believe that a Baroque portraitist felt compromised if he allowed a patron to determine how he or she would be portrayed.

114

It is also evident that women were generally more conservative in their tastes than men. The three-quarter-length seated pose which Hals gave *Cornelia Vooght Claesdr.* (Plate 124) was even more familiar than the scheme he employed for her husband. Titian and Moro had created paradigms for female portraits of this type which were frequently used by later sixteenth-century artists. During the first half of the following century the pose became part of the standard repertory of many European portraitists. Hals used variations on it during the thirties and again during the course of the following decades. The portrait he painted in 1639 of *Maritge Vooght Claesdr.* (Plate 207), Cornelia's younger sister, uses the same scheme, except for small changes, that he had used for Cornelia eight years earlier (Plate 124) – perhaps because Maritge Vooght had requested the portrait to be 'just like the one you painted of my sister' – a requirement which would be rare indeed among women of our own time.

But within these stock poses variations are always found; during the course of a career that covered more than half a century Hals never repeated himself. His vivid characterizations, of course, always speak to us first but in some works the hands seem to be as expressive as the heads he painted. For example, Cornelia Vooght's hand holding the bottom edge of her stomacher brings an intimacy to the formal portrait scheme; although we cannot prove it, we sense that here Hals is recording the type of habitual, unconscious gesture which psychologists use to help them determine an individual's personality traits. Cornelia's other hand rests easily on the arm of her chair. In a *Portrait of a Seated Woman* made two years later a similar pose was employed (Plate 135). This woman's hands are as powerful as her massive head (Plate 138); her grip on the arm of her chair is an iron one. The two portraits also show how the intensity of the light that filters through his pictures varies during these years; bright, sparkling sunlight reappears in the 1633 portrait. Our age, which has learned to appreciate the qualities of expressionistic and abstract painting, can take special delight in the way Hals used his bold technique to vary and enliven large expanses of black clothing during this phase. The well preserved 1635 *Portrait of a Seated Woman* (Plate 172; Frick Collection, New York), yet another work which uses the same pose, makes one regret that this lady did not commission a full length so that even more of the wizardry of Hals' touch could be seen. But it is dead wrong to isolate such passages and consider them antecedents of abstract painting. His animated brushwork gives pictorial movement to the surface of his pictures, but it is always related to the expression of specific forms in space.

The pendants of *Tieleman Roosterman* (Plate 154) and his wife *Catherina Brugman* (Plate 155) painted in 1634, appear to personify the *nouveaux riches* of the period. Roosterman and Willem van Heythuyzen, who posed for Hals' unique life-size, full-length (Plate 56), were friends; Van Heythuyzen named Roosterman one of the executors of the testament he made on September 13, 1639. Both men evidently had strong convictions about their own importance, and Hals served both of them well. His knee-length of Roosterman is almost as impressive as the much better known full-length of Heythuyzen, which was painted about a decade earlier. The expression of Roosterman's cocksureness is more direct and has been achieved with simpler means. All the Baroque trappings of the earlier work have been eliminated, and we are confronted only by the

man and his decorative coat-of-arms. His face has been thrown into strong relief, so that we can study his small, puffy eyes, bulbous nose, rakish moustache and the soft underside of his chin as thoroughly as he appears to appraise us. In his young wife's portrait, clothes rather than a personality are on parade. Millstone ruffs were seldom larger than the one she wears, and she is dressed – or overdressed – in rich clothing that combines the uttermost limits of the fashionable costume of earlier decades (the large lace cuffs, the décolletage edged with an elaborate border of lace) and the more simplified and restrained costume which was already à la mode.

The companion portraits of *Lucas de Clercq* (Plate 169) and his wife *Feyntje van Steenkiste* (Plate 170), painted only a year after the ostentatious Roosterman couple, are beautiful examples of the modest grandeur Hals achieved when he depicted his models dressed in the simple regent costume. Black now predominates in both portraits and there are only a few, restrained colour accents. The woman's portrait shows the artist's new tendency to simplify forms while that of her husband reveals that the artist's urge to create movement with emphatic diagonals was not completely suppressed. However, the jagged contours of De Clercq's figure have been subdued by the deep ochre shadows behind him, which are close in value to his great black cape and trousers. We have seen that sober black clothes were worn in the Netherlands long before these portraits were painted in 1635, but until this time gaily coloured accessories were frequent and young people often wore bright colours. The decision whether to wear black or something gayer was regulated by age, by temperament, and sometimes by religion. Around 1625 Jan Jansz. Starter wrote in his poem *The Mennonite Courtship* (*Mennistenvrijagie*) that his sweetheart frowned upon his fashionable dress:

> But when she looked at me, it was to be displeased;
> My hair was far too long, and far too wild my ruff,
> My cuffs were far too large, the starching was too blue,
> My trousers baggy, wide, my jerkin far too tight,
> Too long my garters were, and roses on my shoes.
> In short it would be a sin to kiss this worldly man. . . .

This appraisal of the impression he made prompted the poet to change his clothes and mien:

> It was not long before I came to her once more,
> Entirely changed in speech, in manners, and in dress.
> My coat was plain and black, and all my hair cut short,
> My ruff, now starched white, was flat, just as a board,
> And on my whole attire no tassel to be seen.

Soon high fashion as well as love began to dictate black as the colour for clothes, and by the end of the thirties it was *de rigueur* among the classes which formed the majority of Hals' clientele.

The half-lengths and bust portraits made during the decade are not as restrained as the larger commissioned works of the period. The model for the *Portrait of a Man* painted in 1633 (Plate 148; London, National Gallery) turns as if caught in an unguarded moment; the diagonal

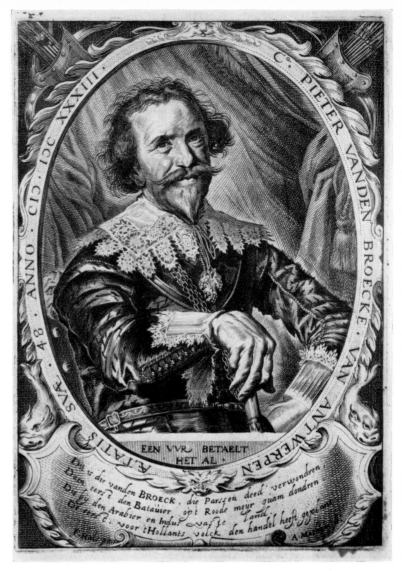

Fig. 111. Adriaen Matham: Engraving after
Hals' *Pieter van den Broecke* (Plate 136). 1633

arrangement of his figure and the light tonality of the work make it a postscript to the banquet
pieces of the 'twenties rather than a forerunner of what was to come. Remarkable is the intense
plein-air effect and the way Hals allowed the folds of the white ruff to dissolve in bright light. More
complex spatial arrangements and pronounced foreshortening were used to enliven *Pieter van
den Broecke*, also done about 1633 (Plate 136; London, The Iveagh Bequest, Kenwood House),
and the *Portrait of an Officer* (Plate 130; São Paulo, Museum). The sturdy, stern model for the
latter work remains unidentified, but quite a bit is known about Van den Broecke. He had a long,
successful career as a trader, first in West Africa, and later with the Dutch East India Company in
Arabia, Persia and India. The journal of his stay in West Africa, published in 1634, reveals a
vigorous, straight-forward and self-confident man; it confirms the visual impression Hals gave
us of him. Van den Broecke was also admiral of the fleet which brought the widow of Jan
Pietersz. Coen, the principal founder of the Dutch empire in the east, back to Holland from
India in 1630. Upon his return Van den Broecke was rewarded by the Dutch East India Company
with a gold chain worth 1200 guilders. Hals portrayed him wearing this chain; and an engraving
by Adriaen Matham after the portrait, which is embellished with an oval frame bearing appro-
priate symbols and a back-cloth (Fig. 111), served as the frontispiece of his *Journal*.

Equally lively and sparkling are the half-length pendants of *Nicolaes Hasselaer* and his wife
Sara van Diemen (Plates 143–6; Rijksmuseum, Amsterdam), which can be dated in the first half
of the 'thirties. Their fresh, economical treatment recalls the free touch of Hals' genre pictures,

117

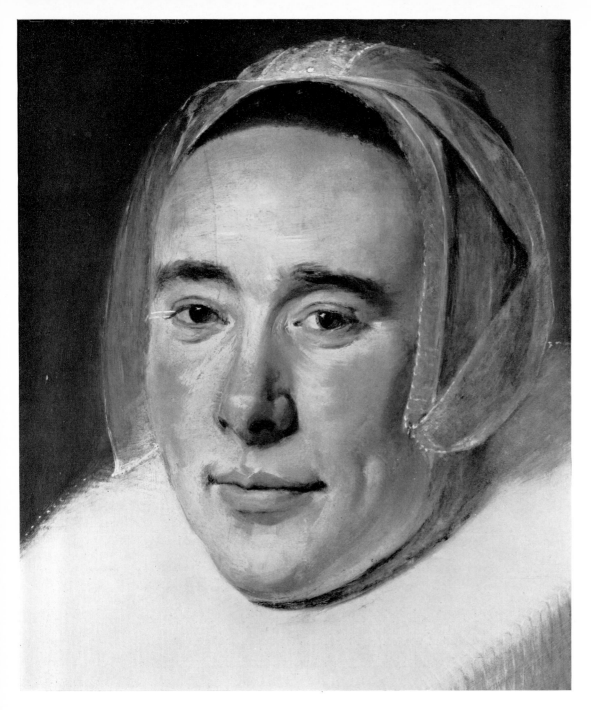

Fig. 112. Judith Leyster: Detail of *Portrait of a Woman*. 1635. Haarlem, Frans Hals Museum

yet apparently enough attention was paid to the details of their rich apparel to satisfy the demand for a rendering of stuffs as well as faces. In the portrait of the woman Hals demonstrates his ability to transcribe intricate lace and embroidery without being hard or trivial, while his exquisite colouristic refinement is evident in the contrast he sets up between the warm flesh tones and the pale-green embroidery of her dress and grey lining of the sleeves. More impulsive touches were used for the portrait of the husband, where the large cuffs and belt have been suggested with only a few decisive strokes. If we remember the scrupulous attention to minute detail in portraits made by other artists of the period, it may seem astonishing that Hasselaer did not insist that some passages be made less abbreviated. But judging from the painting, he did not. His portrait is one of many which testify that the brilliant effects Hals achieved with his original technique did not go unappreciated during his lifetime. Granted, virtually nothing was written about them, but their success made itself felt in a more concrete way: people commissioned his works. Even pro-

118

Fig. 113. Detail of *Portrait of a Woman* (Plate 159). 1634. Detroit, The Detroit Institute of Arts

fessional calligraphers, whose instincts one imagines would send them to a finer finisher than Hals was, sat to him.

It is more difficult to understand why so few Dutch painters of the time were inspired by his pictorial innovations. One of the few artists who made a serious effort to use them was Judith Leyster. In her small *Portrait of a Woman* of 1635, now at the Frans Hals Museum, Haarlem, she comes very near to the master, yet when the head of this sitter (Fig. 112) is juxtaposed with one painted by Hals in 1634 (Fig. 113) it becomes apparent that even at her most Halsian she misses his full sculptural roundness and fluent touch. Not more than a nodding acquaintance with Hals' brushwork is needed to conclude that the cap she painted lacks the convincing suggestiveness of his own works. However, Judith Leyster proved to be a fickle follower. Not long after she painted this portrait she gave up imitating him. But at least she had dared try. Not many others did. Perhaps they were more prudent. Copies of his works by later artists as great as Courbet or as

clever and facile as John Singer Sargent show that neither the sureness nor the refinement Hals achieved with his original technique came easily to many painters.

The assignment to paint Nicolaes Hasselaer and his wife (Plates 143, 144) is further testimony to the considerable reputation the artist enjoyed during the decade. Hasselaer was a well-to-do Amsterdam brewer who belonged to the ruling class; he was a regent of the city's orphanage and served as a Captain Major of the troops. Perhaps the pendants were painted when Hals visited the city in 1633. Like so many Dutchmen of the period, Hasselaer also knew the world beyond the borders of the Netherlands; he served as a member of a diplomatic mission to Moscow. We have seen that in 1626 Hals painted Isaac Massa (Plate 64), who acquired a more intimate knowledge of Russia, in a pose similar to the candid one he gave Hasselaer. Possibly a man willing to risk the arduous trip to Moscow was more inclined than others to be shown in such an unorthodox fashion. In any event, the portraits of Hasselaer and his wife are the earliest known pendants in which the husband is shown informally seated; his arm is resting on the back of a chair. Hals' brilliant innovation heightens the impression of immediacy while subtly but firmly linking the companion pieces. It seems as if the seated husband and wife were turned toward each other when the beholder suddenly caught their attention. Each of them now looks at the person whose presence has just been discovered. When the pendants are viewed separately the relationship Hals established between the two is destroyed. Indeed, without her husband it is impossible to tell if Sara van Diemen is seated or standing; Hals gave no indication of her chair. However, when she is seen with her husband, the question does not even arise; since Hasselaer is shown seated and their heads are on the same level the artist knew he could eliminate this small clue. Here he was as suggestive and economical in establishing a relationship between portraits of a husband and wife as he was with his brushwork.

The half-length companion pieces (Plates 150, 151) now at Berlin-Dahlem, which can be dated around the same time as the Hasselaer portraits, have been effectively linked in a more traditional manner. Turned toward each other, they almost make mirror images, though here as elsewhere the movement of the hands, the flow of light, and the contours of the silhouette are more active in the male portrait than in the pendant. A close view of their faces (Plates 152, 153) convinces us that he records with sincerity. Yet human warmth and sympathy are not missing, and unlike most portrait specialists of his age, Hals' portrayals of women are always as interesting as those he made of men. Close and frequent scrutiny of women seemed to deepen his understanding of them, and as he grew older his power to characterize them increased.

A few of Hals' small porthole portraits can be dated into the first half of the decade, and at least seven life-size ones were made from around 1635 to 1640. Amongst the finest of the latter are the pendants dated 1638 now in the collection of His Majesty the King of Sweden (Plates 182, 183). As in others made during these years, the sitters have been placed well behind their simulated stone frames. They appeal to us by their expression and bearing, not by extending a hand beyond the painted frame, a device used in earlier portraits to heighten the illusionistic effect. The man may not be as attractive as his friendly wife, but Hofstede de Groot went too far when he

Pieter van den Broecke. About 1633. Detail from Plate 136. London, Kenwood House, Iveagh Bequest

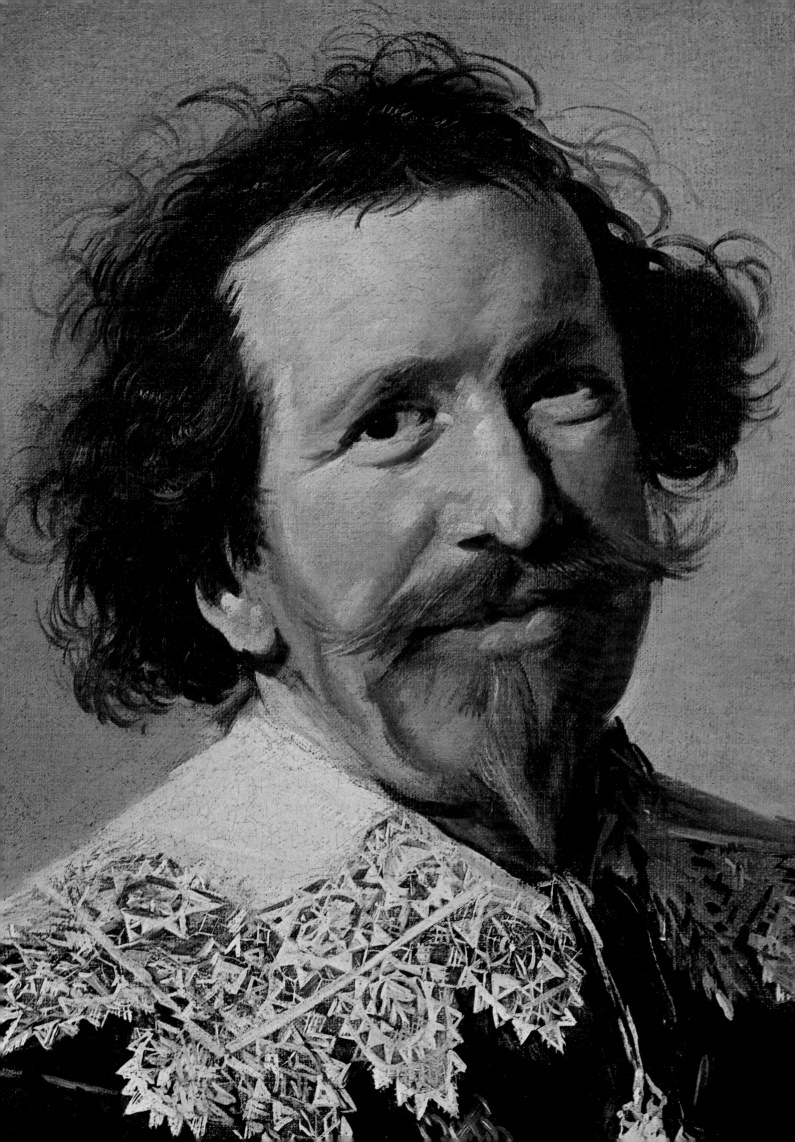

described him as somewhat humpbacked and tubercular. What was read as a physical deformity is, in fact, part of his costume, and his sickly appearance disappeared when a layer of old, discoloured varnish was stripped from the surface of the picture.

How and when these portraits came into the possession of the Swedish royal family has not been determined. The earliest reference to them is found in the 1849 inventory of Oscar I, a king who never earned a reputation as a great art collector. With the exception of those purchased for the stupendous collection formed by Catherine the Great, few pictures by Hals found their way into royal houses. Portraits of Dutch burghers were hardly subjects to fascinate foreign sovereigns. As far as we know, not a single painting by Hals ever entered a collection in southern Europe, where a classical as well as a Catholic bias made it difficult to find much to admire in portraits or genre pictures painted by a seventeenth-century Dutchman. Even today there is not a single painting by Frans Hals in Italy or Spain, and it is necessary to travel to Cape Town to find a work by Hals south of Lugano.

The portrait of a formidable woman (Plates 209, 210; Musée des Beaux-Arts, Ghent), dated 1640, and (if we can trust the engraving made after it in the same year) the lost portrait of the calligrapher *Theodore Blevet* (Fig. 124) are the latest known ones by Hals which employ painted stone frames. After that date the artist presented his sitters without placing a wall between them and the beholder. The mature painter lost interest in such *trompe-l'oeil* tricks, while his younger contemporaries not only continued to use them but also adopted the more naturalistic device of placing their models behind simulated open windows and half-open Dutch doors. Rembrandt found such props helpful. In 1708 a connoisseur as discerning as Roger de Piles praised Rembrandt's painting of a *Girl at a Window* because it deceived passers-by when it was exhibited in a real window. Whether Rembrandt's painting – or any other – ever really deceived pedestrians is debatable; however, there is no doubt, that Dutch artists of the time and their patrons were fascinated by *trompe-l'oeil* effects. People bombarded, as we have been since early childhood, with countless reproductions of the three-dimensional world on a two-dimensional surface find it hard to imagine the impact of this kind of illusionism on earlier beholders, but Jacob Houbraken's eighteenth-century engraving of Captain Cocq (Fig. 114), the principal figure of Rembrandt's *Night Watch*, hints at what they found fascinating. Houbraken made a faithful copy of Captain Cocq's bust and outstretched arm, and added a simulated frame. Indeed, the Captain's lively gesture, which plays such a crucial part in the complex spatial organization of Rembrandt's most famous picture, might have been made to order for an engraver who wanted to exploit a gesture often used with make-believe frames. Rembrandt, himself, was not one to overlook the illusionistic possibilities of Cocq's outstretched arm; he made it cast a dramatic shadow across the canary-yellow uniform of his Lieutenant, who appears to stride out of the group portrait with him (Fig. 115). The print-maker did not fail to add the shadow Cocq's hand casts upon the frame he engraved.

Rembrandt used simulated frames for some of his portrait etchings, and he continued to use the device after it had been abandoned by Hals. His portrait of *Jan Cornelis Sylvius* (Fig. 116) of

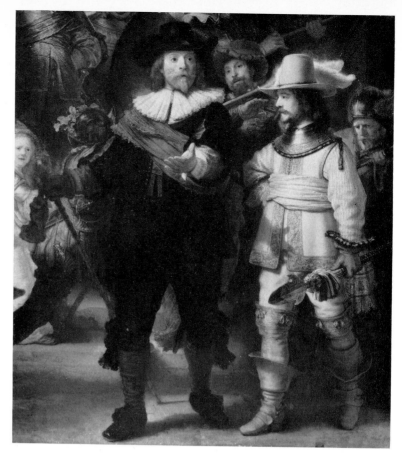

Fig. 114. Jacob Houbraken: Engraving of
Frans Banning Cocq. After Rembrandt

Fig. 115. Rembrandt: *The Night Watch*, detail of Captain Cocq and Lieutenant
Willem van Ruytenburch. 1642. Amsterdam, Rijksmuseum

1646 shows the preacher with his hand poked beyond the frame in a manner that recalls a small portrait Hals had painted twenty years earlier (Plate 82). A preliminary sketch for the etching indicates that Rembrandt had considered portraying the preacher behind the simulated wall but he probably decided that his etching of the dead preacher would look more life-like if additional *trompe-l'oeil* effects were used.

Portraits in simulated frames had a future as well as a lengthy past. Eighteenth- and nineteenth-century portraitists used them as did pioneer photographers who tried to make their works look like paintings by putting their subjects behind elaborate frames similar to those used by earlier artists. The photograph made around 1860 of the French man of letters Isidore Taylor shows him with his hand resting upon a swatch of drapery which has been swung out from behind the frame (Fig. 117). The photographer used props to show his patron's many interests, but he apparently had nothing on hand to indicate that Taylor had also organized the expedition which brought the obelisk of Luxor to Paris. Today the porthole frame is still used by photographers in amusement parks around the world and by a few other artists still able to arrest the attention of men with a *trompe-l'oeil* effect (Fig. 118).

Perhaps Hals gave up painting simulated frames during the last half of his career because he felt that they decreased rather than enhanced the directness of his portraits. Stripped of the oval peep-hole, the man traditionally identified as Pieter Tjarck (Plates 176, 177; Estate of Sir Harry Oakes, Nassau, Bahamas) would look not less but more natural and casual than he does now as he sits turned in his chair with a rose – probably an emblem of love or *vanitas* – dangling in his hand. And in his portraits of *Claes Duyst van Voorhout* (Plates 195, 197; Metropolitan Museum of Art.) painted around 1638, and *Pieter Jacobsz. Olycan* (Plates 206, 208; Ringling Museum of Art.

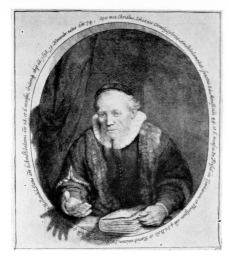

Fig. 116. Rembrandt: *Jan Cornelis Sylvius*. 1646. Etching

Fig. 117. Photograph of Isidore Taylor. Nineteenth century

Fig. 118. Cover of *Esquire*

Sarasota, Florida) of 1639, he convinces us that we are confronted by men who never could be contained by sham walls.

The portrait of *Van Voorhout* (Plates 195, 197) is another outstanding example of Hals' dazzling characterizations of the confidence and pride we associate with the men who helped make the United Provinces the leading nation in Europe. Van Voorhout was not, however, a statesman or empire-builder; he was yet another brewer who posed for Hals. He owned the Swan Brewery at Haarlem, and the size of his stomach suggests he consumed considerable quantities of the beverage he made. The Baroque element prominent in the 'twenties is still present in the pronounced diagonals and strong foreshortening of his tremendous figure, but the contours have been simplified and the colour harmony has become more restricted. Audacious highlights and shadows as well as sensitive gradations of tone suggest the sheen and reflections of light on his grey satin jacket while an increase in the range of values, from a deep dark to a light grey in the background, introduces a subdued atmospheric effect.

In the imposing three-quarter length of *Pieter Olycan* (Plate 206) the tonality is even darker and the brushwork broader and more spontaneous. The most intense light concentrates on his snow-white head and ruff, creating a major focus (Plate 208), and Hals uses his suggestive touch not merely in a few selected passages, as he had done in earlier commissioned portraits, but here it is found everywhere. Both the incisive characterization of the model and the summary technique anticipate works of the following decades. On the other hand, the seated portrait of his wife *Maritge Vooght* (Plate 207), as we have seen, is more conventional in conception and the execution is not nearly as free. Pieter Olycan was one of Hals' more eminent patrons. He served as a burgomaster of Haarlem and was a member of the States-General, the body which represented the United Provinces in foreign affairs. Hals' portrait suggests that Pieter Olycan could also have held another high office. Even when dressed as a proper Dutch burgher, it is easy to imagine him as the god of the north wind; Hals' likeness conveys more unrestrained energy than most representations of Boreas done by Baroque artists whose bread and butter work was painting gods.

Hals was a favourite portraitist of the Olycan family. Earlier he had received commissions to paint the children of Pieter and Maritge Olycan. In 1625 he had portrayed their son *Jacob Pietersz. Olycan* and his wife *Aletta Hanemans* (Plates 58, 59), and he made pendants of their daughter *Maria Olycan Pietersdr.* and her husband *Andries van der Horn* (Plates 189, 188) in 1638, the year of their marriage. We have already heard that the sister and brother-in-law of Maritge posed for

123

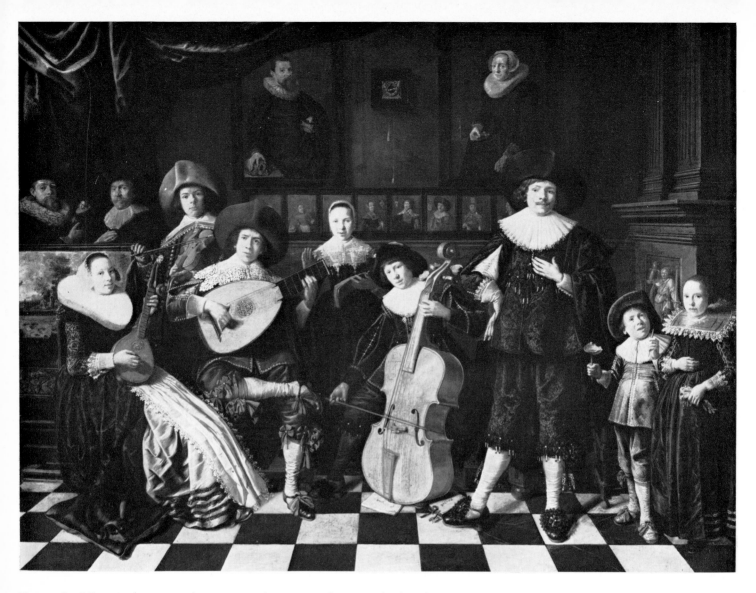

Fig. 119. Jan Miense Molenaer: *Family Portrait*. Haarlem. Frans Hals Museum (on loan from Dienst voor 's Rijks Verspreide Kunstvoorwerpen)

him in 1631 (Plate 124, 123). Their son Jacob Pietersz. also appears as an officer in the St. George banquet piece of 1627 and another son, Nicolaes Pietersz., as well as their future son-in-law Andries van der Horn, are in the St. Hadrian group portrait of 1633. In all Hals painted nine members of this well-known family and two of them were portrayed twice.

Except for the two spirited little portraits now at Dresden (Plates 141, 142) and one at The Hague (Plate 140), all the existing small male bust and half-length portraits made during the 1630s served as modellos for contemporary engravings. The Dresden and The Hague panels, which are identical in size and alike in treatment, can be dated around 1633. Individual character-istics have been carefully observed, yet the men appear to share the same thoughts and feelings; they seem to belong together. Perhaps Valentiner was right when he suggested that they were preparatory studies for an unfinished collective portrait, but we have already noted that it is extraordinary that three preliminary studies for an unidentified group portrait are known while not a single one has been discovered for any of the scores of men portrayed in his existing militia or regent pieces. It is also possible that the three panels were part of a series of small portraits similar to the set hanging in the imaginary interior that serves as a setting for Jan Miense Mole-naer's family portrait (Fig. 119). Around this time nothing about their technique would have made them unacceptable as finished portraits to Hals' patrons, who did not expect the enamel-like surface other artists gave their small pictures. Criticism of the broad technique he used for

124

Fig. 120. Adriaen Matham: Engraving after
Hals' lost *Portrait of Pieter Bor*. 1634

such works came only later. When Goethe saw the little Dresden pictures on a visit to the gallery in 1794 he recognized their high quality but thought they were unfinished. He jotted down in his catalogue: 'Schöne kleine Bilder, aber nur untermalt.'

Samuel Ampzing, the preacher and historian who commended Hals' bold handling in his poem on Haarlem published in 1628, commissioned the artist to paint a little portrait of him around 1630 (Plate 139). Painted on copper, it is one of Hals' smallest; it measures only about $6\frac{1}{2}$ by $4\frac{1}{2}$ inches. Soon after it was completed Jonas Suyderhoef made an engraving after it which is more than twice the size of the original; the portrait was also engraved by Jan van de Velde. Ampzing appears with his face dramatically lit and his fiery eyes fixed upon the beholder. He holds a book, the ubiquitous prop of theologians and scholars in Renaissance and Baroque portraits. Hals had equipped earlier sitters with volumes. Schrevelius, painted in 1617, displays his like a symbol (Plate 23). Ampzing, however, has his forefinger inserted in the volume, suggesting that he has stopped reading and is marking the page with his finger for a moment to look at us. Other small pictures made around this time were also enlivened by convincing portrayals of momentary action. A small porthole portrait of the historian Pieter Bor made in 1634 showed him with pen in hand, ready to write. The portrait was destroyed in the disastrous fire at the Boymans Museum at Rotterdam in 1864, but a fine engraving after it by Adriaen Matham (Fig. 120) gives us a good idea of the work. Even if Thoré-Bürger had not published a description of it in 1860 we would know from the print that Bor's beard and moustache were completely white and that his costume was black figured silk. Thoré-Bürger had high praise for the portrait: 'Everything about it shows ingenuity, knowledge, freedom and spirit.' The astute connoisseur of Dutch painting added: 'Brouwer caught these aspects of his master – or almost caught them – and it was from Brouwer that Teniers acquired his lauded touch. But how thin Teniers is compared to Brouwer, who is himself less solid than Frans Hals! And most unexpected! This small portrait is reminiscent of Watteau, that delicious painter, so subtle in his handling, so ingeniously right with his accents of light, the most authentic painter of the French school.'

125

Fig. 121. Adriaen Matham: Engraving after Hals'
Portrait of Isaac Abrahamsz. Massa (Plate 168). 1635

Fig. 122. Jonas Suyderhoef: Engraving after Hals' lost
Portrait of Casparus Sibelius, 1637

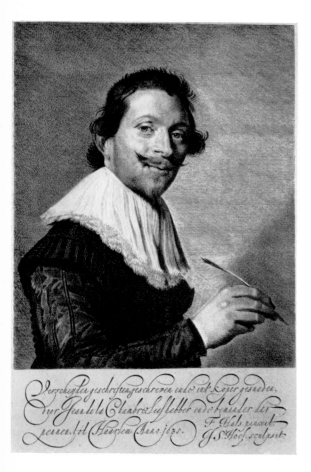

Fig. 123. Jonas Suyderhoef: Engraving after Hals'
Jean de la Chambre (Plate 194). 1638

Fig. 124. Theodor Matham: Engraving after Hals' lost
Portrait of Theodore Blevet. 1640

In 1635 Hals made a small portrait of *Isaac Massa* (Plate 168), the Dutch merchant, explorer and cartographer he had already portrayed in 1626 (Plate 64). The intense colour and value contrasts of the earlier work are replaced here by a more monochromatic effect. His suit is now a fine silvery grey enriched by the light blue of his sash and white accessories, while the warm, dark brown neutral background creates a delicate airy effect. When Adriaen Matham made an engraving of the portrait, he replaced Hals' neutral background with swathes of drapery (Fig. 121). The engraver's garnish dissipates some of the concentrated informality of Hals' portrayal of Massa, who appears before us with his head slightly cocked, his lips parted, and his hand outstretched as if speaking directly to the beholder. Casparus Sibelius, a Deventer preacher (Fig. 122), was also painted in small as if addressing an auditor. His daughter was married in Bloemendaal, a town near Haarlem, in January 1637, and the portrait, painted in the same year, was probably made on the occasion of Sibelius' visit to the neighbourhood. Jonas Suyderhoef engraved an enlarged copy of the portrait in 1637; his print, a few old copies of it and some rare photographs of a version which was destroyed by fire in 1956 are the only records we have of the lively portrait.

The small painting of the calligrapher and French teacher *Jean de la Chambre*, dated 1638 (Plate 194), was engraved by Jonas Suyderhoef and used as the frontispiece for a volume of engraved specimens of his fine hand published at Haarlem in the same year. Suyderhoef's print (Fig. 123) is a faithful copy and is one of the rare contemporary engravings which do not reverse Hals' original. Normally printmakers who copied his portraits did not trouble to engrave them in reverse, and hence produced a mirror image of the painting. Thus when a modello ascribed to Hals and a seventeenth-century print after it are in the same direction, the question arises: is the small painting a copy by another hand after the print? Here the firm modelling, which gives De la Chambre's head the sculptural roundness of a carved portrait, the fine gradations and lively accents as well as the subtle colour harmonies convince us that the little panel is by Frans Hals. Then why is the print not in reverse? Jean de la Chambre probably asked for an engraving showing him precisely the way Hals had painted him; with his pen in his right, not his left, hand. If Hals' lost portrait of the calligrapher Theodore Blevet is ever found there is a good chance that it too will reveal that the engraving Theodor Matham made after it in 1640 (Fig. 124) is not a mirror image of the original. The skillful engravers who made reproductions after Hals' portraits could cope without much difficulty with the problem of reversal, which he occasionally posed for them.

Rembrandt, who did not always worry whether his prints reversed his preparatory studies for them, made certain that his two etched portraits of the calligrapher Lieven van Coppenol showed this well-known writing master with his pen in his right hand (Figs. 125, 126). Coppenol also commissioned Cornelis Visscher to engrave his portrait and Artus Quellin, the leading sculptor of the Low Countries, to make a half-length marble bust. It would be nice to be able to report that his fine feeling for art led him to commission these important works, but that was not the case. By that time Coppenol was mentally deranged and his illness expressed itself in a kind

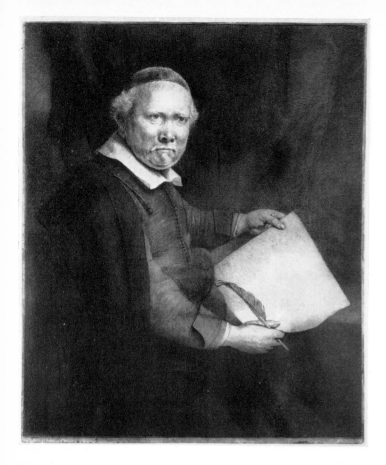

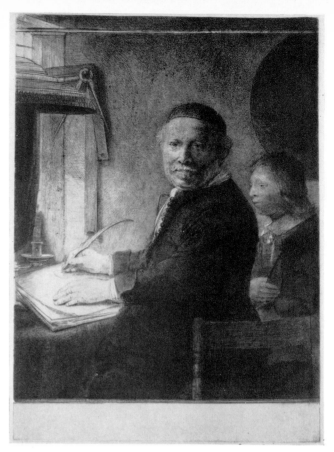

Fig. 125. Rembrandt: *Lieven Willemsz. van Coppenol*; the larger plate. Etching

Fig. 126. Rembrandt: *Lieven Willemsz. van Coppenol*; the smaller plate. Etching

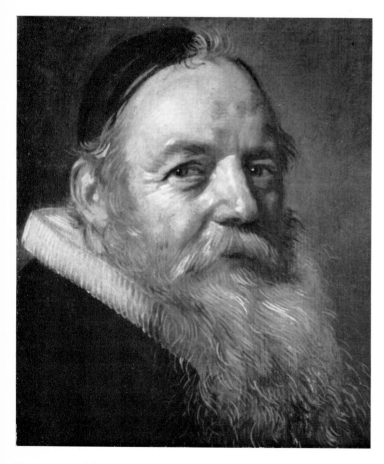

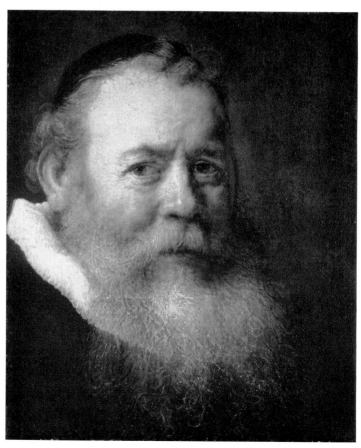

Fig. 127. Detail from *Hendrick Swalmius* (Plate 204). 1639. Detroit, Detroit Institute of Arts

Fig. 128. Rembrandt: *Eleazar Swalmius*. 1637. Detail from Fig. 129

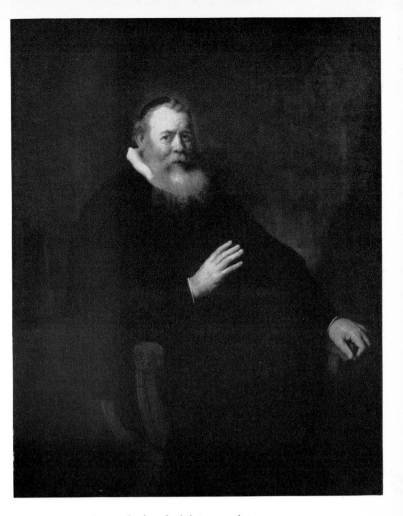

Fig. 129. Rembrandt: *Eleazar Swalmius*. 1637.
Antwerp, Musée Royal des Beaux-Arts

of egomania which, it seems, compelled him to have portraits made and also led him to hire poets to compose verses praising his calligraphy as well as his face. He spent the last years of his life insane. In 1657, around the time his passion for portraits of himself was at its height, he lived in Haarlem and therefore could have commissioned a work from Hals. But apparently the pathetic man did not take advantage of the opportunity; had he done so he would have enabled us to see how Holland's two greatest portraitists represented the same subject.

Today we do not know any works by Hals and Rembrandt which can unequivocally be said to represent the same model. In my view none of the attempts to identify paintings by the older master as likenesses of Dr. Nicolaes Tulp (Plate 242), Jan Asselyn (Plate 304) or Jan van de Cappelle (Plate 311), who were also portrayed by Rembrandt, is entirely convincing. The suggestion that Hals' *Portrait of a Painter* (Plate 288; Frick Collection, New York) is a portrait of Rembrandt can be rejected. However, a telling juxtaposition can be made of paintings done in the 'thirties by each artist of patrons who have been identified as brothers. Their resemblance is so close that one is inclined to think that they were identical twins or that they actually represent the same model (Figs. 127, 128).

The one by Rembrandt, painted in 1637, is said to be a portrait of the Amsterdam preacher Eleazar Swalmius, while the sitter in Hals' portrait, done two years later, has been identified as his brother Hendrick Swalmius, a minister at Haarlem. To be sure, there is a significant difference in scale between the two works. A total view of the Rembrandt (Fig. 129), which already reveals the younger painter's supreme ability to subordinate all but the salient features of his composition to the general chiaroscuro effect, shows a life-size commissioned portrait; it demands a large wall in a grand room. Hals' little half-length, on the other hand, was painted as an engraver's modello and is best seen at close range, the way one looks at prints or drawings (Plate 204).

Fig. 130. Chair, Dutch, first half of the seventeenth century.
Amsterdam, Rijksmuseum

In spite of these dissimilarities, a comparison shows the characteristics of each artist's pictorial treatment; during this phase, whether they painted on a large or a small scale there was no fundamental difference in their techniques. At first glance it is striking how alike the schemes for representing three-quarter views of heads are and how closely the general disposition of the light and dark areas which model the forms correspond. Clearly there were conventions which even the towering portraitists of the period followed. But more remarkable is the way each artist put his unmistakable stamp upon these schemes. In the Hals there is an obvious delight in the effects achieved by spontaneous brushwork. Shifts in the value of the distinct touches express the variety of surfaces and textures and the vibrating quality of light. Rembrandt's light has quite another quality. He made it softer and more subdued by fusing his strokes and using gradual, almost imperceptible, changes in tone. His forms are more generalized and the range of value from the light to the dark areas on his model's head is narrower. Sparkling highlights have been virtually eliminated and delicate half-tones make the shadows more transparent. When compared to the Hals, there is a loss of brilliance in the surface treatment, but a subtle gain in the interpenetration of the intangible elements of light and shadow enveloping his model.

Hals' most remarkable small portrait of the decade is that of Willem van Heythuyzen (Plate 198; Musée Royal des Beaux-Arts, Brussels), where his love for representing the momentary is successfully combined with the model's nonchalant attitude. Movement is expressed by the pronounced diagonal composition, the swift brushwork, the flickering light as well as by the precarious balance of the tipped-back chair. The interior has been effectively subordinated to the figure; only the chair is shown in some detail – enough to see its striking similarity to one of the same type now at the Rijksmuseum in Amsterdam (Fig. 130). This is the man whom Hals had depicted more than a decade earlier proudly standing in a formal pose as large as life (Plate 56), but now neither his rather quizzical expression (Plate 196) nor his attitude are designed for public

130

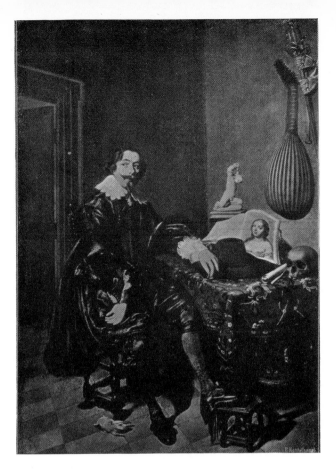

Fig. 131. Thomas de Keyser and David Bailly: *David Bailly*. About 1627. Formerly Paris, Madame E. Stern

Fig. 132. Dirck Hals: *Seated Man*. Paris, Collection F. Lugt

encounters. The smaller scale permitted a lessening of formality. One can believe that only intimate friends saw Heythuyzen in this unbuttoned mood. He is shown in the kind of pose which the late sixteenth-century Italian theorist Giovanni Paolo Lomazzo advised portraitists not to use when they portrayed honourable personages of high rank. According to Lomazzo, to suffer an eminent model 'to put one knee upon the other or to cross his legs' was as bad as to show him 'standing picking his ears.' It is nice to think that Lomazzo would have annulled – or at least amended – his rule if he had lived to see what a Haarlem painter could do when he broke it.

Although there is no precedent for the fresh, transitory effect achieved here by Hals, charming little portraits of full-length standing or seated figures had made their appearance in the new Republic before Hals painted this one in the late 1630s. The Amsterdam artists Thomas de Keyser and Pieter Codde had begun to make highly finished ones around 1625; others soon followed suit. These portraits were not merely reduced versions of traditional life-size commissioned works. They took on a new genre-like character, apparently derived from the small gallant company scenes then in vogue. As portrayed in little by Thomas de Keyser around 1627, the Leiden painter *David Bailly* (Fig. 131) would be perfectly at home in one of Dirck Hals' little pictures of swaggering gallants, although it is doubtful whether Dirck's elegant crowds would have been delighted with the conspicuous *vanitas* symbol included in the portrait (the still life was painted by Bailly, not De Keyser). Dirck Hals painted similar figures in compositions he made around the same time, and one of his most spirited works is the fresh oil study of a relaxed seated man (Fig. 132), now in the Frits Lugt Collection, Paris. In this sketch Dirck surpasses himself in boldness and spontaneity. More characteristic of him are the minuscule touches that seem to be stitched rather than painted in the violinist seated in a tilted-back chair (Fig. 133), who appears in a merry company scene done in the 'twenties. Probably Dirck's unusually vigorous

Fig. 133. Dirck Hals: Detail from *Merry Company on a Terrace*. Rotterdam, L. A. A. van der Heijden.

Fig. 134. Jan Miense Molenaer: *Seated Man Smoking*. Budapest, Museum of Fine Arts

sketch in the Lugt Collection was inspired by his older brother's studies of the same type, and it is possible that pictures by other genre painters of Frans Hals' circle, such as Jan Miense Molenaer's *Smoker* (Fig. 134; Museum of Fine Arts, Budapest), ultimately derive also from prototypes created by Frans Hals. If this hypothesis is correct, Hals did not turn to earlier small portraits by his contemporaries for inspiration when he painted his intimate portrait of Heythuyzen around 1638, but was himself one of the pioneers of this category of portraiture.

Thomas Keyser, Pieter Codde and Jan Miense Molenaer also helped popularize small-scale family portraits in the 1630s. Rembrandt once tried his hand at this type of portraiture when he painted the *Portrait of a Married Couple* in 1633 (Bredius 405) shortly after he had settled in Amsterdam. Only one by Hals is known to us: his *Family Group* of about 1635 (Plates 164-7; Cincinnati Art Museum, Cincinnati, Ohio). During the following decades other Dutch artists occasionally made little pictures of a group informally gathered in what appears to be a familiar setting, among them Gerard Terborch, Adriaen van Ostade, Jan Steen, Pieter de Hooch and Gabriel Metsu as well as artists of lesser stature. These small collective portraits are the fore-runners of the 'conversation pieces' which enjoyed such a great vogue in Holland and England during the eighteenth century.

Hals' little family portrait is principally unified by the sharp diagonal organization of the group, which has been placed well in the foreground, and by the dominant black of their costumes, re-lieved only by the warm brown dress worn by the youngest child. Their contagious smiles also establish a kind of inner bond between them. Not easily forgotten is the joyous relationship between the two girls who clasp hands (Fig. 135). Once again one is reminded of Dirck Hals' genre pictures such as his little painting of *Two Girls with a Cat* (Fig. 136), which was painted

132

Fig. 135. Detail from *Family Portrait* (Plate 164). About 1635. Cincinnati, Cincinnati Art Museum

Fig. 136. Dirck Hals: *Two Girls Playing with a Cat.* Williamstown, Sterling and Francine Clark Art Institute

around the same time as the Cincinnati Family Portrait and which shows Dirck at his best. A juxtaposition reveals the difference between their techniques. Frans' convincing roundness without loss of vivacity of touch, which is particularly apparent in the drapery, was never matched by Dirck. Dirck at his best plays Lancret to Hals' Watteau.

The imaginary background behind Hals' unidentified family group combines a view of an interior with a vista of a garden and a stately house. The straightback chair is a familiar one, but the *roemer* and lemon on the table covered with a turkey carpet are unusual in Hals' *oeuvre*; it is one of his rare still lifes. By Hals' standards, the two chairs and the miniature still life were a lengthy description of the things people live with. He also painted the large swatch of drapery; here, however, he may have stopped. The large structure in the middle ground (was it meant to represent part of a triumphal arch?) and the view beyond it seem to have been done by another hand. The short, thinly painted strokes of the foliage recall the landscapes Pieter Molyn made around this time. If he did paint these parts of the picture, it was neither the first nor the last time Molyn collaborated with Hals. As we have seen, the northern landscape in the 1626 portrait of *Isaac Massa* (Plate 64) can be attributed to him, and in my opinion the prominent landscapes in Hals' two large family portraits of the late 'forties (Plates 272, 279) were also painted by Molyn.

A few of the commonplace symbolic allusions that appear in some of the master's other works are found in this conversation piece. The vines clinging to the cracked edifice in the middle ground allude to steadfast love. The reference is an appropriate one in a family portrait and was familiar to writers of the period who manufactured emblems on the theme: 'While you stand steadfast, I will flourish.' Jacob Jordaens had the same idea in mind when he placed ivy clinging to a wall in his *Portrait of a Couple* (Museum of Fine Arts, Boston). Gertrude Stein's dictum that 'a rose is a

rose' is not always applicable to those that appear in Dutch paintings of the period: it is probable that the roses strewn on the floor in Hals' little group portrait are allusions to the joys of love as well as to man's quick passage on this earth. A viewer familiar with Lemmens' *Herbal for the Bible* would also find them particularly appropriate in a family portrait. Lemmens wrote that the rose, like the myrtle, is a plant 'which antiquitie dedicated to Venus: for that at brideales the houses and chambers were woont to be strawed with these odoriferous and sweet herbes: to signify, that in wedlocke all pensive sulleness and lowring cheer, all wrangling strife jarring variance and discorde ought to be utterly excluded and abandoned, and that in place thereof, al mirth, pleasantnes, cheerfulnes, mildnes, quietnes, and love should be maintained. . . . ' These conceits titillated Hals' contemporaries but the artist did not lean heavily upon them to convey the spirit of a happy marriage and the satisfactions of family life. For Hals a visualization of mirth and cheerfulness was preferable to any oblique reference to them.

CIVIC GUARD GROUP PORTRAITS

THE general tendency toward greater restraint is also found in the three large group portraits which Hals painted for militia companies during this decade. In the two made for the Haarlem guards the setting has changed: the men are no longer indoors celebrating at a banquet table, but are now portrayed in the open air. The portrait of the *Officers and Sergeants of the St. Hadrian Company* (Plate 127), made around 1633, shows the men gathered around a conference table in the yard of their headquarters, *de Oude Doelen*. A faithful old watercolour copy by Wijbrand Hendricks indicates that the general effect was once much more airy and spacious (Fig. 137). In its present state the wooden picket fence and gate behind the officers and the trees and heavy foliage, which once filled more than one third of the background, can scarcely be distinguished. Natural aging of the oil medium and pigment has considerably darkened the thinly applied greens and browns of this large area. A surface layer of old, discoloured varnish also covers the background; probably early picture restorers were reluctant to strip it away because they believed that the paint it covered would be vulnerable to their solvents. Familiarity with the disastrous results which less prudent picture cleaners have produced only increases our gratitude and admiration for those who have been circumspect. However, if a new investigation were to prove that the early restorers were over-cautious and that this veil of deteriorated varnish can in fact be safely removed, a judicious cleaning would help restore a balance between the figures in the foreground and the view of the yard. If not, we must continue to rely upon Wijbrand Hendricks' modest watercolour for an idea of the painting's original spatial and tonal effect.

We are also indebted to Wijbrand Hendricks for an engraving showing the group portrait of the St. Hadrian officers mounted in the main hall of their headquarters (Fig. 138). This late eighteenth-century engraving is the only known view of one of Hals' militia pieces *in situ*. If it was hung the same way in Hals' time, one can understand why his two group portraits of the

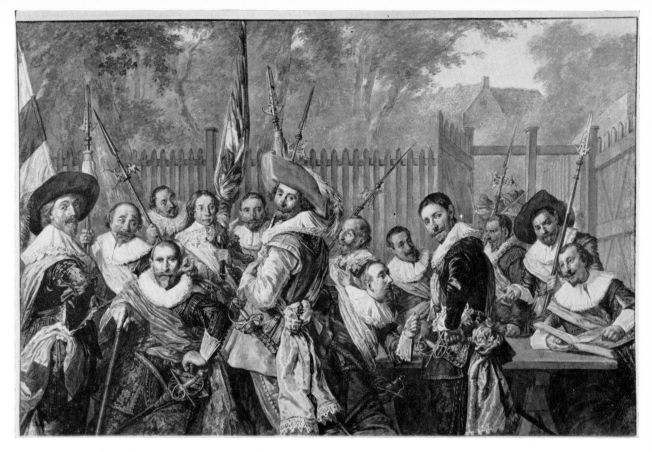

Fig. 137. Wijbrand Hendricks: Watercolour copy after Hals' *Officers and Sergeants of the St. Hadrian Company* (Plate 127). Haarlem, Teylers Stichting

BEËEDIGING DES GENOOTSCHAPS PRO ARIS ET FOCIS,

als eene van de drie Bataillons van de Schutterij der

Stad Haarlem, op den 5: April, 1787.

Fig. 138. Engraving after Wijbrand Hendrick's *View of Headquarters of the St. Hadrian Militia Company*

The Middle Phase: 1630-1640

St. Hadrian guards show three-quarter length figures; wall space simply was not available for life-size, full-length collective portraits. Since Hals' three militia pieces for the St. George Company of Haarlem are also three-quarter lengths, it was probably the size of the walls in their headquarters, and not that will-o'-the-wisp, the Haarlem *Kunstwollen*, which dictated this format for their portraits too. Only when Hals was called to Amsterdam to paint the so-called *Meagre Company* (Plate 134), did he make a full-length militia piece.

In the St. Hadrian group portrait the figures still retain much of the colouristic vivacity and dazzling brushwork of the earlier banquet scenes; bright blue, sparkling white and vivid orange sashes identify the companies in which the officers serve. The momentary quality of the figures is still apparent, but there is less agitation and instantaneous action. The complicated play of diagonals, which interlaced the figures in the earlier militia pieces, has now given way to a horizontal accent, which ingeniously links the group of officers standing around the imposing colonel seated on the left with those who flank the captain standing in the foreground on the right. Sergeants as well as commissioned officers have been included, and the arrangement by rank, which was followed when the men were shown around a banquet table, has been abandoned. Weapons rather than a hierarchical seating arrangement help establish a man's rank: the colonel holds his commander's staff, other commissioned officers bear spontoons, the ensigns have flags, and halberds identify the sergeants. There is also a distinct increase in the power and subtlety of the characterization. Louis XIV never had a court painter able to give his royal sitter the authority and determination expressed in Hals' portrait of Johan Claesz. Loo (Plate 125), the Dutch burgher who was the colonel of this group of Haarlem militia men.

In 1633, around the time when Hals painted the St. Hadrian guards of Haarlem, he was commissioned to make a militia piece for a group of Amsterdam civic guards (Plate 134). The group portrait, now on loan at the Rijksmuseum, is popularly known as *The Meagre Company*, probably because, unlike most seventeenth-century collective portraits of civic guards, it does not portray a single corpulent officer. Its proper title is the *Corporalship of Captain Reynier Reael and Lieutenant Cornelis Michielsz. Blaeuw*. Here Hals followed the Amsterdam tradition, established by Cornelis Ketel in his 1588 group portrait of *The Company of Captain Dirck Jacobsz. Rosecrans and Lieutenant Pauw*, of representing the militia men full-length.

The fact that the Amsterdam officers turned to the Haarlem artist for their portraits is yet another sign of the high esteem Hals enjoyed during this phase of his career. They could have given the commission to one of the popular Amsterdam portraitists or to young Rembrandt, who had already established his reputation in the great metropolis. Substantial financial reward as well as honour was to go with the assignment; the Amsterdam guards agreed to pay Hals sixty-six guilders for each figure he painted. Thus the commission was clearly a choice one. But for Hals it was only a headache. Three years after he had begun work on the group portrait it was still unfinished at Amsterdam. The irritated officers summoned Hals by legal writ to make the short trip to their city to complete it. Hals refused. He told the notary who read the writ to him on March 20, 1636, at his home, where he was confined to his bed with a sore leg, that he had

Portrait of a Man. About 1650-2. Detail from Plate 298.
New York, The Metropolitan Museum of Art

originally agreed to paint the group portrait at Haarlem, not at Amsterdam. Then, he said, he had consented to begin work on the individual portraits in Amsterdam and finish them in Haarlem ('de Troninges tot Amstelredamme soude beginnen ende tot Haerlem voorts op-maeken'). But he complained that he had difficulty getting his models to pose at Amsterdam and the trip there was expensive. If they would only come to Haarlem to pose he would be pleased to get on with the job.

On April 29 the officers acknowledged receipt of Hals' 'frivolous and untruthful response.' They stated that at first they had agreed to allow him to begin the portraits at Amsterdam and complete them in Haarlem. His fee under this arrangement was to have been sixty guilders for each figure. Then, they added, they contracted to pay him sixty-six guilders for each portrait if he would begin and finish them in Amsterdam, as he had already done with some of the models.

On July 26 the suit was pressed again, and once again Hals argued that the officers should pose for him in Haarlem. He was prepared to bring the canvas to his home to work on it and he assured the guards that posing would not take long – excellent proof, if it is needed, that Hals painted rapidly. He also added that, if the six or seven guards unwilling or unable to travel to Haarlem did not visit him, he would be willing to make the journey to Amsterdam, where he would paint sketches of them, which he would then incorporate into the painting. His offer indicates that in this special case Hals was prepared to make preparatory portrait sketches but that he did not have preliminary studies on hand for the individual figures. If this was his normal way of working it helps explain the mysterious absence of preliminary studies in his *oeuvre*.

Whether any of his patrons complied with his request to pose for him at Haarlem or whether he finally went to Amsterdam to make oil sketches of the officers who still refused to come to his studio is not known. We do know, however, that Hals never finished the group portrait. It was finally completed in 1637 by Pieter Codde. The disposition of the figures in the large composition, which is quite similar in conception to Hals' outdoor group portrait of the *St. Hadrian Company* (Plate 127), was probably entirely the master's invention. He painted most of the left half of the composition, and traces of his hand can also be seen on the right side (the portraits of the third, fifth and seventh man from the right). Codde, in turn, probably touched passages on both the left and right sides to help unify the finished group portrait. He made a concerted effort to simulate Hals' technique, but when the inimitable brushwork of Hals' ensign standing on the extreme left (Plate 132) is compared with the touch Codde used for the figure standing to the right of the two seated officers (Plate 133), one can understand why no other portraits à la Hals by this painter are known. After Codde had finished his task he was apparently quite willing to abandon his attempt to rival the Haarlem master.

Van Gogh wrote after a visit to the Rijksmuseum in 1885 that he 'was literally rooted to the spot' when he saw Hals' ensign (Plates 129, 132) in the Amsterdam militia piece. His passionate, intensely personal appraisal of the figure is worth quoting at length:

'. . . there is a picture (unknown to me till now) by Frans Hals and P. Codde, about twenty officers full-length. Did you ever notice that??? that alone – that one picture – is well worth

the trip to Amsterdam – above all for a colourist. There is a figure in it, the figure of the ensign, in the extreme left corner, right against the frame – that figure is in grey, from head to toe, I shall call it pearl-grey – of a peculiar neutral tone, probably the result of orange and blue mixed in such a way that they neutralize each other – by varying that basic tone, making it somewhat lighter here, somewhat darker there, the whole figure is as if it were painted with one same grey. Yet the leather boots are of a different material than the leggings, which differ from the folds of the trousers, which differ from the doublet – expressing a different material, very different in relation to colour – but all one family of grey. But wait!

Now into that grey he brings blue and orange – and a bit of white; the doublet has satin bows of a heavenly soft blue, sash and flag orange – a white collar.

Orange, white, blue, as the national colours were then – orange, and blue, side by side, that most splendid colour harmony, on a ground of grey, cleverly mixed by uniting just those two, let me call them poles of electricity (speaking of colours though) so that they annihilate each other against that grey and white. Further, we find in that picture – other orange harmonies against another blue, further, the most beautiful blacks against the most beautiful whites; the heads – about twenty of them, sparkling with life and spirit, and a technique! and a colour! the figures of all those people superb and full-length.

But that orange white blue fellow in the left corner . . . I seldom saw a more divinely beautiful figure. It is unique.

Delacroix would have raved about it – endlessly raved. . . . '

The militia piece of the *Officers and Sergeants of the St. George Company* (Plate 201) made around 1639 includes nineteen men, the largest group Hals portrayed. The number poses a minor problem. The normal complement of a Haarlem militia company officer corps included three Lieutenants and three Ensigns, but here we find four of each rank. The reasons offered to explain the presence of these additional officers need not detain us here but the presence of yet another extra man should be noted: Hals himself appears as one of the least conspicuous figures in the middle plane (Fig. 1).

In this group portrait the compositional boldness of the earlier guard groups has been re-pressed. The rather static effect, but not the touch, suggests a closer connection with Hendrick Pot's *Officers of the St. Hadrian Company of Haarlem* (Fig. 139), painted around 1630, than with the animated gatherings Hals depicted in his other militia pieces. (Pot appears in the large 1639 group portrait in his role as Lieutenant; he is in the second row, the fourth figure from the left.) The figures have been subordinated to the dominant horizontal band formed by the dozen officers in the front plane; variety of position and movement in the principal group has been minimized, each man having virtually equal importance. If Colonel Johan Claesz. Loo had not been equipped with his commander's staff (Plate 199) it would be difficult to determine who served as the leading officer of the group. Even Michiel de Wael (Plate 200), who plays such an extroverted role in a group portrait Hals had painted more than a decade earlier (Plate 84), has been restrained. Not a conspicuous action but the distinct accent made by his yellow-ochre jacket and silver-grey

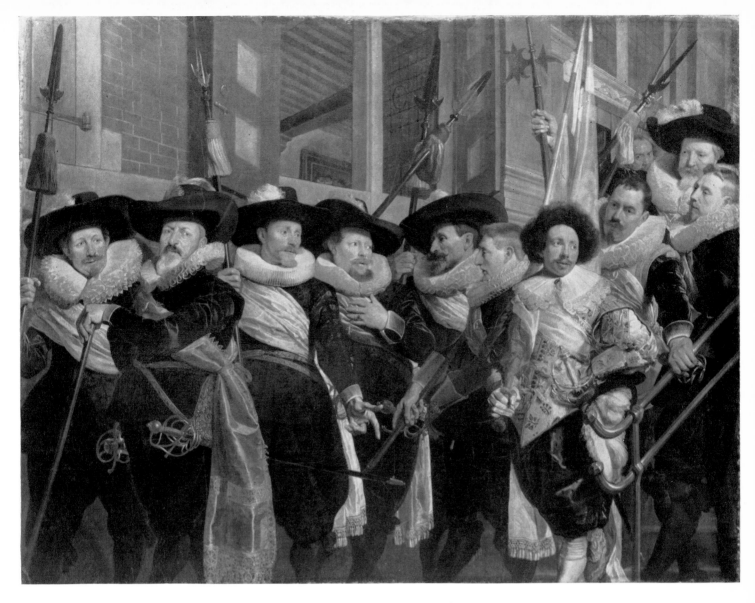

Fig. 139. Hendrick Pot: *Officers of the St. Hadrian Company*. About 1630. Haarlem, Frans Hals Museum

sleeves, which contrast with the sober black worn by most of his fellow officers, distinguishes him here.

Unlike the other militia pieces this one divides into two rather distinct groups; one in the foreground and a smaller one in the middle plane. The gentle descending line formed by the latter and the pointing gestures made by two officers are the principal means used to link the group with the men lined up in the foreground. However, Hals' contemporaries would have noticed another bond. Colonel Loo's son, Nicolaes Jansz. van Loo, is in the second rank (Fig. 140). His handsome head is seen in the same position as his old father's grey head (Fig. 141). It is unusual if not unique to find this kind of repetition in a Hals group portrait. One need not seek far to explain why it occurs here: by repeating the pose Hals was able to show how closely the son favoured the father.

A warm, golden-olive tonality and a subdued, harmonious colour accord have replaced the full daylight and vivid hues of the earlier civic guard pieces. Although the officers are seen in the open air – probably at the entrance of their headquarters – there is less of a *plein air* effect than Hals had achieved in the banquet pieces of the 'twenties, which were set in interiors. It must be admitted that the landscape in the background is dull. G. D. Gratama suggested that perhaps it was painted by the self-taught Haarlem landscapist Cornelis Symonsz. van der Schalke, who appears on Hals' proper left in the group portrait. We like to think Gratama's supposition is correct.

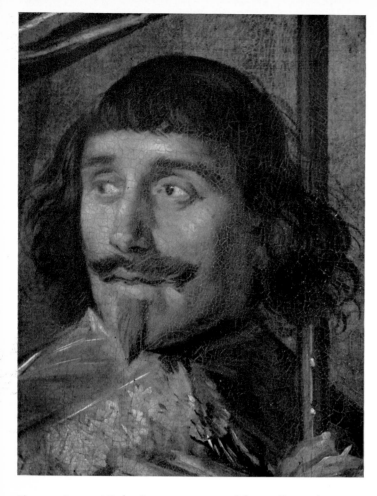

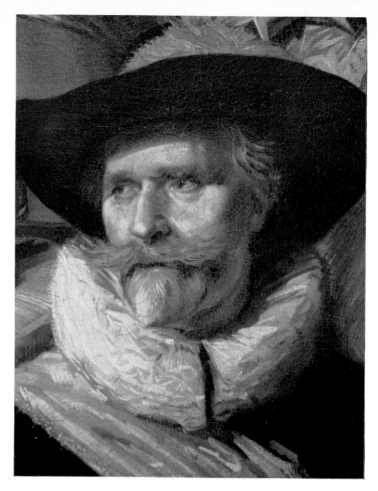

Fig. 140. *Sergeant Nicolaes Jansz. van Loo*. Detail from *Officers and Sergeants of the St. George Company* (Plate 201). About 1639. Haarlem, Frans Hals Museum

Fig. 141. *Colonel Johan Claesz. Loo*. Detail from *Officers and Sergeants of the St. George Company* (Plate 201). About 1639. Haarlem, Frans Hals Museum

The 1639 group portrait of the *St. George Militia Company* was the last civic guard piece Frans Hals painted. Dutch militia men continued to commission them – the *Night Watch* was painted three years after Hals had completed this one – but the category became less popular during the following decades. After the triumphal ratification of the Treaty of Münster in 1648, which ended an eighty-year struggle for independence and accorded the United Provinces of the Netherlands *de jure* recognition, Dutchmen preferred to be seen as regents of charitable institutions rather than as officers of militia groups.

GENRE AND ALLEGORICAL PAINTINGS

THE *Fruit and Vegetable Seller* (Plate 112), now in the collection of Lord Boyne, bears the signature of the Haarlem still-life painter Claes (Nicolaes) van Heussen and is dated 1630. Details about Van Heussen's activities are sparse and only a handful of his works have been identified but he won enough local acclaim in his day for Samuel Ampzing to mention him in his history of Haarlem published in 1628. Judging from Van Heussen's colossal still life in the Boyne collection, he was inspired by the abundant displays of fruits and vegetables painted by contemporary Flemish artists, not by the unpretentious still lifes painted around this time at Haarlem by Pieter Claesz and William Heda. Like so many of the exuberant Flemish artists of the period, he also felt compelled to animate his *natures mortes* with some live action. The still-life specialist called upon a figure painter to provide the lively staffage. He could not have found a better collaborator. The

coquettish young woman who has momentarily turned to look directly at the beholder as she reaches into a basket was painted by Frans Hals. The master's characteristic firm modelling and economical accents are unmistakable in a close view of the girl's head (Plate 113). The technique is one we have seen before. After blocking in the light and dark areas he added a few sure strokes to establish the contours of her features and suggest her instantaneous expression. The final touches seem to be drawn rather than painted. It is a technique which makes one believe that on the lucky day when a cache of Hals' drawings is found in some forgotten attic there will be some breathtaking *trois crayons* studies amongst them. Hals' typical hatched strokes are also apparent in the young woman's costume, and a comparison of the fluid touch of the fluttering ivy that clings to the fluted column behind her with the meticulously painted branches and leaves in the still life by Van Heussen indicates that Hals worked up this passage too.

Today, when hardly a soul would think of mentioning Van Heussen's name in the same breath with Hals', the presence of the former's signature and the absence of the latter's on the Boyne picture seems strange indeed. Obviously the value we place on Hals' work and signature was not shared by all of his contemporaries. In this case Van Heussen probably indicated that he took responsibility for work done by his collaborator because he received the commission or was the entrepreneur who wanted the picture in stock. In Hals' time it was not unusual for one artist to take credit for a cooperative venture. Joint efforts by seventeenth-century Dutch painters ordinarily bear one, not two signatures. Salomon de Bray's signature on Hals' signed *Family Portrait* (Plate 29) is not an exception to the rule; as we have seen, there is good reason to believe that the child De Bray painted in the *Family Portrait* (Fig. 41) was not the result of planned collaboration but a later addition.

There is nothing about Hals' girl that would make one doubt that she was painted in 1630, the year Van Heussen inscribed on the picture. Since Hals' 1623 painting of a prodigal couple in a tavern (Plate 42) is the only known subject or genre piece by the master which is dated, the date on the Boyne picture is of more than antiquarian interest. A group of Hals' paintings of fisherchildren seen against a background of dunes and the sea can be dated around the same time – or perhaps a few years later. One of the most impressive of these is the *Fisherboy* (Plate 115), now at Antwerp, which ranks with the great Baroque portraits of children. Strictly speaking, of course, it is not a portrait. The parents of this youth, who is portrayed with his arms wreathed in a characteristic fisherman's pose, hardly belonged to the social class that commissioned genealogical portraits. He would not have been at home with the elegantly dressed children of well-to-do burghers portrayed by Backer, Flinck or Jacob Cuyp. When seen close up the boy's smiling face (Plate 114) speaks to us with a disarming childish frankness and unaffected simplicity. Only when we recognize what appears to be a deformity in one of his eyes does a faint shade seem to pass across his joyful expression.

A juxtaposition of the Antwerp boy's head with that of the young woman in the Boyne picture (Plate 113) shows striking affinities. Although the brushwork is freer and bolder in the painting of the boy and angular strokes have been used more extensively to blur outlines, the sharp con-

Fig. 142. Follower of Frans Hals: *Fishergirl*. Cincinnati, Cincinnati Art Museum

Fig. 143. Jan Miense Molenaer: *Beach Scene with Fisherchildren*. Formerly The Hague, S. Nijstad

Fig. 144. Jan Miense Molenaer: *Beach Scene with Fisherfolk*. Location unknown

Fig. 145. Engraving designed by Adriaen van de Venne to illustrate a poem in J. Cats, *Invallende Gedachten, Op voorvallende ghelegentheden, Doodt-Kist voor de Levendigen* . . . Amsterdam, 1655

trasts of light and shadow which model forms and the miraculously few detached strokes that give definition to the salient features are very similar. The range of the viscosity of the paint, from the thinly brushed-in passages to the heavy impasto white highlights, which provide such lively accents, is also the same. The close analogies which can be drawn between these works and the *Fisherboy* (Plate 117) at Dublin and the *Fishergirl* (Plate 116) formerly at Brooklyn indicate that they too were painted in the early thirties. As in the Antwerp painting, the red sleeves worn by these fisherchildren provide vivid colour accents, but the general effect has become more monochromatic than in the earlier genre pieces. Remarkable is the dune landscape behind the *Fishergirl*. It has opened up a new overall airiness and spaciousness by the subdued contrast of light greens, pale yellows and silvery greys, and by the brightening of the sky at the horizon. We have already noted that the way Hals depicted inanimate objects in a few of his other works makes us regret that he did not try his hand as a still-life painter; in the painting formerly at Brooklyn it is apparent what a sensitive landscapist was lost in the master (Plate 119).

Numerous contemporary copies and variants after Hals' half-lengths of fisher folk indicate that the theme was a popular one, and it is not improbable that the artist himself as well as members of his circle continued to employ the motif after the early thirties. The dark tonality and exceptionally fluid brushwork of the *Fishergirl* (Fig. 142; Art Museum, Cincinnati) suggests that it was painted later than the group just discussed. Although this remarkable precursor of Hogarth's more famous *Shrimp Girl* bears the artist's monogram, I hesitate to assign it to Hals without reservation. The splashy strokes – particularly in passages of the face and hair – are mechanical and fail to model convincingly the full roundness of the forms. However, there can be little doubt that this difficult borderline case is closely related to an original by the master. The girl appears again as a full-length in Jan Miense Molenaer's small beachscape which is populated by some of the well-known fisherchildren Hals painted (Fig. 144). The *Fishergirl* formerly at Brooklyn and the Dublin *Fisherboy* can be recognized in Molenaer's painting while the boy with a

143

basket on his back who approaches the principal group may have been derived from Hals' *Fisherboy* at Antwerp. Molenaer borrowed some of the same characters for a second group portrait of Hals' fisherchildren on a beach (Fig. 143). His interest in them suggests that he may have painted some of the fisherchildren done in Hals' manner which are nameless today; however, none of these trouble-some school pieces can be firmly attributed to him.

We have seen that the motif of fisherchildren can be related to earlier representations of the personification of 'Water' when this allegorical theme was shown as a beach scene and to the popular prints which depicted the various occupations. Julius Held has rightly indicated that some contemporary Dutchmen also probably found a didactic meaning in such works. He notes that Jacob Cats, who seldom missed an opportunity to moralize, – and perhaps others with a similar propensity – may have looked upon Hals' pictures of fisherchildren as reminders of the virtues of the 'natural life' over 'town life.' Cats' way of interpreting such subjects is found in his poem, published in 1655, 'On the Situation of a Young Woman of Scheveningen Who Carries a Basket of Fish on her Head . . . ' ('*Op de gelegentheyt van een Scheveninghs vroutje dat een benne met visch op haer hooft draeght . . .* '). The poem proclaims that life and work at the seashore, where one can be happy and free, is preferable to the pomp of town life. It is illustrated by an engraving designed by Adriaen van de Venne of a fishergirl at the Scheveningen shore (Fig. 145), who recalls the one now in Cincinnati (Fig. 142), but appears to be more concerned with balancing the large basket on her head than with her happy lot. Possibly Van de Venne, one of the few seventeenth-century Dutch artists who made works protesting the unjust plight of man's condition, had reservations about Cats' vision of the idyllic life led by fisher folk. In any event, an engraving after one of Hals' fisherchildren also could have served as an illustration for Cats' poem.

A scheme not unlike the one used for the fisherchildren was employed for the *Man with a Beer Jug* (Plate 118), now in the Henry Reichhold collection, White Plains, New York. This happy drinker, who affectionately embraces his monumental wooden jug, is seen outdoors silhouetted against the sky in much the same way as the Dublin *Fisherboy* is posed. The landscape, which is only summarily suggested, is the type that made Bode postulate that Adriaen Brouwer may have painted some of the views in Hals' pictures of this type, but Valentiner was probably closer to the mark when he wrote that Adriaen Brouwer's rare nature studies are elaborations of motifs introduced by Hals. The diagonal arrangement of the composition is given stability by the emphatic horizontal of the drinker's arm while the wide metal hoops of the huge jug contribute a bold decorative note. Warm flesh tints, a few wheeling birds and patches of blue in the stormy sky, and the bright-scarlet deer painted on the wooden jug relieve the dark tonality. The deer probably indicates that the jug belonged to the Red Deer ('Root Hart') Brewery of Haarlem; around 1660 Hals painted a portrait of *Cornelis Guldewagen* (Plate 325), the owner of the brewery.

When the *Man with a Beer Jug* was published by Tancred Borenius in 1932 he understandably dated it between 1630 and 1635. Its close similarity to the group discussed here of other half-

length figures seen outdoors supports that date. It should, however, be emphasized that the unusual breadth and sketchiness of the man's hand and jug are rarely found in Hals' works before his last phase. In this genre piece and in the better known *Malle Babbe* (Plate 120), which we are inclined to date around the same time, Hals evidently anticipates his late style. But the paucity of dated genre pictures should remind us that this is not an established fact, but merely a working hypothesis, which discovery of new evidence may modify. I thought some had been encountered when I read the date '1645' on the copy of *Malle Babbe* Courbet made in 1869 (Fig. 149). This mysterious date has not been discussed in the literature on Hals. But everything indicates that the date of 1645 as well as Hals' monogram, which is also found on the copy, are Courbet's inventions. A thorough examination of Hals' well preserved original *Malle Babbe* at Berlin-Dahlem failed to reveal a trace of the year or monogram. Not a single early catalogue mentions a date on the original, and when Thoré-Bürger first published the painting in the *Gazette des Beaux-Arts* in 1869 – the very year Courbet made his copy – he did not mention the date either. If it bore one, it is hard to believe that Thoré-Bürger, who systematically searched for inscriptions and published facsimiles of those he found, would have discussed the probable date of *Malle Babbe* on the basis of its style. 'Where can one place this marvel of painting in Hals' *oeuvre*?' he asked. 'Although the brushwork is extremely impetuous, as it is in his last manner, the tone has an exquisite fineness and the colour is not harsh, as in the paintings of *Regents* and *Regentesses* at the Haarlem Museum. Great masters are so capricious! This diversion of a genius can be dated between 1630 and 1640. . . .'

The frenzied vitality of Hals' famous *Malle Babbe* has been admired from the time when Thoré-Bürger enthusiastically wrote that he had the pleasure of introducing her to the world and the mature Courbet paid homage to the great Baroque realist by copying it. Since then it has been universally recognized as an outstanding example of Hals' supreme power of characterization, his mastery of expressing spontaneous movement and emotion, and the fury of his suggestive brushwork. Nowhere does he better succeed in convincing us that he has recorded an instant when endlessly moving life is lived at its highest intensity.

The identification of the model is based on an old inscription on a piece of the old stretcher which has been let into a new one. It reads: 'Malle Babbe van Haerlem . . . Frans Hals.' Thoré-Bürger, in his thorough way, published a facsimile of the inscription, but he erroneously read 'Hille Bobbe' for 'Malle Babbe'; this accounts for the incorrect title found in the older literature. Although we know nothing about Malle Babbe, it is easy to understand why she is popularly known as the 'Witch of Haarlem.' It is not necessary to believe in sorcery to be convinced that her wild, animal-like movement and demonic laugh are not the result of the amount of beverage she has consumed from her gigantic tankard, but are controlled by more potent, mysterious dark forces which could challenge man's faith as well as his rational powers. Only Goya, in his late phase, conjured up similar aspects of the savage side of man's nature.

Other portraits of Malle Babbe are known. We have seen that what appears to be a copy of a lost one (Fig. 91) is found in Jan Steen's *Baptismal Party* as a companion piece to Hals' *Peeckel-*

haering now at Cassel. Amongst the existing variants, the painting in the Metropolitan Museum (Fig. 146) comes closest to the high standard set by the Berlin picture, but when seen next to the latter, it loses considerably. With all its spontaneity the pictorial organization of the Berlin picture remains clearly thought out. Malle Babbe's sharply turned head makes a strong counter-movement to the emphatic diagonal thrust of the design, which is subtly reinforced by the direction of the energetic brushwork on her collar, cap, sleeve and apron. In the New York painting the taut design has considerably slackened, the detached strokes are hardly part of the dominant rhythm established by the movement of the figure and we miss the decisive accents which give a convincing roundness to the forms even when they are suggested with a single touch of light or dark paint. A Morellian comparison of the eyes of the two women is also telling (Fig. 156). In the Berlin work (Plate 121) daring contrasts of shadow and light establish their contours and the puffiness of the flesh around them; the direction of the brush strokes and fine gradations in tone establish their precise position. When we turn to the New York picture we are disappointed. Here the free brushwork weakens rather than establishes the firmness of the forms, and the more limited range in value between the light and dark areas fails to establish clear spatial relationships. Similar weaknesses in other parts of the picture – particularly the brushwork of the owl on the shoulder of the New York *Malle Babbe*, which only vaguely resembles Hals' characteristic touch – indicate that the painting was not the work of the master on a Monday morning but the invention of a gifted follower or a copy after a lost original.

A coarsely painted work called *Malle Babbe and a Smoker* (Fig. 155) is at Dresden, where it is attributed to Frans Hals the Younger. The picture is a mélange of the New York *Malle Babbe*, Adriaen Brouwer's *Smoker* (Fig. 154) at the Louvre, and a fish still life similar to those done by Abraham van Beyeren (Fig. 157). The ascription of the Dresden picture to Frans Hals the Younger has led some students to ascribe the New York painting to him too. Since there is no basis for the attribution of the Dresden work to Frans the Younger, the ascription of the New York painting to this nebulous son of the master is also without foundation.

Yet another unidentified pasticheur transformed Malle Babbe into a fishwife and gave her a gay male drinking companion (Fig. 158). The artist who painted this work based part of his copy on the Berlin picture. Perhaps the man with a glass was taken from a work done by Hals' son-in-law Pieter Roestraten or by Petrus Staverenus, an obscure genre painter active in Haarlem around 1635; in any case he scarcely reflects a lost original by the master. Paintings which some specialists have attributed to Hals and identified as Malle Babbe are also at Lille (Fig. 147) and in a New York collection (Fig. 148). In my view neither the ascriptions nor the identifications of these works are correct.

A more recent effort to rival Hals' peerless original was made by the notorious Dutch forger H. A. van Meegeren (Fig. 150). This skilful counterfeiter, who based his deception on the head of the Berlin *Malle Babbe* and derived the collar and other parts of his painting from the New York picture, was only able to produce a superficial imitation of Hals' surface treatment, and, as always, when we turn to works by Hals' followers, copyists and forgers, the psychological

penetration of the master is missing. Admittedly, judging the latter aspect of Hals' work will always remain partially subjective, but who would argue that Van Meegeren's gross drinker, who looks more like a man than a woman, touches depths of the human spirit? In the final analysis, approximating the types and moods created by a great master poses a more difficult problem for the forger than imitating his technique. This is apparent here and can also be seen in Van Meegeren's best fake, his *Supper at Emmaus* done in Vermeer's manner. In the latter painting he did a better job of aping Vermeer's way of painting and colour harmonies than he did in his imitation of Hals. But in that work the conspicuous disciple of Christ, who bears a much closer resemblance to an American Indian than to a pilgrim at Emmaus painted by a seventeenth-century Dutch artist, betrays the forger.

After learning that ties can be established between some of Hals' works and commonplace moralizing and allegorical traditions of his time, it is reasonable to ask whether the artist intended his incomparable *Malle Babbe* now at Berlin to be nothing but a study of a fleeting moment in the life of the shrieking old crone or whether the subject may have some other significance. Perhaps her pet owl (Plate 122) offers a clue.

Nowadays the owl is most frequently thought of as a symbol of wisdom. Its connection with sagacity and learning is ancient, and it is a venerable attribute of both Athena and Minerva. However, an owl can personify many different ideas and it figures in numerous proverbs to illustrate a wide range of truisms. References to owl symbolism are frequent in medieval, Renaissance, and Baroque texts and the subject has not been neglected in the modern literature. Jakob Rosenberg has made a convincing analysis of the levels of meaning in Bosch's drawing *Owls in a Tree* (Boymans-Van Beuningen Museum), based on his reconstruction of the sketch. He shows that Bosch makes use of an old tradition and depicts the bird that prefers darkness to light as a personification of sin, and moralizes about the power of evil over man. Bosch would have found Malle Babbe's owl a most appropriate symbol of the demonic forces which appear to possess the 'Witch of Haarlem.' Although there is no proof that citizens of Haarlem in Malle Babbe's day thought she was in league with evil spirits, there is ample evidence that the nocturnal bird perched upon her shoulder has been associated with the powers of darkness since the idea was expounded in medieval encyclopaedias and bestiaries. Traditionally the owl also personifies foolishness, stupidity and ignobility. It appears as a symbol of gross folly in Bosch's work, and is used in analogous ways by Lucas van Leyden, Peter Huys, Karel van Mander and Jacob Jordaens. The grinning Amsterdam civic guard posing with his head cocked and with an owl on his shoulder (Fig. 151), while his twenty severe-looking companions sit bolt upright for the group portrait painted of their shooting company by an anonymous Dutch artist in 1554 (Rijksmuseum, Amsterdam), must have had a considerable reputation for tomfoolery. Valeriano lists foolishness among the ideas the owl can signify in his *Hieroglyphia*, a voluminous treatise published in 1556 and frequently reprinted to satisfy the demand of a public devoted to emblems. Ripa, citing Valeriano as an authority in his *Iconologia*, uses the owl as one of the attributes of vulgar and common people (*Vulgo, overo ignobilità*) because it is the bird the Egyptians had employed to

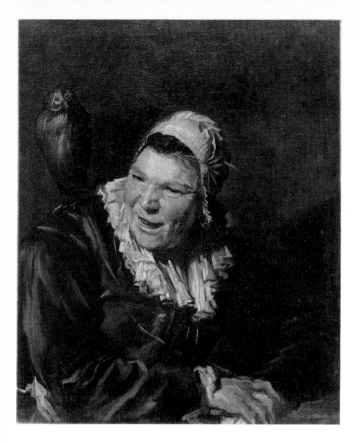

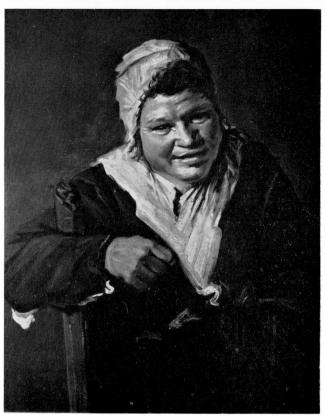

Fig. 146. Follower of Frans Hals: *Malle Babbe*.
New York, Metropolitan Museum of Art

Fig. 147. Follower of Frans Hals: *Seated Woman*.
Lille, Musée des Beaux-Arts

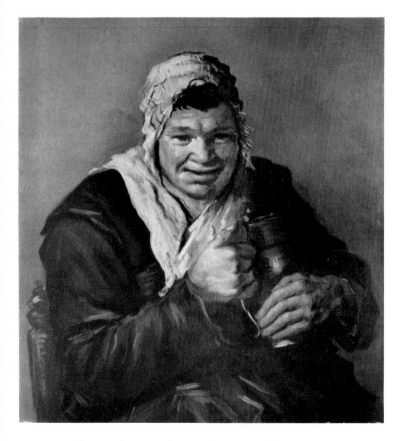

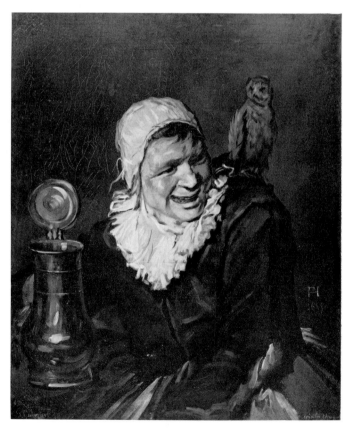

Fig. 148. Follower of Frans Hals: *Seated Woman Holding a Jug*.
New York, Jack Linsky

Fig. 149. Gustav Courbet: Copy after *Malle Babbe* (Plate 120). 1869.
Hamburg, Kunsthalle

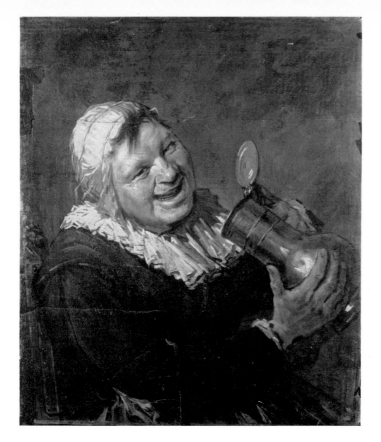

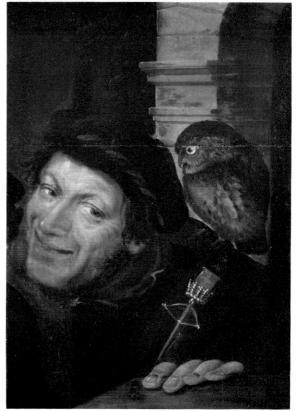

Fig. 150. H. A. van Meegeren: *Woman Drinking.*
Location unknown

Fig. 151. Netherlandish School: Detail from
Twenty-one Civic Guards of Company E. 1554.
Amsterdam, Rijksmuseum

Fig. 152. Louis Bernhard Coclers: Etching after *Malle Babbe*
(Fig. 146)

Fig. 153. Bartolomaeus Maton: *A Fool with an Owl.*
Stuttgart, Private Collection

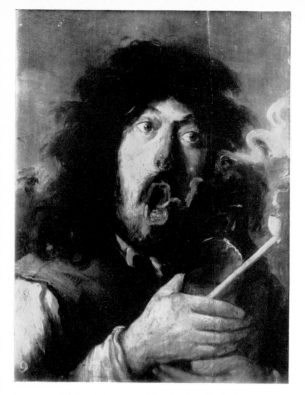

Fig. 154. Adriaen Brouwer: *The Smoker*. Paris, Louvre

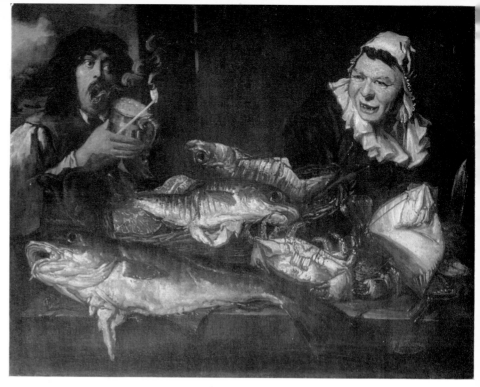

Fig. 155. Pastiche after *Malle Babbe* (Fig. 146). Adriaen Brouwer and Abraham van Beyeren. Dresden, Gemäldegalerie

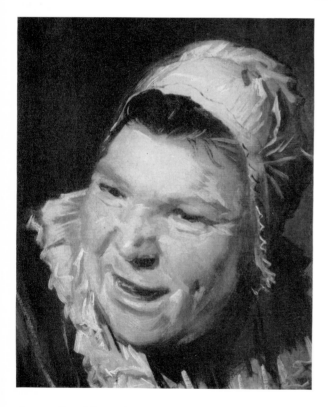

Fig. 156. Detail from Fig. 146

Fig. 157. Abraham van Beyeren: *Fish Still Life*. Budapest, Museum of Fine Arts

represent ignobility. Erudite seventeenth-century collectors probably nodded with approval at the appropriateness of the owl perched on the shoulder of the indiscreet shepherd leering at the raised skirts of the seated young woman in Rembrandt's bucolic etching of *The Flute-Player* (1642; Bartsch 188).

Owls have also been accused of drunkenness. ' "Clumsy fellows," said I; "they must still be drunk as owls," ' is a line given to Jim Hawkins, the young hero of Robert Louis Stevenson's *Treasure Island*, who had more than one occasion to study the action of drinking men. Jim's line

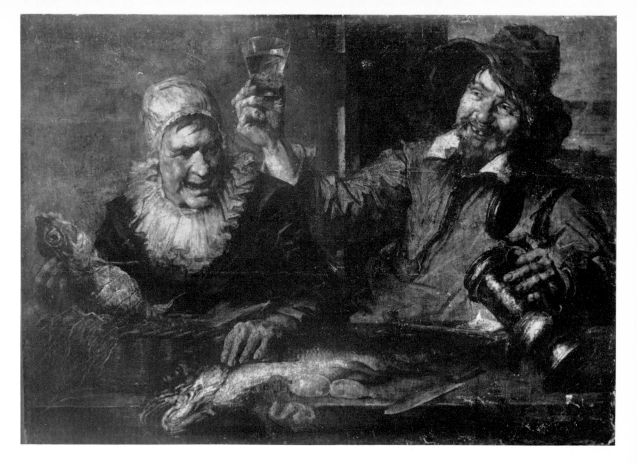

Fig. 158. Follower of Frans Hals: *Malle Babbe and a Drinking Man*. The Hague, S. Holden

is used as a source for the proverb 'Drunk as an owl' in *English Proverbs and Proverbial Phrases* by G. L. Apperson, who comments: 'Why the solemn bird should be taken as the ideal drunkard I know not.' It is difficult to give a direct answer to Apperson's query.

The hypothesis that the supposed dipsomaniacal tendencies of birds (crows, jays, and magpies have also been compared to drunkards) made them symbols of inebriation has been rightly dismissed as improbable. A more helpful suggestion is found in D. Bax's thorough analysis of Bosch's symbolic use of the owl. Bax writes that the clumsy, fluttering movements of the bird during the daytime helped make it a popular symbol of folly, stupidity, ignorance and drunkenness. Birds and animals are generally associated with an idea because of their real or supposed character, their capers and their calls. The proverb 'He is as drunk as an owl' ('*Hij is zoo beschonken als een uil*') is listed in Harrebomée's compendium of Dutch proverbs, and in parts of the eastern Netherlands the phrase 'as tight as an owl' ('*zoo zat als een uil*') is said to be frequent. Whether Hals or his contemporaries used this proverb, or even thought of it, in connection with the Berlin *Malle Babbe* remains unanswered. However, a common Dutch adage about owls was inscribed below an etching (in reverse) made by Louis Bernhard Coclers (1740–1817) of the problematic version of *Malle Babbe* now at the Metropolitan Museum (Fig. 152), or of one similar to it. This version shows Malle Babbe with her owl on her shoulder, but without her tankard in hand. Coclers inscribed his print:

> Babel of Haarlem,
> To you, your owl is a falcon. O Babel! I am glad of it.
> Play with an illusion. You are not alone.

The proverb 'Everyone thinks his owls are falcons' ('*Elk meent zijn uil een valk te zijn*') is an

151

old one. It is included in a verse inscribed on Van Mander's drawing of *A Fool with an Owl* (Albertina, Vienna) and Jacob Cats, who repeatedly found inspiration in folk sayings, quotes it – good testimony that it was popular in seventeenth-century Holland. It probably dates back to a time long before Van Mander's day when falconry was a favourite sport. English equivalents of the proverb are: 'Every mother thinks her sprats are herrings' and 'Everyone thinks his own geese are swans.'

The owl perched on the shoulder of the grimacing man (Fig. 153) painted around 1675 by Bartolomaeus Maton, an obscure Leiden follower of Dou and Frans Mieris the Elder, is probably meant to be a personification of foolishness. This interpretation is supported by the verse inscribed on the piece of paper this latter-day Till Uilenspiegel holds. It reads:

> Wise people, look, this is rare.
> A fool, an owl, a ridiculous pair.

Perhaps some wits of Leiden who had close contact with the distinguished university of Maton's native town preferred to view the fool's owl as an attribute of Pallas Athena. For them, Maton's couplet would still be appropriate: a fool's search for wisdom is preposterous. Carolus Tuinman, who made the first extensive compilation of Dutch proverbs, wrote in 1726 that to call a person an owl ('*t is een uil*') is an opprobrious saying used by the Dutch to characterize an ignoramus. And like many of us Tuinman wondered why this was the fate of the bird used by the ancients as an attribute of Athena, the goddess of wisdom.

The man leaning out of the oval stone porthole in Maton's picture is dressed in a fancy actor's costume. He may have belonged to a local group of rhetoricians or perhaps he was a member of a theatrical company and played the part of *Peeckelhaering* or *Hanswurst* in Dutch farces. A similar Falstaffian type appears in Hals' early *Shrovetide Revellers* (Plate 8), and one of the old copies of that painting (Fig. 16) shows an owl perched in a circular niche in a high wall behind the celebrants. Whether this copy is a faithful replica of the master's own conception of the group in its entirety or the additions were made by the copyist is moot. It is, however, relevant to note here the presence of the owl (not a very friendly one – the bird is shown befouling some of the merry-makers) in an old copy of Hals' painting of festivities on a day traditionally dedicated to fools and foolishness.

The pictorial organization of Bartolomaeus Maton's picture – particularly its strong oblique axis – is unusual in a Dutch painting around 1675. It suggests that this minor artist had a chance meeting with Hals' *Malle Babbe*. But little else in his highly finished and contrived picture recalls Hals' explosive masterwork. Maton also found it imperative to add an inscription to explain the meaning of his model's owl. Frans Hals, of course, did not. He never found reason to carry owls to Athens.

CHAPTER VI

Portraiture: 1640-1650

DURING the 1640s a taste for Van Dyckian elegance and aristocratic airs became fashionable both among Dutch portraitists and among their patrons. The vogue, which caught on quickly and remained popular during the following decades, began at the small court at The Hague, where the more international trends of Baroque art had always found greater favour than the home product. Even before Van Dyck died in 1641, portraitists were beginning to appear on the scene who reflected his dazzling late style. Adriaen Hanneman settled at The Hague in 1637, after spending more than a decade in England assimilating aspects of the Flemish master's mature, supple manner. Cornelis Jonson van Ceulen, who was born in London of Dutch parents and emigrated to Holland in 1643, and Jan Mytens, a native of The Hague, also helped popularize the new ideals in court circles. At Amsterdam the gifted portraitist Bartolomeus van der Helst, after feeling the influence of Hals, Rembrandt and Nicolaes Eliasz., soon adopted something of Van Dyck's studied poses, bright colours and liquid touch. Works he did in this manner had immediate appeal and by 1645 Van der Helst replaced Rembrandt as the most stylish portraitist of Amsterdam. Not long afterwards Rembrandt's pupils Bol and Flinck succumbed to the new fashion.

Hals was not unaffected by the change in taste but he did not follow it slavishly. Perhaps this helps explain the drop in the number of commissions he received after 1640. It is, however, incorrect to speak of a drastic loss of patronage during this phase or in his final years. After all, we know many more portraits by Hals the septuagenarian than by young Hals. Important assignments continued to come his way.

A prize one was offered to him in 1641 when he was commissioned to paint a group portrait of the *Regents of the St. Elizabeth Hospital* at Haarlem (Plate 226). Two years later Paulus Verschuur, the director of the largest textile factory in Rotterdam and one of that city's civic leaders, chose him to do his portrait (Plate 247). Verschuur may have had business connections with the Coymans family of Haarlem, who were also textile manufacturers; Hals, as we shall see, was a favourite of the Coymans family – perhaps they introduced him to the wealthy financier of Rotterdam. In any event, it is significant that this highly placed and well connected patron – Verschuur served as burgomaster of Rotterdam and as a director of the Dutch East India Company – turned to Hals and not to an artist from his own city or nearby Delft, or to one from The Hague or Amsterdam.

Although there is no foundation for the traditional identification of Hals' *Portrait of a Man* dated 1644 (Plate 242; Six Collection, Amsterdam) as Dr. Tulp, the anatomist immortalized by

Fig. 159. Matthys van den Bergh: Drawing after Hals'
Portrait of Daniel van Aken (Plate 221). 1655. Ink.
Rotterdam, Boymans-van Beuningen Museum

Rembrandt in 1632, we know that during the 1640s Hals' clientele included patrons who belonged to Tulp's social class. Around the end of the decade he was commissioned to paint two monumental life-size family portraits. About the same time René Descartes sat for him – hardly a sign of oblivion. Further proof that he was held in high esteem in some circles during these years is the appraisal his early patron Theodorus Schrevelius (Plates 23, 74, 75) made of his art in *Harlemias*, published in 1648. It will be recalled that Schrevelius praised his unusual, entirely personal manner of painting and wrote that his portraits appear to live and breathe.

Hals never lost his touch for making speaking images but during this period his sitters seem to acquire a new way of speaking and a new sense of propriety. Around this time most of the men he portrayed appear to be less aggressively ambitious than their fathers were. The bravura of the generation which established the new Republic was replaced by the more stolid respectability of the men who began to consolidate its gains. Both the painter and his patrons avoid excesses. Ostentatious poses become less frequent. Now when Hals paints an arm akimbo he seldom attempts to create the illusion that his model's elbow pokes out beyond the frame into the spectator's world; the arm turns so that it is parallel to the viewer. Clearly in some circles it had become bad form to push.

The new conservatism did not deprive Hals' portraits of their spontaneity and immediacy. Nothing, it seems, could do that. He continued to achieve these qualities, but by more subtle means. The exuberance and movement of the earlier works are calmed, and gay genre subjects virtually disappear from his *oeuvre*. One of the last paintings of a genre-like character is his portrait of *Daniel van Aken* (Plate 211), who is shown as a joyful violinist. The identification of the sitter is based on an inscription on a pen drawing of the painting made in 1655 by Matthys van den Bergh (Fig. 159). If the copy can be trusted, the painting has been cut on all four sides and a swatch of drapery once decorated the background. The portrait has been heavily restored, which makes it difficult to assign it a secure date, but in my view Valentiner placed it too early when he grouped it with the genre paintings made around 1629–30. Trivas suggested a date of about 1634 on the basis of the costume but this same evidence can be used to date the portrait as late as 1640.

154

We are on firmer ground when we turn to Hals' 1641 collective portrait of the *Regents of the St. Elizabeth Hospital* (Plate 226), which indicates the direction his art was to take during the following years. The gaiety of the early group portraits of men gathered around a banquet table has been appropriately replaced by a new dignity and sobriety. An unspecified business matter, not a spectacular performance of eating and drinking, is the order of the day; an inkpot has replaced the *roemer*, and a ledger, instead of a dish of oysters, is found on the table. A few coins lying before the regent seated on the right probably identify him as the treasurer of the group. The mild light, which enters the room through a side window, illuminating the map on the wall and focusing on the faces and hands of the regents, lends an intimate quality to the scene. This chiaroscuro effect may reflect the influence of Rembrandt on the mature Hals, but dark shadows do not predominate as they would in a Rembrandt painted around 1640. There is still a brightness that recalls Hals' own earlier paintings. The dominant colour harmony, however, has become almost monochromatic, showing a subdued accord of blacks, greys, olive greens and golden browns, with only a few accents of pure colour.

Hals also abandoned the device he had used in his early group portraits of making some of his models appeal directly to the beholder. Here not one of the five regents has been related to the spectator. On the other hand Hals did not create an inner unity between them by focusing their attention on a common action. Some of the regents glance at the man seen from the back in the front plane, but the latter appears quite unaware of their attention. Yet a bond has been established between the men by the subdued accentuation of their finely characterized heads and their lively hands. The position of the head of the regent seen in profile (Plate 225) appears as casual as the subtly observed position of his little finger resting on the edge of the table. We sense that as soon as he turns toward his colleagues the group will concentrate as one man on their agenda.

Though Hals' 1641 regent portrait was apparently one of the earliest painted at Haarlem, such corporation pieces had been made in Amsterdam since the end of the sixteenth century. Hals may have turned to those painted there for ideas when he received the commission. One that is related in mood and composition to Hals' group is the little oil sketch Thomas de Keyser painted in 1638 of *Four Burgomasters of Amsterdam Receiving News from a Counsellor of the Arrival of Maria de Medici* (Mauritshuis, The Hague), which was engraved in reverse by the Haarlem printmaker Jonas Suyderhoef (Fig. 160). Similarities between the engraving and Hals' regent piece suggest that Hals took more than a passing glance at the print. Hals had close contact with Suyderhoef, to whom he was distantly related (Suyderhoef's brother married his niece, the daughter of Dirck Hals). We have already mentioned some of Suyderhoef's engravings done after Hals' works of the 1630s. In all, sixteen are known; no other seventeenth-century graphic artist made as many. If De Keyser sent his little panel to Haarlem to be engraved it is not difficult to imagine Suyderhoef and Hals discussing the merits of the Amsterdam painter's little composition in the print-maker's studio. It is not far-fetched to suggest that the oil sketch was transported to Haarlem for Suyderhoef's convenience. The architectural painter Dirck van Delen shipped his panels over a much greater distance when he sent them from Zeeland, the southern-most province of

EFFIGIES NOBILISSIMORUM ET AMPLISSIMORUM DD. CONSULUM QUI REIP. AMSTELODAMENSI PRÆFUERE TUNC,CUM EORUM MANDATO ADVOCATUS CORNELIUS
A DAVELAER,D.IN PETTEN,EQUITATUS PATRITII PRÆFECTUS,CHRISTIANISSIMAM REGINAM MARIAM DE MEDICIS,EANDEM URBEM IN GREDIENTEM,DEDUXIT.
D. ANTONIUS OETGENS *van Waveren,*　　D.ALBERTUS CONRADI BURGH,*nuper ad*　　D.PETRUS HASSELAER,　　D.ABRAHAMUS BOOM, *in*
equit.Dominus in Waveren, Bethsholl, Rugewillis, &t　　　*magnum Moscoviæ Ducem;jam nunc ad Daniæ Regem Legatus.*　　　*Militiæ Urbicæ Tribunus.*　　　*Confesfou illust.DD.Hollandiæ ac Westfris.antehac delegatus.*
Keyser pinxit　　*I. Suyder hoef sculpsit.*

Fig. 160. Jonas Suyderhoef: Engraving after Thomas de Keyser's *Four Burgomasters of Amsterdam Receiving News from a Counsellor of the Arrival of Maria de Medici*

the Netherlands, to Haarlem, where Dirck Hals painted figures in Van Delen's fanciful interiors.

In his little painting of 1638 De Keyser followed the Amsterdam predilection for full-length group portraits. The counsellor, who has just entered the room with news of Marie de Medici's arrival, was the commander of the guard of honour that escorted the Queen Mother into the city. Two of the burgomasters seated at the table appear to concentrate on his message; the other two seem to have been struck dumb by the news or are too phlegmatic to respond. When Hals painted his regent piece three years later, he made no attempt to show his figures reacting to a single, specific event, and unlike De Keyser, he chose – or was commissioned – to make a three-quarter-length group portrait, not a full-length one. But he did seem to be impressed by the way De Keyser grouped four seated figures around a table. As we would expect, Hals made variations on the Amsterdam artist's invention but the correspondences in the general arrangement of the seated men, particularly the position of the man seen in profile from the back, can hardly be accidental.

The reader will have noticed that profile portraits are rare in Hals' *oeuvre*. In none of his paint-

set upon the crown of the hat resting on his lap. His legs are spread and one senses that his feet are firmly placed on the ground – but if given the chance, he is ready to spring. His vivacious wife appears quite satisfied with her lot. Her colossal collar, sleeves and cuffs, her gold embroidery and silver ribbons, her open skirt, which shows a panel of greenish-gold watered satin, all make clear she took great pleasure in dressing fashionably. Her costume was the *dernier cri* in Holland around 1645–50. Apparently she was also more informal – or perhaps more at ease – than many of her countrywomen; she evidently did not object to being depicted seated sideways with one arm hooked over the back of her chair. Hals used a similar pose for a few other portraits of women made about the same time (Plates 265, 289). This casual attitude was once reserved for the gay women who appear in little genre pictures by Buytewech and Dirck Hals, but Frans Hals dared employ it for commissioned portraits.

More traditional were the poses the artist used in 1644 for the half-length pendants of *Joseph Coymans* (Plate 243; Hartford, Wadsworth Atheneum) and his wife *Dorothea Berck* (Plate 244; Baltimore Museum of Art), but Hals breathes new life into the well-tried portrait formulae with the rich pictorial effects he achieved with his restricted palette, his original technique and the variations he made on the conventional schemes. Coymans' massive head turns toward us creating the impression of arrested movement. He has been placed a bit to the left of the vertical axis of the picture yet the composition remains perfectly balanced. The light-yellow accent of his gloved hand, which darts out of the sling he has made of his cape, counterbalances the large light areas of his face, his collar and the reflections glistening over his figured black satin costume. The warm tones of the subtle gradations of his ruddy face are set off by the delicate cool greys of his hair and white collar. A muted play of warm and cool colours is also found in the grey background, which is close in value to the black of his cape and hat, softening the transition between the bulk of his figure and the space around him. Coymans' short-brimmed hat cannot form the kind of sweeping silhouette made by the tremendous hats worn by Hals' earlier patrons. His long hair makes an easy transition to his linen collar, which follows the line of his shoulders – by the time Hals painted this portrait, most Dutchmen, like their wives, abandoned the fashion of collaring themselves in projecting millstone ruffs – and his stylish cape has been pulled straight and taut by the weight of his arm.

The portrait of his wife *Dorothea Berck* (Plate 244) has even more simplified outlines. Her firm, upright figure has been organized into a classic pyramid shape, and the horizontal accents of her cuffs and hands emphasize the stability of the symmetrical composition. This pictorial arrangement suggests that for the moment Hals was one of the Dutch artists impressed by Italian Renaissance portraiture. When the portrait was painted, a classical revival, or, to put it more precisely, yet another classical revival, was underway in the Netherlands. Architects had paved the way for a new interest in the work of Renaissance masters; painters soon followed suit. Paintings by Titian and works attributed to him were collected and studied. Raphael's *Portrait of Baldassare Castiglione* caused a flurry in the Amsterdam art market when it was auctioned there in 1639. Rembrandt copied it at the sale and the portraits he made in the following years show the

impact of Raphael's method of composing. We also know that Rembrandt owned an important collection of prints by Italian Renaissance masters and of engravings after their works. He borrowed motifs from them and soon after 1640 began to incorporate aspects of their simplicity and monumentality into his work.

There is no reason to believe that Hals shared Rembrandt's passion for collecting or possessed his urge to assimilate qualities of High Renaissance art into his own personal style. On the other hand, it is unlikely that a glimpse of a Renaissance portrait would not have briefly stimulated him as much as an engraving after a Thomas de Keyser. But try as he might, Hals could never repress his urge to show fleeting aspects of life. A Renaissance portraitist would have found the hooked position of Dorothea Berck's gloved forefinger too transitory for a commissioned portrait (Plate 246). That tiny detail would also have disturbed Leonardo, who wrote: 'It is the extremities of all things which impart to them grace or a lack of grace.'

Hals did not lose touch with the Coymans family after he had painted these pendants in 1644. In the following year he made a portrait of a smart young man who belonged to the family (Plate 253; National Gallery, Washington). The precise identification of this model is difficult to establish because the inscription giving his age has been tampered with, apparently to make it agree with the age of Balthasar Coymans, the eldest son of the couple. However, there can be no doubt that this grey-eyed dandy is a young Coymans; Hals himself painted the family coat-of-arms on the portrait. The family's armorial bearings are canting arms or *armes parlantes*, a type that alludes to the name of the bearer and was often adopted by the *nouveaux riches* around this time. They are in full agreement with the family name: Coymans = *Koeymans, Koey, Koei*, now written *Koe*, the Dutch equivalent for 'cow.'

More secure is the identification of the portrait Hals painted around 1650–52 of *Isabella Coymans* (Plate 291; Paris, Baronne Edouard de Rothschild), the youngest daughter of Joseph Coymans and Dorothea Berck. It is a companion piece to the portrait of her husband *Stephanus Geraerdts* (Plate 290; Antwerp, Musée Royal des Beaux-Arts). Isabella married Stephanus on October 4, 1644, and the refined pendants which Hals painted of her parents were made perhaps for her new home. There was once again contact between Hals and a Coymans when the artist and his occasional collaborator Pieter Molyn appraised pictures owned by Conraet Coymans at Haarlem in 1660. It has not been possible to determine Conraet's relationship to the family, but the five existing portraits Hals made for it, which are now scattered in American and European collections, provide additional evidence that the aging master continued to receive commissions from the patrician class.

Assignments also came from other quarters. Johannes Hoornbeeck (Figs. 258, 260), a twenty-seven year old professor of theology at Leiden University, selected the artist to paint him in his academic robes, with book in hand. Hoornbeeck chose well: he received one of the best portraits of the 1640s. At least one swaggering painter (Plate 251) and a small group of elegant young men also found Hals' style of this period appealing. The 1645 portrait of an unidentified Coymans (Plate 253) belongs to the latter group, as does the nonchalant *Portrait of a Man* (Plate 256) now at

160

the National Gallery, Washington, which was incorrectly called 'Francis Halls, Sir Godfrey Kneller's Master, a Head by himself' when it was in the Walpole collection at Houghton Hall. The painting was acquired as a self-portrait of Hals by Catherine's agents when they purchased the magnificent Walpole collection for the Russian Empress in 1779. The letter which 'C.D.' wrote to the editors of *The European Magazine* in February, 1782, after this sale shows there is good precedent for the consternation heard today when great works of art leave England:

> 'The removal of the Houghton Collection of Pictures to Russia is, perhaps, one of the most striking instances that can be produced of the decline of the empire of Great Britain, and the advancement of our powerful ally in the North. The riches of a nation have generally been estimated according as it abounds in works of art, and so careful of these treasures have some states been, that, knowing their value and importance, they have prohibited the sending them out of their dominions. . . . That so noble a collection could not be retained in England, is a very humiliating and deplorable proof of the beginning poverty, and want of taste, in the people; and seems to indicate a relapse to the state of barbarism, from the reproach of which the great influx of wealth, and the consequent cultivation of the arts, during half a century, had redeemed us.'

The author of the letter was particularly disturbed by the loss of Guido Reni's *Doctors of the Church Consulting on the Immaculateness of the Virgin*, not by the departure of Hals' so-called self-portrait. But he found the entire affair shameful:

> 'Considered in a national point of view, the object was of sufficient important to claim the attention of the legislature, that the disgrace attending the loss of so many monuments of taste, which have so long done honour to the kingdom, might have been prevented.'

Jasper Schade van Westrum (Plate 261) was another young patrician who sat for Hals around 1645. He was Lord of Tull and 't Waal and was later to serve as deacon of Oudmunster at Utrecht, as a representative to the States-General and as president of the Court of Utrecht. Hals' firm control of the pictorial organization of the portrait and his penetrating characterization of his model convince us that Jasper was a vain and proud peacock. This impression is supported by a contemporary report that Jasper spent extravagant sums on his wardrobe. A subtle emphasis on verticality in the portrait contributes to the model's haughty air – not that a stress of upright forms need always express arrogance, but here it certainly does. The upturned brim of his hat and the straight arrangement of his long hair accentuates the length of the face of a man capable of looking down at people below his station (Plate 263). And, while thin, frail bodies may contain the most noble of spirits, this one hardly inspires confidence in its inner strength. As dazzling as Hals' appraisal of his model are the zig-zag and angular strokes which suggest the nervous dance of bright light on his green taffeta jacket while creating an electrifying movement on the picture

Fig. 163. Cornelis Jonson van Ceulen:
Jasper Schade van Westrum. 1654.
Rotterdam, J. A. Grothe van Schellach

surface (Plate 262). The same model was portrayed in 1654 by Cornelis Jonson van Ceulen (Fig. 163). His dress is still elegant, the pose is similar but a juxtaposition of the two works shows the difference between talent and genius.

The demand for Hals' small portraits did not wane during the 1640s. Some of them continued to serve as modellos for engravings while others were most likely made as little cabinet pieces designed for private enjoyment. The portrait of a stern, swarthy *Man with a Cane* (Plate 235; Washington, D.C., George L. Weil) dated 1643 and the poignant one of a *Seated Man Holding a Branch* (Plate 236; Ottawa, National Gallery of Canada) apparently belong to the latter category; no engravings after them are known. Their dark tonality and sober mood anticipate Hals' final phase. The two small male portraits at Cassel (Plates 237, 238) raise questions similar to the ones we considered in connection with the little portrait at The Hague (Plate 140) and the unusual miniature pair now at Dresden (Plates 141, 142), which were painted about a decade earlier. Were they commissioned by two men who were friends and intended to be seen as companion pieces or were they preliminary oil sketches for an unrealized or lost group portrait? In either case they would be exceptional; male pendant portraits are almost as rare in seventeenth-century Dutch painting as are preparatory studies in Hals' *oeuvre*.

162

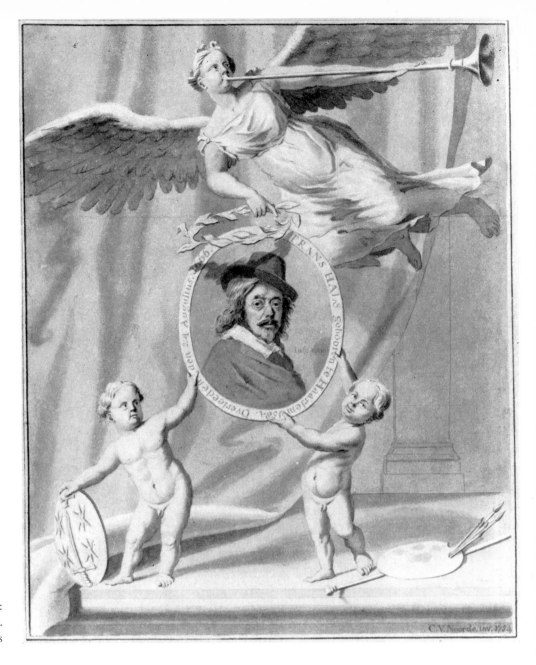

Fit. 164. Cornelis van Noorde:
Apotheosis of Frans Hals. 1754. Watercolour.
Haarlem, Municipal Archives

Hals also painted a small portrait of himself around the end of the decade. The original is un-
traceable, but a number of copies of it are known; the best is in the Clowes Collection, Indiana-
polis, Indiana (Fig. 2). Doubts about its being a portrait of the artist are unjustified. It bears a
resemblance to his self-portrait in the group portrait of 1639 (Fig. 1), and the many existing ver-
sions of it indicate that the tradition that it is a self-portrait is an old one. The earliest known dated
reference to it as a self-portrait is found on a water-colour of 1754 by the Haarlem artist Cornelis
van Noorde (Fig. 164), which shows the work, inscribed '*ipse pinxit*,' in an oval frame supported
by two putti, one bearing the arms of Haarlem, the other with a palette at his feet, as a winged
figure of Fame blows her trumpet and crowns the portrait with a laurel wreath. Van Noorde's
Apotheosis of Frans Hals was touching but not very effective. The blast Van Noorde's Fame blew
on her trumpet for the artist was not often heard beyond the town of Haarlem around the middle
of the eighteenth century. Van Noorde also made a mezzotint after the self-portrait, inscribed
'*ipse Pinxit . . .*' and dated 1767, and other drawings and water-colours after Hals' works. Perhaps
he tried his hand at making paintings after them too. When more light is thrown on the activities
of eighteenth-century Dutch artists it would not be a surprise to discover that some nameless
painted copies after Hals' works were done by Van Noorde.

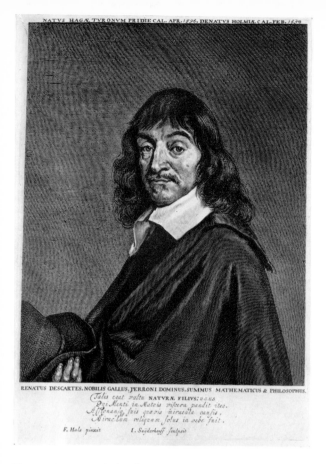

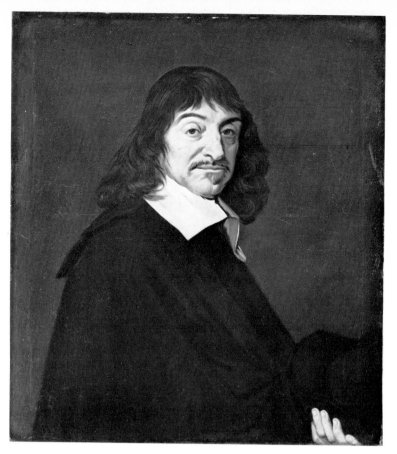

Fig. 165. Jonas Suyderhoef: Engraving after Hals' *Portrait of René Descartes* (Plate 264). 1650

Fig. 166. Copy after Hals' *René Descartes*. Paris, Louvre

A score of artists – among them Rembrandt, Jan Lievens and Jan Baptist Weenix – made portraits of René Descartes but the image of the French philosopher most firmly fixed in the public's mind is the one by Hals, which can be dated in the late 'forties. The many versions of it have been frequently discussed. In my view, the original is the small oil sketch at Copenhagen (Plate 264) which served as a modello for Jonas Suyderhoef's fine 1650 engraving (Fig. 165) while the others are copies either after this little painting or the print. The absence of space around the half-length figure indicates that the panel was cut down at a later date. Moreover, it is hard to imagine that Hals, even in a sketch, would have painted merely the tips of three fingers. Maybe these feeble fingers were added after the panel was cut; possibly they are the work of the restorer who repainted the bad scratches on the surface of the painting.

The *terminus ante quem* for the portrait is September, 1649, when Descartes boarded a ship for Sweden and entered the service of Queen Christina after spending two decades in Holland. His decision to leave was much regretted by his Dutch friends. One of them was the philosopher Augustijn Bloemaert, a Catholic priest of Haarlem, who asked for a portrait of Descartes so that he could find 'quelque légère consolation dans la copie d'un original dont il risquoit la perte.' It has been suggested that the Haarlem priest commissioned Hals to make the small portrait of his most famous model.

Descartes' stay in Sweden was brief and tragic. After his arrival he must have thought of the reservations he himself had expressed about going 'to live in the land of bears among rocks and ice.' Queen Christina insisted upon an hour of instruction in philosophy every morning at five, an uncongenial hour for most people and an unconscionable one for Descartes, who as a boy had acquired the life-long habit of spending his mornings in bed. We have no way of establishing

164

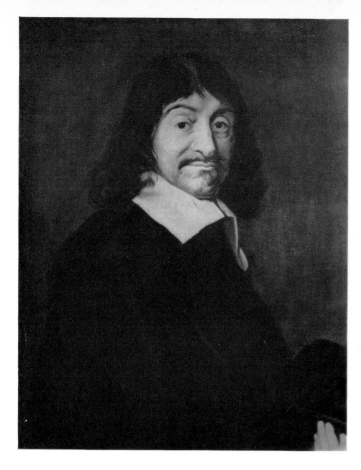

Fig. 167. Copy after Hals' *René Descartes*. Hälsingborg, Museum

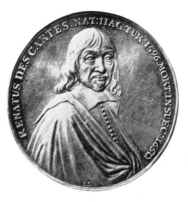

Fig. 168. Medal of Descartes, after Hals' portrait. About 1685. The Hague, Koninklijk Penningkabinet

whether or not Stockholm's early morning air affected him adversely, but late in January, 1650, he caught a bad chill, and died on February 11 of the same year. Descartes was internationally mourned, a fact that helps explain the number of portraits made of him soon after his death; judging from the number made during the following decades, the demand for them increased rather than diminished.

The best known versions of Hals' portrait are the life-size ones now at the Louvre (Fig. 166) and at the Hälsingborg Museum (Fig. 167). Neither has the psychological power, the vigorous touch or decisive modelling of the Copenhagen sketch. Though the artist who made the Louvre painting was timid, he seems to have had a better understanding of Hals' technique than the man who painted the Hälsingborg portrait. But the latter had a more sensitive grasp of Descartes' personality – or, to be more precise, of Descartes' personality as seen by Frans Hals. He captured more of the lively expression Hals gave the philosopher and something of the intense, penetrating glance which, Alain wrote, seemed to say 'encore un qui va se tromper.'

Other painted and many engraved copies based on Hals' portrayal, as well as a medal struck in Descartes' honour after his death (Fig. 168), offer testimony to the popularity of the portrait. The difficulty of ascribing names to the artists who made painted copies of it is underlined by a reference to an unfinished one by the Haarlem genre painter Cornelis Dusart in an inventory of his effects compiled in 1704. Dusart's portrait of Descartes had to be a copy; he was born a decade after the philosopher had died. We cannot tell whether his copy was subsequently finished by another hand and is one of the existing versions after Hals' original. However, it is safe to assert that, if we did not have the 1704 inventory reference, even on their wildest flights of fancy not many specialists of Dutch painting would suggest that Dusart, best known as a clownish follower of Ostade and Steen, made a portrait of the founder of modern rationalism.

Fig. 169. Jan Lievens: *René Descartes*. Black chalk. Groningen,
Museum voor Stad en Lande

Fig. 170. Jan Baptist Weenix: *René Descartes*. Utrecht,
Centraal Museum

How accurate is Hals' portrayal of Descartes? Such a question does not permit a categorical answer; when it is asked about portraits by old masters the crucial evidence, the model himself, is missing. Without the *corpus delicti* there can be no case. Common sense tells us that contemporary reports about the accuracy of a likeness are difficult to appraise; in addition, they are often contradictory. Even an avowal as strong as the one Cardinal Bembo made when he said that 'the portrait which our Raphael has made of Tebaldeo is such an amazing likeness that it is even more like him than he is himself' must be taken with a grain of salt. After all, we ourselves have not seen Tebaldeo. What in one man's opinion is an 'amazing likeness' in another man's view may be a portrait that 'does not look like him at all.' Nevertheless, the question of the quality of a likeness always lurks when a portrait is examined and the more famous the model, the larger the question looms.

It is not without interest to see how some of Hals' contemporaries portrayed Descartes. A lively chalk drawing Jan Lievens made of him is at Groningen (Fig. 169) and Jan Baptist Weenix's painting showing the philosopher holding a book inscribed '*Mundus est fabula*' is at Utrecht (Fig. 170). We would give much to see the lost brush drawing which Rembrandt made of Descartes and which was in the enviable collection Valerius Röver assembled at Delft of Rembrandt's works early in the eighteenth century. In an article published in 1957–58, Johan Nordström rightly attributed a portrait of Descartes to Frans van Schooten the Younger (Fig. 171), a distinguished mathematician and devoted Cartesian, who was not without artistic gifts (his uncle was Joris van Schooten, a Leiden artist who according to an old but unsubstantiated tradition was one of Rembrandt's teachers). Van Schooten's portrait, which the inscription tells us was drawn and engraved in 1644, merits special attention. Nordström has shown that Van Schooten's pupil, the mathematician and physicist Erasmus Bartholinus, considered it a superior likeness of

166

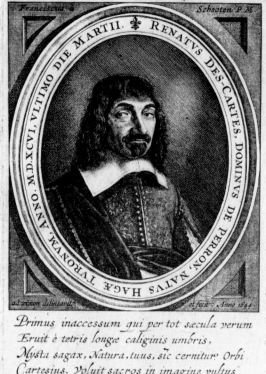

Primus inaccessum qui per tot sæcula verum
Eruit è tetris longæ caliginis umbris,
Mysta sagax, Natura, tuus, sic cernitur Orbi
Cartesius. Voluit sacros in imagine vultus
Jungere victuræ artificis pia dextera famæ,
Omnia ut aspicerent quem sæcula nulla tacebunt.

CONSTANTINI HVGENII F.^{IX}

RENATVS DESCARTES.

NOBILIS GALLVS, PERRONI DOMINVS, SVMMVS MATHEMATICVS ET PHILOSOPHVS.
NATVS HAGÆ TVRONVM PRIDIE CALENDAS APRILES 1596. DENATVS HOLMIÆ.
CALENDIS FEBRVARIIS 1650.

C. V. Dalen sculp. Sign. Merh. excudit.

Fig. 171. Frans van Schooten the Younger: Fig. 172. Cornelis van Dalen: *René Descartes.*
René Descartes. 1644. Engraving Engraving

Descartes. In a letter dated June 2, 1650, Bartholinus wrote to a friend abroad: 'I am sending a portrait of Mr. Descartes which represents him exactly according to nature, as far as I and others can judge. So far I have been unable to obtain more specimens of it, as its author has had only 100 copies printed, of which two have fallen to my lot; if I can get more later, I will send them with pleasure.'

The passage not only establishes Bartholinus' high estimate of Van Schooten's likeness, but is also one of the rare references to the size of an edition of a seventeenth-century Dutch engraved portrait. In the same letter Bartholinus adds that Descartes '. . . has been engraved here in copper twice more, and this with stately appearance [or perhaps: in imposing size], also with excellent skill, but as they [*viz.* these engravings] do not at all express the features of Descartes I have not thought it worth while to send them.'

Nordström has shown that the two engravings Bartholinus referred to are those by Cornelis van Dalen (Fig. 172) and the close copy Jonas Suyderhoef (Fig. 165) made after Frans Hals' modello. Thus, according to a contemporary who had contact with Descartes the likeness Hals made of the philosopher was poor.

Was Bartholinus' appraisal a fair one? Or was he wittingly or unwittingly prejudiced in favour of the portrait made by his own teacher, who was a faithful commentator, translator and disciple of the recently deceased philosopher? In my opinion we shall never know.

However, it is evident that Bartholinus' brief critical comments permit more than one interpretation. On the basis of Bartholinus' rejection of the engraving after Hals' portrait as a good likeness Nordström has argued that there is good reason to believe that Descartes never sat for Hals, and that his portrait 'is practically a creation of the artist's imagination, probably with Van Schooten's engraving as its only basis.' Nordström has also suggested that Hals' portrait was

167

Fig. 174. Detail of inscription from Fig. 173

Fig. 173. Jan Hals: *Portrait of a Man*. 1648. Frederikstad, Norway,
Mrs. Hans Theodore Kiaer

possibly a posthumous one, painted 'on the instigation of his friend and relative Suyderhoef who, for the benefit of both, wanted to exploit the situation created by Descartes' death.'

Now, while it is clear that in Bartholinus' opinion Hals did not make a satisfactory portrait of Descartes, one cannot place full reliance on an acquaintance's estimate of what is or is not an exact likeness. Even in these days of photography there can be sharp disagreement among friends on the subject. It is also significant that Hals' portrayal, not Van Schooten's, was the one which was most frequently copied after Descartes' death and was used as a model for the portrait on the obverse of the medal (Fig. 168) struck around 1685, which the reverse tells us is dedicated to 'The prodigy of the Universe whose acute spirit enabled him to investigate the mysteries of Nature.' Finally, it is difficult to accept the hypothesis that Hals' portrait was based on Van Schooten's engraving. The point is a critical one. In my view, if it was based on the print, Hals would have made a much more faithful transcription of the physiognomy depicted by the amateur engraver. I find it more reasonable to conclude that the differences between the two portraits are a result of the radically different talents of the artists, as well as of their different conceptions of their model, than to maintain that Hals was either unable to make an accurate oil sketch after a print or that he was inclined to let his imagination run away with him when he was commissioned to make this portrait.

If there are substantial reasons for doubting that Hals copied Van Schooten there is ample evidence that the artist's mature as well as his early paintings were copied during his lifetime. It has also been possible to identify portraits by at least one artist who imitated Hals' style of the 1640s so closely that his works have been erroneously attributed to the master. This faithful follower was his son Jan.

Jan Hals is not unknown in the literature but until recently it has never been noted how

168

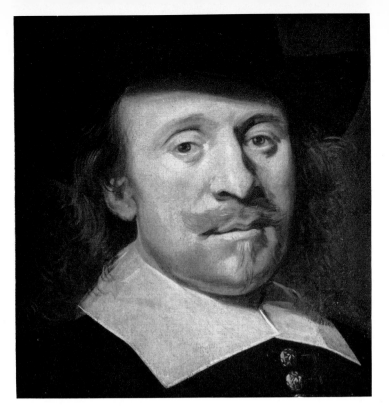

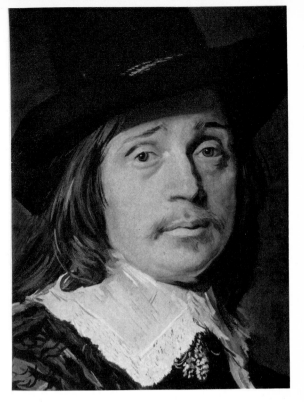

Fig. 175. Detail from Fig. 173

Fig. 176. Frans Hals: Detail from *Portrait of a Man*
(Plate 257). About 1645. Bielefeld, Germany, August Oetker

similar some of his portraits are to those his father made during this decade. Jan's other claims to fame are hardly weighty. He travelled to Rome, where he joined the fraternal organization of Netherlandish artists called the *Bentveughels*. Like all members of the *Bent* he was given a nickname: he was dubbed 'Jan de Gulden Ezel' (Jan the Golden Ass). He also painted religious and allegorical pictures and won praise from Vondel for his painting of Homer – a distinction his father never achieved. This is not astonishing, however; Vondel may have been the greatest Dutch poet of the time but he was blind to the achievement of contemporary Dutch painters. It is characteristic of him to have dedicated a poem to the Homer painted by Jan the golden Ass, but to remain silent about the classical subjects painted by Rembrandt.

The year of Jan's birth has not been established; but a group of pictures show that by the late 'thirties he had developed his own style as a genre painter, specializing in little views of kitchens and inns populated by a curious race of dwarf-like people. A few of his rare drawings have an affinity with some problematic ones sometimes attributed to Vermeer. Here we are concerned with his portraits and their relation to his father's. Examination of them throws light on the supreme qualities of Frans Hals' originals of the 1640s.

A key work for the identification of paintings done by this deceptively close follower of the artist is the *Portrait of a Man* (Fig. 173; Frederikstad, Norway, Mrs. Hans Theodore Kiaer) which was erroneously published in 1914 by Bode and Binder as a signed and dated Harmen Hals. It is, in fact, unmistakably signed and dated: 'Jan Hals 1648' (Fig. 174). The pose is similar to those Frans Hals used during the 'forties for some of his half-lengths, and the work has the characteristic restraint and subdued tonality of Frans' originals of this phase. A detail of the sitter's head (Fig. 175) gives a good idea of Jan's level, and a comparison of it with one done by Frans around the same time (Fig. 176) shows how faithfully he imitated his father. The disposition of light and dark areas is virtually identical; a one-to-one correspondence can even be established between some of the shadows and highlights. But the differences are equally clear. Jan's touch is

Fig. 177. Detail from Fig. 173

Fig. 178. Frans Hals: Detail from *Joseph Coymans* (Plate 243). 1644. Hartford, Connecticut, Wadsworth Atheneum

never as fluent or spontaneous as his father's. This becomes particularly evident when passages in the hair are compared. At first view the brush strokes in Jan's picture appear to resemble his father's free touch but the lively accents are missing. There is little variety in the length and width of Jan's strokes; they tend to remain on the surface of the canvas without suggesting forms in space or creating pictorial movement.

Differences between father and son are made even clearer when the gloved hand in the Frederikstad portrait (Fig. 177) is seen next to one Hals painted in 1644 (Fig. 178). Superficially the resemblance is close; however, Jan never matched the liveliness of Frans' incisive brushwork and did not respond to the sheer joy of allowing paint to flow upon a canvas. A characteristic of Frans Hals' original works is the delicate balance maintained between a delight in paint *qua* paint and the solidity of the forms. The three long strokes Jan painted on the right side of the glove his sitter holds have not been integrated into the form of the glove. With Frans it is different. In Frans' picture it may be difficult to make out what the three large diagonal strokes above the thumb and forefinger represent, but the fourth one clearly and decisively defines a knuckle. As soon as there is a possibility that the brushwork could be interpreted as a flat pattern Hals changes the size of a stroke or makes a marked shift in value to help define the shape of the hand as well as the position and structure of the joint of a finger. The final effect of his rapid, rhythmical touch is the pulsating life of a hand in a glove.

Some signed paintings by Jan Hals have escaped attention – or have passed as works by Frans Hals – because Jan's monogram is very similar to his father's. Jan's monogram is a connected 'I' and 'H' (Fig. 179). The dot over the first vertical bar of the monogram is clearly visible. Psychologists, as well as art historians, will be interested to learn that monograms on pictures which clearly read 'I H' have been read 'F H.' The case can be complicated by unscrupulous people who

170

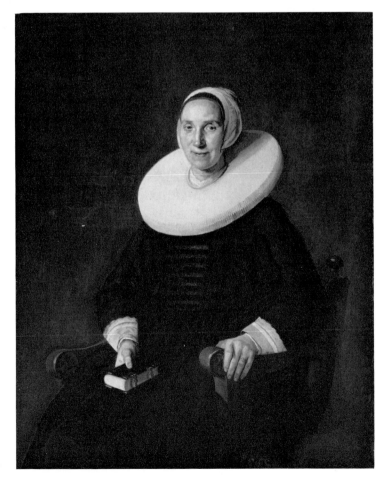

Fig. 179. Jan Hals: Detail of inscription from Fig. 180

Diagram

have little faith in our ability to look at pictures without preconceived ideas. A slight adjustment in the son's monogram can transform it into his father's more famous one. As the diagram above shows, the operation is simple: remove a dot from Jan's monogram, add a horizontal bar and serif and – presto – a valuable Frans Hals monogram is created.

The Jan Hals inscription reproduced in figure 179 is on the *Portrait of a Seated Woman* (Fig. 180), dated 1648, at the Museum of Fine Arts, Boston. J. G. van Gelder was the first scholar (1954) to recognize that the monogram read 'I H' not 'F H' and to attribute the work to Jan Hals. Before his discovery even the most severe critics of Hals' works accepted the attribution to Frans. With close examination, or to put it another way, with the benefit of hindsight, the Boston *Portrait of a Seated Woman* fails in drawing and, except for passages in the face, lacks solidity of form.

Fig. 180. Jan Hals: *Portrait of a Woman*. 1648.
Boston, Museum of Fine Arts

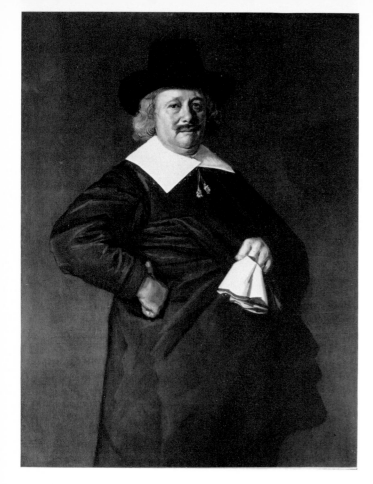

Fig. 181. Jan Hals: *Portrait of a Man*. 1648.
Toronto, Art Gallery of Toronto

Another picture which has been called a signed Frans Hals in earlier catalogues of Hals' works, but which is in fact inscribed with Jan Hals' monogram and dated 1648, is the *Portrait of a Man* (Fig. 181) in the Art Gallery of Toronto. It is most likely the companion piece to Jan Hals' *Portrait of a Woman* at Boston. The Toronto painting was stolen in 1959 but is now safely back in the museum. Will the thief feel sorely cheated when he discovers that he purloined a monogrammed Jan Hals and not an original by Frans? The Toronto portrait also looks like a characteristic Frans Hals of the 'forties at first glance. However, the silhouette of this knee-length portrait is flabbier than any Frans ever made. A juxtaposition of the head of the sitter (Fig. 182) with one painted in 1644 by the master (Fig. 183) makes the differences clearer. Jan's work, as always, lacks the richness of his father's. This is seen in every aspect of the work – the expression, the play of light on the sitter's head, the vivid brushwork and the fine contrast of warm and cool tones. Comparison of the collars is instructive. Jan's has a dull, flat surface and monotonous hard edges. In Frans' there is a subtle modulation of greys and whites; bold hatching and a few angular strokes help mark the difference between the weight and transparency of the bold expanse of the collar and its border. The right side of the collar painted by Frans flaps up off the model's chest; it would appear lifeless if it were perfectly aligned with its mate. Jan was insensitive to such subtleties.

A third work that has been ascribed to Frans Hals but which should be attributed to Jan is the *Portrait of a Man* (Fig. 184), dated 1644, now in the North Carolina Museum of Art, Raleigh. The monogram in this painting appears to have been adjusted to look like Frans Hals' well-known one (Fig. 185). It shows both the dot over the 'H' used by Jan and the horizontal bar Frans employed to represent his initial 'F.' It is possible that Jan Hals devised a monogram for his full name, Jan Franszoon Hals. If he did, it could look like the monogram in Fig. 185. But that was not the case here; an ultra-violet examination of the Raleigh picture revealed that the top part of the 'F' is a later addition.

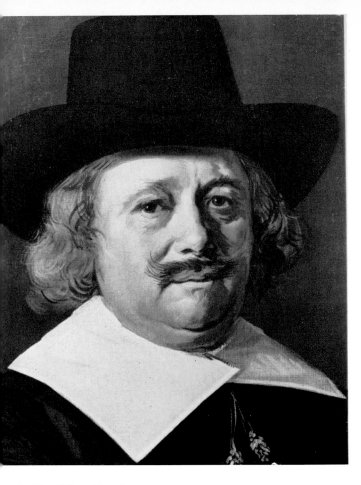

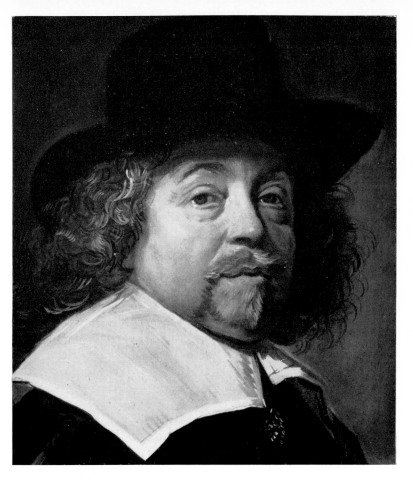

g. 182. Detail from Fig. 181

Fig. 183. Frans Hals: Detail from *Joseph Coymans* (Plate 243). 1644.
Hartford, Connecticut, Wadsworth Atheneum

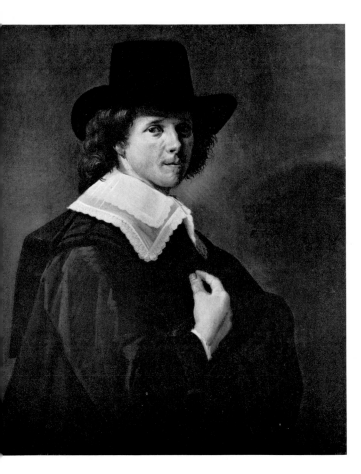

ig. 184. Jan Hals: *Portrait of a Man*. 1644. Raleigh, North Carolina,
orth Carolina Museum of Art

Fig. 185. Jan Hals: Detail of inscription from Fig. 184

Portraiture: 1640-1650

Even genuine signatures and monograms on seventeenth-century Dutch pictures cannot be accepted as conclusive evidence of authorship. Frans could have signed a picture painted by his son and the opposite case is not out of the question. The final test must always remain the character and quality of the painting itself. In the Raleigh picture the unconvincing bulk of the sitter's body, the bumpy silhouette of the figure, and the clumsy hand make one suspect an attribution to the master. A juxtaposition of a detail of the portrait (Fig. 186) with a detail from a painting made by Frans Hals a year earlier (Fig. 187) supports the conclusion that the Raleigh portrait is another example of Jan Hals' conscientious but uninspired honesty, and not of his father's animated light passages, subtle gradations and sparkling accents.

Among the most important commissions Hals received during the second half of the decade are the two life-size, full-length family portraits which are now in the National Gallery in London (Plate 272) and in the Thyssen-Bornemisza Collection at Lugano–Castagnola (Plate 279). They are the only existing works which show the artist's accomplishment as a group portraitist between the time he painted the *Regents of the St. Elizabeth Hospital* in 1641 and his late masterworks, the *Regents* and *Regentesses of the Old Men's Alms House.*

It has been suggested that the father portrayed in the National Gallery family group is either the man who posed for the Budapest portrait made in the following decade (Plate 304) or the man traditionally identified as Mattheus Everswijn in Hals' *Regent* piece of 1664 (Plate 340; the regent called Everswijn is the second figure from the left). There is no consensus about either identification. One specialist who agrees that the father resembles Everswijn notes that it is hard to believe that the man aged so little in the years between the two pictures. This reservation is not irrelevant but we also know that Hals did not always make his sitters look their age. The seventy-three-year old man painted in 1643 traditionally known as Heer Bodolphe (Plate 231) is exceptionally well preserved. It has also been suggested that the male members of the London family group look Jewish. Physiognomy, however, is as unreliable an index of a man's religion or race as it is of his character. Moreover, it is doubtful if a seventeenth-century Jewish patron would have commissioned a life-size family portrait set in the countryside with cows at pasture, when his own activities were restricted to commerce or medicine in the city.

Marks of the original tacking edge of the canvas of the London family group can be seen along the sides of the original canvas but not at the top or bottom. This indicates that the large painting has been cut at the top and bottom; it probably also explains why the figures in the group portrait appear a bit crowded. Comparison of it with the Lugano *Family Portrait* (Plate 279), which shows a similar disposition of figures in a landscape, suggests that it has been cropped a bit at the bottom and a rather wide strip (about 15 or 20 inches in width) was cut from the top. If this hypothesis is correct, the National Gallery family group originally looked less cramped. In the portrait Hals accented the importance of the father. He occupies the central position and is encircled by six members of the large family, but as in the earlier groups, variety of pose and gesture as well as the bold brushwork, which becomes particularly animated in the violets and greens of the girls' dresses, create an effective variety of interest. Hals' earlier tendency to allow

Fig. 186. Detail from Fig. 184

Fig. 187. Frans Hals: Detail from *Paulus Verschuur* (Plate 247). New York, The Metropolitan Museum of Art

diagonals to play an important role in the organization of his design appears again here but it has been muted. The quality of the characterizations of the individual heads varies. None is as fine as the shy mother, who wears a costume which had been *à la mode* in her youth and who appears to have aged before her time (Plate 275). She is yet another example of the sensitive portrayals Hals made during this phase, which were overlooked by earlier critics, who pigeon-holed the artist as a swashbuckling Douglas Fairbanks of the brush whose principal gift was making portraits of boisterous clients of Haarlem's tavern-keepers.

The suggestion has been made that the baby held by the girl on the left is distinctly inferior to the other figures and may be the work of an assistant. However, I see nothing inconsistent between the way the baby is painted and Hals' style of the late 'forties. On the other hand, not a single brushstroke in the thick clump of trees or in the panoramic view of the hilly plain in the background shows Hals' fluid touch, while the ten figures offer a dictionary of the artist's mature brushwork. Here as before one could argue that Hals set off the family group from the landscape by deliberately using another technique, but again it is hardly likely that Hals could paint such a large surface without leaving a single trace of his highly personal brushwork. I endorse Neil MacLaren's observation that the landscape background is clearly by another hand and suggest that once again Hals chose Pieter Molyn as his collaborator. Analogies can be found in Molyn's work for the fan-like arrangement of the outermost foliage of the trees into a cluster of clumps, and even more characteristic is the treatment of the hilly panoramic view as a series of wedges, which Molyn first employed in his early phase (Fig. 188) and continued to use during his middle years.

The ample landscape background of the Thyssen-Bornemisza *Family Portrait* (Plate 279) can also be attributed to a co-worker and here too it is possible to recognize Molyn's style and touch. The young trees silhouetted against the sky and the distant panoramic view of the plain in Molyn's *Wayfarers on a Road* of 1647 (Fig. 189) show the hand that painted the feathery trees and flat landscape to the right of the girl in this *Family Portrait*. In spite of the significant differences in scale between the two pictures, close parallels can also be found in Molyn's landscape for the treatment of the branches and heavy foliage above the family group. Molyn, however, was not responsible for all the flora in the work. The fluid and economic brushwork of the plant in the lower left corner of the painting (Plate 280) belongs to Hals not Molyn. One can almost hear him say to Molyn: 'Piet, don't embroider leaves! Paint them like this!' His vigorous oil sketch of a plant is another of the rare details in his *oeuvre* which make us regret that the impulse to paint nature did not strike him more often.

Also of particular interest in the Thyssen-Bornemisza family group is the portrait of the young negro boy (Fig. 190) standing between the two women. The boy's role is a minor one and it is difficult to distinguish him in reproductions of the large painting – even in the original he virtually merges with the foliage behind him. This only makes the special attention the artist gave him more moving. It also gives us a clue to Hals' attitude toward his fellow men. Granted, it is dangerous to make generalizations about a professional portraitist's estimate of a client. Many un-

Fig. 188. Pieter Molyn: *Landscape*. Poznan, National Museum

Fig. 189. Pieter Molyn: *Wayfarers on a Road*. 1647. Haarlem, Frans Hals Museum

Fig. 190. Detail from *Family Group in a Landscape* (Plate 279). About 1648. Lugano-Castagnola, Collection Thyssen-Bornemisza

controllable and unmeasurable factors must be considered. A portraitist's view of humanity, like that of all of us, is in flux. His relation to his wife, his viscera or the burnt sienna on his palette can colour his view. Moreover, every model must needs produce a different response in a painter. The artist's will and his ability to transcribe that response must also be considered. Society's demands must be weighed and the beholder's role is an equally complex part of the intricate portrait transaction. With all this in mind, it is still possible to assert that a great humanity is apparent in Hals' portrait of the negro boy. A comparison of it with one painted by Hals' contemporary, the modish portraitist Abraham van den Tempel (Fig. 191), supports the claim. Hals' portrayal of the boy's dignity and reserve has nothing in common with van den Tempel's stereotype. Rembrandt, Rubens and Van Dyck also painted closely observed studies of negroes but it is noteworthy that in finished works by these masters they were often transformed into stock types.

The head of the other boy and of the girl in the Thyssen-Bornemisza *Family Portrait* are equally sensitive (Plates 277, 278) while the subtle value painting and vivacious brushwork show the

178

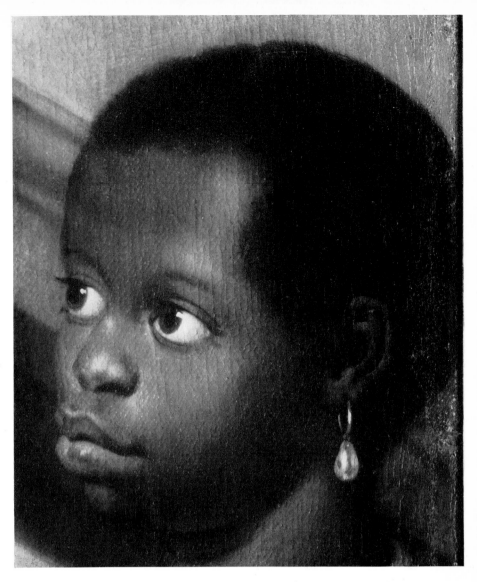

Fig. 191. Abraham van Tempel: Detail from *Jan van Amstel and Anna Boxhoorn with a Negro Servant*. 1671. Rotterdam, Boymans-van Beuningen Museum

qualities which helped the artist win his posthumous fame. The group also reveals Hals' ties with pictorial and iconographic traditions of his time. The attitude of the seated father and mother is an allusion to marital fidelity which would have been recognized immediately by most of the artist's contemporaries (Plate 276).

A picture of a couple seated in a landscape, with the woman always on the man's left and with their hands clasped, has been employed to symbolize fidelity at least since it was used to accompany the motto and poem which makes up the emblem 'In fidem uxoriam' in Alciati's *Emblematum Liber* of 1531 – mentioned earlier in connection with the *Married Couple* at Amsterdam (Plate 33). Figure 192 reproduces a woodcut in an edition of Alciati's work published in 1608. From what we know about Hals he was hardly a close student of emblem books but surely some of his patrons were. Hals and one of his patrons may well have discussed whether or not all of Alciati's references to marital fidelity should be included in a family portrait.

As we have seen, Hals' contemporaries were more accustomed to looking for symbolic allusions in paintings than we are. This explains why the one in the Thyssen-Bornemisza *Family Portrait* has never been mentioned in the literature. It also raises a familiar but difficult question: when does an event or an object in a seventeenth-century Dutch picture signify nothing but itself, and when does it have symbolic significance? The dog to the right of the girl in Hals' *Family Portrait* (Plate 281) is a case in point. Is the shaggy dog part of the symbolic story? Dogs were well-known symbols of fidelity, and one plays an important part in Alciati's emblem 'In

Ecce puella, viro quæ dextrâ iungitur : ecce
Vt sedet, vt catulus lusitat ante pedes !
Hæc sidei esl species: Veneris quam si educat ardor,
Malorum in læua non malè ramus erit;
Poma etenim Veneris sunt. sic Scheneïda vicit
Hippomenes , petiit sic Galatea virum.

Fig. 192. *"In fidem uxoriam"*. Woodcut from Andrea Alciati,
Emblemata, Plantin, 1608

Fig. 193. Marriage Medal. Dutch,
seventeenth century. The Hague,
Koninklijk Penningkabinet

Fig. 194. Marriage Medal. Frisian,
seventeenth century.
Private Collection

fidem uxoriam'. However, a dog which alludes to marital fidelity is always shown near the couple; it is usually at rest upon the woman's skirt. Hals either modified the tradition or he painted a straightforward portrait of a family pet.

There can, however, be no doubt that the clasped right hands of the couple in Hals' picture had symbolic meaning for seventeenth-century beholders even if they did not know Alciati's emblem book. Joined hands have been a popular symbol of faithfulness from ancient times up to this day. The device was commonplace in Renaissance and Baroque emblematic imagery to affirm the virtues and pleasures of love, marriage and friendship. Variations can be found in every language on the epigrams:

> Where lovers fittly matched be
> In mutuall-duties, they agree

or

> The safest richest riches, he shall gaine,
> Who always Faithful doth remaine.

which appear in George Wither's *A Collection of Epigrams Ancient and Modern*, published in 1635, with explanatory verses and pictures which include clasped hands. The most frequent motif on seventeenth-century Dutch betrothal and marriage medals is a picture of a couple with joined hands (Fig. 193). Like the joined hands in Jan van Eyck's portrait of the *Marriage of Arnolfini*, the motif alluded to the actual joining of hands which was part of the wedding ceremony. When a couple went to the new Town Hall of Amsterdam to register their intentions of marriage in the Chamber of Matrimonial Affairs, they saw a pair of clasped right hands carved in the centre of the mantel piece. When they were married there they heard the officiating magistrate say: 'Take off your gloves and give each other the right hand,' and holding hands the couple took their

vows. Clasped hands were also found appropriate for medals commemorating engagements and silver and golden wedding anniversaries. They were shown with familiar symbols – burning hearts, loving doves, horns of plenty, cupids, lover's knots. The one reproduced here (Fig. 194) includes a skull and bone and is inscribed 'Getrow tot in den doot' ('faithful until death').

In the Western world a handshake still seals a pledge. Clasped hands are also a symbol of partnership. Roland H. Bainton, the historian of the Reformation, wrote that the term 'partnership' expresses the attitude some Protestants, particularly Anabaptists, had toward marriage. Divorce, he states, was allowed by the Reformed Churches and by Anabaptists for causes other than adultery. The primary cause was diversity of faith. Anabaptists did not allow mixed marriages. If only one member of a couple joined their sect the union was declared dissolved. This member was free to contract a new marriage within the religious society. The same principle, Bainton adds, became operative in a more restricted way in Calvinism; if one party refused to follow the other into exile for the sake of the gospel, their union was terminated:

'The emphasis upon unity of faith within the marriage bond did much to foster another attitude toward matrimony which may be expressed in the term *partnership*. The stress was not upon marriage as a remedy for sin, nor upon the home as a school for character. Of any romantic touch there was not a trace. The centrality of faith made first for independence between husband and wife. Each must live by his or her own faith, and not by that of the partner. But if that faith did exist in them both, then a basis existed for partnership in marriage, not merely in the propagation of children, but in training them in the fear of the Lord and in labouring together in other respects for the glory of God and the advancement of his kingdom. This partnership is even more noteworthy among the Anabaptists where a missionary charge was laid upon every member of the community.'

It is not possible to establish a relationship between Bainton's observations about the conception of marriage as a partnership in some Protestant circles and the tightly clasped hands of the couple in the Lugano *Family Portrait* until the husband and wife have been identified and their religion has been established. It is possible, however, to maintain that most of Hals' contemporaries recognized that he used a symbolic conceit in the family portrait as readily as we recognize his characteristic brushwork.

Commonplace seventeenth-century emblematic references in Hals' work have been neglected in our time because of the generally accepted idea that the artist merely painted what he saw without giving much thought to what he was about. It goes without saying that Hals' achievement was not that of a somnambulist. It also goes without saying that he was not a profound or dedicated symbolist either. There can be no mistake. During the course of his long career his principal concern was the close observation of man. This was the prime source of his strength. But for a seventeenth-century Dutch portraitist and genre painter this did not – indeed could not – preclude occasional use of symbolic motifs and themes which had been well established by his predecessors and in his day were still part of a living tradition.

CHAPTER VII

The Final Years: 1650-1666

DOCUMENTARY evidence to establish a firm chronology for the last period of Hals' life is
meagre. Except for three portraits of 1650 (Plates 267, 282, 283) none of the works
generally assigned to the artist's final phase is dated. The date of 1656 given to the portrait
of Tyman Oosdorp (Plate 314; Berlin-Dahlem), as well as the identification of the sitter, is based
on a mutilated eighteenth-century label and a nineteenth-century inscription on the stretcher.
Though nothing known about the artist's development contradicts the date, evidence of this sort
is rightly received with some scepticism. The only other scrap that helps determine a chronology
is the old tradition that the group portraits of the *Regents* and *Regentesses of the Old Men's Alms
House* (Plates 340, 349) were painted in 1664. Hals did not date – let alone sign – either of them,
and no contemporary document supports their traditional date, but since the five men who
appear in the male portrait are said to have served as regents of the institution from 1662 until
1665 the tradition may very well be correct. Moreover, it will be remembered that Hals was able to
act as guarantor for the large sum of money which his son-in-law borrowed in 1665, and the fee
he received for these paintings may explain how he was suddenly able to produce over four
hundred and fifty guilders. In any event the two group portraits must have been painted not long
before his death in 1666.

These more or less steady reference points of 1650, 1656 and 1664 are the only ones we have for
the works made during the last sixteen years of Hals' long career. Obviously they do not enable
us to assign other than approximate dates to paintings of the artist's late period and particularly
those of the last decade of his life. No matter – in the final analysis there could not have been much
difference between a portrait Hals painted when he was in his late seventies and one made when
he was in his eighties.

There is no marked change in style between his paintings of the late 1640s and those of the early
1650s either; in the seventeenth century none of the Dutch masters made revolutionary shifts in
their way of working during their later years. But a general trend is evident. The paintings
become darker, the blacks richer and more predominant. Deep olive greens and dark greys in-
creasingly replace the ochre and silver-grey backgrounds found earlier. The paint becomes
thinner, the touch broader and even more summary, deliberately suppressing detail while increas-
ing the emphasis on character and mood. Anticipations of these changes can be found in paintings
made before the middle of the century, although now and then a revival – or perhaps a survival –
of youthful tendencies is also seen in the aged master's works.

As the 1650 portrait of *Nicolaes Stenius* (Plate 267; Haarlem, Bisschoppelijk Museum) shows,

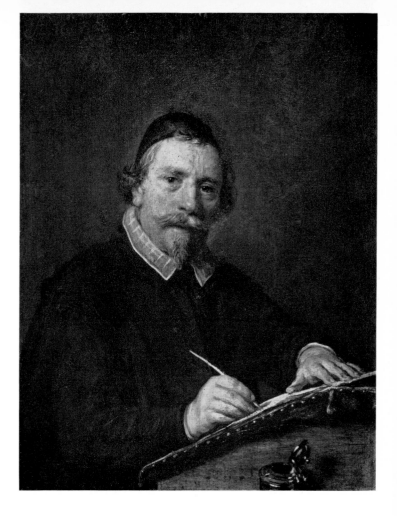

Fig. 195. Ludolph de Jongh:
Copy of Hals' *Nicolaes Stenius* (Plate 267). 1652.
Donsbrüggen. Freiherr von Hövell

Hals' ability to capture a momentary impression did not leave him. He portrayed this Catholic priest of Akersloot with pen in hand as if he had just been interrupted while writing at his desk. The pose was a common one. Variations on it were used by Rubens, Rembrandt and other Baroque artists for portraits of theologians and scholars. We have seen that Hals also painted variations on the scheme in his early portraits of calligraphers; his *St. Luke*, made about a quarter of a century before Stenius was painted, indicates that he knew at least one of the iconographic traditions from which the pose was derived. Unusual here, however, is the suggestion that Stenius has stopped writing this very instant. He looks at us with his pen still in place on the sheet before him while his other hand holds it firmly in place. Today the immediacy of the portrait is not as apparent as it once was. Even from the reproduction it can be seen that the portrait is sorely abraded and there are significant losses of the original paint surface. We do not criticize, but sympathize with, the picture restorer who worked on it shortly before it was first published in 1916. A photograph made of the painting before its restoration reveals that a magician not a technician was needed to make it exhibitable. A copy of the portrait, made in 1652 by Ludolph de Jongh (Fig. 195), offers some idea of the expressive head and hands, the spirited brushwork and the vivid contrasts of light and shadow of the original before it suffered damage. De Jongh's copy is of interest also because it reveals that an artist well-known for his receptivity to the manner of other painters in his genre pieces, landscapes and portraits had made a concerted effort to capture the qualities of Hals' late style. De Jongh's effort underlines how scanty our knowledge of some aspects of seventeenth-century Dutch painting remains. It is fair to say that if his copy had not been fully signed, it would have been ascribed to a Haarlem artist active in Hals' circle and not to Ludolph de Jongh of Rotterdam.

The Final Years: 1650-1666

The two other portraits dated 1650 are the half-length *Portrait of a Man* (Plate 282; Heirs of Sir Algar Stafford Howard, Penrith) and its pendant *Portrait of a Woman* (Plate 283; Museum of Fine Arts, Houston, Texas). The woman has been identified as Elizabeth van der Meeren on the basis of an old inscription on the back of the painting; until the identification rests on more solid ground it is not possible to claim the companion piece as Elizabeth's husband Jonkheer Willem Adriaan, who was Seigneur of Kessel, then Count van Hoorn and a general in the Dutch army. But there can be no question about Hals' sympathetic interpretation of the elderly couple. The dark colour harmony is enlivened in the man's portrait by the freedom of the broad brushwork and the contrast of the blacks and deep browns of his heavy, fur-trimmed coat. In the companion piece the old woman's hands (Plate 292) attract as much attention as her strong head. The intense light areas of the hands, cuffs and gloves have been so thinly brushed that the warp and woof of the canvas are still visible. On this thin ground incredibly fine modulations of tones integrated with bold and delicate brush strokes model the forms without lingering over details. A few nervous strokes are enough to suggest the lace on her cuffs while crackling impasto touches of bright yellow indicate her glittering ring and the chains of her gold bracelets. Equally expressive and beautifully painted hands appear in Hals' other portraits of women made in the 'fifties (Plates 293, 295, 296). The unforgettable hands of the *Regentesses of the Old Mens' Alms House* are rightly famous, but we cheat ourselves if we overlook others painted by the master in his last period.

Four sets of companion pieces can be dated a few years after the 1650 pendants were made. Only one pair, the imposing husband and wife at Vienna (Plates 286, 287), can still be seen in the same museum. Another couple is now dispersed in collections at Kansas City (Plate 284) and St. Louis (Plate 285); a third is in New York, the husband at the Frick Collection (Plate 288) while his wife is a few blocks uptown at the Metropolitan Museum (Plate 289). However, of all these cases of separated pendants, the most unfortunate is that of the fourth pair: *Stephanus Geraerdts* (Plate 290; Antwerp, Musée Royal des Beaux-Arts) and *Isabella Coymans* (Plate 291; Paris, Collection Baronne Edouard de Rothschild). In these pictures Hals not only related husband and wife by inventing compositions and using colour harmonies which complement each other but he also arranged some action between the two figures. The portrait of Isabella was designed, as was the custom, to hang as the sinister pendant. She stands and turns toward her husband to offer him a rose. Hals seldom allowed the women in his commissioned portraits to move this much. Usually he restricted their movements to their eyes and lips. Stephanus Geraerdts remains seated with his arm outstretched. Apparently it was difficult for this fat Haarlem alderman to rise even when his wife approached him bearing a token of her love. The direction of the glances of the models and their outstretched arms creates a state of tension which psychologically and rhythmically relates the pendants when seen together. Disunited, the tension is broken. Though husband and wife turn toward each other their torsos remain frontal, emphasizing the bulk of their bodies, one massive, the other slender and elegant, but both invigorated by the artist's vibrant touch. Like other fashionable young women around the middle of the century, Isabella Coymans modified the strict regent costume by wearing an off-the-shoulder, low-cut collar (Plate 297).

Isabella Coymans. About 1650–2. Detail from Plate 291.
Paris, Baronne Edouard de Rothschild

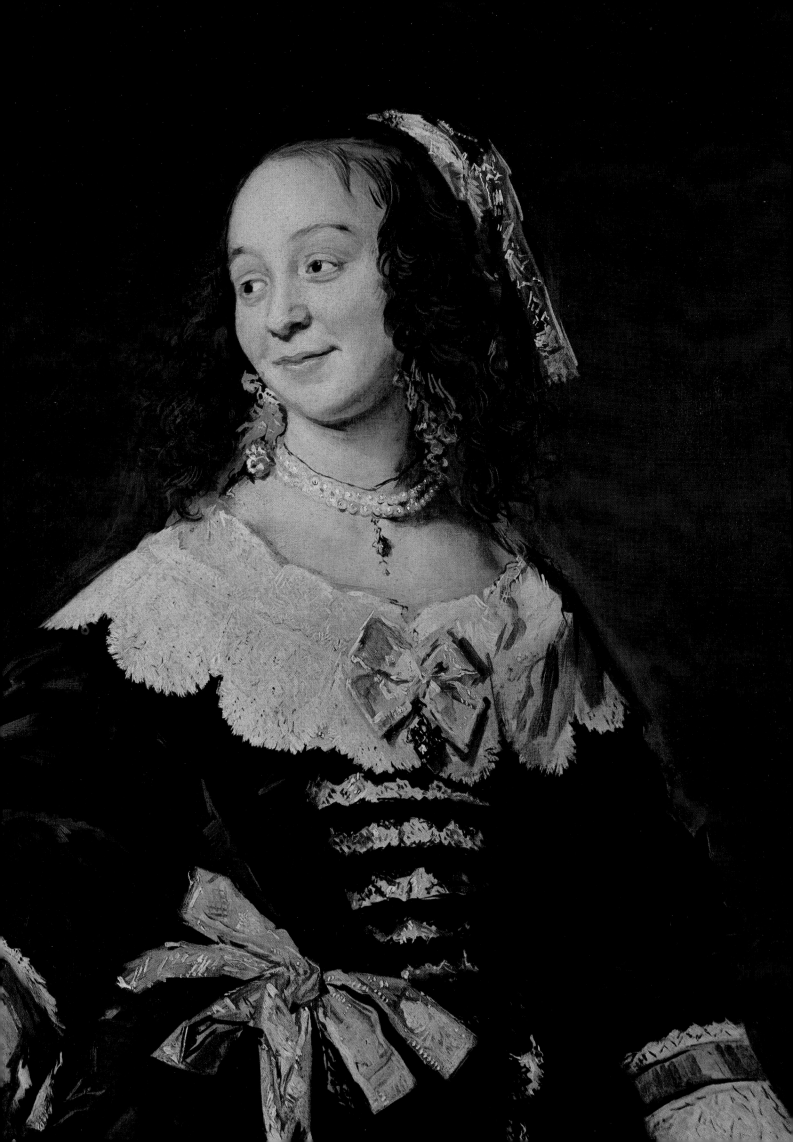

When this portrait was painted her décolletage must have appeared as daring to Dutch ladies of her mother's generation as bikinis and miniskirts do to another older generation of women today. The red ribbons in Isabella's hair, her huge silver bow and the black lace on the white satin panel in her skirt also reflect a new taste for showy frills. Hals delighted in painting these bright accents as well as the intense whites and glittering gold embroidery of Stephanus' costume. In his hands they became dynamic elements enlivening monumental forms.

The coats-of-arms which identify Stephanus Geraerdts and Isabella Coymans are unusual accessories in the artist's late portraits, and were probably ordered especially by the couple since a neutral background would otherwise have been the rule around this time. The pair belonged to a class of society which took pride in armorial bearings; as we have seen, Hals also included the escutcheon of other members of Isabella Coymans' family when he portrayed them in the 1640s (Plates 243, 244, 253). Even more exceptional than these coats-of-arms is the large column in the *Portrait of a Painter Holding a Brush* (Plate 288) at the Frick Collection and the architectural mishmash of a column placed next to a pillar and a distant view of an unidentifiable city against a rosy evening sky seen in the background of the pendant now at the Metropolitan Museum (Plate 289). The dull treatment of these trappings and their incongruity with the candid poses of the models suggest that they were added by another hand; and the discrepancy in scale and handling between the columns in the pendants makes it likely that the additions were made by two different hands. Both portraits gain rather than lose when we imagine them placed against Hals' characteristic plain backgrounds. In this connection it should be noted that the *Portrait of a Woman* of 1627, now at Chicago, was Hals' only other portrait that included a cityscape behind the sitter but close examination of that painting revealed it was a later addition. It was removed when the picture was restored in 1969; the reproduction of the Chicago portrait seen in Plate 77 shows it after cleaning.

As in his early companion pieces of seated figures, Hals linked his portraits of an artist and his wife by turning their torsos toward each other and once again he suggests the dominance of the man by depicting the husband closer to the viewer than his wife.

Various attempts have been made to identify this relaxed couple. They have been unconvincingly called a self-portrait of Hals and his second wife Lysbeth Reyniers, and, even less plausibly, portraits he made around 1643 of Rembrandt and Geertje Dircx, the trumpeter's widow who entered Rembrandt's household and became his common-law wife soon after the death of Saskia. The painter portrayed here bears no resemblance to Rembrandt as we know him from his self-portraits. Moreover, the style of the paintings and the costumes of the sitters support a date in the early 'fifties, not the early 'forties. If the date we have assigned is correct it takes a wild leap of the imagination to see the woman as Geertje Dircx: Rembrandt's relationship with her was short and ended acrimoniously, probably after she had discovered that Rembrandt found Hendrickje Stoffels a more congenial companion. Geertje sued Rembrandt for breach of promise and won her case. He was forced to pay 200 guilders annually for her support. In 1650 Geertje was confined to a house of correction in Gouda and there is reason to believe that Rembrandt

behaved badly in this messy affair; a review of the evidence makes it hard to escape the conclusion that he tried to get rid of her by having her put away. Though Rembrandt continued to pay for Geertje's maintenance until her release in 1655 he would hardly have commissioned a portrait of her during these years.

Beside the anonymous painter who posed for the portrait now at the Frick Collection, other artists sat for Hals during this last period. It is not known if these portraits of his colleagues were made as tokens of friendship or if they were commissioned works. We like to think the latter was the case and that his colleagues not only wanted but were willing to pay for something by his hand. As was so often the case in previous years, financial help was desperately needed. Every commission helped pay for bread and cheese. And what higher tribute could an artist pay Hals than to ask him to paint his portrait? We would also like to believe Houbraken's report that 'Anthony van Dyck, the Phoenix of his time, when in the service of Charles I,' went to Haarlem expressly to see Hals and that he posed for him in the guise of a hurried foreigner who wanted his portrait painted straightway. Houbraken writes that Hals had to be fetched from the local tavern – which he refused to leave before finishing his pint – but once he set to work he obliged the stranger quickly. His patron was pleased with the portrait and after exchanging some pleasantries asked: 'Is this the way painters work? Is it not possible that I can do the same?' Then he placed another canvas on the easel and asked Hals to pose for him. By the manner in which his mysterious visitor began to paint Hals knew that this was not the first time he had held a palette and brushes. However, he still had no idea who he was. In a short time the man finished his painting and allowed Hals to see what he had done. As soon as Hals looked at the portrait he exclaimed: 'You are Van Dyck. No other person can do what you have done.' He then embraced and kissed him.

Houbraken writes that Van Dyck left Haarlem with the portrait Hals had painted of him. Efforts to discover it have failed. The portrait Van Dyck is said to have painted of Hals has not been found either. Houbraken's tale is probably apocryphal. It is a variation on the familiar story of a competition between two famous artists which can be found in classical and Renaissance texts. Usually the tale serves as the point of departure for praise of an artist's special skill. Houbraken, however, also used it to censure Hals. He tells us that Van Dyck had great respect for Hals' gifts and tried to persuade him to accompany him to England, but that Hals was too attached to his bad ways to think of leaving Haarlem; to drive his point home Houbraken adds that Frans even drank up the money Van Dyck kindly gave his children.

Around 1655 the original Haarlem painter Frans Post, who accompanied Prince Maurits to Brazil and made the first landscapes of the New World done by a European, posed for a small oil sketch (Plate 318), which served as a modello for an engraving by Jonas Suyderhoef. Like the unidentified painter who sat for the Frick portrait (Plate 288), Frans Post is seen seated with his arm resting casually on the back of his chair. However, no correlation can be made between the posture and the profession – we have seen that Hals also employed the pose for patrons who had nothing to do with the arts.

186

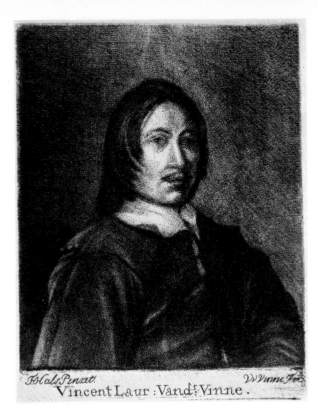

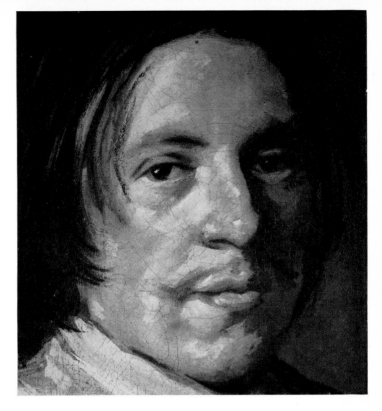

Fig. 196. *Vincent Laurensz. van der Vinne.* Copy after Hals' portrait of him (Plate 317). Mezzotint

Fig. 197. Detail from *Vincent Laurensz. van der Vinne* (Plate 317). About 1655-60

The portrait Hals painted of Vincent Laurensz. van der Vinne (Plate 317), another Haarlem artist, could not have been painted before 1655, the year Van der Vinne returned to his native city after a three-year journey to Germany, Switzerland and France. The sober mood, the thin washes and the brevity of touch place it toward the end of the decade. Van der Vinne was Hals' pupil; born in 1629, he probably studied with him in the late 'forties. According to Houbraken, Van der Vinne painted anything that came his way – kitchens and attics as well as signboards and cabinet pictures. Houbraken notes that he was good at making portraits too and that these were done with bold brushwork, in the manner of Frans Hals who, he adds, used to tell his students: 'You must smear boldly; when you are settled in art, neatness will surely come by itself.' Houbraken also states that Van der Vinne became skillful in this bold way of painting. Thus he is yet another contender for some of the puzzling paintings done in Hals' style of the 'forties and 'fifties. However, none has been identified, and the still lifes and landscapes which can be firmly attributed to him show little trace of the impact of Hals' original technique. Van der Vinne approached his work like a journeyman and, Houbraken writes, he dedicated himself to painting signboards because he usually applied himself to what was most profitable. Because of his gift in this field his contemporary Job Berckheyde dubbed him 'The Raphael of the Signboard Painters.'

Hals' portrait of Van der Vinne has been identified on the basis of his model's own rather coarse mezzotint after it (Fig. 196), which is entitled 'Vincent Laur: Vandr. Vinne' and inscribed 'F. Hals Pinxit, VvVinne Fec.' The suggestion that an indecipherable monogram on the painting is Van der Vinne's and that he, not Hals, painted this outstanding portrait cannot be taken seriously. Not only does Van der Vinne's print explicitly state that Hals painted it, but his own works give no indication that he could ever approach the fluidity of Hals' brushwork while maintaining the fine adjustments in the transitional tones suggesting the shimmer of silvery light filtering over surfaces without sacrificing solidity of form (Fig. 197). Only Velazquez could match this performance. The attempt to pass the portrait off as a Velazquez in the nineteenth century was an

187

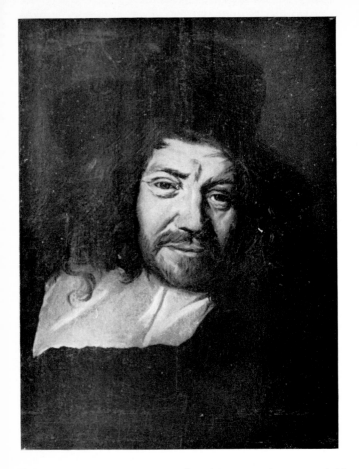 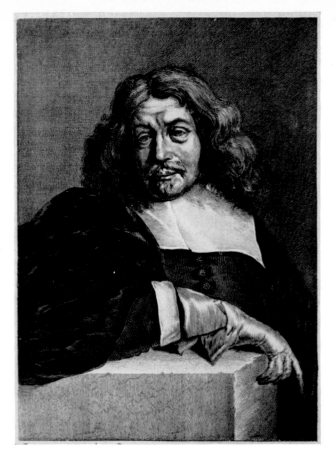

Fig. 198. *Jacob van Campen*. Copy after a lost portrait by Frans Hals (?). Amiens, Musée de Picardie

Fig. 199. Abraham Lutma: *Jacob van Campen*. Engraving after a lost portrait by Frans Hals (?)

intelligent bit of skullduggery. An earlier age was as fascinated by the intensity and economy of the portrait as we are. More copies of it are known than of most of Hals' late works. In addition to Van der Vinne's mezzotint, six other eighteenth-century copies have been identified. Clearly the French impressionists were not the first artists who studied Hals' technique. They were, however, the first to grasp that it could express a fleeting moment animated by sparkling light.

Attempts have been made to identify as Dutch artists other models in Hals' late portraits. Such attempts are worth considering because so little is known about Hals' friends and acquaintances. Bits and pieces that help us learn more about the circle in which he moved are always welcome and, even when there is disagreement about the identity of sitters, in some cases the evidence merits review. All historical judgements are subject to critical examination but few demand it more than conclusions about the identification of a model who has been anonymous for centuries. Those who do the donkey work in this field of art history deserve a special patron saint – an appropriate candidate would be St. Denis, who is traditionally represented standing with his own severed head in his hands.

One of the identifications offered is Hofstede de Groot's suggestion that the painting now at the Musée de Picardie at Amiens is Hals' portrait of Jacob van Campen (Fig. 198), a Haarlem artist whose claim to fame as a painter is not very great but whose reputation as the outstanding architect of the Netherlands in his day is secure. In my view the Amiens portrait is not an original by the master but could very well be a cropped copy after one made around 1655. Abraham Lutma's engraved portrait of Van Campen (Fig. 199) which appears in the volume of plates published in 1661 of his masterpiece, the Town Hall of Amsterdam, appears to be based on this portrait. The engraving is virtually a mirror image of the painting. The printmaker removed the model's hat, but the physiognomy and expression of the portraits are strikingly similar and the

188

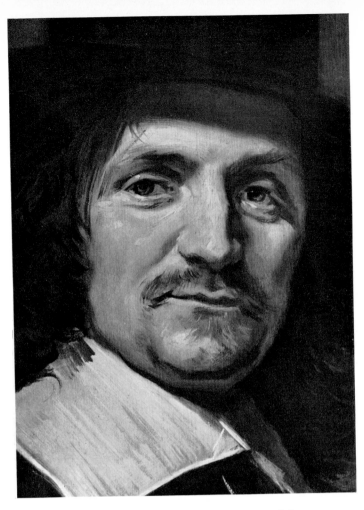

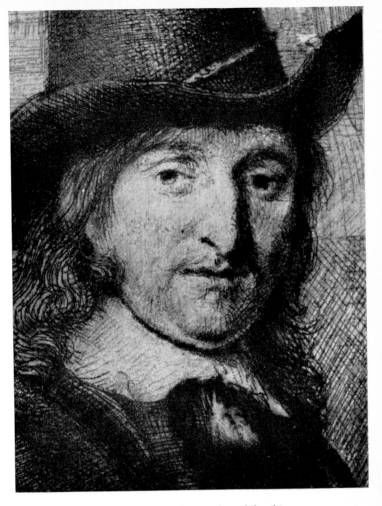

Fig. 200. Detail from *Portrait of a Man* (Plate 304). Painted about 1652–54. Budapest, Museum of Fine Arts

Fig. 201. Rembrandt: *Jan Asselyn*. Etching, enlarged detail in reverse

large collar partially hidden in both works by the sitter's cape indicates either that the engraver used the Amiens painting as his model or that both works were derived from a lost original.

The identity of the robust sitter who posed for the *Portrait of a Man* (Plate 304) now at Budapest is more controversial. For more than 150 years critics have tried to establish that he is a seventeenth-century Dutch artist. In the 1812 catalogue of the Esterhazy Collection and in an inventory made of the same collection in 1820 the work is listed as a self-portrait by Du Jardin. Later in the century the line between a painting made by Du Jardin and one by Hals became much clearer but the desire to see the work as a self-portrait did not die. In 1878 it was called a self-portrait of Frans Hals. More recently André Pigler identified the sitter as the Italianate landscape painter Jan Asselyn. Pigler's identification is the only one which warrants attention. He compares the head of the model (Fig. 200) with the etching Rembrandt made of Asselyn around 1647 (Bartsch 277) and writes: 'La juxtaposition parle pour elle-même.' An enlarged detail of the print, which is reproduced in reverse here (Fig. 201), shows a certain resemblance to the Hals. The cramped arm and the hidden right hand of the model in the painting also appears to bolster the identification as Asselyn, who was nicknamed 'Crabbetje' (Little Crab) because he had a deformed hand and crooked fingers. If Hals' portrait represents Asselyn, and is not a posthumous one, it must have been painted not later than 1652, the year of his death. Although a date of 1652 is not impossible, I am inclined to place it a bit later.

But how secure is this identification? After making allowances for differences in technique, scale, and, even more important, for the fundamental differences in spirit between Rembrandt and Hals, dissimilarities between the physiognomies of the two models remain. As portrayed by

Rembrandt, Asselyn has an oval-shaped face, beady eyes, a sharp-hooked nose and a small mouth. Hals' sitter, on the other hand, has strong, square features, which make him look rather brutal compared to the shy, bird-like head etched by Rembrandt. Before arriving at final conclusions about the model's cramped arm it is also necessary to consider whether or not the picture has been cut. The unusually narrow format of the Budapest panel and the fact that Hals generally put more space around his figures than is seen here suggest the picture has been cropped. Even in his last years, when he tended to push his figures towards all edges of his pictures to achieve more monumental effects, Hals gave his models more room than this one has. And finally, I wonder if Hals' feeling for decorum ever left him; I know of no reason to think so. In my view he would have subdued the brushwork on a crippled arm and not called attention to it with a blaze of brush strokes.

Tradition, once again based on an old inscription on the back of the original canvas, has it that Hals' three-quarter-length *Portrait of a Man* (Plate 303) from the early 'fifties, now in the Mellon Collection at the National Gallery, Washington, represents the Italianate landscapist Nicolaes Berchem. A pen-and-wash self-portrait drawing (Fig. 202) by Berchem does not entirely rule out this identification, if we assume that Hals painted him before he became heavy and somewhat flabby. However, the unpublished suggestion made by I. Q. van Regteren Altena that the sharp-nosed model with distinctive pursed lips is Adriaen van Ostade is more credible if we compare the portrait (Fig. 203) with one Ostade painted of himself around the same time (Fig. 204).

There is documentary evidence that Hals painted a portrait of Jan van de Cappelle, who has properly been called the greatest Dutch marine painter. The portrait is listed in an inventory made of Van de Cappelle's effects after his death in 1679. The same inventory also lists portraits of him by Rembrandt and Eeckhout as well as a copy after Jan van Noordt's drawing of him. No likeness of Van de Cappelle has been discovered which could serve as a guide for identifying any of these portraits although Valentiner made a valiant effort to establish his iconography and searched through the anonymous portraits by the four artists to find a man who sat for each one. He believed he found his man in the sitter who posed for Hals' *Portrait of a Man* now in the Norton Simon Collection (Plate 311). Valentiner's case, however, is not a substantial one. He claimed that he recognized the same sitter in the *Portrait of an Artist* attributed to Rembrandt at the Frick Collection (Bredius 254), but this part of his case must be rejected. Not only is the similarity between the two models unconvincing, but the Frick *Portrait of an Artist* is not by Rembrandt and has rightly been excluded from Rembrandt's *oeuvre* by all recent specialists. Valentiner himself admitted that the identity of the model who posed for the Van Noordt drawing, which he had used to bolster his argument, is not very certain. That leaves the Eeckhout. Here Valentiner found a 1652 drawing which he called a preliminary study for the lost Eeckhout painting listed in the inventory. Although there is a certain resemblance between the two sitters, until more conclusive evidence is found there is no reason to call the Norton Simon painting a portrait of Jan van de Cappelle.

Van de Cappelle's interest in Hals' work was genuine. His inventory lists eight other paintings

Fig. 202. Nicolaes Berchem: *Self-portrait.* Ink and wash. Amsterdam, Rijksmuseum, Prentenkabinet

Fig. 203. Detail from *Portrait of a Man* (Adriaen van Ostade?) (Plate 303). About 1650–52. Washington, National Gallery of Art, Mellon Collection

Fig. 204. Adriaen van Ostade: *Self-portrait.* Detail from *The Members of the De Goyer Family.* The Hague, Bredius Museum

by the Haarlem master – including an unidentified portrait of Hals' wife and a *Rommel Pot Player* – more than any other seventeenth-century inventory. Hals' works were in excellent company, for Van de Cappelle, who amassed a great fortune – probably from his management of his family's dye-works, not from his work as a painter – also managed to assemble one of the best art collections of his time. Rembrandt, Rubens and Van Dyck were not as well represented as Hals; he owned six, four and six paintings respectively by these artists. As one would imagine, his special passion was for works by marine painters and landscapists. He owned sixteen paintings by Jan Porcellis, nine by Simon de Vlieger, and ten by Jan van Goyen, as well as works by Hercules Seghers, Esaias van de Velde, Pieter Molyn, Avercamp, Vroom and Koninck. Paintings by leading sixteenth-century Netherlandish and German artists were also included and there are references to pictures by Elsheimer, Liss, Pieter van Laer and Brouwer. In all he possessed about 175 paintings.

Even more spectacular was his collection of drawings. It numbered about 7,000 and included around 1,300 by De Vlieger, 900 by Avercamp, 400 by Van Goyen, and, most enviable, about 500 by Rembrandt. He probably was very active in September, 1658, when Rembrandt's drawings were auctioned at Amsterdam. Van de Cappelle's inventory also lists almost 900 drawings by his own hand. Today hardly a handful of his sketches are known, a painful reminder of the high mortality rate of old master drawings. One cannot help but wonder if Van de Cappelle owned some of Hals' lost drawings. Were they in the portfolio described as containing '382 drawings by various masters' or in the one with '76 drawings by various masters'?

The mystery surrounding Hals' activity as a draughtsman has been mentioned earlier. We have also noted that attempts have been made to recognize his hand in a few drawings. Here it is appropriate to discuss a sheet at the British Museum (Fig. 205) which has been called a preliminary study for the *Portrait of a Man* (Plate 299) now at The Hermitage. At first blush it appears to stand a chance of qualifying as an original, but upon closer examination the ambitious attribution becomes doubtful. The Hermitage painting is rightly admired as one of the most impressive performances of Hals' last period – seldom has the weight of a powerful head and huge torso been painted so convincingly and with such economy. The broad, vigorously brushed washes which

191

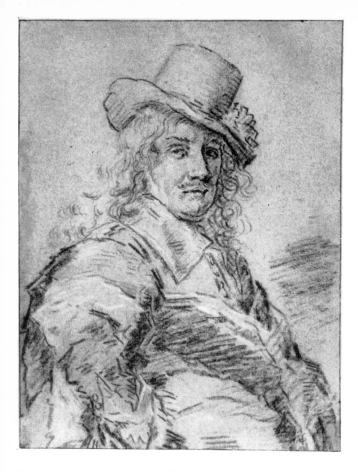

Fig. 205. Drawing after *Portrait of a Man* (Plate 299). Black and white chalk. London, British Museum

Fig. 206. Jacob Houbraken: *Portrait of Frans Hals.* Engraving in Arnold Houbraken, *De Groote Schouburgh*. Amsterdam, 1718

render the ponderous form of the body anticipate the abbreviated touch of his late regent group portraits but the fusion of tones in the flesh tints and the relative restraint of the accents that model the head and hair point to a date shortly after the middle of the century. To be sure, a one-to-one correspondence can be established between many of the nervous black chalk strokes in the drawing and passages in the painting, but to me this indicates the hand of a careful copyist working after Hals' finished portrait, not a literal translation into paint by the master of what he had done in chalk. The lines that define contours and establish values in the drawing are less decisive and not as suggestive as Hals' characteristic touch. Even with the aid of white chalk highlights they do not compellingly model the head or the bulk of the monumental figure. The highlights are decorative and have been scattered too generously without due consideration of the light source; they flatten forms rather than round them. Like so many of Hals' followers, the draughtsman achieved an animated surface at the expense of solidity and clarity of spatial relationships.

The British Museum drawing, however, remains a valuable document because it shows the original state of the Hermitage portrait. As we see in the drawing, the sitter once wore a hat tilted to the right. It has been overpainted in the portrait but unmistakable traces of it can still be seen when the painting is viewed in strong sunlight. Hals himself cannot be held responsible for its removal. The dull, opaque passage which now covers part of the forehead and the hat betrays the hand of another painter; his clumsy effort is apparent even in a reproduction (Plate 300). The model's hat was probably eliminated because it did not suit the taste of another generation. As we shall see, Hals' late *Portrait of a Man* at the Fitzwilliam Museum, Cambridge (Plate 338), was also once deprived of his hat, and probably for the same reason. Laboratory tests of the Hermitage portrait may indicate that the repaint on the upper part of the picture can safely be removed, and the sitter could once again appear wearing a tall hat decorated with a pompon.

192

An additional point about the Hermitage painting and the British Museum drawing should be noted. The man represented bears a rather close resemblance to the engraved portrait of Hals (Fig. 206) used to illustrate his biography in Arnold Houbraken's *Groote Schouburgh*, which appeared in 1718. The engraving, like most of the portraits in the *Groote Schouburgh*, can safely be ascribed to Arnold's son Jacob Houbraken (1698–1780). Since Houbraken's biography was the main source of information about the master until nineteenth-century historians began to do systematic research, his son's print became the principal source for the popular image of Hals; as late as 1843 the wood-engraver who provided illustrations for Immerzeel's popular lexicon on Netherlandish artists based his portrait of Hals on it. To our eyes the likeness of Hals which Jacob Houbraken bequeathed to posterity does not bear much resemblance to his known self-portraits (Figs. 1, 2). But its similarity to the works at Leningrad and London is more than passing. Is this fortuitous? Or did Hals' first biographer consider the work a self-portrait and instruct his son to base his engraving on the painting or the drawing? These questions do not permit unqualified answers. But we do know that Jacob Houbraken did not always make exact copies. His desire to achieve a kind of elegance always comes to the fore. It shows here in the long, silken locks he gave Hals and it can also be seen in the way he groomed Rembrandt in the print he made after one of his more casual self-portraits. It is also noteworthy that the elongated face the engraver gave Hals bears a closer resemblance to the face in the British Museum drawing than to the rather broad one in the Hermitage painting. One would like to say that Jacob Houbraken used the drawing as a point of departure for his engraving, and even go further and propose that he himself drew it. I would not rule out the possibility that the British Museum sheet is an eighteenth-century copy but the similarities between it and the print do not provide a firm enough basis to maintain that it served as a model for the engraving, and not enough is known about Jacob Houbraken's gift as a draughtsman to suggest that he drew it. Admittedly, notice of the congruences between the engraving and the other two works raises more problems than it solves. They could be ignored, but ignoring evidence just because it cannot be neatly explained would only create the erroneous impression that the history of art is tidy.

If around 1718 some people believed the Hermitage *Portrait of a Man* was Hals' self-portrait, the notion was apparently rejected later in the eighteenth century. When we consider the propensity of early collectors, auctioneers and critics to see his portrait almost everywhere, the point is not a minor one. The earliest documented reference to the Hermitage painting is found in the catalogue made of Catherine the Great's collection in 1774, where it is called a 'Portrait of a Man' not a 'Self-Portrait.' Catherine soon made good – or thought she made good – the deficiency in her stupendous collection. As we have heard, when she acquired the *Portrait of a Man* in 1779 (Plate 256; Washington, National Gallery of Art) from the Walpole Collection, it was called a self-portrait by Hals. This identification, like so many others, was later proved false. A tally of all the erroneous identifications of Hals' sitters during the last three centuries would produce a large number – perhaps not as astronomical as the number of lovers Catherine the Great is reputed to have had, but fairly close to it.

The Final Years: 1650-1666

Aged Hals did not get bored with portrait painting. On the contrary, his most persuasive characterizations were made during his last phase, when he convinces us that he has probed deeply into the personalities of the burghers who posed for him: the strong and the vulnerable, the proud and the meek, the brutal and the tender. Frontal poses become more frequent and in his pictures this stock attitude always gives us a startling sense of the presence of a fellow human being. One of the finest of this type is the imposing three-quarter length *Portrait of a Man* (Plate 298) at the Metropolitan Museum, where mien and expression appear to sum up the will and dignity which can endow ordinary men with unexpected grandeur. Black is the dominant colour. The seemingly spontaneous treatment of the model's suit, large hat, and the mantle draped over his arm shows the gain in Hals' control over fine distinctions of this hue. Manet, who learned to use blacks with similar strength and subtlety in his portraits, would have been particularly impressed with this performance. Here, as in so many of the late works, Hals' flickering brushwork is most evident in the light passages. Unusual are the lilac, grey-green and rose ribbons dangling at his model's waist, which provide daring accents against the deep black of his costume while establishing a delicate accord with the indescribable warm and cool colours Hals finds in a face (Plate 301).

The frontal pose Hals used so often during this phase suggests that he was not unaffected by the current classicizing trend, which led Dutch artists to seek quieter and more stately effects. However, his dynamic tendencies were unsuppressable, and as his palette grew more restricted, his fluid brushwork became bolder. The strong structural accents and the insistence upon clarity of form used by other painters to achieve a classic balance and order were fundamentally alien to him. He seldom stressed the vertical and horizontal forms that lend stability to a painting. Where others would use the broad, flat collar worn by a model to give a kind of firmness to a portrait, Hals places it askew (Plate 306). The rigidity of a bust *Portrait of a Woman* (Plate 307; Hull, Ferens Art Gallery) seen *en face* is broken by his keen observation that this wisp of a woman posed with her head tilted ever so slightly. For Hals a record of his close study of nature took precedence over a preconceived schematic arrangement. His sympathetic portrait of this young woman also shows that old Hals lost none of his ability to characterize the poignantly tender side of a young woman's nature (Plate 309).

The increase in Hals' power of simplification and concentration is seen in his portrait of *Tyman Oosdorp* (Plate 314; Berlin-Dahlem), which, as we have noted, may be dated 1656. Shadows have deepened and within them the sitter's mood becomes the dominant note. Oosdorp is seen seated in profile, turning his head and intense gaze toward us. The silhouette of his torso is uncomplicated but Hals carefully avoided any suggestion of a strictly geometric configuration by breaking the rhythm of its outlines. Light is mainly focused on his head and collar with a glimpse of his hand providing a secondary accent. A close view of his powerful head (Plate 315) shows how he combined strong contrasts of shadow with incredibly fine tonal gradations in the light areas to model his features. Forms are built up with liquid strokes of thin paint that has been transformed by his touch into a vibrant, living medium.

194

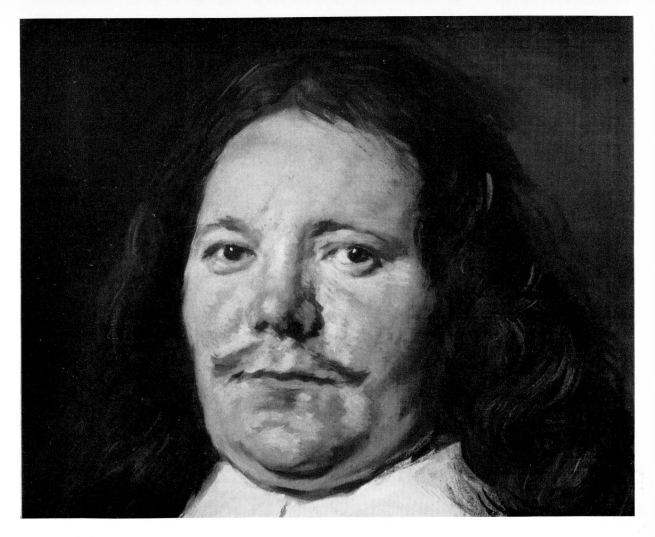

Fig. 207. Detail from *Portrait of a Man* (Plate 329). About 1660. New York, The Frick Collection

The technique of the three-quarter-length *Portrait of a Man* (Plate 316) now at Copenhagen suggests that it was painted around the same time as Tyman Oosdorp. In the same decade Cromwell sat for his portrait in England. Vertue's report of the instructions Cromwell is reputed to have given his painter could have also been uttered by the anonymous model who posed for the Copenhagen portrait:

> 'Mr. Lilly I desire you would use all your skill to paint my face truly like me, & not Flatter me at all but [pointing to his own face] remark all these ruffness. pimples warts & every thing as you see me. otherwise I never will pay a farthing for it.'

Sitters with more flamboyant tastes than the man portrayed in the Copenhagen painting also continued to patronize Hals. One of them posed for the mighty three-quarter-length *Portrait of a Man* (Plate 329) now at the Frick Collection. When it was shown at the memorable exhibition of art treasures of the United Kingdom at Manchester in 1857 it was identified as Michiel de Ruyter, Holland's greatest admiral. Thoré-Bürger, who fired the first shot in his campaign for a reappraisal of Hals' achievement in a review of the Manchester show published in *Le Siècle* in 1857, noted the error. Every Dutch schoolboy could also have told the cataloguers of the exhibition that the identification was untenable.

Hals' forceful characterization of the robust model for the Frick portrait (Fig. 207) is matched by his treatment of the man's costume, where large zigzag and diagonal touches suggest the play of light on his shiny black costume and vigorous slashes of his brush detonate the explosive display of his white shirt and gigantic double cuffs. As we shall see, a small bit can be inferred about the

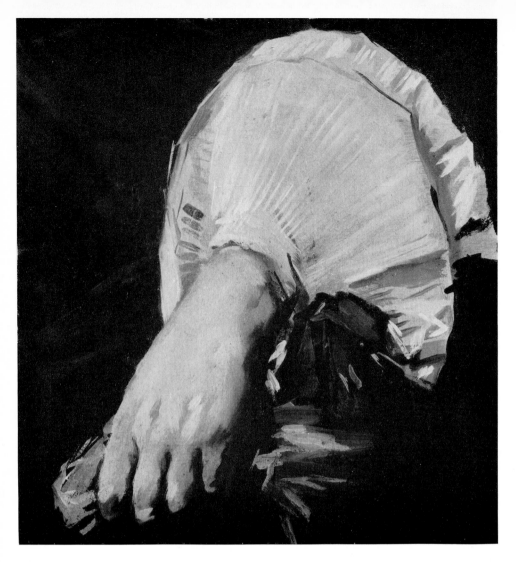

reactions of some of Hals' contemporaries to his technique, which grew increasingly more daring as he grew older. But his late patrons, like the early ones, did not leave a single word about their own response to his work. If any of them wondered why Samuel van Hoogstraeten neglected to cite Hals in the passage of his handbook for artists (*Inleyding tot de Hooge Schoole der Schilder-konst*, 1678) which recommends that painters use bold brushstrokes instead of blended ones, he left no reaction to the theorist's omission. Hoogstraeten wrote that he preferred a free to a fused technique because it was less boring. Hals' patrons probably agreed that a fine finish could be tedious, and some of them must have been as dazzled as we are by the wizardry of his late technique, where no attempt was made to hide the touch of his brush. They too must have received pleasure from determining how his disembodied touches manage to suggest a cuff, a hand and a glove (Fig. 208). If not, why did they sit for him? A man who decided to pose for old Hals knew full well that he would not receive a piece of *Feinmalerei*. Those who wanted portraits with a licked finish could easily find a host of competent face painters ready to satisfy their demand.

The Frick portrait shows the flexibility of the old master's pictorial treatment. Distinctly different touches model the flesh tones of the head and the hand. The technique of the latter (Fig. 208) is characteristic of his late style when he relied primarily upon a minimum of touches to build up forms, while the former (Fig. 207) is mainly modelled with numerous short hatched strokes, which recall the parallel ones he had favoured in the 1620s to capture the sparkle of light and create a vibrating surface. Perhaps the model asked the artist to use an earlier technique for

196

Fig. 209. Jonas Suyderhoef: Engraving after Hals' lost *Portrait of Theodor Wickenburg*

Fig. 210. Jonas Suyderhoef: Engraving after *Conradus Viëtor* (Plate 248)

the head, or Hals himself may have responded to an impulse to employ it. In any event, the idea was a success. Not only is the treatment of the head compatible with the late technique used for the hand but it creates a vital accent in the crucial part of a portrait bursting with other areas of attraction. Cross-currents in Hals' style have been met before. More than a foretaste of the breath-taking economy of his late phase was given long before 1650; recurrences of earlier tendencies appear elsewhere in the last years.

The group of precious oil sketches which can be assigned to this phase reveals that Hals remained equally at home making portraits on a small or a life-size scale. As before, some of them served as modellos for engravers; prints after the little paintings of the artist *Frans Post* (Plate 318) and the Haarlem preacher *Adrianus Tegularius* (Plate 319) and his lost portrait of *Theodor Wickenburg* (Fig. 209) are known. When we look at seventeenth-century engraved reproductions of Hals' portraits we usually think of the painter's achievement, not the print-makers'. The verse inscribed on Jonas Suyderhoef's engraving of the portrait Hals made in 1644 of the Haarlem minister *Conradus Viëtor* (Fig. 210) shows that seventeenth-century men could look at them in another way. The first line of the poem reads: 'The engraver made this image of him to whom God gave being.' Strictly speaking, of course, Suyderhoef made the likeness; his print was engraved in 1657 or later to commemorate Viëtor's death. We would give credit to the painter instead of the engraver, but the poet saw things differently. His verse mentions the copyist and completely ignores its inventor. The only reference to the painter is the usual one: 'F. Hals pinxit.' On another print made around the same time Hals was almost deprived of this laconic credit line; the first state of Suyderhoef's engraving after the artist's lost portrait of *Jacobus Revius* (Fig. 211), inscribed 'A.V.Dyk.Pinsit.'—an impossible attribution for this characteristic portrait by

197

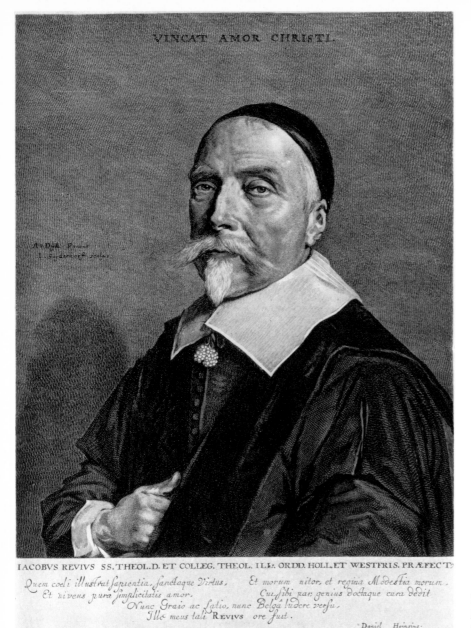

VINCAT AMOR CHRISTI.

IACOBVS REVIVS SS.THEOL.D. ET COLLEG. THEOL. ILI. ORDD. HOLL.ET WESTFRIS. PRÆFECT:

Quem cœli illustrat sapientia, sanctaque Virtus, Et morum nitor, et regina Modestia morum,
Et nivens pura simplicitatis amor. Cui sibi par genius doctaque cura dedit.
Nunc Graio ac Latio, nunc Belga ludere versu.
Ille meus tali Revivs ore fuit. Daniel Heinsius.

Fig. 211. Jonas Suyderhoef: Engraving after Hals' lost *Portrait of Jacobus Revius*; first state, erroneously inscribed "A.V. Dyk. Pinsit."

Hals. The disconcerting error demonstrates that not all inscriptions on contemporary prints made after paintings can be accepted as proofs of the authorship of a picture. The mistake is also difficult to explain. Did Revius demand that the engraver inscribe Van Dyck's name on the print because he wanted his friends to believe he had been portrayed by the internationally famous Flemish master and not by Frans Hals? Hardly. Nothing known about this passionate Dutch patriot, militant Calvinist minister and zealous poet suggests that he would have ever engaged in such chicanery. A more plausible explanation is that the inscription was not lettered by Suyderhoef but by a numskull in his studio who did not know the difference between a Hals and a Van Dyck. In any event the error was corrected in the second state of the print; it is inscribed 'F. Hals Pinsit.'

Two little portraits of dignified men traditionally identified as preachers, now at Amsterdam (Plate 321; Rijksmuseum) and at Philadelphia (Plate 322; formerly Mrs. Efrem Zimbalist), manifest the sombre undertone not uncommon in these years. Equally compelling is the small *Portrait of a Man* (Plate 323) at the Mauritshuis in The Hague which impresses by its utter simplicity and fiery intensity. A close view of this anonymous model's face (Plate 324) sums up in miniature the freedom of handling and haunting complexity of expression of the late portraits.

Bode was impressed by the little Hague portrait when he introduced it to the literature in

198

1883. He noted the surety of each brushstroke that models form while eminently expressing the personality of the sitter as well as the intensity and clarity of the flesh tones – and all of this in spite of what Bode called the weakness of old age. According to Bode, the infirmity brought on by advanced age was betrayed by the artist's trembling hand: 'In putting in the highlights on the whites a couple of drops fell on the dark coat which the painter did not remove and which the present owner has allowed to remain, like medals, evidence of the mint condition of the small picture.' However, in view of the passages in Hals' late portraits which still show the occult control of his earlier works, to attribute the nervous strokes of this period to the weakness brought on by extreme age is similar to explaining El Greco's elongated figures by a defect in his eyesight. E. W. Moes, who published a monograph on Hals in 1909, must have read carefully what Bode wrote about the small Hague portrait; however, he saw even greater signs of the artist's senility in the painting. According to Bode, the artist's hand trembled, but his touch was still sure. Moes wrote that 'the hand of the painter, already weakening, lacked surety.' Moes went farther. He added that, when laying the whites, Hals' brush splashed some drops on the model's dark jacket 'but his feeble sight was no longer able to see these details.' The drops remain, he added, thanks to the religious care with which the owner has preserved the painting, proof of Hals' defective eyesight. What Bode considered accidental drops and called, in passing, medals which honour the impeccable state of the portrait, Moes seemed to read as notarized statements from an optometrist certifying that Hals' eyesight had failed.

From one point of view a discussion of these few drops of white on the model's coat is academic, as they are no longer visible on the portrait. After Moes wrote, apparently some finicky owner felt compelled to have them removed or overpainted. However, it is worth stressing that the claim that the artist's eyesight had deteriorated to the point where he could no longer see accidental droppings of his brush is patent nonsense. This erroneous notion is part of what can be called the physiological explanation of Hals' late style. We shall see that it was offered as early as 1660 in a poem dedicated to the artist's portrait of *Herman Langelius* (Plate 330), and echoes of it are still heard in accounts written by modern critics.

If we turn to the small, late portrait of a *Seated Woman* (Plate 326; Oxford, Christ Church, Senior Common Room) and argue that Hals' keen characterization of his stout model, his decisive modelling of the hands holding a fan, his control of the monochromatic colour harmonies, and his use of incredibly fine intermediary half-tones in the flesh tints are not the work of a man with feeble eyes we flog a dead horse. The Christ Church painting is the only existing little portrait of a woman Hals made during this period. Evidently candour and a spontaneous touch, the things that a patron had to expect from old Hals, were qualities not many Dutch ladies looked for when they employed an artist to make a miniature-like portrait. Indeed, there is reason to believe that the wife of at least one of Hals' clients chose not to sit for hers. Jan de Bray, not Hals, made the pendant (Fig. 212) to the freely painted little portrait which Hals painted of *Cornelis Guldewagen* (Plate 325; Urbana, Illinois, Krannert Art Museum) around 1660. De Bray's portrait of Gulde-wagen's wife is dated 1663. If she decided not to pose for Hals around this time, she could not

Fig. 212. Jan de Bray: *Agatha van der Hoorn*. 1663.
Luxembourg, Musée Pescatore

have made a better choice than De Bray. He was able to provide her with a degree of finish that was alien to old Hals and he was also able to provide a first-rate companion piece to Hals' little portrait since it was during these years that this gifted artist's limited palette and grey tonalities came closest to the master's works.

Guldewagen (Plate 325) wears the black skull-cap so frequently worn by Dutch preachers when they sat for their portraits. However, this hat was also worn by men who were not theologians. Guldewagen was one of them. He was not a minister, but owner of the Red Hart Brewery in Haarlem. Earlier in his career Hals had painted a man embracing one of the colossal beer kegs that probably belonged to Guldewagen's brewery (Plate 118). Nothing is known about the stocky, square-faced man traditionally identified as Willem Croes (Plate 327; Munich, Alte Pinakothek). The portrait was said to bear the date 1658; today there is no sign of that date on it. However, 1658 cannot be wide of the mark although its exceptionally fluid treatment suggests that it may have been painted a few years later. As in his other little portraits the artist carefully adjusted the size of each stroke to the small scale of the panel. Here virtually every trace of conventional finish has been eliminated. The sacrifice could hardly have been more worthwhile. Smooth surfaces and neat outlines were a small price to pay for the enormous gain in spirit.

The stern characterization Hals made of the leading Amsterdam minister Herman Langelius (Plates 330, 332) in his life-size half-length now at Amiens, Musée de Picardie, is confirmed by a contemporary who described him as a man who 'fought with the help of God's word, as with an iron sword, against atheism.' Langelius played an important role in the struggle of the church to ban Vondel's drama *Lucifer*. The campaign was successful. After two performances Vondel's tragedy of the passionate revolt of an individual against authority was banned from the Amsterdam stage and the printed edition of the work was confiscated. The interdiction of a book in Amsterdam in those days had the same effect as banning a book in Boston in more recent times: Vondel's tragedy immediately became a bestseller and numerous editions were published to satisfy the public's hunger for a proscribed play.

Hals' portrait of Langelius was engraved by Abraham Blooteling (1640–1690); hence it must

Portrait of a Man. About 1655-60. Detail from Plate 316.
Copenhagen, Royal Museum of Fine Arts

have enjoyed some popularity. But not all of Hals' contemporaries approved of the way he had portrayed him. The amateur poet Herman Frederik Waterloos criticized the portrait in a verse he published in 1660, in *De Hollantsche Parnas*, an anthology of Dutch poetry:

> 'Old Hals, why do you try to paint Langelius?
> Your eyes are too weak for his learned rays,
> And your stiff hand too rude and artless
> To express the superhuman, peerless
> Mind of this man and teacher.
> Although Haarlem boasts of your art and early masterpieces
> Our Amsterdam will now witness with me that
> You did not understand the essence of his light by half.

If Waterloos' poem refers to the portrait now at Amiens – and it most probably does – it establishes 1660 as the *terminus ad quem* for the painting. The poem, one of the rare contemporary references to a specific work by the artist, is also the earliest published claim that old Hals' eyes had failed him and his hand had become benumbed. As we have heard, this clinical explanation of Hals' late style was repeated by subsequent critics. However, it was never uttered by later painters who did not place a premium on a high finish. When they studied the brushwork of Hals' last pictures they must have muttered: 'If this is senility, may the gods afflict me with it now.'

It is evident that Waterloos was not favourably impressed by Hals' broad technique and we in turn may wonder about his choice of the adjective 'stiff' (*stramme*) to describe the hand that laid the flowing strokes which build up the forms of Langelius' portrait. But the import of the Amsterdam poet's criticism of the Haarlem painter is distorted if we do not recognize that it contains an element of parochial civic pride. It also follows the well-established poetic convention of praising the model of a portrait at the expense of the man who painted it. Furthermore, not all of Hals' contemporaries endorsed Waterloos' view that the old artist's powers had failed him. The patrons who continued to give him commissions did not. And perhaps Arnold Moonen wrote about a late work when he dedicated a short verse written in 1680, which was published in 1700, in praise of Hals' untraceable portrait of the Haarlem preacher Jan Ruyll:

> Here is the portrait of your devout Ruyll
> O Haarlem, your hero, your support, and pillar
> Of temple peace, as naturally as if he lived,
> Thanks to Hals, whose brush ingeniously glides
> In and out. But if the spirit of the man had ever charmed you,
> Retain the lessons heard from his golden mouth.

These lines do not tell us very much – only that the Deventer poet, who was two generations younger than Hals (he was born in 1644), found satisfaction in one of Hals' portraits and had a few complimentary words to say about the artist's *geestigh* brushwork. Moonen also follows a

convention of the time when he gently urges us to use Hals' portrait as a reminder of the admonitions the artist's model preached.

We clutch these scraps of unexceptional verse because they are amongst the few faint clues which remain of the reactions of Hals' contemporaries to his work. Very little is known about Moonen's appreciation of painting. Since he was twenty-two years old when Hals died in 1666, he could have commissioned a portrait from him but as far as we know he did not. Perhaps Moonen, who was born in the province of Overijsel and mainly active in the eastern part of the Netherlands, never even met the Haarlem artist.

A little more is known about Herman Waterloos' connection with the arts. If we assume that collectors own what they like, Waterloos was a man of some taste and judgement. He had two of Rembrandt's paintings in his possession: a *Christ Appearing to Mary Magdalene* and a portrait of his friend *Jeremias de Decker*. Unfortunately it is not possible to identify either work with certainty. One would like to know if the man who called Hals' portrait of Langelius rude and artless owned mature paintings by Rembrandt which had bold impasto touches, or earlier, more finished ones; we do know that his *Jeremias de Decker* was not the broadly modelled, late one now at the Hermitage (Bredius 320); for this painting is dated 1666, and Waterloos' poem about the one he owned had been published in 1660. The lines he dedicated to his Rembrandt *De Decker* are not as critical as those he wrote about Hals' *Langelius*. Indeed, he did not make an appraisal of Rembrandt's work; he offered him some hackneyed advice instead. Waterloos wrote that famous Rembrandt must take special pains when he paints this extraordinary poet, for he is not an ordinary man. If Rembrandt wants his brush to surpass De Decker's pen he must not paint him the way he paints ordinary people. He must not think of a handful of gold, but must dip his brush in sunshine. Only then will he make an immortal portrait, and then De Decker's poetry will bring fame to Rembrandt's painting and the artist's work will enhance the poet's creations. Rembrandt could not have received much more pleasure from these platitudes than Hals did from Waterloos' critical verse on the portrait of Langelius.

During his final years Hals again made use of the informal pose of a seated model turned in a chair with his arm resting on its back. We have seen that the scheme was one of Hals' favourites. After he had introduced it in his 1626 *Portrait of Massa* (Plate 64) he continued to ring changes on it, and variations on the theme are found again in two works which can be assigned to the 1660s. In the *Portrait of a Man* (Plate 331; Paris, Jacquemart-André Museum) the erect attitude of the model and the horizontal position of his arm on the back of the chair give a firmness and stability, while vigorous summary accents free the painting from any trace of rigidity. The pictorial organization of his more famous *Man in a Slouch Hat* (Plate 334) at Cassel, which also employs the scheme, is quite different. Here the way in which the great curved sweep of the brim of the hat and the dashing diagonals organize the dynamic design as well as the impression of vivid animation and the hint of a view of a landscape through the open window recall earlier works, but there is no parallel for the consistently bold, broad treatment. Yet a close-up of the smiling model's face (Plate 335) and of his hand (Plate 333) show that there has been no fundamental

change in his way of working. Forms are still built up with light and dark touches on a middle tint, but the fluid strokes have become swifter and the economic juxtaposition of tones more courageous. It is fair to ask if the widely admired shorthand of the Cassel portrait is, in fact, the brushwork of a painting never carried beyond an intermediate stage. The answer partially depends upon one's notion of a finished painting. As we have already noted, Goethe thought that Hals' characteristic little portraits at Dresden (Plates 141, 142) showed only the underpainting. He expected the transitions between colours to be blended and softened in a finished work.

Similar sentiments were voiced at somewhat greater length by Sir Joshua Reynolds in the *Discourse* he delivered in 1774 to students of the Royal Academy on the importance of studying 'the great works of the great masters, forever.' Study nature attentively, Reynolds urged, but always with those masters in mind: 'Consider them as models which you are to imitate, and at the same time as rivals with whom you are to contend.' He told the students that every school of painting has produced artists who, in spite of their faults, are well worthy of attention and, in some measure, of imitation. Among the artists in this category whom he singled out for their special attention was 'Frank Halls' of the Dutch school. Reynolds, who professed the importance and nobility of history painting but practised portraiture, paid Hals the highest tribute. But the first president of the Royal Academy also believed that Hals' portraits had a serious defect; they lacked finish:

'In the works of Frank Halls, the portrait-painter may observe the composition of a face, the features well put together, as the painters express it; from whence proceeds that strong-marked character of individual nature, which is so remarkable in his portraits, and is not found in an equal degree in any other painter. If he had joined to this most difficult part of the art, a patience in finishing what he had so correctly planned, he might justly have claimed the place which Vandyck, all things considered, so justly holds as the first of portrait-painters.'

Reynolds condemned paintings which have an excessively high finish; he cites Cornelis Jonson (see Fig. 163) and Adriaen van der Werff as artists who went too far in this direction. However, in his opinion, Hals did not go far enough.

Nineteenth- and twentieth-century artists have given us a quite different conception of finish. They have taught us to appreciate the distinctive qualities of the handwriting of an artist, and we like to think that a study of it allows us to delve into a painter's personality, even his soul. But what about Hals' clients? Would one of his patrons have been satisfied with a head of hair suggested by a few sweeping brushstrokes of yellow ochre, no matter how personal (Plate 335), or by a hand which is hardly defined (Plate 333)? Evidently some were. The Cassel *Man in a Slouch Hat* is not Hals' sole testament of the expressive and suggestive power of his late brushwork. Other portraits done during his last years show a similar brevity.

Equally abbreviated and audacious is the technique of the *Portrait of a Man* (Plate 338) at the Fitzwilliam Museum, Cambridge. This sitter also wears a large black hat, which a former owner removed by overpainting it and the background with an opaque, flat brown (Fig. 213), probably

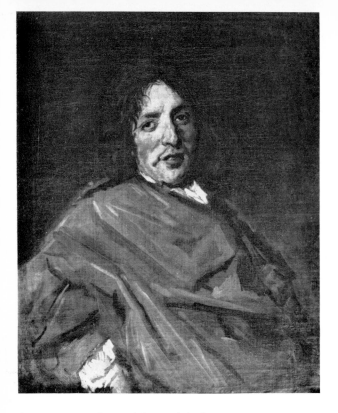

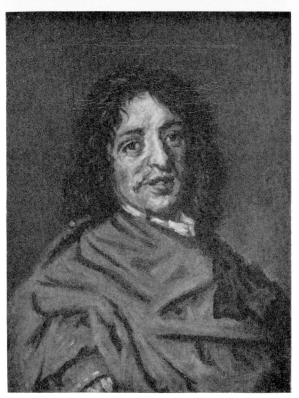

Fig. 213. *Portrait of a Man* (Plate 338), before restoration. Cambridge, Fitzwilliam Museum

Fig. 214. Copy after *Portrait of a Man* (Plate 338), before restoration. Stockholm, Hallwyl Collection

because he found the angle of the hat too rakish. A cleaning of the picture in 1949 revealed that there were two levels of repaint, a patchy lower one, which had become extremely hard, and a complete upper one, which was relatively easy to remove. The restorer estimated that the lower layer was painted in the late eighteenth or early nineteenth century and suggested 'that what remained of it was probably the residue of an earlier attempt at cleaning, which was abandoned uncompleted, leaving it necessary to replace the partially removed coating with a fresh layer of paint. In this case, the "improved form" of the picture must be due to the preferences of the eighteenth century.'

Restoration of the Cambridge portrait to its original state was hardly needed to demonstrate that the small oil sketch (Fig. 214; Stockholm, Hallwyl Collection) is not a preliminary study for the painting, but a feeble copy of it made after the hat and background had been repainted. But it proved that yet another candidate for the honour of standing as an autograph preliminary study by the master must be rejected. The successful cleaning also restored compositional and colouristic harmony to the portrait. The solid mass of the great black hat serves as an essential counter-balance to the strokes that sketchily suggest the face and figure while the original background was revealed as a silver-grey, not a dull brown, making a delicate accord with the grey cape.

The light tonality of the Cambridge painting is rare but not unique in Hals' late *oeuvre*. The Jacquemart-André portrait (Plate 331) is not painted in the dark monochromatic tones which occur so often in this period either; the model for this work wears a light-grey jacket and bright touches of gold enliven the sash he wears across his breast, while the background here is also grey rather than the deep olive-green found so often when Hals' sitters wear black. A change in men's fashions rather than a pronounced shift in the artist's late palette helps account for these unexpected colour harmonies. After wearing predominantly black costumes for about a generation, Dutchmen had begun to choose lighter and brighter clothes. Artists were prepared to make the most of

Fig. 215. Karel du Jardin: *Men with a Dog*. Cambridge, Fitzwilliam Museum

Fig. 216. Jan Vermeer: *Young Woman Drinking with a Man*. Berlin-Dahlem, Staatliche Museen

the change. They welcomed the contrasts afforded by vivid colouristic accents. Much of the pictorial splendour of the portrait Rembrandt painted of Jan Six in 1654 is based on the effect he achieved by the contrast of his model's grey coat and the bright red cape draped over his shoulder. An Emanuel de Witte architectural painting is hardly complete without the scarlet or bright blue mantels worn by the elegant men standing amidst the majestic spaces of his interior views of churches and synagogues. Grey capes were also popular. Inventories of the time cite grey travelling mantels and we see them worn by the romantic vagabonds in paintings by Dutch artists who worked in Italy. The principal figure of Karel du Jardin's *Men with a Dog* (Fig. 215), a painting done by this gifted Italianate Dutch artist in Italy around 1650, wears a grey cape and a cocked black hat not unlike those worn by the model who sat for the Fitzwilliam portrait. This garment must have been a familiar sight in Holland during Hals' last years. The man in Vermeer's painting of a *Young Woman Drinking with a Man* (Fig. 216; Berlin-Dahlem) wears the same outfit and he too is seen with his hat set askew, but, as we have learned to expect in a work by the Delft master, with greater restraint. No early collector would have felt compelled to tamper with such a hat. However, Vermeer's little masterwork was subjected to a different kind of 'improvement.' When the Berlin Museum acquired the painting in 1896 the window had been completely painted over with a view of landscape in a crude attempt to make the picture look like a Terborch. The alteration was probably made while Jan Vermeer was still waiting to be resuscitated by Thoré-Bürger and when Terborch fetched far higher prices in the international art market than Vermeer did.

Although Hals and Vermeer are worlds apart, a comparison of Hals' life-size *Portrait of a Man* (Plate 338) with the man in Vermeer's small genre painting (Fig. 217) is instructive. Both can be dated into the first half of the 1660s. Thus they are contemporaneous but it will be remembered that there was about a half-century difference between the ages of the two artists. Around this time Hals was an octogenarian and Vermeer had just passed his thirtieth birthday. But the gap

205

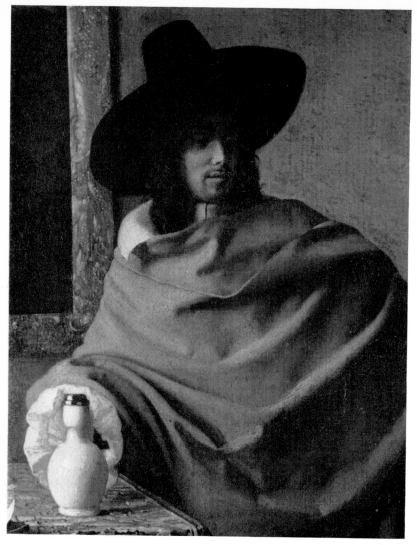

Fig. 217. Detail from Fig. 216

between their ages seems small compared to the gulf between their temperaments. Vermeer is a cool, detached observer as intent upon showing the way a man looks at a woman as he is upon using his magical mastery of fine gradations of light and power of design to give sculptural strength and clarity to his protagonist's figure. The trivial subject which Vermeer turned into high art remained as foreign to Hals as the classic order and harmony the Delft painter brought to his vision. During his last decades Hals' Baroque impulses may have been subdued but they were never conquered and occasionally they erupted with not less but greater intensity. In the Cambridge portrait his broad, streaming brushwork has become more personal and arbitrary. A passionate delight in the suggestive power of his touch and in the flow of paint has taken precedence over the more scrupulous attention he had given in earlier works to the modulation of light on a model's face. By the standards of some of his contemporaries, even the face of his sitter must have seemed to lack finish. Like Rembrandt, Hals may have been criticized for working up parts of his paintings and merely daubing the rest. If so, he probably answered with the reply Houbraken tells us Rembrandt gave his critics: 'A picture is finished when the master has achieved his intentions.'

During his very last years the master continued to have admirers. By 1661 something of his fame had spread to neighbouring Flanders. At Antwerp in that year Cornelis de Bie published *Het Gulden Cabinet*, a rich collection of biographical notices on seventeenth-century painters, architects, sculptors and print-makers. De Bie did not devote an entry to Hals but in a brief reference to Philips Wouwerman he took more than passing notice of Wouwerman's teacher:

206

'He [Wouwerman] studied with Franchois Hals, who is still active and living at Haarlem and miraculously excellent at painting portraits or counterfeits which are very rough and bold, nimbly touched and well ordered. They are pleasing and ingenious and seen from afar they seem alive and appear to lack nothing. . . . '

As we have seen, none of Hals' patrons mentioned a word about the character and quality of their painter's technique but the Flemish chronicler De Bie writing in the small town of Lier near Antwerp did. Neither the number of people who shared De Bie's opinion nor the works by the master he knew can be ascertained. However, his brief comment indicates that the special character of Hals' brushwork won more than local acclaim in the artist's lifetime. De Bie also seems to have been well informed. He noted in his volume, published in 1661, that Hals was still working. Since he had nothing but praise for the artist at this late date we can assume that he – or his informant – found no reason to be critical of Hals' last works.

Two years after De Bie's book appeared, another foreigner, the Frenchman Balthasar de Monconys, found Hals worthy of special mention. When this widely travelled nobleman visited Haarlem on his trip through the Low Countries in 1663 he recorded the highspots of his visit in his diary. His account is included in the second volume of his chatty *Journal* published in 1666, the year of Hals' death. Monconys' first trip to Haarlem was busy and brief. He gave about as much time to the city as most tourists do today. He arrived from Leiden on the evening of August 17th. On the following day, after looking for bargains in the art market – which he often did and seldom found – and after seeing some of the principal sights, he departed for Amsterdam. With his guide for the day he included a visit to the headquarters of a Haarlem militia company. He wrote:

'There is also a building called *le Doul* where the officers and magistrates of the city assemble to shoot harquebuses and practice with the pike which is called *Butte* in France. There are very large portraits of the assembled men and among them one by Hals, who is with reason admired by the greatest painters.'

From Monyconys' brief reference it is not possible to determine which militia piece he saw or what he thought of the artist's late works; the civic guard portrait he admired could not have been painted after 1639 and it may have been the one Hals had painted as early as 1616. Although high claims cannot be made for Monconys' sensitivity as a critic, he did not parrot everything he heard or unquestionably accept the evaluation others placed on works of art. He had a mind of his own and was able to appreciate Hals' bold brushwork as well as Dou's smooth paintings. Dou, he wrote, 'est incomparable pour la délicatesse du pinceau.' In the seventeenth century admiration for one style of painting did not necessarily exclude appreciation for a drastically different one. Monconys also had his blind spots. After visiting Vermeer's studio at Delft he noted in his diary: 'I saw the painter Vermeer, who had none of his works with him; but we saw one at the house of a baker that had been bought for six hundred *livres*, although it contained only one figure, which I should have thought expensive at six *pistoles*.' If we consider the small size of

The Final Years: 1650-1666

Vermeer's total production it is hard to imagine that he ever had many of his own works in his studio. Probably the Delft painter had nothing to show because he worked so slowly.

On a quick return trip to Haarlem in the same year Monconys bought a small, inexpensive (12 *richdalers*) *Hermaphrodite* by Salomon de Bray and at Pieter Saenredam's studio he saw 'un parfaitement beau' Bamboccio, for which he offered a high price (300 *louis*), but Saenredam wanted even more than he was willing to pay. Monconys did not make a pilgrimage to Hals' studio on either of his visits to Haarlem. The aged artist would not have had much more in stock to show the French nobleman than Vermeer had on hand. Though Hals probably continued to paint with astonishing speed, his studio must have been virtually bare. At this time he worked primarily on commission. As soon as a portrait was finished it would have been removed by his patron. And his own collection could hardly have been considered one of the sights to show a foreign nobleman in 1663. It will be recalled that his paintings by Heemskerck and Van Mander as well as two by his sons and one of his own had been sacrificed in 1654 to help settle a debt he owed his baker. What the impoverished artist acquired after that date could not have been very impressive.

Monconys' statement that Hals was a portraitist 'qui est avec raison admiré des plus grand peintres' may suggest that he was already beginning to earn a reputation as a painter's painter, but others also had their reasons for admiring the master. Until the very end fashionable patrons continued to come to him. The young man who posed for the half-length now at the Bührle Foundation, Zurich (Plate 336) was one of them. Hals responded vividly to the handsome sitter and with swift, powerful strokes captured his intent momentary expression and the lively reflections of bright light on his face. To our eyes his open collar with its huge dangling tassels lends an unbuttoned quality to the portrait. This apparent casualness was not Hals' invention. There had been a vogue for a kind of studied negligence in Holland since the middle of the century. The pose Hals gave his model is much more familiar than his neckwear but by the brevity and freedom of handling of the claw-like hand and huge white cuff the artist brings new life to the commonplace attitude of a model posed with his hand resting on his chest.

Hals gave the anonymous patron who commissioned the portrait now at the Museum of Fine Arts at Boston a similar posture (Plate 337). The consistently broad technique and the model's attire suggest that the Boston portrait is one of Hals' last known works. The model's long hair, which falls well below his shoulders, is a reflection of French taste, which had begun to permeate Dutch art and life after the middle of the century and became a dominant note during its last decades. Although the possibility that Hals' sitter has dressed his own hair in the French wig style cannot be ruled out, he is probably wearing an expensive, full-bottomed wig in emulation of the style set at the court of Louis XIV. Despite the protests of preachers the French fad of cutting off one's own hair in order to wear someone else's gained popularity in Dutch upper-class circles. The deep red-brown 'Japanese kimono' he chose to be portrayed in also sets him apart as a man of high fashion.

The Shoguns of Japan were responsible for starting the Dutch kimono craze, which became popular during the last quarter of the century and even more so during the course of the following

one. It was the custom of the Shogun to give thirty kimonos to officers of the Dutch East Indies Company after their annual trade agreement was signed in Tokyo. When these rare and exotic garments were brought back to Holland they created a small sensation and fetched enormous prices in the trade. The vogue quickly spread to other countries. Since the demand for kimonos was far greater than the supply, the East India Company found it profitable to commission oriental tailors to make others for export, and Europeans were soon creating their own versions of the gown. They became a kind of status symbol. Statesmen, scholars and merchants who could afford them were proud to have themselves portrayed in this négligé outfit. In England men who were unable or unwilling to purchase them could rent them. Samuel Pepys records in his diary on March 30, 1666, that he sat for John Hayls 'till almost quite darke upon working my gowne, which I hired to be drawn in; an Indian gowne, and I do see all the reason to expect a most excellent picture of it.' What Pepys called an 'Indian gowne' in 1666 a Dutchman would have called a 'Japonsche rock.'

Hayls' portrait of Pepys wearing the yellow-brown gown he hired, and in a kind of momentary attitude not unlike those Hals used, is now at the National Portrait Gallery, London (Fig. 218). Thanks to Pepys' compulsion to record the details of his daily life, Hayls' painting, which was made around the same time Hals painted the Boston picture, is one of the most fully documented seventeenth-century portraits. Since the social class and taste of most of Hals' patrons were not much different than Pepys', we can infer that the thoughts they had and the demands they made while their portraits were on his easel were not unlike those of the tireless English diarist.

On March 17 Pepys wrote that Hayls started his portrait and noted: 'I sit to have it full of shadows and do almost break my neck looking over my shoulders to make the posture for him to work by.' We follow its progress when he sat again on March 20 'and had a greate deale done, but, whatever the matter is, I do not fancy that it has the ayre of my face, though it will be a very

The Final Years: 1650-1666

fine picture.' Pepys thought the likeness improved in subsequent sittings, but he apparently asked for some changes in the sheet of music he is portrayed holding since he noted on April 11 that this part of the picture 'now pleases me mightily, it being painted true.' Two days later, however, he demanded a big change. He wanted Hayls to put 'out the Landskipp, though he says it is very well done, yet I do judge it will be best without it, and so it shall be put out.' On April 18 he again visited his painter, who 'would have persuaded me to have had the landskipp stand in my picture, but I do not like it and will have it otherwise.' Two days later, again to Hayls 'and there, though against his particular mind, I had my landskipp done out, and only a heaven made in the roome of it, which though it do not please me thoroughly now it is done, yet it will do better than as it was before.' On May 16th he paid Hayls £14 for the portrait and 25 shillings for the frame, and half that price for a portrait of his friend Thomas Hill, the latter 'being a copy of his only, and 5s. for the frame; in all, £22 10s. I am very well satisfied in my pictures; and so took them in another coach home along with me, and there with great pleasure my wife and I hung them up, and, that being done, to dinner.'

Would that Pepys had sat for Frans Hals, not for John Hayls in 1666, and left such a detailed report of a portrait transaction done during the last year of the artist's life. Chances are slim that an account will ever be discovered which will tell the story of posing for Hals from beginning to end. His clients were mainly Dutchmen and the Dutch cannot boast of great diarists or memoir writers. We would even be grateful for notes which tell less than the full story. Hayls was paid £14 for his portrait of Pepys in an 'Indian gowne.' How many guilders did Hals receive for his half-length of a man in a 'Japonsche rock'? We do not know. As we have seen, not a single reference to a fee paid to Hals has been found. It is only known that the artist agreed in 1633 to paint full-lengths in a militia piece for 66 guilders per figure – and this was a work he never finished. Knowledge of the price Hals received for a portrait done in his old age might help explain why the artist, whose reputation was established in some circles and who continued to receive assignments from modish patrons, was destitute during his last years.

To be sure, commissions probably became rarer by this time. No matter how great the portraitist, sitting for one who is in his eighties is not to everybody's taste. But as in earlier times, some of the leading members of the ruling class of the city continued to patronize him. Around 1664 the regents (Plate 340) and the regentesses of the Old Men's Alms House of Haarlem (Plate 349) chose him to paint their group portraits.

It should be stressed again that when these masterworks were made Hals was not the charge of the regents who posed for him. Although he was then dirt poor he was never an inmate of the Alms House. The story that he seized the opportunity to take shattering revenge on his heartless and miserly caretakers when he was asked to paint them may be a good episode for a historical novel but it has no factual basis. Moreover, by the standards of the time the social services offered by Dutch charitable institutions were exemplary and they did not fail to impress foreign visitors. Sir William Temple, the English Ambassador to the Netherlands, noted in his *Observations upon the United Provinces of the Netherlands*, written around the time Hals' group portraits were done:

'Charity seems to be very National among them, though it be regulated by Orders of the Country, and not usually mov'd by the common Objects of Compassion. But it is seen in the admirable Provisions that are made out of it for all sorts of Persons that can want, or ought to be kept, in a Government.'

Hals was never in the hands of those who made 'admirable Provisions' for indigent old men of Haarlem. He had no reason for personal vengeance when he painted the regent pieces. But the portraitist, who had been scrutinizing his countrymen for more than five decades, may have observed what the diplomatic witness noted when he wrote that Dutch charity is 'not usually mov'd by the common Objects of Compassion.'

We have already heard that the payment for the large group portraits may have enabled him to stand security in 1665 for a debt of 458 guilders, 11 stuivers, which his son-in-law had incurred. The money he was able to scrape together just a year before his death must have looked like a small fortune to the impoverished artist, who had to implore the city officials for public relief in 1662, who was granted an annual subsidy of 200 guilders in the following year and was given three carloads of peat by the municipality in 1664.

The idea of helping the needy artist by awarding him the commission may have crossed the minds of his patrons but it could hardly have been the determining factor. When a portrait is designed for public display, vanity plays a greater role than charity in the choice of a portraitist. If the regents and regentesses had not believed that Hals was up to painting their collective portraits they could easily have assigned the prime commission to another portraitist of the city or from near-by Amsterdam. Besides, if they were not satisfied with the first group, there is no reason to believe that he would have been permitted to go on with the second. Johannes Verspronck had died in June, 1662. Jan de Bray, however, was probably a front runner for one or both of the commissions. By the early sixties his reputation was well established at Haarlem and he proved his competence in this important branch of painting in 1663 with his suave group portrait of the *Regents of the Haarlem Orphanage* and was called upon to paint the regentesses of the same institution in 1664. But the governors of the Alms House decided upon Hals. Their artist did not fail them. His vision of the men and women who confronted him created two of the most searching portraits ever painted.

The portrait of the regentesses excels as much by the great power and order of its design as by the characterizations of the women. The four lady governors are seen gathered around a table while the servant on the right appears to enter the room bearing some message without disturbing the tranquillity of her superiors. They appear to exist in a stable, well-ordered world, which gains strength from the strong individuality of its members. The outstretched hand of the regentess at the head of the table (Plate 346) is a conventional gesture frequently found in group portraits (she is not pleading for money from the beholder) while the glove laced between the fingers of the standing regentess (Plate 348) shows that Hals' penchant for recording small realistic details has not left him. Unforgettable as the haunting expression of the seated woman on the right (Plate 351) is her long, thin hand (Plate 347), which tells more about the fragility of life than a warehouse

of *Vanitas* still-life paintings. Each woman speaks to us of the human condition with equal importance. Each one stands out with equal clarity against the enormous dark surface, yet they are linked by a firm rhythmical arrangement and the subdued diagonal pattern formed by their heads and hands. Subtle modulations of the deep, glowing blacks contribute to the harmonious fusion of the whole and form an unforgettable contrast with the powerful whites and vivid flesh tones where the detached strokes reach a peak of breadth and strength.

In the portrait of the men Hals' old tendency of creating an impression of casual informality and the instantaneousness recurs, but the pictorial unity appears less successful than in earlier works. The intense light areas of the flesh tones, the great expanses of white linen, and the daringly broad red touch on the knee of the man on the right tend to jump and are not fully integrated into a coherent design. However, when the painting was in its original state it probably created quite a different effect. A faithful but rather uninspired old copy of it (Fig. 219) shows that the portrait has darkened considerably during the course of more than three centuries. When the copyist saw the group portrait (probably in the eighteenth century) the rich effects of light filtering over the figures were still apparent and the surfaces of the conference table were clearly defined. Today the clarity of the spatial relationships is lost and delicate adjustments in the surface animation of the black clothing which formerly softened the great diversity of attraction have virtually disappeared. But these losses are quickly forgotten as soon as one examines Hals' grasp of the personalities or the fresh, spontaneous brushwork of passages which have not been obscured by the darkening of the paint (Plate 345).

As in so many other pictures by Hals, the penetrating characterizations almost seduce us into believing that we know the personality traits and even the habits of the men and women portrayed. And in the case of some critics the seduction has been a total success. It has, for example, been asserted that the regent in the tipped slouch hat, which hardly covers any of his long, lank hair, and whose curiously set eyes do not focus (Plate 344) was shown in a drunken state. This interpretation is in accord with the erroneous notion that the group portrait is Hals' revenge upon the stratum of society which institutionalized him, but there is no more support for the assertion that the regent is drunk than for the claim that the artist lived in the Alms House. The idea that the regent was portrayed inebriated entered the literature late. P. J. Vinken and E. de Jongh, who have published an account of the history of critical reactions to both group portraits show that it first appears in an article published in 1877 by the forgotten Dutch critic Jeronimo de Vries. Some later writers, who also contributed analyses of the other models based on the idea that Hals avenged himself in these works, accepted this false accusation and it is still heard today. It seems that the longevity of a calumnious report is in direct proportion to the number of titters it produces.

The supposed drunkenness of the regent is based on the tipsy position of his hat, the apparent disarray of his hair and the expression on his face. None of the evidence is convincing. The angle of his hat is a reflection of a contemporary fashion, not an index of his sobriety. We have seen large hats worn in the same way by other models Hals painted around the same time (Plates 334,

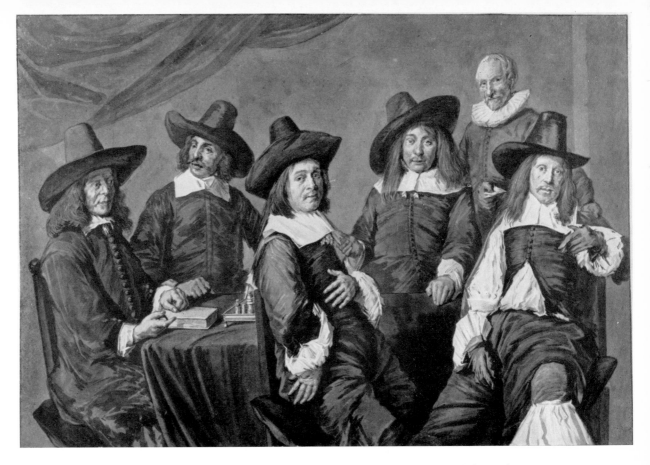

Fig. 219. Wijbrand Hendricks: Watercolour copy afer Hals' *Regents of the Old Men's Alms House* (Plate 340). Haarlem, Teylers Stichting

338); these men have not been – and should not be – accused of being drunk. The way the regent wore his hair or the expression on his face cannot be accepted as proof of the amount of alcohol he has consumed. Laymen as well as psychologists and police officers know that appearances are deceptive and that more than the look of a man and his hair style is needed to establish inebriation.

The regents of the charitable institution may or may not have been paragons of temperance but we can be certain that they insisted upon being seen in a sober state when portrayed in a group portrait designed to hang in their board room. Even a trace of the high spirits Hals showed in his early group portraits of civic guards celebrating around a banquet table would have been out of place in a picture of the governors of an Alms House at a conference table. If the regent or his colleagues thought he had been shown drunk the portrait would have been found unacceptable. It was not.

Vinken and De Jongh have offered a medical explanation for the unusual expression on the regent's face. They claim it is the result of a partial facial paralysis, not of the effects of liquor. Their analysis is sensible – one only wonders how firm that diagnosis can be if it is based solely on Hals' portrait. Neurologists are best qualified to answer this question. In any event, the hypothesis that the regent has some sort of facial deformity is the best one offered for the expression which some critics have erroneously interpreted as the look of a man in a drunken stupor.

If the regent had a facial deformity it is noteworthy that neither he nor his artist felt that it had to be hidden. A portraitist who endorsed humanist ideas about decorum would have posed him in profile or shown a three-quarter view that tactfully hid his defect. On more than one occasion Hals displayed that he was not insensitive to such niceties but in this case he did not feel bound by the convention of showing a man's best side. Such candour was unusual even in seventeenth-century Holland, where portraitists did not gain reputations for endowing their sitters with more

213

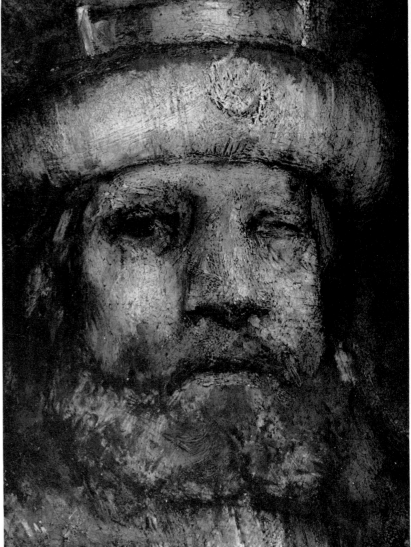

Fig. 220. Bartholomeus van der Helst: Detail from *Egbert Cortenaer*. Amsterdam, Rijksmuseum

Fig. 221. Rembrandt: Detail from *The Conspiracy of Julius Civilis*. 1661–62. Stockholm, National Museum

natural beauty than their creator gave them. A rare exception is the portrait Bartholomeus van der Helst painted around 1660 of *Egbert Cortenaer* (Fig. 220), the Dutch admiral who had an eye maimed in battle. The great admiral is portrayed here with a glass eye; apparently he wanted to display, not disguise, the fact that he had been crippled in the service of his country. Rembrandt also broke the rules of decorum when he did not attempt to hide one-eyed Julius Civilis' infirmity (Fig. 221) in his *Conspiracy of Julius Civilis*, the monumental painting he made for the Town Hall of Amsterdam in 1661–62. Rembrandt's failure to show the ancient Batavian hero in the best possible light helps explain why his work was rejected by the city fathers of Amsterdam. In some circles a breach of decorum in a history painting made around this time was evidently more difficult to tolerate than one in a commissioned portrait.

Hals' contemporaries have left no commentaries on his late group portraits and only few eighteenth-century writers cited them. The earliest known reference to them is found in Pieter Langendijk's history of the Old Men's Alms House at Haarlem, which he left unpublished at his death in 1756. His brief passage is of interest because he notes that in his time the works hung in different rooms. If they were mounted the same way in Hals' day, they were not intended to be viewed as pendants. Langendijk has virtually nothing to say about the quality of the works except that they are artfully painted, and he is silent about Hals' characterization of his models. What

214

later eighteenth-century critics published does not tell us much more, but their remarks are neither critical of the artist's technique nor suggest that Hals was critical of his sitters.

The plain fact is that seventeenth-century documents and literary evidence tell us virtually nothing about the men and women Hals portrayed in his late group portraits. In each regent piece the servant remains anonymous. Archival research has revealed the names of the five regents and four regentesses but it has not been possible to correlate a single name with a face.

The story is a familiar one. Not much more has been discovered about most of the sitters Hals portrayed during the course of more than half a century. Yet once contact is made with them we not only sense the rush of their blood, but we also know they have profoundly affected our view of man's estate. We attempt to control the powerful impact his paintings make upon us by considering the tradition in which he worked and the range of possibilities open to him. The effort only increases our admiration for Hals' unwavering commitment to his personal vision, which enriches our consciousness of our fellow men and heightens our awe for the ever-increasing power of the mighty impulses that enabled him to give us a close view of life's vital forces.

Bibliographical Note

The bibliographical material given here is divided into two parts: a BIBLIOGRAPHY ON FRANS HALS and a GENERAL BIBLIOGRAPHY.

The BIBLIOGRAPHY ON FRANS HALS is selective. Additional references to special studies and to individual paintings will be found in the forthcoming Catalogue Volume. For further literature on the artist, the reader should also consult H. van Hall, *Repertorium voor de Geschiedenis der Nederlandsche Schilder- en Graveerkunst*, 2 vols., 1936–49 (up to 1946) and the *Bibliography of the Netherlands Institute for Art History* (1943–). The BIBLIOGRAPHY ON FRANS HALS is arranged under the following headings:

1. Documents
2. Seventeenth- and Eighteenth-Century Literary Sources
3. Painting Catalogues
4. Exhibition Catalogues
5. Monographs
6. Lexica
7. General Studies and Critical Essays
8. Special Studies
 a. Biblical Subjects
 b. Portraiture
 c. Group Portraits
 d. Genre
 e. Landscape
 f. Drawings
 g. Cleaning and Restoration
 h. Iconography
9. Pupils and Followers
 a. Hals' family
 b. Other pupils and followers

The GENERAL BIBLIOGRAPHY includes works which have been cited in the text and selected studies which will be found helpful for other topics discussed within this book. It is arranged under the following headings:

1. Documents and Literary Sources
2. General and Special Art Historical Studies
3. Iconographic Studies
4. Cultural, Social and Economic History
5. History of Haarlem
6. The *Rederijkers*
7. Costume

List of Abbreviations used in the Text and Bibliographical Note

Bartsch Adam Bartsch, *Le Peintre Graveur*. 21 vols. Leipzig, 1854–76.

Bredius A. Bredius, *Rembrandt: The Complete Edition of the Paintings*. Revised by H. Gerson. 3rd ed., London and New York, 1969.

GBA *Gazette des Beaux-Arts*.

OH *Oud-Holland: Nieuwe Bijdragen voor de Geschiedenis der Nederlandsche Kunst, Letterkunde, Nijverheid, enz.*

Bibliography on Frans Hals

1. DOCUMENTS

Willigen, A. van der. *Les Artistes de Harlem*. 2nd ed., Harlem, 1870.
Revised edition of the Dutch edition published in 1866. An early systematic review of the documents which should be collated with those published by Bredius.

Bredius, A. 'De Geschiedenis van een Schutterstuk', *OH*, XXXI, 1913, pp. 81–84.
Documents related to *The Corporalship of Captain Reynier Reael*, commissioned from Hals in 1633 and finally completed by Pieter Codde in 1637.

Bredius, A. 'De ouders van Frans Hals', *OH*, XXXII, 1914, p. 216.

Bredius, A. *Künstler-Inventare: Urkunden zur Geschichte der holländischen Kunst des XVI^{ten} XVII^{ten} und XVIII^{ten} Jahrhunderts*.
Lists of 17th and 18th century inventories which include scattered references to Hals' paintings. Most of these works remain unidentified. A comparison of the generally low prices at which they were appraised with the evaluations placed on works by other Dutch artists indicates that Hals was not a favourite of collectors during this period.

Bredius, A. 'Een conflict tusschen Frans Hals en Judith Leyster', *OH*, XXXV, 1917, pp. 71ff.
On Judith Leyster's law-suit against Hals for taking an apprentice who deserted her studio.

Bredius, A. 'Heeft Frans Hals zijn vrouw geslagen?', *OH*, XXXIX, 1921, pp. 64ff.
Publication of documents which indicate that the man reprimanded for drunkenness and immoderate acts at Haarlem in 1616 was the weaver Frans Corneliszoon Hals, not the painter Frans Franszoon Hals.

Bredius, A. 'Archiefsprokkels betreffende Frans Hals', *OH*, XLI, 1923–24, pp. 19–31.
Many important additions based on material in the Haarlem Municipal Archives.

Roey, J. van. 'Frans Hals van Antwerpen: Nieuwe gegevens over de ouders van Frans Hals', *Antwerpen*, III, 1957, pp. 1–4.
New documents strongly supporting the hypothesis that Hals was born in Antwerp between 1581–85.

Hees, C. A. van. 'Archivalia betreffende Frans Hals en de zijnen', *OH*, LXXIV, 1959, pp. 36ff.
On the collaboration of Hals and Buytewech, and a reference in an inventory dated November 17, 1631, to a copy of Hals' *Peeckelhaering*.

2. SEVENTEENTH AND EIGHTEENTH CENTURY LITERARY SOURCES

Van Mander, Carel. *Het Schilder Boeck*. . . . Haarlem, 2nd ed., 1618.
Includes an anonymous biography of Van Mander (unpaginated), which states that Hals was Van Mander's pupil.

Ampzing, S. *Het Lof der Stadt Haerlem in Hollant*. Haarlem, 1621.

Ampzing, S. *Beschrijvinge ende Lof der Stad Haerlem in Holland*. Haarlem, 1628.

Buchell, A. van. *Arnoldus Buchelius, 'Res Pictoriae'* (Aanteekeningen over Kunstenaars en Kunstwerken), 1583–1639. Ed. by G. J. Hoogewerff and I. Q. van Regteren Altena. The Hague, 1928.

Schrevelius, T. *Harlemias*. Haarlem, 1648.

Waterloos, H. F. *Hollandsche Parnas*. Vol. I. Amsterdam, 1660.
Includes a poem (p. 408) on Hals' portrait of *Herman Langelius*.

Bie, C. de. *Het Gulden Cabinet van de edele vry schilderconst*. Antwerp, 1661.

Monconys, B. de. *Journal des Voyages*. 3 vols. Lyon, 1665–66.
For a compilation of this widely travelled French nobleman's references to art, see A. Marsy, *Balthasar de Monconys, Analyse de ses voyages au point de vue artistique*. Caen, 1880.

Houbraken, A. *De Groote Schouburgh der Nederlantsche Konstschilders en Schilderessen*. 3 vols. Amsterdam, 1718–21.
Houbraken's biography of Hals, which was used as the major source for information about the artist's life until 19th century scholars began to publish archival material, appears in vol. I, pp. 90ff. A modern reprint of *De Groote Schouburgh*, edited by P. T. A.

Bibliography on Frans Hals

Swillens (3 vols., Maastricht, 1943–53), has handy indexes. See C. Hofstede de Groot, *Arnold Houbraken und seine 'Groote Schouburgh'*, The Hague, 1893, for an analysis of Houbraken's text and sources.

Weyerman, J. C. *De levensbeschryvingen der Nederlandsche Kunstschilders.* 4 vols. The Hague, 1729–69.

The author flagrantly plagiarized Houbraken's text, and the trustworthiness of his original material is questionable. For a defence of his reliability, cf. A. von Wolffers, *L'école néerlandaise et ses historiens*, Brussels, 1888. Also cf. D. J. H. ter Horst, 'De geschriften van Jan Campo Weyermann', *Het Boek*, XXVIII (1944).

Descamps, J. D. *La vie des peintres flamands, allemands et hollandais.* 4 vols. Paris, 1753–63.

Account of Hals (vol. I, pp. 360ff.) is mainly derived from Houbraken.

Loosjes P.z., A. *Frans Hals; Lierzang.* Haarlem, 1789.

A poem in praise of Hals read at the distribution of prizes awarded by the Haarlem Drawing Academy in 1789. The published poem includes some reliable as well as some less reliable notes on the artist's life and works.

Reynolds, Sir Joshua. *Discourses on Art.* Edited by R. R. Wark, San Marino, California, 1959.

3. PAINTING CATALOGUES

Hofstede de Groot, C. *Beschreibendes und kritisches Verzeichnis der Werke der hervorragendsten holländischen Maler des XVII. Jahrhunderts.* Vol. III, Frans Hals . . ., Esslingen a.N. – Paris, 1910. English translation of vol. III by E. G. Hawke, London, 1910.

Indispensable for its provenances and numerous references to untraceable or unidentified pictures. Includes a biography as well as a brief discussion of pupils and followers. No reproductions. Hofstede de Groot's own annotated copy of his catalogue and notes made for a projected supplement to it are at The Netherlands Institute for Art History, The Hague.

Bode W. v. and M. J. Binder. *Frans Hals: sein Leben und seine Werke.* 2 vols. Berlin, 1914. English trans. by M. W. Brockwell, Berlin, 1914.

Edited by Bode with a short essay by Binder. Sumptuously illustrated catalogue, including some reproductions of versions and variants of Hals' works by his followers. Minimal notes on the individual paintings.

Valentiner, W. R. *Frans Hals . . . mit einer Vorrede von Karl Voll* (*Klassiker der Kunst*, vol. XXVIII). Stuttgart-Berlin, 1921; 2nd revised edition, Stuttgart-Berlin-Leipzig, 1923.

Brief critical notes. Valentiner published additions to his corpus in *Art in America*, XVI, 1928, pp. 235ff;

XXIII, 1935, pp. 85ff.

Valentiner, W. R. *Frans Hals Paintings in America.* Westport, Connecticut, 1936.

Trivas, N. S. *The Paintings of Frans Hals.* New York, 1941.

The documentation of the history of the paintings included in this critical *catalogue raisonné* is thorough; however, the author eliminated numerous original works when he rejected about two-thirds of the paintings published by Bode and Valentiner.

4. EXHIBITION CATALOGUES

Detroit, 1935. *An Exhibition of Fifty Paintings by Frans Hals.* Jan. 10–Feb. 28, 1935. The Detroit Institute of Arts.

Introduction and catalogue by W. R. Valentiner.

Haarlem, 1937. *Frans Hals. Tentoonstelling ter gelegenheid van het 75-jarig bestaan van het Gemeentelijk Museum te Haarlem.* 1 July–30 Sept., 1937. Frans Hals Museum Haarlem.

Introduction by G. D. Gratama; catalogue by G. D. Gratama and J. L. A. A. M. van Rijkevorsel.

Haarlem, 1962. *Frans Hals. Exhibition on the Occasion of the Centenary of the Municipal Museum at Haarlem.* June 16–Sept. 30, 1962. Frans Hals Museum, Haarlem.

Introduction by H. P. Baard; catalogue by S. Slive.

5. MONOGRAPHS

Bode, W. *Frans Hals und seine Schule.* Leipzig, 1871.

This pioneer monograph was Bode's dissertation. Reprinted in *Jahrbücher für Kunstwissenschaft*, IV, 1871. Includes a transcription of Mathias Scheits' notes on Hals' life which the Hamburg painter appended to his copy of *Het Schilder Boek*, June 23, 1679.

Bode, W. *Studien zur Geschichte der holländischen Malerei.* Braunschweig, 1883.

The chapters on Hals are an expanded version of Bode's 1871 dissertation. In this work he appended a list of 155 paintings which he attributed to Hals. His list grew rapidly; when he published his 1914 catalogue of the master's works (cf. above) he listed around 280 paintings.

Knackfuss, H. *Franz Hals.* Bielefeld and Leipzig, 2nd ed., 1896.

Davies, G. S. *Frans Hals.* London, 1902.

Of this monograph, W. M[artin]., *The Burlington Magazine*, II, 1903, p. 109, rightly noted: '. . . as a critical guide to the art of Frans Hals it is wholly untrustworthy.'

Moes, E. W. *Frans Hals, sa vie et son oeuvre.* Traduit par J. de Bosschere. Brussels, 1909.

Monograph which incorporates the documentary material known at the date of its publication. Includes a list of paintings.

Fontainas, A. *Frans Hals*. Paris, 1909.

Péladan, J. *Frans Hals*. Paris, 1912.

Lucas, E. V. *Frans Hals*. London, [1926].

Dülberg, F. *Frans Hals: ein Leben und ein Werk*. Stuttgart, 1930.
Still worth consulting.

Gratama, G. D. *Frans Hals*. The Hague, 1943 [1944]; 2nd ed. 1946.
The author was director of the Frans Hals Museum at Haarlem and principal organizer of the Hals exhibition held at Haarlem in 1937.

Luns, Th. M. H *Frans Hals*. Amsterdam, [1946].

Höhne, E. *Frans Hals*, Leipzig, 1957.

Senenko, M. S. *Frans Hals*. Moscow, 1965. [Russian text].

Descargues, P. *Hals*. Geneva, 1968. English trans. by J. Emmons, Cleveland, 1968.

6. LEXICA

Immerzeel, J. *De levens en werken der Hollandsche en Vlaamsche kunstschilders, beeldhouwers, graveurs en bouwmeesters*. 3 vols. Amsterdam, 1842–43.
The entry on Hals in this pioneer lexicon appears in vol. II (1843), pp. 10–11.

Kramm, C. *De levens en werken der Hollandsche en Vlaamsche Kunstschilders . . .* Amsterdam, 1857–64.
Additions to Immerzeel.

Wurzbach, A von. *Niederländisches Künstler-Lexikon*. 3 vols. Vienna-Leipzig, 1906–11.
The entry on the artist by this peppery lexicographer is principally worth consulting for his useful list of prints made after Hals works. His list should be collated with F. W. H. Hollstein, *Dutch and Flemish Etchings, Engravings and Woodcuts*. Vol. I–. Amsterdam, n.d.

Hofstede de Groot, C. 'Frans Hals' in *Allgemeines Lexikon der bildender Künste*, edited by U. Thieme and F. Becker, vol. XV, 1922, pp. 531ff.

Juynboll, W. R. 'Frans Hals' article in *Winkler Prins van de Kunst*. Vol. II, Amsterdam–Brussels, 1959, pp. 153ff.

Slive, S. 'Frans Hals'. Article in *Encyclopedia of World Art*. Vol. VII, New York, Toronto, London, 1963, 264ff. (Italian trans. *Enciclopedia Universale dell'Arte*. Vol. VII Venice, Rome, 1962, pp. 78ff.)

Gerson, H. 'Frans Hals.' Article in *Kindlers Malerei Lexikon*, vol. III. Zurich, 1966, pp. 30ff.

7. GENERAL STUDIES AND CRITICAL ESSAYS

Eynden, R. van and A. van der Willigen. *Geschiedenis der Vaderlandse Schilderkunst sedert de helft der XVIII eeuw*. 4 vols. Haarlem, 1816–40.
A brief account of Hals is found in vol. I (1816), pp. 374ff. The authors, who had a special interest in artists who worked after 1750, note that C. van Noorde, J. G. Waldorp and W. Hendriks made skilful drawings after the master's paintings.

Nieuwenhuys, C. J. *A Review of the Lives and Works of Some of the Most Eminent Painters.* London, 1834.
Includes a brief, early effort to stimulate interest in Hals. The author, who was a powerful *marchand-amateur*, regrets that some of 'Francis Hals' works are so negligently finished, ' . . . still I must confess, that they are not at the present time duly appreciated . . . [they] are worthy a place in the finest collections' (p. 131). Gault de Saint Germain voiced the same opinion more than a decade earlier in his *Guide des amateurs des tableaux pour les écoles allemande, flamande et hollandaise*, Paris, 1818, p. 281.

Bürger, W. [E. J. T. Thoré]. *Les Musées de Hollande*. 2 vols. Paris, 1858–60.
Appreciative appraisals of Hals' works in Dutch museums by a leading 19th-century French connoisseur and historian. Also cf. his important articles in the *GBA*, 1868, cited below.

Bürger, W. [E. J. T. Thoré]. 'Frans Hals', *GBA*, XXIV, 1868, pp. 219ff.; 431ff.
Path-breaking study of Hals' life and works. The author is best known for rediscovering Vermeer (*GBA*, 1866). His effort to rehabilitate Hals' reputation is less sensational but equally interesting; see a forthcoming study by Frances Jowell, 'Thoré-Bürger and the Revival of Frans Hals'.

Unger, W. *Etsen naar Frans Hals*. Met eene verhandeling over den schilder door C. Vosmaer. Leiden, 1873.
This edition of etchings after Hals' works also was published with English, German and French translations of Vosmaer's text.

Fromentin, E. *Les Maîtres d'Autrefois Belgique–Hollande*. Paris, 1876.
This frequently translated and reprinted classic of nineteenth-century criticism contains a penetrating chapter on Hals. For a brilliant analysis of Fromentin's critical approach see Meyer Schapiro's introduction to the English translation: *The Old Masters of Belgium and Holland*, New York, 1963 (paperback).

Bode, W. 'Frans Hals', *Kunst und Künstler Deutschlands und der Niederlande . . .* , vol. I, no. 22, edited by R. Dohme, Leipzig, 1877, pp. 79–112.

Bibliography on Frans Hals

Bode, W. *Rembrandt und seine Zeitgenossen*. Leipzig, 1906. Characterization of the achievement of Hals and other leading Dutch and Flemish Baroque painters. English translation of revised 2nd edition (1907) by M. L. Clarke, *Great Masters of Dutch and Flemish Painting*, London – New York, 1909.

Veldherr, J. G., C. J. Gonnet and F. Schmidt-Degener. *Frans Hals in Haarlem*. Amsterdam, 1908.

Bode, W. von. *Die Meister der holländischen und vlämischen Malerschulen*. Leipzig, 1917.
A much expanded and partly reworked edition of the author's *Rembrandt und seine Zeitgenossen* (1906). The 8th edition, Leipzig, 1956, has notes by E. Plietzsch.

Rothes, W. *Franz Hals und die holländische Figurenmalerei* (*Die Kunst dem Volke*, no. 37), Munich, 1919.

Schmidt-Degener, F. *Frans Hals*. Amsterdam, 1924.
A short essay; reprinted in F. Schmidt-Degener, *Het Blijvend Beeld der Hollandse Kunst*, Amsterdam, 1949, pp. 68ff.

Konrady, V. *Frans Hals*. Moscow, 1933. [Russian text.]

Martin, W. *De Hollandsche Schilderkunst in de Zeventiende Eeuw*. 2 vols. Amsterdam, 1935–36; 2nd ed. 1942.
Vol. I (*Frans Hals en zijn tijd*) offers a vast amount of material about Hals and his contemporaries. Extensive notes.

Dantzig, M. M. van. *Frans Hals: Echt of Onecht*. Amsterdam, 1937.
An unsuccessful attempt to establish by a check-list system the authenticity of Hals' paintings exhibited at the 1937 controversial loan exhibition of the artist's works held at Haarlem.

Volskaya, V. *Frans Hals*. Moscow, 1937. [Russian text.]

Plietzsch, E. *Frans Hals*. Burg b. M. [1940].
Little picture book with a brief introduction.

Bauch, K. *Frans Hals*. Cologne, 1942.
A lecture delivered to the Freunde des Wallraf-Richartz-Museum in 1942.

Gerson, H. *De Nederlandse Schilderkunst*, vol. I: *Van Geertgen tot Frans Hals*. Amsterdam, 1950.
Includes a good survey of Hals and his contemporaries.

Roitenberg, O. O. *Hals*. Moscow, 1957. [Russian text.]

Dobrzycka, A. *Hals*. Warsaw, 1958.

Beeren, W. A. *Frans Hals*. Utrecht [1962].

Rosenberg, J., S. Slive, E. H. ter Kuile, *Dutch Art and Architecture: 1600-1800*. The Pelican History of Art Series, Harmondsworth, Baltimore, Ringwood, 1966, pp. 30ff.

Linnik, I. *Frans Hals*. Leningrad, 1967. [Russian text.]

Novotny, F. 'Bei Betrachtung der Frans Hals-Ausstellung in Haarlem 1962', essay in *Über das 'Elementare' in der Kunstgeschichte und andere Aufsätze*. Vienna, 1968, pp. 172ff.

Berger, J. 'Hals' in *The Moment of Cubism and Other. Essays*, London, 1969, pp. 124ff.

8. SPECIAL STUDIES

a. BIBLICAL SUBJECTS

Linnick, I. 'Newly Discovered Paintings by Frans Hals', *Iskusstvo*, no. 10, 1969, pp. 70ff. [Russian text.]
Publication of Hals' *St. Luke* and *St. Matthew* at Odessa. Also see Linnick's note in *Soobcheniia Gosudarstvennogo Ermitazha*, XVII, 1960, pp. 40ff. [Russian Text.]

Slive, S. 'Frans Hals Studies II: St. Luke and St. Matthew at Odessa', *OH*, LXXVI, 1961, pp. 174ff.

b. PORTRAITURE

Rathke, E. *Bildnistypen bei Frans Hals*. Typescript, unpublished dissertation, Cologne University [1954].

c. GROUP PORTRAITS

Riegl, A. 'Das holländische Gruppenporträt', *Jahrbuch der preussischen Kunstsammlungen*, XIII, 1902, pp. 71–278.
Riegl's ideas about a Dutch *Kunstwollen* ('will-to-form'), not to mention a distinct Haarlem *Kunstwollen* as opposed to an Amsterdam one, are debatable. Nevertheless the work remains a fundamental study of Dutch group portraiture from Geertgen tot Sint Jans to Rembrandt and includes penetrating observations on Hals' militia and regent pieces. Reprinted Vienna, 1931, 2 vols., with notes by L. Münz.

Baard, H. P. *Frans Hals: Schuttersmaaltijd der Officieren van de Sint Jorisdoelen, Anno 1616*, Leiden, 1948.

Baard, H. P. *Schutterstukken*. Amsterdam, 1948. Translated into English (1949) and French (1950). Includes excellent reproductions of all the civic guard groups.

Baard, H. P. *Frans Hals en het Haarlemse Groepportret in het Gemeentemuseum: 1528-1737*. Haarlem, 1949.

Valkenburg, C. C. van. 'De Haarlemse Schuttersstukken: I. Maaltijd van Officieren van de Sint Jorisdoelen (Frans Hals, 1616). Identicatie der voorgestelde schuttersofficieren', *Haerlem Jaarboek 1958*, Haarlem, 1959, pp. 59ff.; 'De Haarlemse Schuttersstukken: IV. Maaltijd van officieren van de Sint Jorisdoelen (Frans Hals, 1627), V. Maaltijd van officieren van de Cluveniersdoelen (Frans Hals, 1627), VI. Officieren en onderofficieren van de Cluveniersdoelen (Frans Hals, 1633), VII. Officieren en onderofficieren van de Sint Jorisdoelen (Frans Hals, 1639),' *Ibid.*, 1961, Haarlem, 1962, pp. 47ff.

Publication of the results of painstaking archival work which establishes the identity of most of the officers and men represented in the group portraits Hals painted of the Haarlem civic guards.

Slive, S. *Frans Hals Schützengilde St. Georg 1616*. Stuttgart, 1962.

Vinken, P. J. and E. de Jongh. 'De Boosaardigheid van Hals' regenten en regentessen', *OH* LXXVIII, 1963, pp. Iff.
A valuable survey of the history of the criticism of Hals' group portraits of the *Regents* and *Regentesses of the Old Men's Alms House* at Haarlem, but the authors' argument that neither Hals nor any portraitist can portray even an aspect of a sitter's character is unconvincing.

Kauffmann, H. 'Die Schützenbilder des Frans Hals', in *Walter Friedlaender zum 90. Geburtstag*, Berlin, 1965, pp. 101ff.

Slive, S. 'A Proposed Reconstruction of a Family Portrait by Frans Hals', *Miscellanea: I. Q. van Regteren Altena*. Amsterdam, 1969, pp. 114ff.

d. GENRE

Hofstede de Groot, C. 'Frans Hals as a Genre Painter', *The Art News*, vol. XXVI, April 14, 1928, pp. 45ff.

e. LANDSCAPE

Bode, W. von. 'Frans Hals als Landschafter', *Kunst und Künstler*, XX, 1922, pp. 223–228.

f. DRAWINGS

Térey, G. von, 'Eine Zeichnung von Frans Hals', *Kunstchronik*, N.F. XXVI, 1915, pp. 469ff.
Unconvincing publication of a chalk drawing at the Städelsches Kunstinstitut, Frankfurt, as a preliminary study for the *Portrait of a Man*, 1634, at Budapest. The drawing is a copy after the Budapest painting.

Regteren Altena, I. Q. van. 'Frans Hals Teekenaar', *OH*, XLVI, 1929, pp. 149–152.
Publication of a chalk drawing at the British Museum as a preliminary study for the late *Portrait of a Man* at Leningrad. The ascription is not compelling.

g. CLEANING AND RESTORATION

Wild, C. F. L. de. 'Het Rapport-De Wild over de Schilderijen van Frans Hals te Haarlem', *Bulletin van den Nederlandschen Oudheidkundigen Bond*, 2nd ser., III, 1910, pp. 41ff.
Report on the condition of the Hals paintings in Haarlem with a brief introduction by W. Martin. De

Wild's paper convinced the authorities at Haarlem that the master's paintings needed cleaning. The work got under way with the restoration of the 1641 regent piece in 1918. This caused a familiar flurry of excitement; critics claimed that glazes as well as discoloured varnishes had been removed by the cleaner. The authorities, however, were satisfied that there was no foundation to this assertion, and work was done on other paintings. The 1616 St. George Banquet piece was cleaned in 1920 and to judge from contemporary reports the effect of the removal of its nearly opaque brown varnish was sensational. Amongst other things, it was discovered that the large green curtain in the upper right had been overpainted at a later date with dark brown. The restoration of other paintings revealed less startling but nonetheless significant changes. The following articles are all related to this cleaning campaign:

i. Gratama, G. D. 'De Schoonmaak van de "Regenten van het St. Elizabeth's Gasthuis" van Frans Hals', *Bulletin van den Nederlandschen Oudheidkundigen Bond*, 2nd ser., XI, 1918, pp. 245ff.
On the cleaning of the 1641 regent piece by C. F. L. de Wild. Includes a reproduction (p. 246, fig. 1) which shows where repaint was found under dirty varnish.

ii. Martin, W. 'Iets over Gele en Vuile Vernislagen. Naar aanleiding van den herboren Frans Hals te Haarlem', *Oude Kunst*, IV, 1919, pp. 3ff.

iii. Gratama, G. D. 'Schoonmaak van de "Maaltijd van Officieren van de St. Jorisdoelen" door Frans Hals', *Bulletin van den Nederlandschen Oudheidkundigen Bond*, 2nd ser., XIII, 1920, pp. 71ff.
Report on C. F. L. de Wild's cleaning of the 1616 civic guard group portrait.

iv. Deyssel, L. van [K J. L. Alberdingk Thijm]. 'De Gerestaureerde Hals' [*St. George Banquet*, 1616] in *Werk der Laatste Jaren*. Amsterdam, 1923, pp. 143ff.
This essay was first published in the *De Nieuwe Gids*, XXXV, 1920, pp. 895ff.

v. Brockwell, M. W. 'The Frans Hals Pictures at Haarlem', *The Connoisseur*, LIX, 1921, pp. 165ff.

vi. Gratama, [G.D.]. 'Le Nettoyage des Tableaux de Frans Hals à Haarlem et le Résultat de Quelques Recherches sur la Restauration en Général', *Actes du Congrès d'Histoire d'Art*, 1921, I, Paris, 1923, pp. 118ff.

vii. Sleen, G. van der. *Quelques recherches à propos du nettoyage des tableaux des Frans Hals à Haarlem*, introduction by G. D. Gratama. *Archives du Musée Teyler*, ser. III, vol. V, Haarlem, 1922.

viii. Gericke, H. 'Die gereinigten Schützen- und

Bibliography on Frans Hals

Regentenstücke des Frans Hals in Haarlem', *Cicerone*, XIV, 1922, pp. 755ff.

Hirschmann, O. 'Neu aufgetauchte Bilder von Frans Hals', *Cicerone*, VIII, 1916, pp. 234ff.
Includes a reproduction of the damaged state of Hals' Portrait of *Nicolaus Stenius* before its restoration, p. 234, fig. 2.

Wild, A. M. de. 'Gemälde-Röntgenographie', *Technische Mitteilungen für Malerei*, no. 20, October 15, 1930, pp. 230ff.
Discussion of the results of X-raying and restoring *Verdonck* at Edinburgh to its original state. For the letter by H. Birzeniek concerning the version of *Verdonck* repainted by a restorer at St. Petersburg at the end of the nineteenth century and De Wild's response, see *ibid.*, no. 24, December 15, 1930, pp. 283ff.

Wild, A. M. de. 'Frans Hals, het portret van Verdonck', *Historia*, III, July, 1937, pp. 18ff.

Goodison, J. W. 'A Cleaned Frans Hals in the Fitzwilliam Museum', *The Burlington Magazine*, XCI, 1949, pp. 197ff.
Thorough report on the restoration of the Cambridge *Portrait of a Man* which revealed the model's large slouch hat.

Baard, H. P. 'Wedergeboorte en lotgevallen van de "Hotinov-Hals"', *OH*, LXXX, 1965, pp. 211ff.
On the removal of overpaint and the further vicissitudes of the *Portrait of a Man* now at the Kimbell Art Foundation, Fort Worth, Texas.

h. ICONOGRAPHY

Muller, F. *Beschrijvende catalogus van 7000 portretten van Nederlanders, en buitenlanders tot Nederland in betrekking staande. . . .* Amsterdam, 1853.

Someren, J. F. van, *Beschrijvende catalogus van gegraveerde portretten van Nederlanders . . . vervolg op Frederik Mullers Catalogus van 7000 portretten van Nederlanders. . . .* 3 vols., Amsterdam, 1888–91.

Moes, E. *Iconographia Batava*. 2 vols. Amsterdam, 1897–1905.
List of painted and engraved Dutch portraits. A revised and enlarged ms. copy of the work is at the Prentenkabinet of the Rijksmuseum, Amsterdam.

Hofstede de Groot, C. 'Een portret van Jacob van Campen door Frans Hals', *OH*, XXXIII, 1915, pp. 16ff.

Valentiner, W. P. 'Jan van de Cappelle', *The Art Quarterly*, IV, 1941, p. 292.
This attempt to identify the *Portrait of a Man*, Mr. and Mrs. Norton Simon Collection, Los Angeles, as Van de Cappelle rests on very flimsy ground.

Kauffmann, H., 'Die fünf Sinne in der Niederländischen

Malerei des 17. Jahrhunderts' in *Kunstgeschichtliche Studien*, Breslau [1943], pp. 133ff.
A study of the treatment of 'The Five Senses' in seventeenth-century Netherlandish painting which includes references to Hals' works.

Pigler, A., 'Le Portrait de Jan Asselyn par Frans Hals', *Bulletin du Musée Hongrois des Beaux-Arts*, no. 2, June, 1948, pp. 26ff.
Debatable identification of the Budapest painting as a portrait of Asselyn.

Gudlaugsson, S. J. 'Een portret van Frans Hals geidentificeerd', *OH*, LXIX, 1954, pp. 235ff.
Identification of the Metropolitan Museum's 1643 portrait of a man as Paulus Verschuur.

Nordström, J. 'Till Cartesius' ikonographi', *Lychnos*, 1957–1958, pp. 194ff.
Exhaustive study of the iconography of Descartes. However, the author's conclusion that Hals' portrait of Descartes is based on Frans van Schooten's engraving is not convincing.

Slive, S. 'Frans Hals' Portrait of Joseph Coymans', *Wadsworth Atheneum Bulletin*, Winter, 1958, pp. 13ff.
Includes a discussion of Hals' four other portraits of members of the Coymans family.

Jongh, E. de and P. J. Vinken. 'Frans Hals als voortzetter van een emblematische traditie', *OH*, LXXVI, 1961, pp. 117ff.
On allegorical meanings in Hals' *Portrait of a Married Couple* (Amsterdam) and a debatable identification of the couple as Isaac Abrahamsz. Massa and Beatrix van der Laen.

Theil, P. J. J. van. 'Frans Hals' portret van de Leidse rederijkersnar Pieter Cornelisz. van der Morsch, alias Piero (1543–1628)', *OH*, LXXVI, 1961, pp. 153ff.
On the iconography of the herring held by Pieter van der Morsch.

Hall, H. van, *Portretten van Nederlandse Beeldende Kunstenaars*, Amsterdam, 1963.
Includes a list of self-portraits attributed to Hals. Also helpful for references to his own portraits of artists as well as portraits which others made of him.

Slive, S. 'On the Meaning of Frans Hals' *Malle Babbe*', *The Burlington Magazine*, CV, 1963, pp. 432ff.

Vis, D. *Rembrandt en Geertje Dircx: de identiteit van Frans Hals' Portret van een schilder en de vrouw van de kunstenaar*. Haarlem, 1965.
Unsuccessful attempt to identify the *Portrait of a Painter* at the Frick Collection and the *Portrait of a Seated Woman* at the Metropolitan Museum as Hals' portraits of Rembrandt and Geertje Dircx respectively.

9. PUPILS AND FOLLOWERS

There are helpful references to members of Hals' circle scattered in some of the works cited above but a full-dress study of the artist's relation to his pupils and followers has not been published. No wonder. His small circle is difficult to circumscribe. Steady disciples were few and, more often than not, his pupils scarcely show a trace of his style. Furthermore, some of the artists who came into his orbit for brief periods – Jan Steen, for example – cannot, strictly speaking, be categorized as his followers. Indeed, the credentials of a few artists who have traditionally been accepted as followers and who are listed here are also open to question. The question poses a neat art-historical problem: how much must an artist take from another before he qualifies as a follower? For additional references to members of Hals' circle see the entries on the individual artists listed in H. van Hall's standard bibliography and the *Bibliography of the Netherlands Institute for Art History*. Although A. Houbraken, *De Groote Schouburgh . . .*, 3 vols., Amsterdam, 1718–21 and A. van der Willigen, *Les Artistes de Harlem*, 2nd ed., Harlem, 1870, are fallible on some points they remain indispensable. C. Hofstede de Groot's articles on Hals' sons in *Allgemeines Lexikon der bildenden Künste*, edited by U. Thieme and F. Becker, vol. xv, 1922, should also be consulted.

a. HALS' FAMILY

i. Dirck Hals (brother; 1591–1656).

Bürger, W. 'Dirck Hals et les fils de Frans Hals', *GBA* xxv, 1868, pp. 390ff.

Bredius, A. 'Archiefsprokkels betreffende Dirk Hals', *OH*, xLI, 1923–24, pp. 60ff.

Haverkamp Begemann, E. *Willem Buytewech*, Amsterdam, 1959.
Includes the best account of Dirck's early years.

ii. Harmen Fransz. Hals (son; 1611–1669).

Bredius, A. 'Het Schildersregister van Jan Sysmus', *OH*, VIII, 1890, p. 12.

Bredius, A. 'Herman Hals te Vianen', *OH*, xxvII, 1909, p. 196.

Bredius, A. 'Archiefsprokkels betreffende Herman Hals', *OH*, xLI, 1923–24, p. 62; p. 249.

Wiersum, E. 'Harmen Hals te Vianen', *OH*, LII, 1935, p. 40.
A document regarding a debt for rent which was settled by the payment of 60 florins and one day's painting. It is interesting to conjecture what he produced in a day.

iii. Frans Fransz. Hals II (son; 1618–1669).

Bredius, A. 'De Schilder François Ryckhals', *OH*, xxxv, 1917, pp. 1ff.
Important article which established the identity of Ryckhals and showed that he painted the still-lifes formerly ascribed to Frans II.

Bredius, A. 'Eenige gegevens over Frans Hals den jonge', *OH*, xLI, 1923–24, p. 215.

iv. Jan (Johannes) Hals (son; active ca. 1635–1674).

Bredius, A. 'Een Schilderij van Jan Hals [Homer] door Vondel Bezongen', *OH*, vi, 1888, p. 304.

Bredius, A. 'Oorkonden over Jan Hals', *OH*, xLI, 1923–24, pp. 263f.

Slive, S. 'Frans Hals Studies, III: Jan Franszoon Hals', *OH*, LxxvI, 1961, pp. 176ff.

v. Reynier Fransz. Hals (son; 1627–1672).

Bredius, A. 'Het Schildersregister van Jan Sysmus', *OH*, VIII, 1890, p. 12.

Hofstede de Groot, 'Reynier and Claes Hals', *The Burlington Magazine*, xxxvIII, 1921, pp. 92ff.

Bredius, A. 'Oorkonden over Reynier Hals', *OH*, xLI, 1923–24, pp. 258ff.

vi. Nicolaes (Claes) Fransz. Hals (son; 1628–1686).

Hofstede de Groot, C. 'Reynier and Claes Hals', *The Burlington Magazine*, xxxvIII, 1921, pp. 92ff.

Bredius, A. 'Claes Hals: I'. *The Burlington Magazine*, xxxvIII, 1921, pp. 138ff.

Borenius, T. 'Claes Hals: II', *The Burlington Magazine*, xxxvIII, 1921, p. 143.

vii. Antonie Dircksz. Hals (nephew; 1621– before 1702).
The little that is known about Dirck's son is cited in Hofstede de Groot's article in Thieme-Becker.

viii. Pieter Roestraten (son-in-law; ca. 1630–1700).

Hees, C. A. van. 'Archivalia betreffende Frans Hals en de zijnen', *OH*, LxxIV, 1959, pp. 40f.
Document of 1651 stating that Roestraten had been working in Hals' house for five years. In 1654 he married Hals' daughter Adriaentgen.

b. OTHER PUPILS AND FOLLOWERS

i. Hendrick Pot (c. 1585–1657).

Bredius, A. and P. Haverkorn van Rijsewijk. 'Hendrick Gerritsz. Pot', *OH*, v, 1887, pp. 161ff.

ii. Thomas de Keyser (1596/97–1667).

Oldenbourg, R. *Thomas de Keysers Tätigkeit als Maler*. Leipzig, 1911.

iii. Johannes Verspronck (1597–1662).

Kalff, S. 'Een Haarlemsch portretschilder uit de gouden eeuw', *De Nieuwe Gids*, 34² (1918), pp. 745ff.

Bibliography on Frans Hals

iv. Pieter Codde (1599–1678).

Dozy, C. M. 'Pieter Codde, de Schilder en de Dichter', *OH*, II, 1884, pp. 35ff.

Bredius, A. 'De Geschiedenis van een Schutterstuk', *OH*, XXXI, 1913, pp. 81ff.
 On the Amsterdam civic guard piece which Hals began in 1633 and which Codde finished in 1637.

Brandt, Jr., P. 'Notities over het leven en werk van den Amsterdamschen Schilder Pieter Codde', *Historia*, XII, 1947, pp. 27ff.

v. Pieter Soutman (active ca. 1619 – died 1657).

'Pieter Soutman' in *Allgemeines Lexikon der bildenden Künstler*, edited by U. Thieme and F. Becker, vol. XXXI, 1937, p. 313, based on notes by A. Bredius and M. D. Henkel.
 This interesting Dutchman, who first emulated Rubens and then, for a period, was influenced by Hals, deserves further study.

vi. Judith Leyster (1609–1660).

Hofstede de Groot, C. 'Judith Leyster', *Jahrbuch der königlich preussischen Kunstsammlungen*, XIV, 1893, pp. 190ff; p. 232.

Bredius, A. 'Een conflict tusschen Frans Hals en Judith Leyster', *OH*, XXXV, 1917, pp. 71ff.

Harms, J. 'Judith Leyster. Ihr Leben und ihr Werk', *OH* XILV, 1927, pp. 88ff, pp. 113ff; pp. 145ff; pp. 221ff; pp. 275 ff.
 Aspects of this dissertation were corrected by Neurdenburg and Wijnman (cf. below).

Neurdenburg, E. 'Judith Leyster', *OH*, XLVI, 1929, pp. 26ff.

Wijnman, H. F. 'Het geboortejaar van Judith Leyster', *OH*, XLIX, 1932, pp. 62ff.
 Establishes that she was born in 1609 (baptized July 28).

vii. Dirck van Delen (1604/5–1671).

Houbraken's statement (*De Groote Schouburgh* vol. III, p. 309) that this architectural painter was Hals' pupil was not taken seriously until Plietzsch (*Wallraf-Richartz Jahrbuch*, XVIII, 1956, p. 193) noted Van Delen's close connection with Dirck Hals. Plietzsch suggests that if Van Delen had contact with Dirck he possibly worked with Frans too. Plietzsch adds that if this was the case Frans Hals probably painted interiors which are now lost. However, none of Hals' existing works support this ingenious hypothesis.

viii. Adriaen Brouwer (1605/6–1638).

Unger, J. H. W. 'A. Brouwer te Haarlem', *OH*, II, 1884 pp. 161ff.

Schmidt-Degener, F. *Adriaen Brouwer et son évolution artistique*. Brussels, 1908.

Hofstede de Groot, C. *Beschreibendes und kritisches Verzeichnis der Werke der hervorragendsten holländischen Maler des XVII. Jahrhunderts*. Vol. III, . . . Adriaen Brouwer, Esslingen a. N.-Paris, 1910.

Bode, W. von. *Adriaen Brouwer, sein Leben und seine Werke*. Berlin, 1924.

Schneider, H. 'Bildnisse des Adriaen Brouwer' in *Festschrift für Max J. Friedländer zum 60. Geburtstage*. Leipzig, 1927.
 Suggests, with sensible reservations, that Brouwer's *Portrait of a Man* at the Mauritshuis (Cat. 1935, no. 607) may be a portrait of Hals.

Höhne, E. *Adriaen Brouwer*. Leipzig, 1960.

Knuttel, G. *Adriaen Brouwer; the Master and his Work*. Translated by J. G. Talma-Schilthuis and R. Wheaton. The Hague, 1962.

ix. Jan Miense Moelenaer (c. 1609–1668)

Bode, W. and A. Bredius, 'Der haarlemer Maler Johannes Molenaer in Amsterdam', *Jahrbuch der Königlich Preussischen Kunstsammlungen*, XI, 1890, pp. 65ff.

Bredius, A. 'Jan Miense Molenaer. Nieuwe gegevens omtrent zijn leven en zijn werk', *OH*, XXVI, 1908, pp. 41ff.

Plietzsch, E. *Holländische und Flämische Maler des XVII. Jahrhunderts*, Leipzig, 1960, pp. 27ff.

Thiel, P. J. J. van. 'Marriage Symbolism in a Musical Party', *Simiolus* II, 1967–68, pp. 91ff.
 Iconographic study of Molenaer's so-called *Musical Party*, Richmond, The Virginia Museum of Fine Arts.

x. Adriaen van Ostade (1610–1685).

Gaedertz, T. *Adrian van Ostade. Sein Leben und seine Kunst*. Lübeck, 1869.

Hofstede de Groot, C. *Beschreibendes und kritisches Verzeichnis der Werke der hervorragendsten holländischen Maler des XVII. Jahrhunderts*. Vol. III, . . . Adriaen van Ostade . . ., Esslingen a.N.-Paris, 1910.

Rovinski, D., and N. Tschetchouline. *L'Oeuvre gravé d'Adrien van Ostade*. St. Petersbourg, 1912.

Klessmann, R. 'Die Anfänge des Bauerninterieurs bei den Brüdern Ostade', *Jahrbuch der Berliner Museen*, II, 1960, pp. 92ff.

Kusnetzov, J. *Catalogue of Adriaen van Ostade Exhibition held at the Hermitage*. Leningrad, 1960. [In Russian.]
 Excellent introductory essay and catalogue.

xi. Bartolomeus van der Helst (1613–1670).

Gelder, J. J. de. *Bartholomeus van der Helst*. Rotterdam, 1921.
 Standard monograph with *oeuvre catalogue*.

xii. Philips Wouwerman (1619–1668).

Bie, C. de *Het Gulden Cabinet van de edele vry schilderconst*. Antwerp, 1661.

Bredius, A. 'Het Schildersregister van Jan Sysmus', *OH*, VIII, 1890, p. 8.
> Sysmus noted in his register, written between 1669 and 1678, that Wouwerman was a 'discipel van Frans Hals, conterfeiter'.

Hofstede de Groot, C. *Beschreibendes und kritisches Verzeichnis der Werke der hervorragendsten holländischen Maler des XVII. Jahrhunderts*. Vol. II, . . . Philips Wouwerman, Esslingen a. N.-Paris, 1908.

xiii. Jan de Bray (c. 1627–1697).

Moltke, J. W. von. 'Jan de Bray', *Marburger Jahrbuch für Kunstwissenschaft*, 11–12 (1938–39), pp. 421ff.

Basic study with *oeuvre* catalogue. For the attribution of some portraits formerly ascribed to De Bray to Paulus Bor see S. J. Gudlaugsson, 'Paulus Bor als portrettist', *Miscellanea I. Q. van Regteren Altena*, Amsterdam, 1969, pp. 120ff.

xiv. Vincent van der Vinne (1628/9–1702).

Valentiner, W. R. 'Ein Familienbild des Leendert van der Cooghen', *Pantheon*, X, 1932, pp. 212ff.
> Although the portrait published here is probably not a group portrait of Van der Vinne and his family or painted by Van der Cooghen, the article includes useful material about Van der Vinne.

'Vincent Laurensz. van der Vinne (I)' in *Allgemeines Lexikon der bildenden Künstler*, edited by U. Thieme and F. Becker, vol. XXXIV, 1940, pp. 393f., based on notes by H. Gerson.

General Bibliography

I. DOCUMENTS AND LITERARY SOURCES

Rutgers van der Loeff, J. D. *Drie Lofdichten op Haarlem*. Haarlem, 1911.
> Includes publication of the manuscript of Van Mander's 1596 poem 'Het beelt van Haerlem de stadt, waerin is te lesen Haer gelegentheijt, aert, en out, heerlijck wesen' which praises the beauties and pleasures of the countryside around Haarlem. E. K. J. Reznicek first called attention of the relevance of this poem to art historians in *Die Zeichnungen von Hendrick Goltzius*, 2 vols., Utrecht, 1961.

Sainsbury, W. Nöel. *Original Unpublished Papers Illustrative of the Life of Sir P. P. Rubens*, London, 1859.
> Publication of Sir Dudley Carleton's 1616 letter appraising the art scene in Haarlem and Amsterdam.

Nieuwe Ordonnatie van de Schutterije der Stadt Haerlem. Haerlem, 1633.
> Publication of 52 ordinances passed by the Haarlem authorities in 1621 to control the conduct of the city's civic guards. It includes ordinances intended to regulate drinking and general behaviour at the banquets given to the officers of the guards. The manuscript of the ordinances, which is in the Haarlem Municipal Archives (*Oud Archief Schutterij*, no. 21), is dated December 31, 1621; reprinted in A. J. Enschedé, *Inventaris van het Archief der Stad Haarlem*, 1846, vol. II, no. 151.

Worp, J. A. 'Fragment eener Autobiographie van Constantijn Huygens', *Bijdragen en Mededeelingen van het Historisch Genootschap*, XVIII, 1897, pp. 1ff.
> For a Dutch translation and copiously annotated edition of Huygens' Latin autobiography of ca. 1630, see A. H. Kan, *De Jeugd van Constantijn Huygens door hemzelf beschreven*, Rotterdam, 1946; this work includes an essay by G. Kamphuis on Huygens as an art critic.

Norgate, Edward. *Miniatura; or, the Art of Limning*. Edited from the manuscript in the Bodleian Library and collated with other manuscripts by M. Hardie, Oxford, 1919.
> Norgate's treatise on limning can be dated ca. 1650.

Temple, Sir William. *Observations upon the United Provinces of the Netherlands*, London, 1672.
> A modern reprint with an introduction by G. N. Clark was published by Cambridge University Press, 1932.

Murris, R. *La Hollande et les Hollandais au XVIIe et au XVIIIe siècles vus par les Français*. Paris, 1925.

Vertue, G. *Note Books*. Published by the Walpole Society,

General Bibliography

xviii (Vertue i), 1930; xx (Vertue ii), 1932; xxii (Vertue iii), 1934; xxiv (Vertue iv), 1936; (Vertue v), 1938; xxix (Index to Vertue i to v), 1947; xxx (Vertue vi), 1954.

2. GENERAL AND SPECIAL ART HISTORICAL STUDIES

Burckhardt, Jacob. 'Ueber die niederländische Genremalerei', *Vorträge 1844–1887*. Basel, 1919.

Dülberg, F. *Das holländische Porträt des XVII. Jahrhundert*. Leipzig, 1923.

Schneider, A. von. *Caravaggio und die Niederländer*. Marburg-Lahn, 1933.
Pioneer monograph on the subject which includes references to Hals. Reprint: Amsterdam, 1967.

Vries, A. B. de. *Het Noord-Nederlandsch portret in de tweede helft van de 16e eeuw*, Amsterdam, 1934.
Study of the Dutch portraitists who preceded Hals.

Martin, W. *De Hollandsche Schilderkunst in de Zeventiende Eeuw*. 2 vols. Amsterdam, 1935–36; 2nd ed., 1942.

Würtenberger, F. *Das holländische Gesellschaftsbild*. Schramberg im Schwarzwald, 1937.

Boon, K. G. *De Schilders voor Rembrandt, de inleiding tot het bloeitijdperk*. Antwerp, 1942.
Useful short study of the transition from late mannerism to realism.

Waal, H. van de. 'De Staalmeesters en hun Legende', *OH*, lxxi, 1956, pp. 61ff.
History of the criticism of Rembrandt's *Syndics* which includes excellent observations on other Dutch regent pieces and civic guard group portraits.

Plietzsch, Eduard. 'Randbemerkungen zur holländischen Interieurmalerei am Beginn des 17. Jahrhunderts', *Wallraf-Richartz Jahrbuch*, xviii, 1956, pp. 174ff.
Includes an account of Dirck Hals as well as an appraisal of Leyster, Molenaer, Codde and other genre painters who have been associated with Hals' circle.

Haverkamp-Begemann, E. *Willem Buytewech*. Amsterdam, 1959.
A standard monograph with an excellent survey of early seventeenth-century Dutch genre painting.

Fremantle, K. *The Baroque Town Hall of Amsterdam*, Utrecht, 1959.
Includes a valuable account of life and culture in Amsterdam around the middle of the seventeenth century.

Plietzsch, E. *Holländische und Flämische Maler des XVII. Jahrhundert*, Leipzig, 1960.
Includes essays on members of Hals' circle.

Reznicek, E. K. J. *Die Zeichnungen von Hendrick Goltzius*. 2 vols. Utrecht, 1961.

Indispensable for its discussion of the style and art theory of the late mannerists and early realists.

Rosenberg, J., S. Slive, E. H. ter Kuile, *Dutch Art and Architecture: 1600–1800*. The Pelican History of Art Series, Harmondsworth, Baltimore, Ringwood, 1966.

3. ICONOGRAPHIC STUDIES

Rudolph, H. '"Vanitas": die Bedeutung mittelalterlicher und humanistischer Bildinhalte in der niederländischen Malerei des 17. Jahrhunderts', *Festschrift Wilhelm Pinder*. Leipzig, 1938, pp. 405ff.
An important paper that calls attention to allegorical meanings in Dutch painting.

Keyszelitz, R. *Der 'clavis interpretandi' ind er holländischen Malerei des 17. Jahrhunderts*. Typescript, unpublished dissertation, Munich University [1957].
On allegories in Dutch genre painting.

Slive, S. 'Realism and Symbolism in Seventeenth Century Dutch Painting', *Daedalus, Journal of the American Academy of Arts and Sciences*, Summer (1962), pp. 469ff.

Bergström, I. 'Rembrandt's Double-Portrait of Himself and Saskia at the Dresden Gallery', *Nederlands Kunsthistorisch Jaarboek*, xvii, 1966, pp. 143ff.
An iconographic study which shows the close connection of Rembrandt's *Self-Portrait with Saskia on His Lap* with traditional representations of the Prodigal Son. Hals' so-called *Jonker Ramp*, which was painted about a decade earlier, can also be related to representations of the same theme

Jongh, E. de. *Zinne- en Minnebeelden in de Schilderkunst van de Zeventiende Eeuw*, in the series Nederlands en Belgisch Kunstbezit uit Openbare Verzamelingen, 1967.
On emblematic references in painting of the period.

Henkel, A, and A. Schöne, *Emblemata: Handbuch zur Sinnbildkunst des XVI. und XVII. Jahrhunderts*. Stuttgart, 1967.
Exhaustive compendium of Renaissance and Baroque emblems.

4. CULTURAL, SOCIAL AND ECONOMIC HISTORY

Schotel, G. D. J. *Het oudhollandse huisgezin*. Haarlem, 1868.

Schotel, G. D. J. *Het maatschappelijk leven onzer vaderen in de zeventiende eeuw*. Rotterdam, 1869.
Schotel's studies on life in seventeenth-century Holland are still indispensable.

Floerke, H. *Studien zur niederländischen Kunst- und Kulturgeschichte. Die Formen des Kunsthandels, das*

Atelier und die Sammler in den Niederlanden vom 15.–18. Jahrhundert. Munich-Leipzig, 1905.
Still the best survey.

Baasch, E. *Holländische Wirtschaftsgeschichte.* Jena, 1927.

Hoogewerff, G. J. *De geschiedenis van de St. Lucasgilden in Nederland.* Amsterdam, 1947.

Huizinga, J. 'Nederland's beschaving in de zeventiende eeuw' in *Verzamelde Werken,* vol. II, Haarlem, 1948.
Best survey of the culture of the period. A revised and enlarged version of the author's *Holländische Kultur des siebzehnten Jahrhunderts,* Jena, 1932. English translation in *Dutch Civilization in the Seventeenth Century and Other Essays,* London, 1968.

Barbour, V. *Capitalism in Amsterdam in the Seventeenth Century.* The Johns Hopkins University Studies in Historical and Political Science. Series LXVII, no. 1. Baltimore, 1950.

Bainton, R. H. *The Reformation of the Sixteenth Century.* Boston [1952].

Thieme, G. *Kunsthandel in den Niederlanden im 17. Jahrhundert.* Cologne, 1959.

Zumthor, P. *Daily Life in Rembrandt's Holland.* Translated from the French by S. W. Taylor. London, 1962.
Excellent survey of aspects of town and country life.

5. HISTORY OF HAARLEM

Bruyn, G. W. van Oosten de. *De Stad Haarlem en haare Geschiedenis,* Haarlem, 1765.

Koning C., de. *Tafereel der Stad Haarlem en derzelver Geschiednis.* 4 vols., Haarlem, 1807–1808.

Allan, F. *e.a. Geschiedenis en beschrijving van Haarlem. . . .* 4 vols., Haarlem, 1874–1888.

Raaij, W. H. L. Janssen van. *Kroniek der Stad Haarlem.* Haarlem, 1895.

Lintum, C. te. *Das Haarlemer Schützenwesen.* Enschede, 1896.
Comprehensive history of Haarlem's militia companies.

Steur, J. A. G. *Oude Gebouwen in Haarlem.* Haarlem, 1907.

Kurtz, G. H. *Beknopte Geschiedenis van Haarlem.* 3rd edition. Haarlem, 1946.

Loenen, J. van. *De Haarlemse Brouwindustrie voor 1600.* Amsterdam, 1960.

6. THE *Rederijkers*

Schotel, G. D. J. *Geschiedenis der Rederijkers in Nederland.* 2nd ed., Amsterdam, 1871.

Duyse, Pr. van. *De Rederijkkamers in Nederland. Hun invloed op letterkundig, politiek en zedelijk gebied.* 2 vols. Ghent, 1900–1902.

Heppner, A. 'The Popular Theatre of the Rederijkers in the Work of Jan Steen and His Contemporaries', *Journal of the Warburg and Courtauld Institutes,* III, 1939–40, pp. 22ff.

Gudlaugsson, S. J. *De Komedianten bij Jan Steen en Zijn Tijdgenooten.* The Hague, 1945.
Includes a discussion of the *Commedia dell' arte.*

7. COSTUME

Thienen, F. van. *Das Kostüm der Blütezeit Hollands: 1600–1660.* Berlin, 1930.

Thienen, F. W. S. van. 'Een en ander over de Kleeding der Boeren in de Zeventiende Eeuw', *Oudheidkundig Jaarboek,* ser. 4, I, 1932, pp. 145ff.

Kinderen-Besier, J. H. der. *Spelevaart der Mode.* Amsterdam, 1950.

Thienen, F. van. *The Great Age of Holland: 1600–60* (Costume of the Western World Series). London, 1951.

LIST OF TEXT FIGURES

List of Text Figures

List of Text Figures

LIST OF COLOUR PLATES

INDEX

234

Hals, Frans, IDENTIFIED PORTRAITS (contd.)